Edward Ruscha '04

۲۵۱

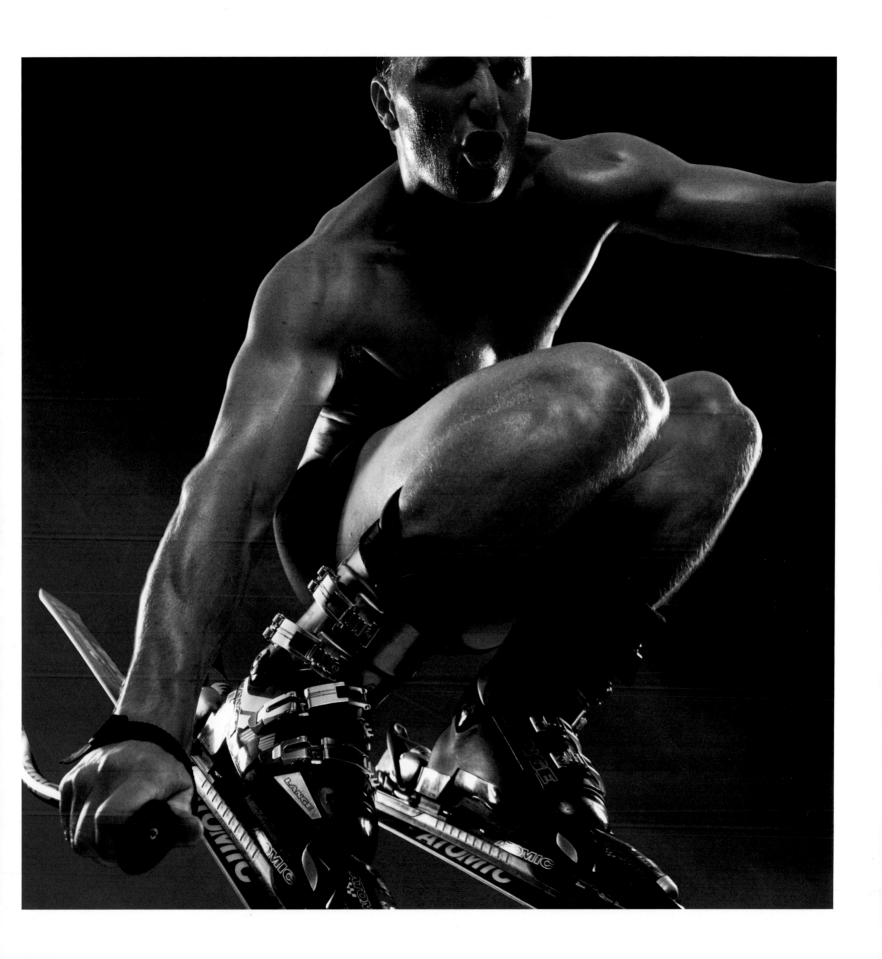

Daron Rahlves
Skiing (Downhill & Super-G)

Giants Stadium, The Meadowlands
East Rutherford, New Jersey

Athlete

photographs by

Howard Schatz

project director/senior editor

Beverly J. Ornstein

foreword by
George Vecsey

afterword by
Ira Berkow

HarperCollins*Publishers*

THE WONDERLAND PRESS

To mark the publication of this book, a set of prints of
the images in this collection will be sold at auction. During the
course of this project, all the athletes signed a "book of memories"
in which, along with their names, they wrote their thoughts about their
sports. This unique "book of memories" will be auctioned off at the same
event. All of the proceeds of that auction will be donated to Special Olympics.

ATHLETE
All photographs © Howard Schatz and Beverly J. Ornstein, 2002
Design © Howard Schatz and Beverly J. Ornstein, 2002
Foreword © George Vecsey, 2002 Afterword © Ira Berkow, 2002
All rights reserved. Printed in Japan.

For information:
HarperCollins Publishers Inc.,
10 East 53rd Street,
New York, NY 10022.

HarperCollins books may be purchased
for educational, business, or sales promotional use.

For information:
Special Markets Department,
HarperCollins Publishers Inc.,
10 East 53rd Street,
New York, NY 10022.

First Edition

Library of Congress Cataloging-in-Publication Data

Schatz, Howard
Athlete / Howard Schatz
p. cm.
ISBN 0-06-019553-3
1. Photography of sports. 2. Athletes—Portraits. 3. Athletes—Biography. I. Title

TR821 .S33 2002 2002017314

779'.9796—dc21

02 03 04 05 06 TOP 10 9 8 7 6 5 4 3 2 1

Book design by Howard Schatz

www.howardschatz.com

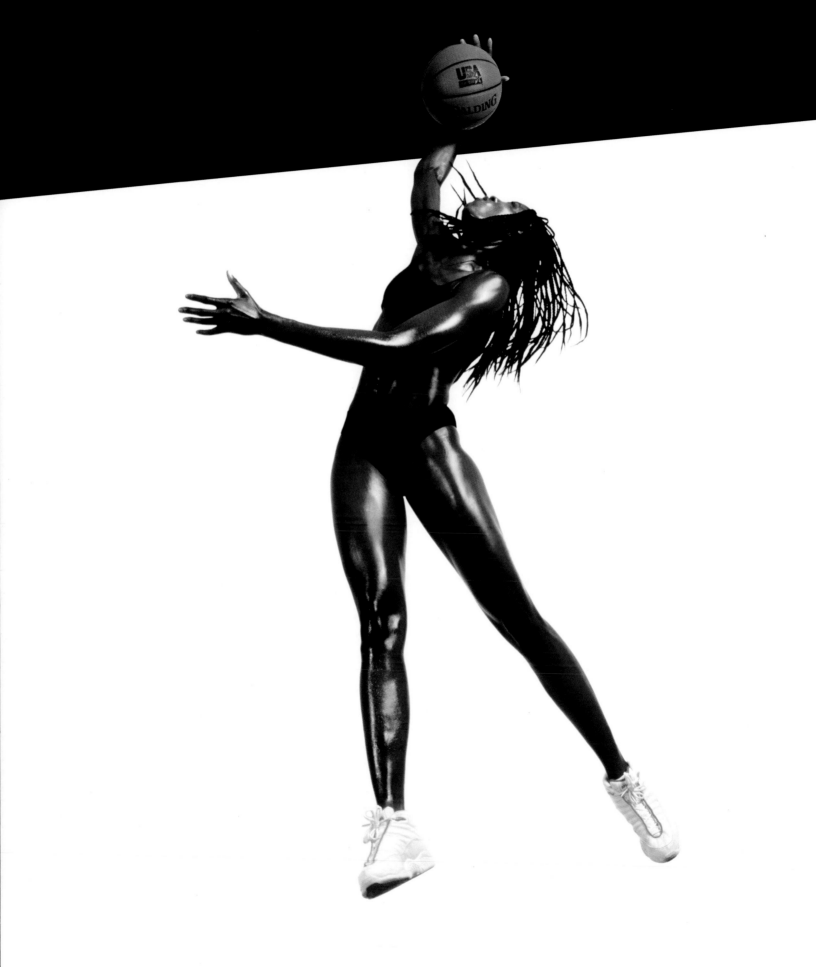

DeLisha Milton
Basketball

previous books by

Howard Schatz and Beverly Ornstein

Gifted Woman
1992, Pacific Photographic Press

Seeing Red: The Rapture of Redheads
1993, Pomegranate ArtBooks

Homeless: Portraits of Americans in Hard Times
1993, Chronicle Books

WaterDance
1995, 1998, Graphis Press

The Princess of the Spring and the Queen of the Sea
1996, Pacific Photographic Press

Newborn
1996, Chronicle Books

BodyType: An Intimate Alphabet
1996, Stewart, Tabori & Chang

Passion & Line
1997, 1998, Graphis Press

Pool Light
1998, Graphis Press

Virtuoso by Ken Carbone with photographs by Howard Schatz
1999, Stewart, Tabori & Chang

Body Knots
2000, Rizzoli Publishers

Nude Body Nude
2000, HarperCollins Publishers

Rare Creatures: Portraits of Models
2001, The Wonderland Press

The fine art work of Howard Schatz is represented by the following galleries:

SoHo Triad Fine Arts, New York, New York

Apex Fine Art, Los Angeles, California

Robert Klein Gallery, Boston, Massachusetts

Photography West Gallery, Carmel, California

Gallery M, Denver, Colorado

JJ Brookings, San Francisco, California

PhotoClassics, Munich, Germany

Photo Eye Gallery, Santa Fe, New Mexico

Benham Gallery, Seattle, Washington

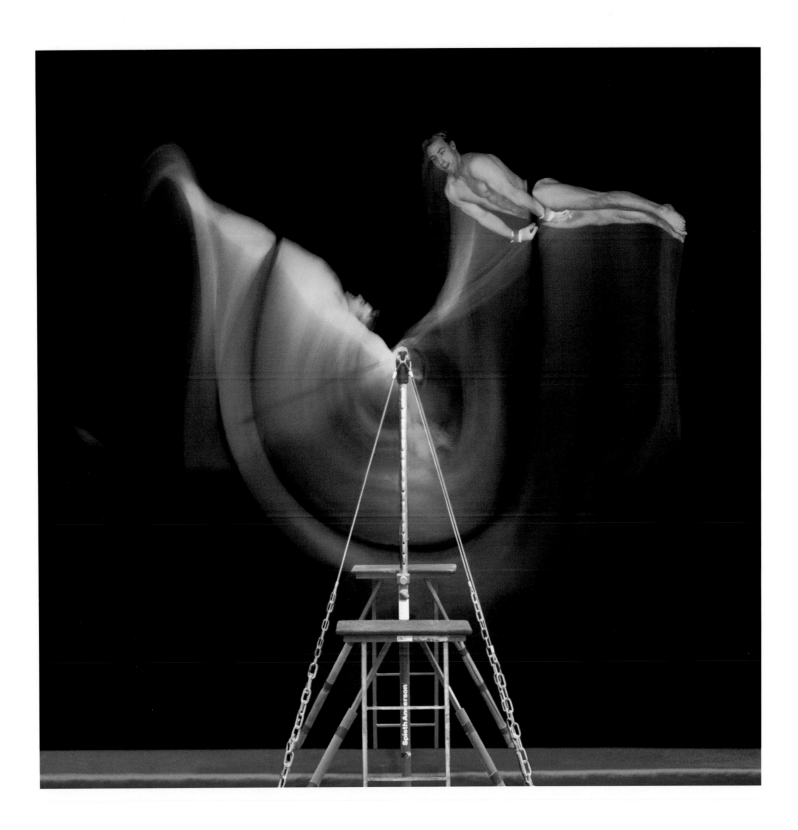

Sean Townsend
Gymnastics

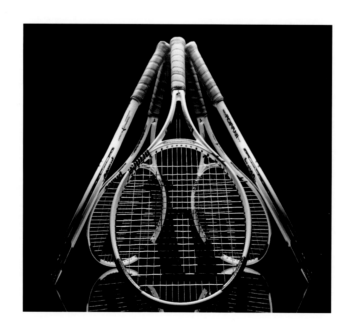

Foreword

The Gift

Some of them immediately understand the gift they have received. With the arrogance of the young and the talented, they accept it as their natural right. Others ignore the talent in their bodies, like somebody who cannot open a birthday present for days or weeks because it is too close, too personal. They do not readily see that they are different from other people.

One young girl could not comprehend why she could catch a ball so easily with a flick of her hand while the same ball would fall from her classmates' hands with the soft thunk of failure. Were they not trying? Did they not want to catch the ball? The girl was frustrated with her gift until the state scientists came around (this was in the old Czechoslovakia) and measured her muscles and her central nervous system and declared that she was exceptionally gifted and must be put into advanced ice hockey and tennis programs. It was only then that Martina Navratilova accepted, at least intellectually, that she had been given a blessing.

The gift was genetic, to be sure, something that was there from the beginning. When people talk about great athletes, they talk of it in terms of muscle, but more likely it is something in the nerve endings that makes them react a little faster, a little more accurately than the average human being. There is also the soul of an athlete, the obsession of an athlete, that sears outward from his person, from her photograph.

In Navratilova's case, the hard work would come much later, producing a flurry of excellence her sport had never seen before. She blended her gifts with her need to excel, and soon other tennis players were taking to gymnasiums and running up steep stairs and watching their diets. Athletes in many other sports had been doing this for decades, facing the reality of the gift flexing in their young bodies. We see them in gaudy team uniforms with their muscles pumping beneath their taut skin as they dunk basketballs and leap over the high bar and ride a bicycle straight up a mountain and blast a soccer ball into the corner of the net. We see them in warmup suits on the podium accepting their medals, and we see them in interviews trying to articulate why they have just won a championship; but it is much harder to comprehend the wedding of their wills with the original gift of their bodies.

There is a cliché that youth is wasted on the young. It is an old person's cliché. In fact, the young very often make spectacular use of their time.

The one thing we need to remember about athletes is that they bring passion, youth, ego, hunger, a voracious desire — or else we never hear of them. Every athlete knows of somebody who seemed just as good or just as promising at the age of 10 or 14 or 18, but who just was not willing, as the saying goes, "to pay the price." The ones you see on television and in the arenas and in the world's great championships are the ones who wanted it the most. You can tell them by their intense burning stares.

At first, perhaps, they think it is their unique personalities that make them different, but soon they look into the mirror and realize that their bodies are engines that move better than other people's engines, so they learn to oil the engine and exercise it and feed it whatever it takes and open it full throttle.

Their pursuit, their passion, their sport, becomes more than a game, more than scoring more points or going faster. It becomes a narcissistic relationship between the psyche and the soma. Anybody who is around world-class athletes becomes aware of their steady involvement with their bodies at any given moment. Even at dinner, even during conversation, they flex, they touch, they shift. There is no downtime. From massive weightlifters to petite gymnasts, they regularly gaze into mirrors or peek sideways at themselves to observe the unique bulge or ripple of each individual muscle, flexing and staring, posturing and preening.

In the security of their hotel rooms, baseball players will stand in front of a full-length mirror, quite likely with little or no clothing on, and observe their batting stance or their pitching motion. They know every muscle, how it works, how it looks, what it can do. They observe themselves, as a master sculptor might observe a statue, or a baker will observe a cake, or a builder will observe a home.

Athletes also have a wariness from knowing that there are rivals out there eager to beat them. They are constantly being challenged, and they practice compulsively and repetitively so as always to be ready for that challenge.

Ask Michael Jordan after he has made a spectacular gravity-defying move against men his own size if he improvised this on the spot. His response is liable to be a patronizing "Hah!" meaning that he has done just such a thing a hundred times before in the privacy of the gymnasium, with one eye on

the basket, one eye on the opponent, and one eye on himself. If that adds up to three eyes, well, that is the point. These people are different.

Their body types determine what sport they will play. Football linemen will not be jockeys, and gymnasts will not be high jumpers. Once the natural selection is made, the differences are accentuated by self-improvement. Aside from the odd baseball player who pours sacks full of American fast food into his body and has the flabby physique to prove it, almost all athletes today are products of the personal trainer and the nutritionist and the pharmacist and the psychologist.

Sprinters are almost a breed unto themselves. Their entire being is tied into power in the butt and thighs and upper body without carrying extra baggage. On a Monday morning, coaches and trainers glance at the sprinter and spot an extra ounce of weight and declare it to be an entire ruinous hundredth of a second attached to his waist. One sprinter depicted in these pages talked of a quarter century of work, six days a week, at his regular routine – stretching, lifting, running, stretching – just so he could be microseconds faster than his rivals.

To be sure, not all great athletes are easily defined by muscle mass. Neurological reactions are important, too. Hockey goalies are the most obvious examples, ranging from gaunt specters with sunken eyes to nearly pudgy specimens with ill-defined musculature. But when the frozen piece of rubber known as a puck is screaming toward them, they can pull it out of the air like a child catching lazy fireflies. They go to clinics to develop their hand-to-eye speed. Very little is left to chance.

From endless repetitions, the cyclist develops thighs the size of Plymouth Rock, the left-hander's pitching arm dangles inches lower than his right arm, football players develop stretch marks on their chests and biceps like the stomach of a woman who has delivered a half dozen children. Power always comes from the gluteus, the butt muscles, whether thick or compact or elongated. Tailors work overtime to fit home-run sluggers into their expensive suits.

Early in the last century, athletes went out and played their games as a projection and continuation of their daily lives of work and study. Now they are almost a different caste. In their preoccupation with bodies and selves, they are much like dancers, except for one crucial difference. Dancers have choreography, whereas athletes must deal with the vagaries of the playing

field and the skills of the opponents and the strategies of rival coaches and the hostility of enemy fans and the ticking of the game clock. They all must learn to improvise on the spot.

In the Olympic Winter Games of 1994, Oksana Baiul, a Ukrainian teenager with the sad, fragile beauty of a ballerina, recognized that she was falling out of contention for the gold medal. In the middle of her final four-minute skate, while the music was playing, she made a seamless segue into unplanned jumps, and earned herself the gold medal. Athletes understand this. Do what you have to do, that day, that moment. The result of this improvisation is a haughty, wary self-reliance.

Athletes never know when an opponent might trip them up, when a judge might make a monumental blunder, when the wind might shift or the surface grow slippery. So they become light on their feet, quick to adjust, always cautious, believers in their own judgment.

The athletes who make it to public consciousness have a heightened belief in their immortality. This enables them to perform their deeds, but it also convinces them they can live forever on their own instincts, not always a good idea in a world of fast cars and proffered delights and business decisions with money that may come around only once.

Marketers talk about "lifetime sports," like swimming and tennis and kayaking, things that can be enjoyed by octogenarians. Even dancers have only twenty- or thirty-year careers, from adolescence into middle age before they face professional mortality.

Many athletes have a peak like the life span of the mayfly. It may last a month or a year. Athletes have been known to reach their peak within the four-year span between Olympics, never reaching the victory podium in that quadrennial jamboree. From a safe seat in the stands, paying customers are quick to shout, "Come on, don't you want it?" This bleat from the fans becomes irrelevant when we see athletes in abbreviated gym wear, their muscles glistening with sweat.

They cannot, they would not, conceal their naked obsession. They make the most of this mystery they have been given, this body, this gift.

<p align="right">**George Vecsey**</p>

Hit
Shoot
Kick

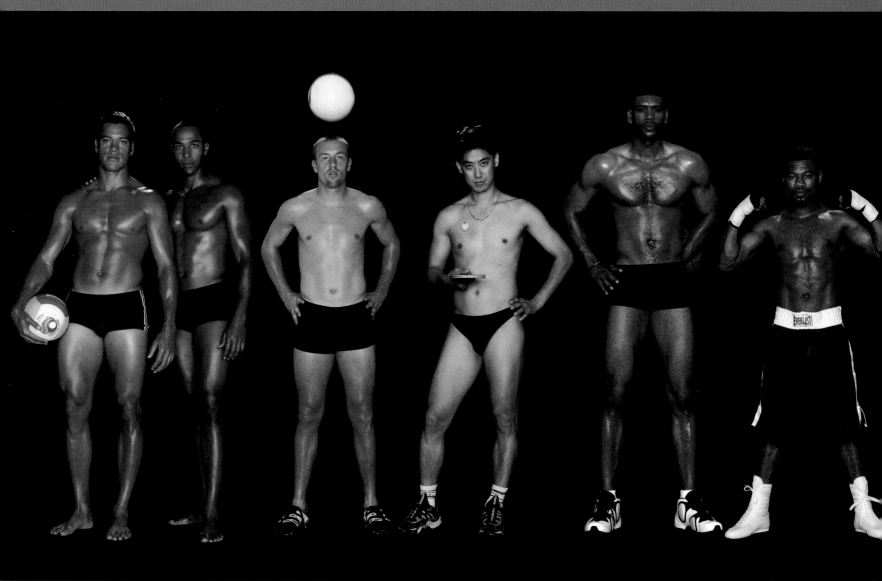

Eric Fonoimoana & Dain Blanton
Beach Volleyball
6' 3" 205 lbs.; 6' 2" 205 lbs.

Clint Mathis
Soccer
5' 10" 170 lbs.

David Zhuang
Table Tennis
5' 10" 165 lbs.

Allan Houston
Basketball
6' 6" 200 lbs.

"Sugar" Shane Mosley
Boxing
5' 9" 147 lbs.

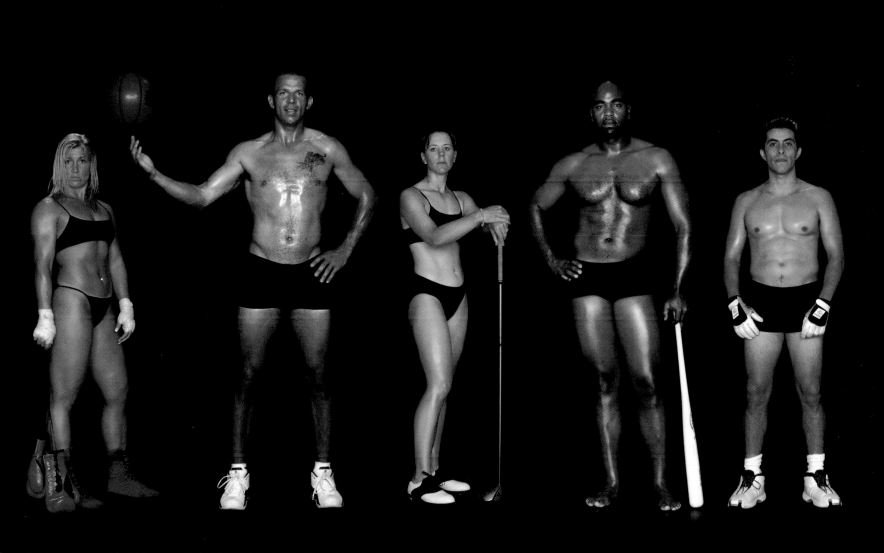

Kathy Collins
Boxing
5' 5" 137 lbs.

Jason Kidd
Basketball
6' 4" 212 lbs.

Annika Sorenstam
Golf
5' 5" 120 lbs.

Carlos Delgado
Baseball
6' 3" 225 lbs.

Vince Muñoz
Handball
5' 7" 165 lbs.

Carlos Delgado
Baseball

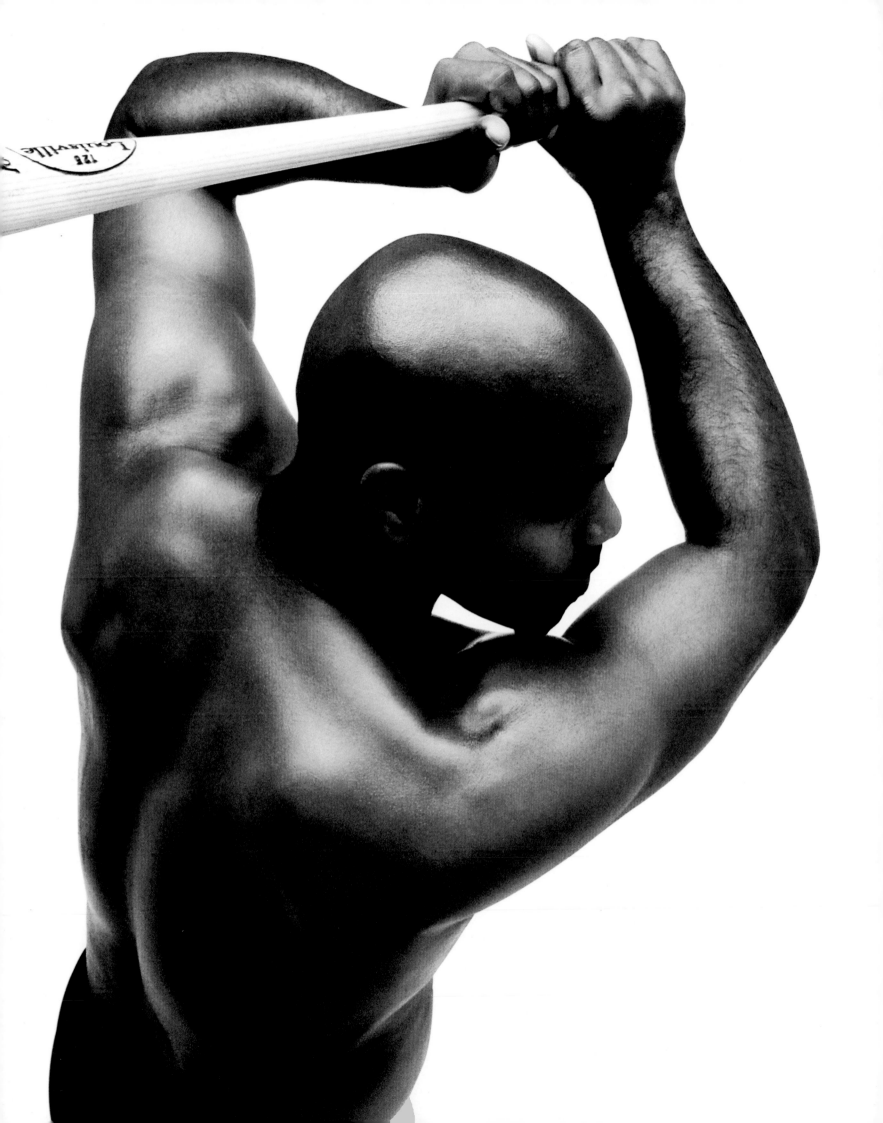

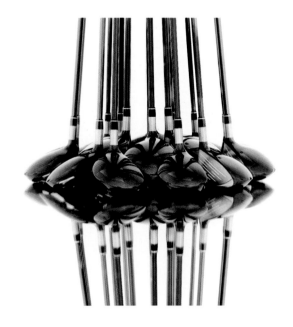

Annika Sorenstam
Golf
18

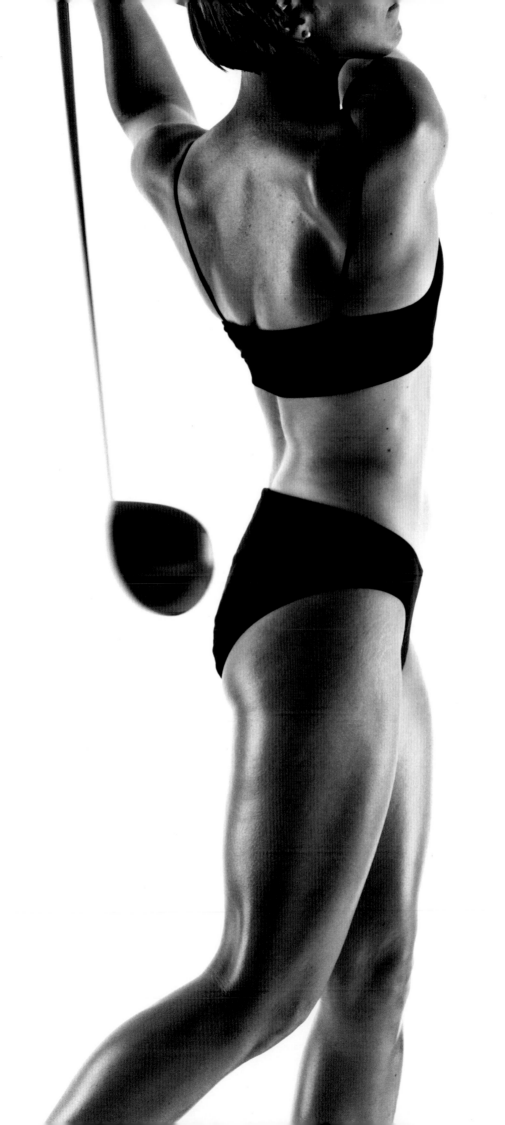

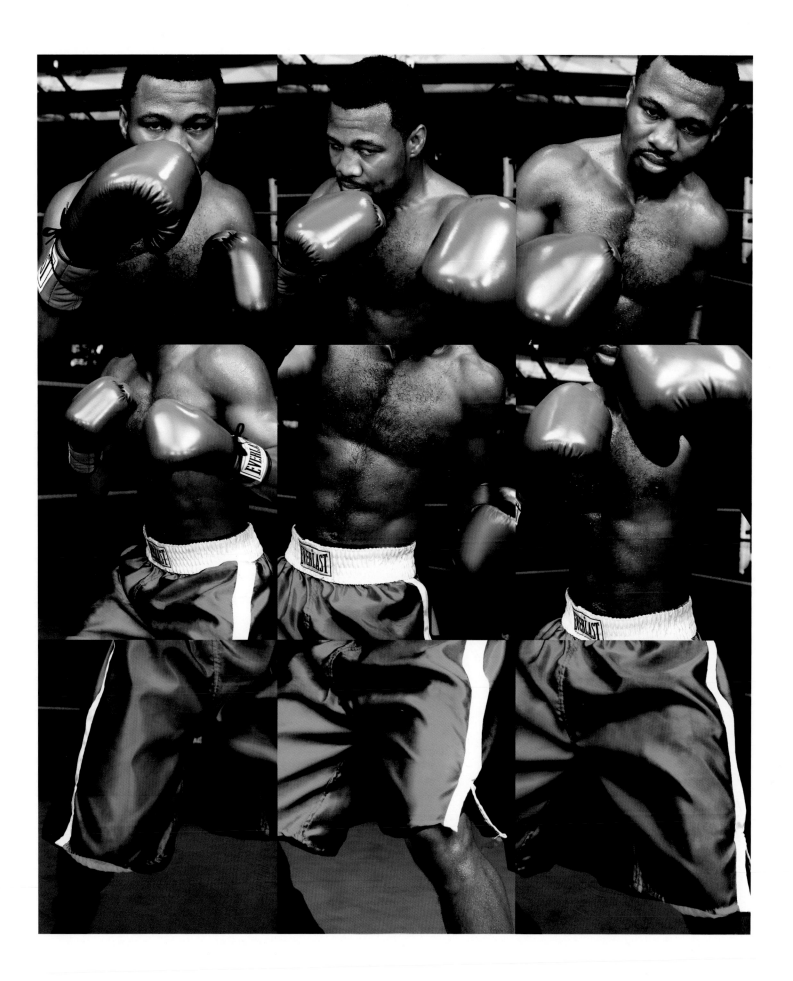

"Sugar" Shane Mosley
Boxing
(Shadowboxing)

Kathy Collins
Boxing
22

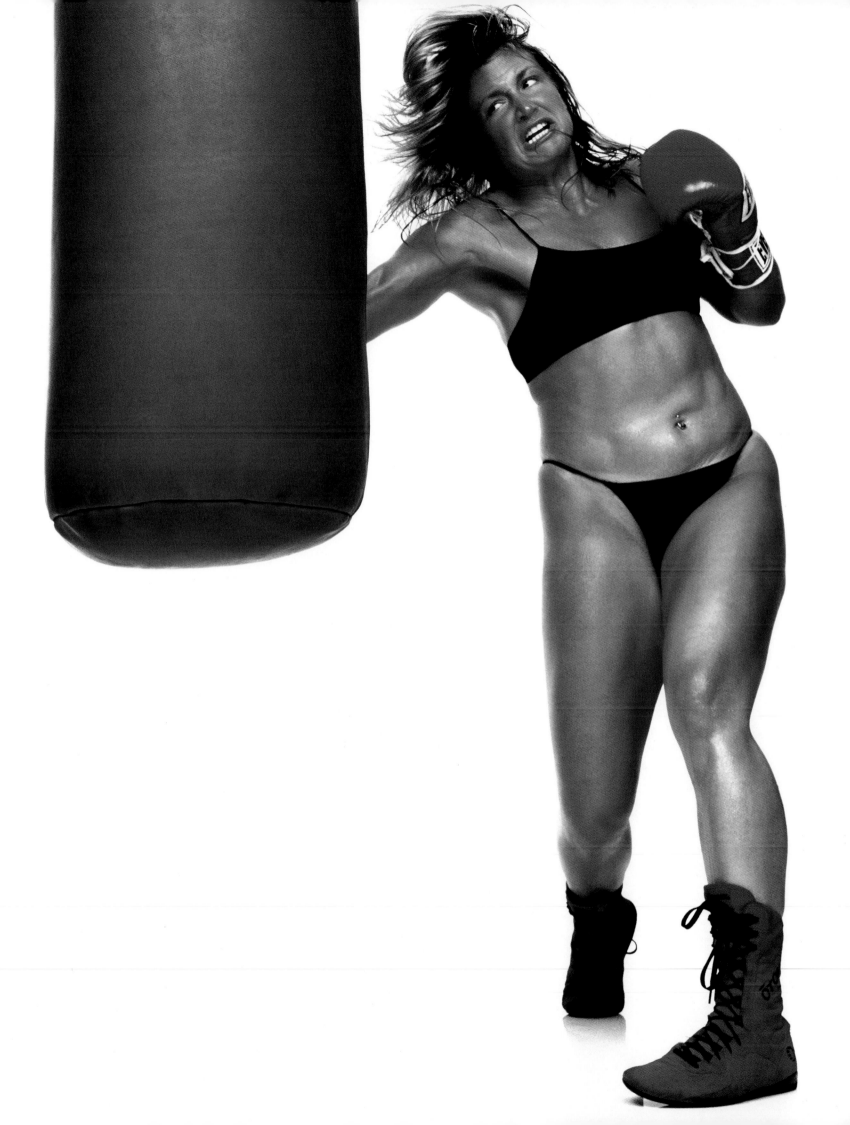

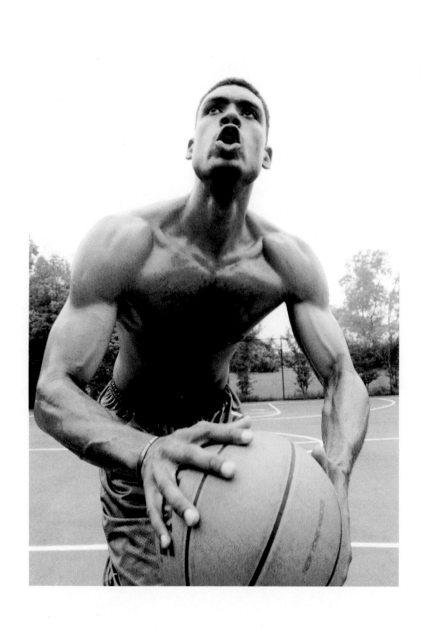
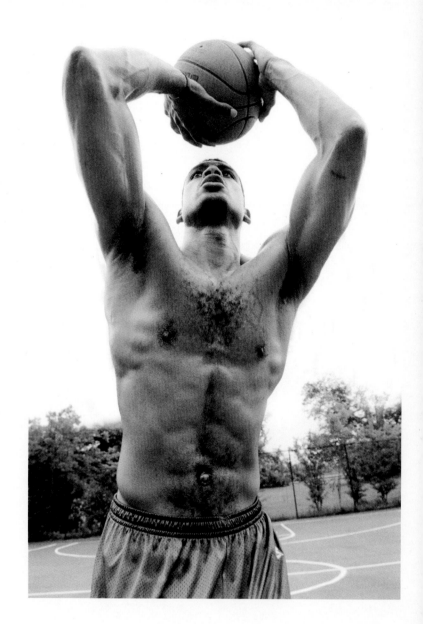

Allan Houston
Basketball
25

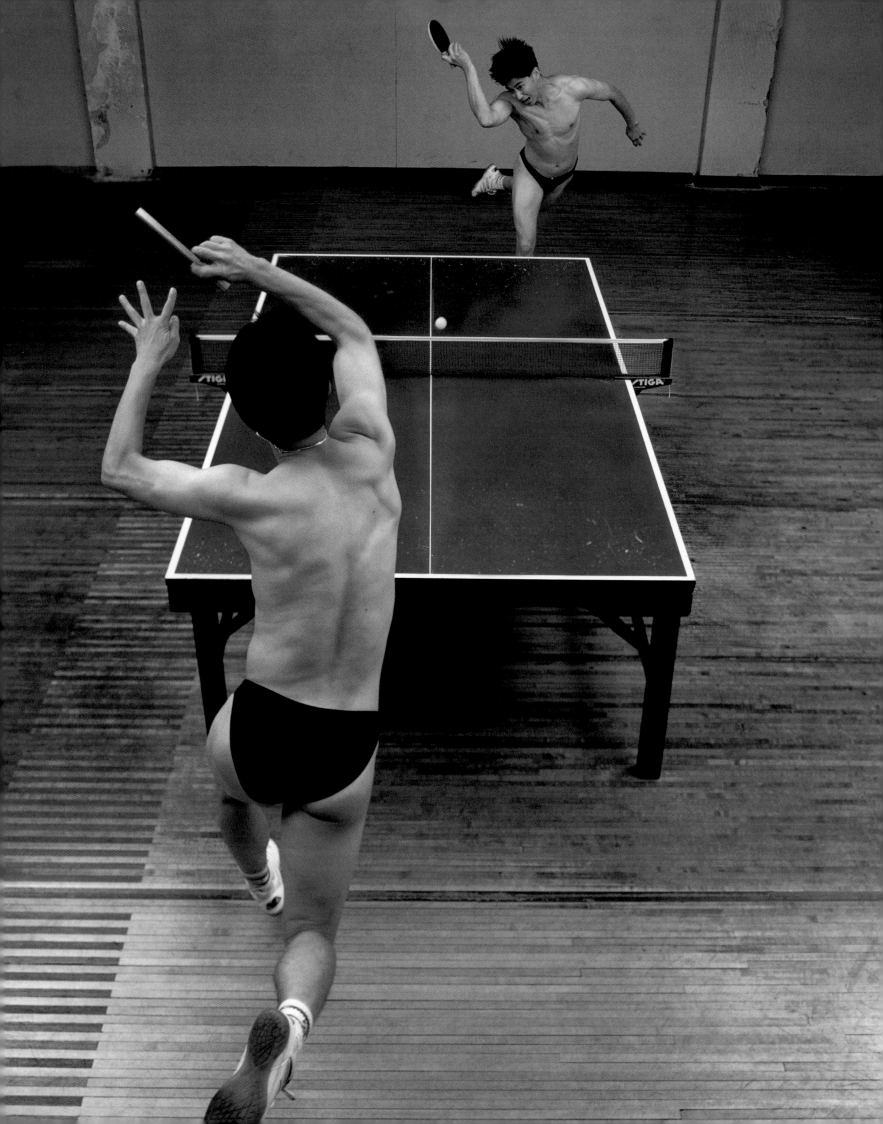

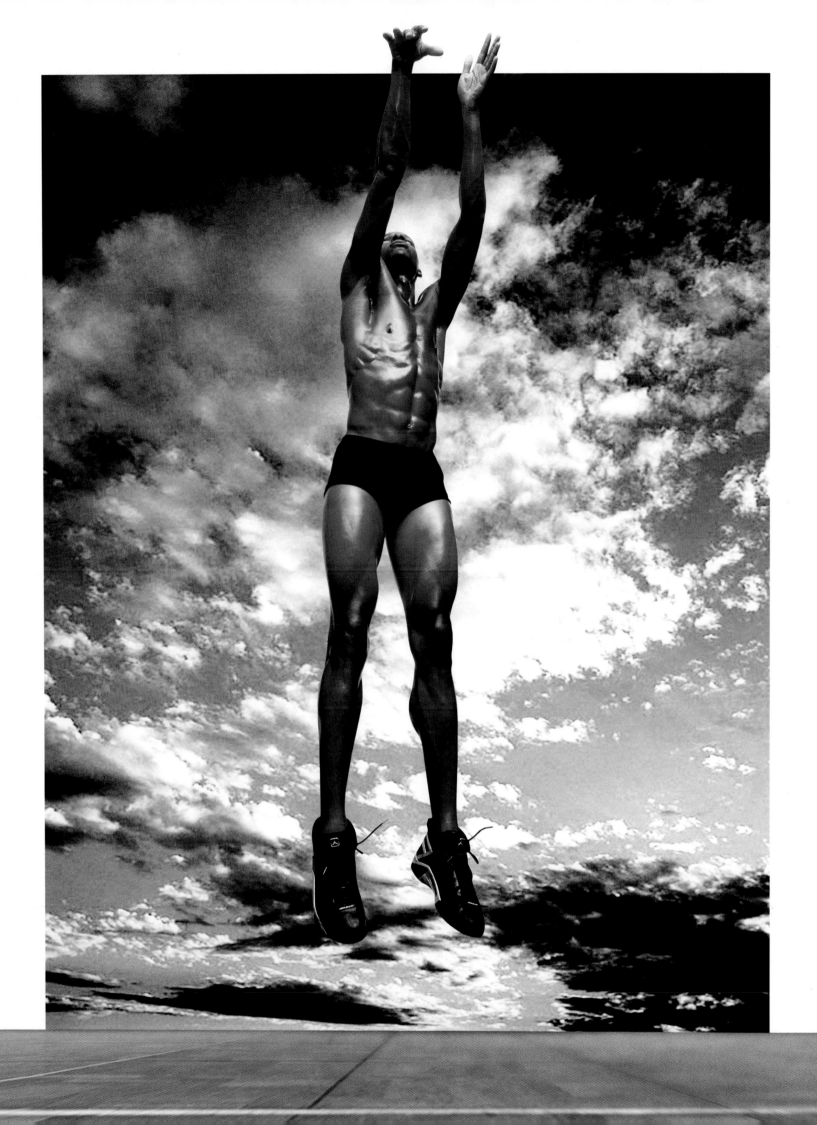

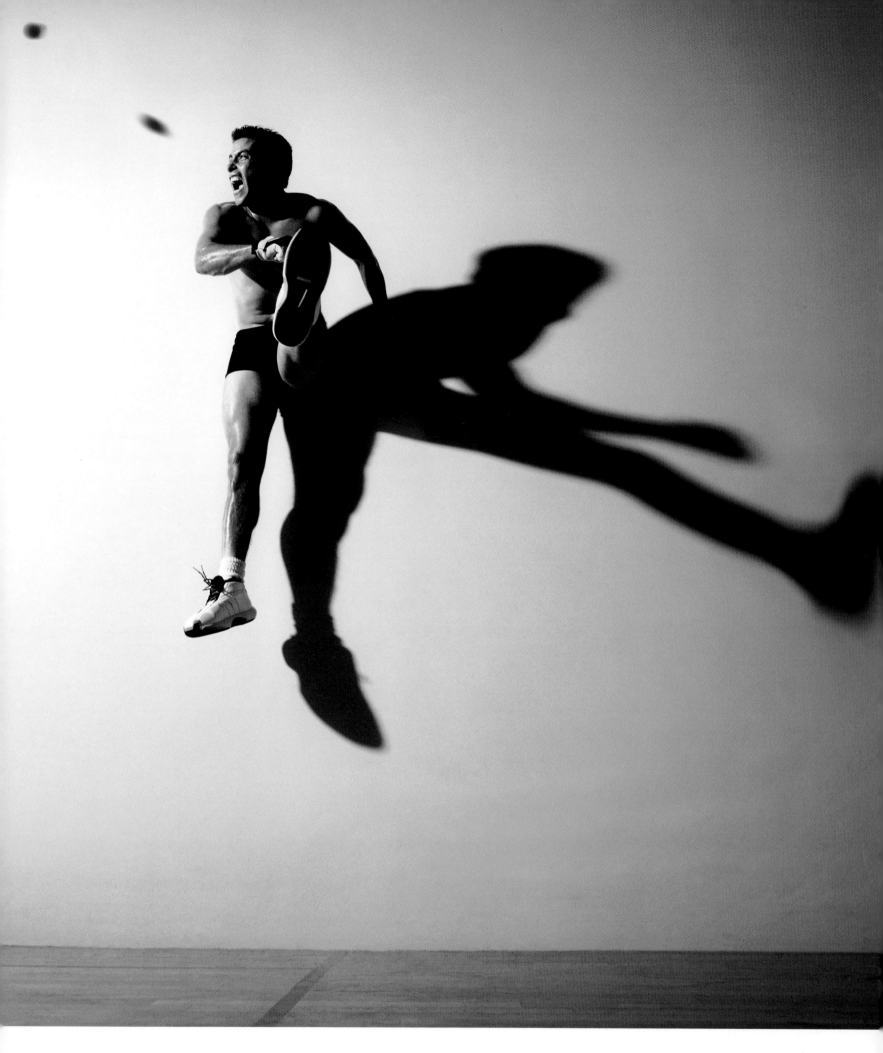

Vince Muñoz
Handball

Preceding Pages

David Zhuang
Table Tennis

Ray Allen
Basketball

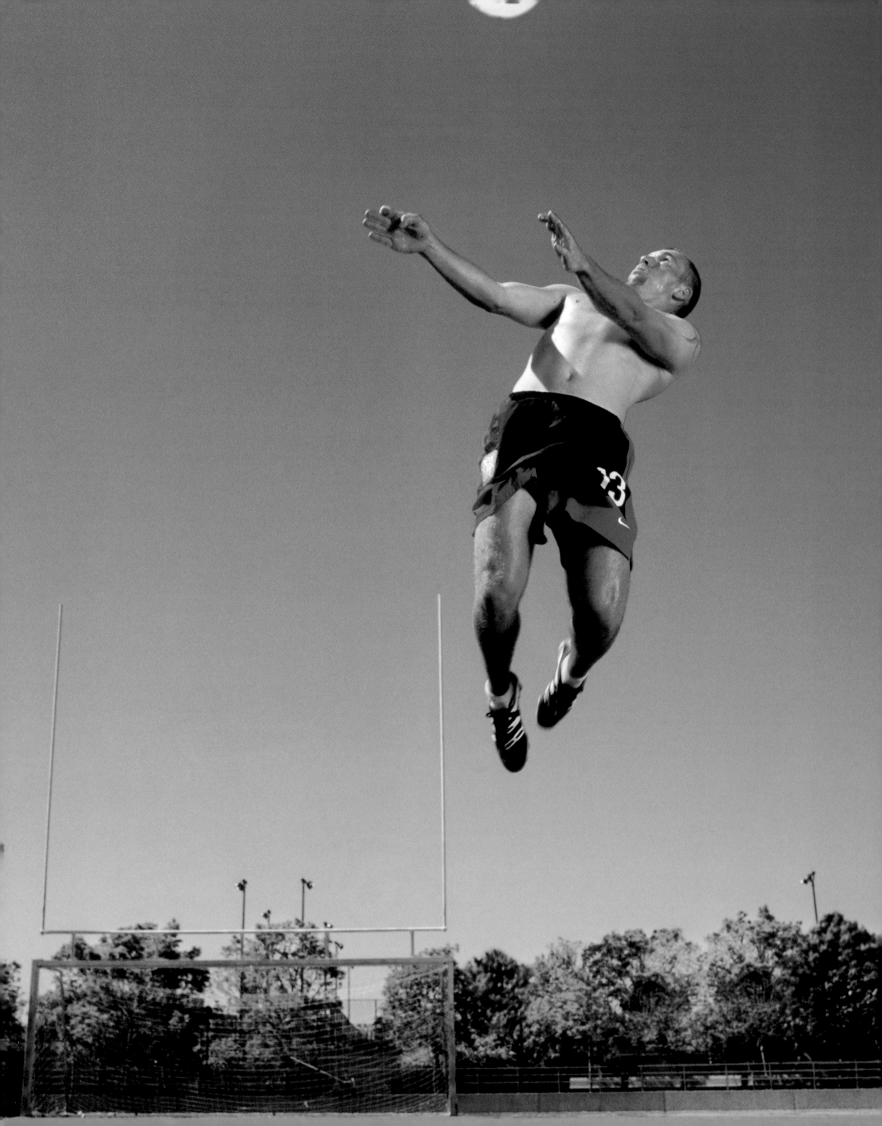

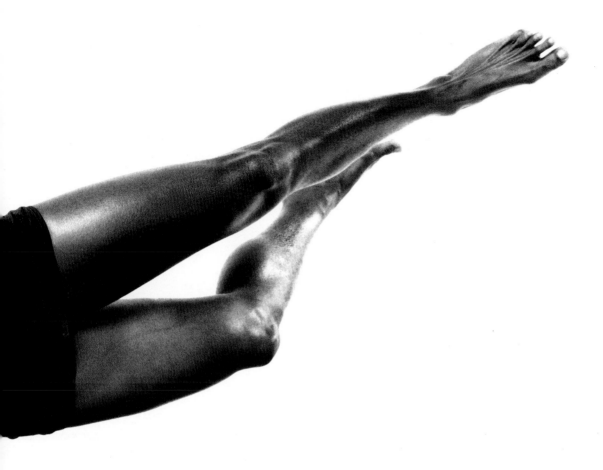

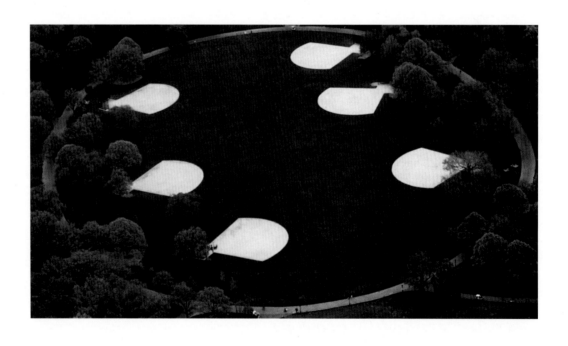

Baseball diamonds in Central Park
New York, New York

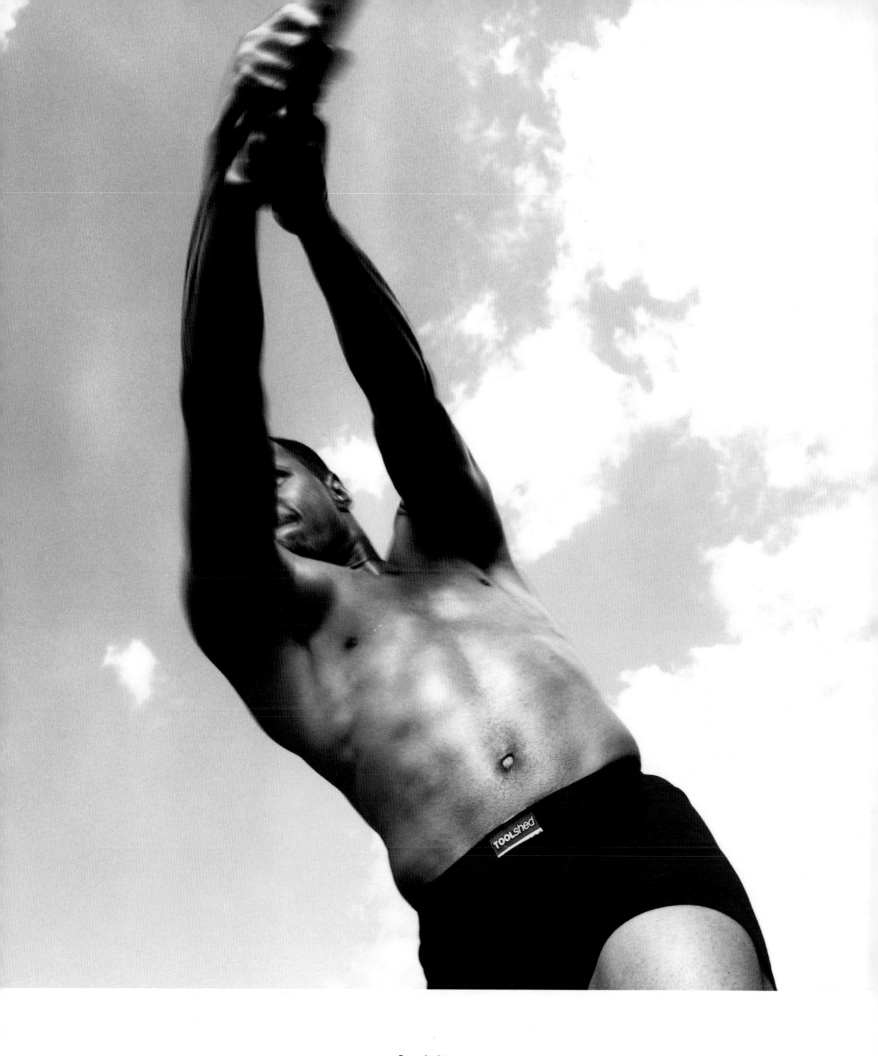

Barry Larkin
Baseball
35

Jump
Dive
Flip
Fly

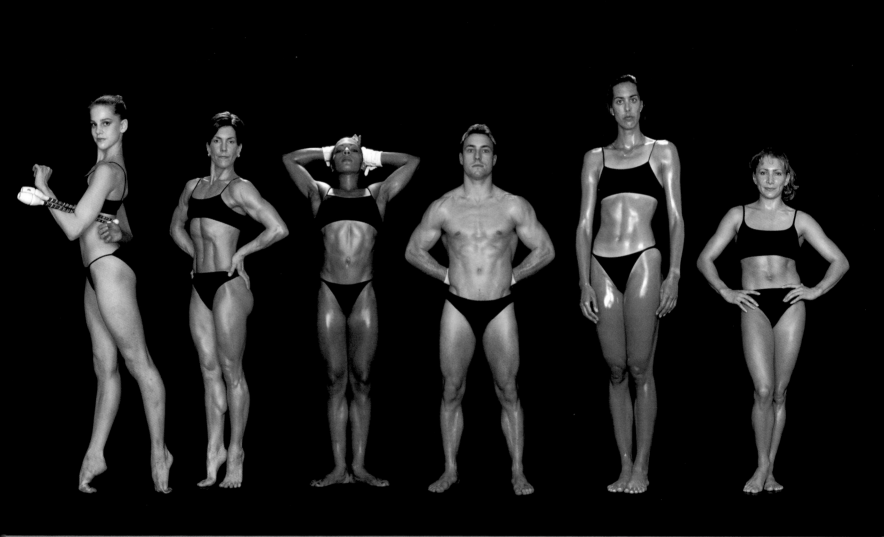

Jessica Howard
Rhythmic Gymnastics
5' 7", 100 lbs.

Tobey Gifford
Sport Aerobics
5' 3" 118 lbs.

Tasha Schwikert
Gymnastics
5' 1.5" 110 lbs.

Sean Townsend
Gymnastics
5' 4" 135 lbs.

Erin Aldrich
High Jump
6' 1" 143 lbs.

Shannon Miller
Gymnastics
5' 0" 97 lbs.

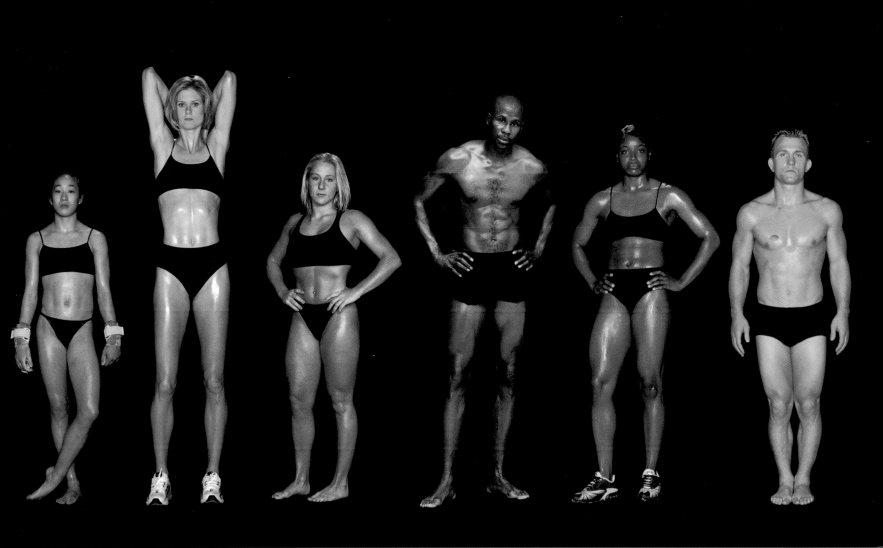

Tabitha Yim
Gymnastics
4' 8" 85 lbs.

Amy Acuff
High Jump
6' 2" 145 lbs.

Jennifer Parilla
Trampoline
5' 1" 120 lbs.

Charles Austin
High Jump
6' 0.5" 170 lbs.

Stacey Bowers
Triple Jump
5' 6" 130 lbs.

Cary Kolat
Wrestling
5' 5" 138 lbs.

Erin Aldrich
High Jump

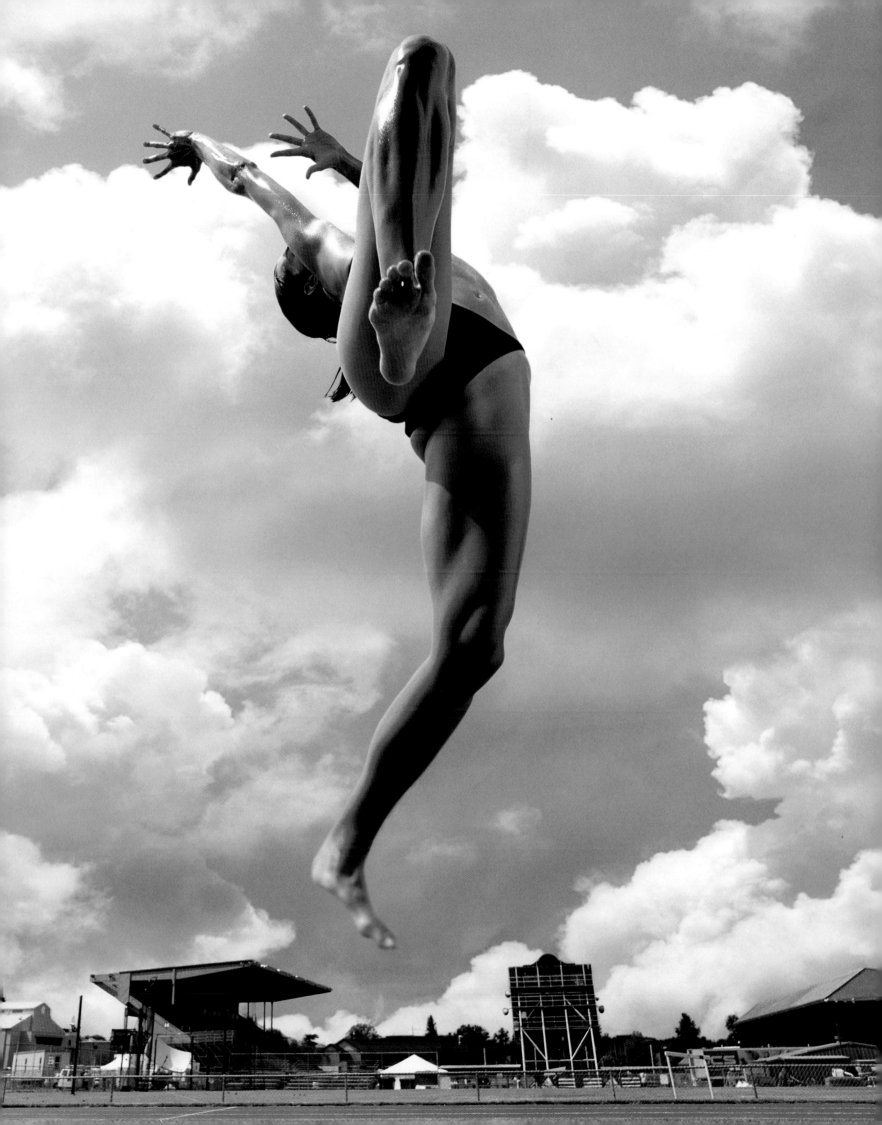

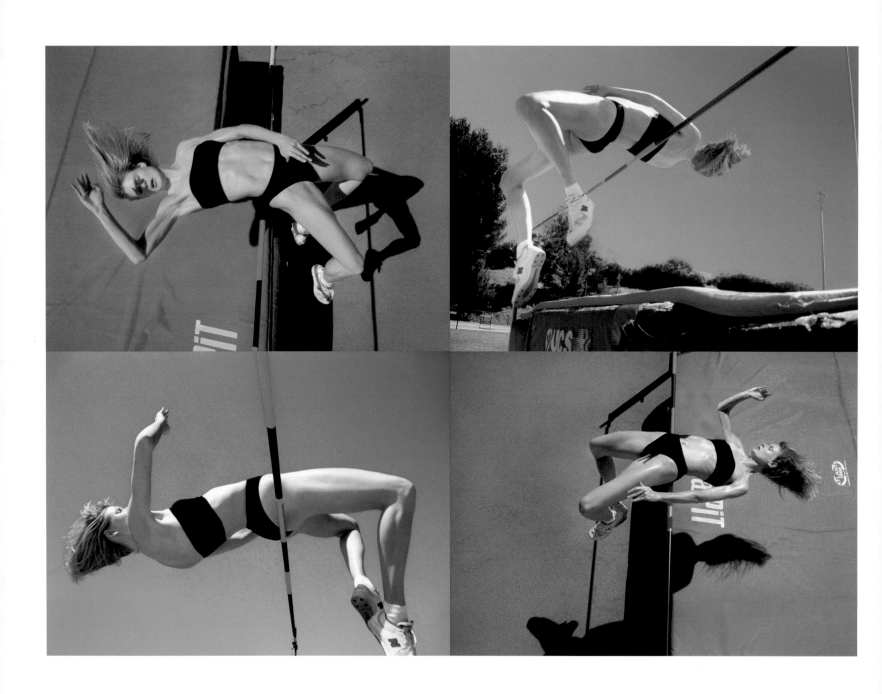

Amy Acuff
High Jump

Tabitha Yim
Gymnastics
(Dismount from the balance beam)

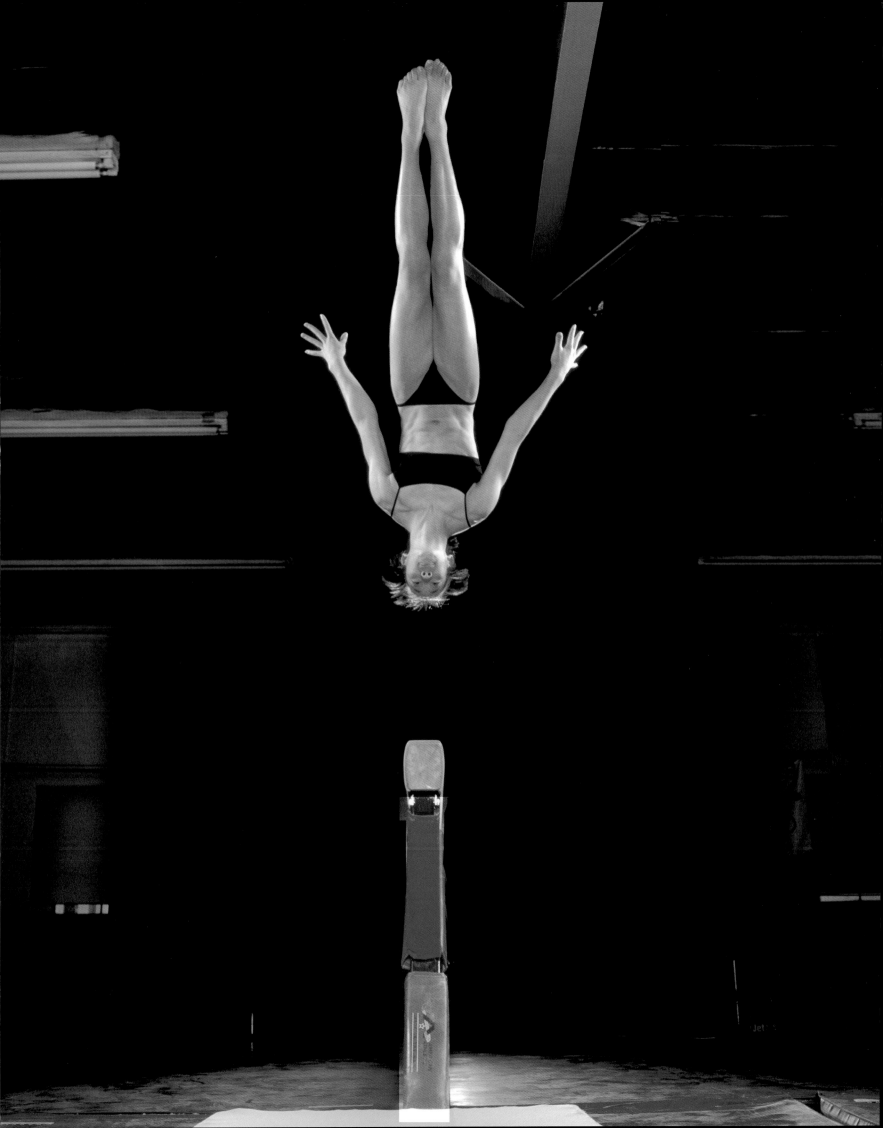

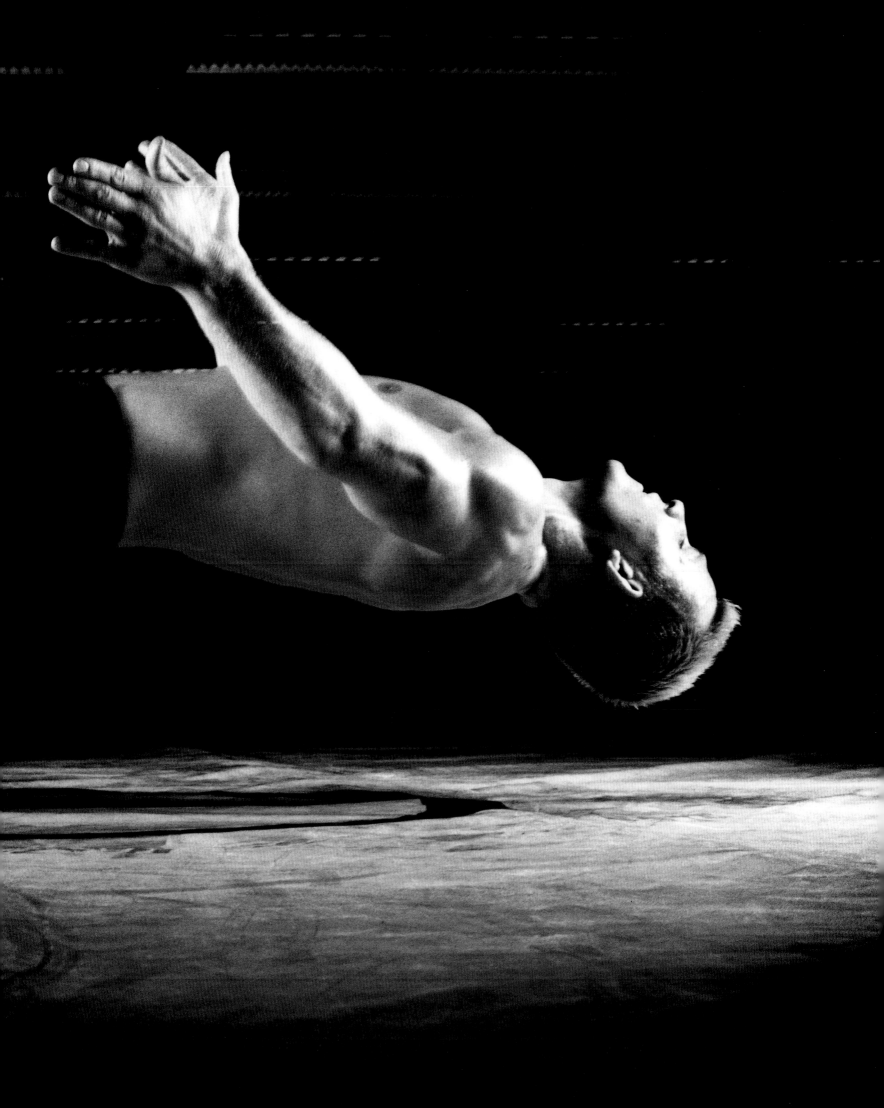

Cary Kolat
Wrestling

Jessica Howard
Rhythmic Gymnastics

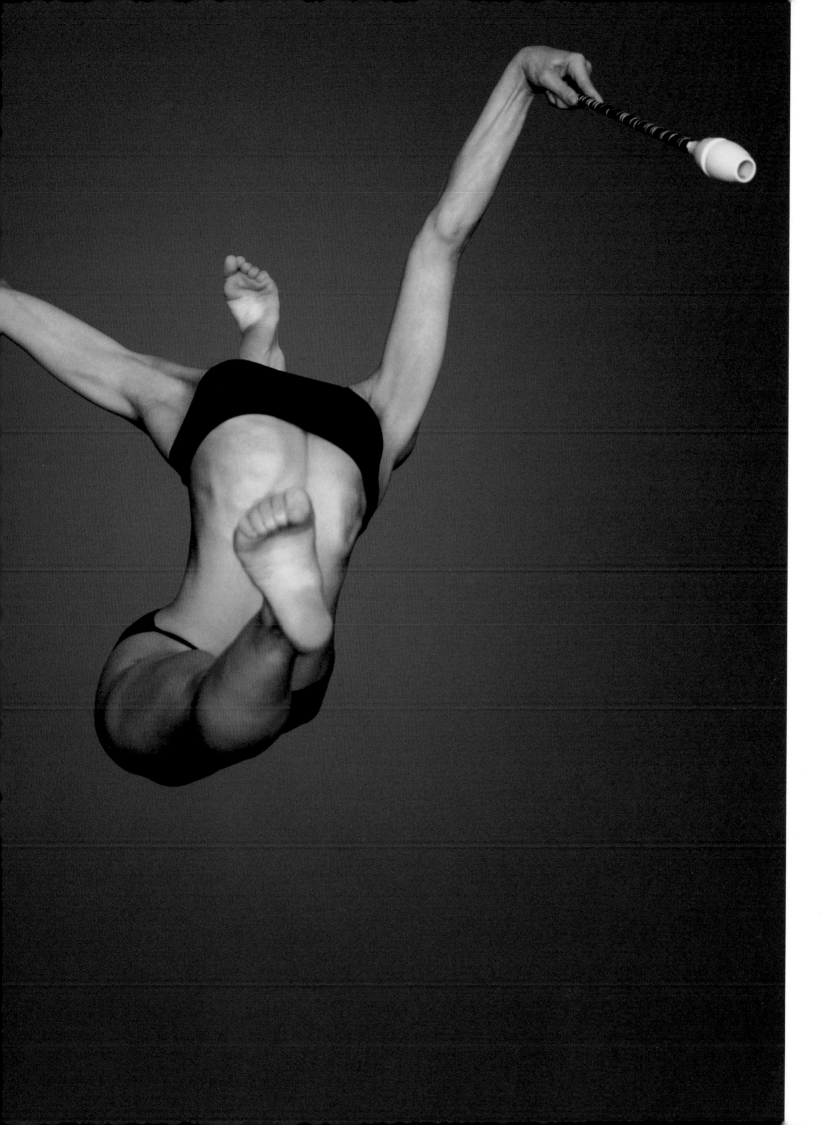

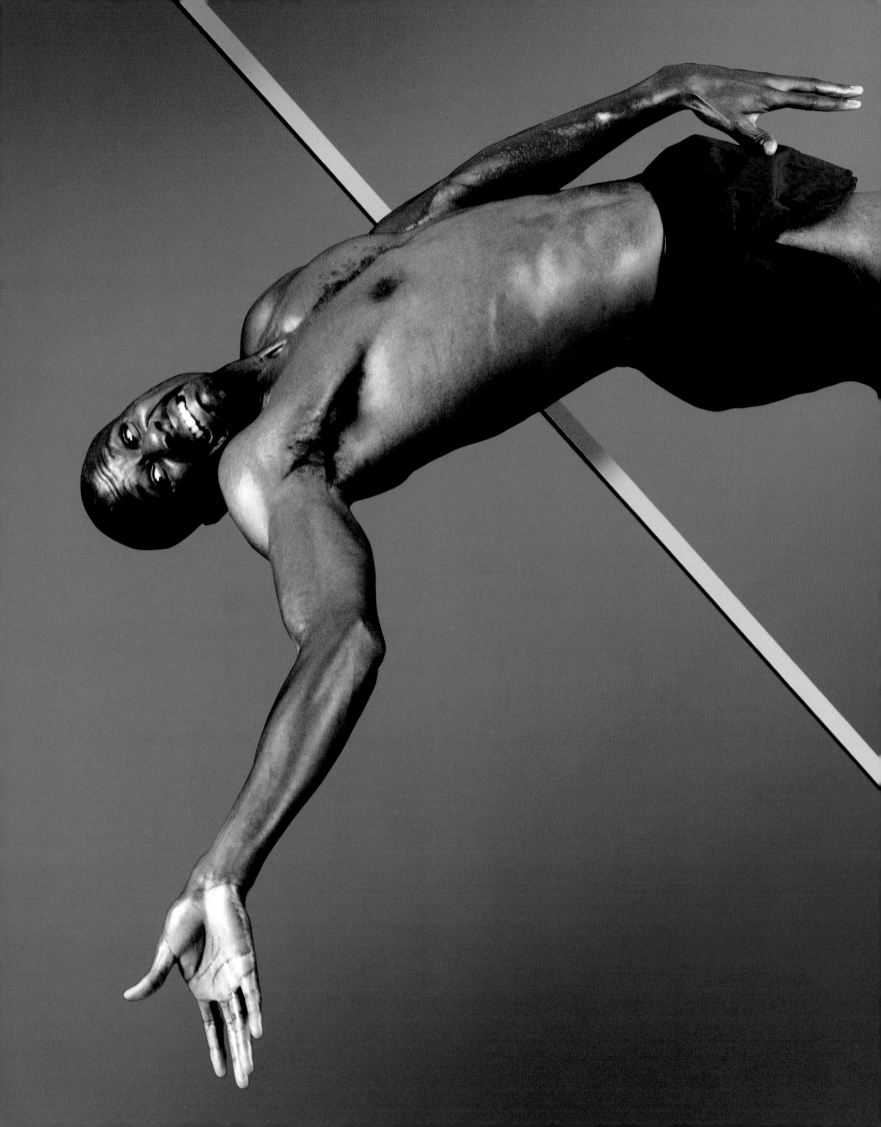

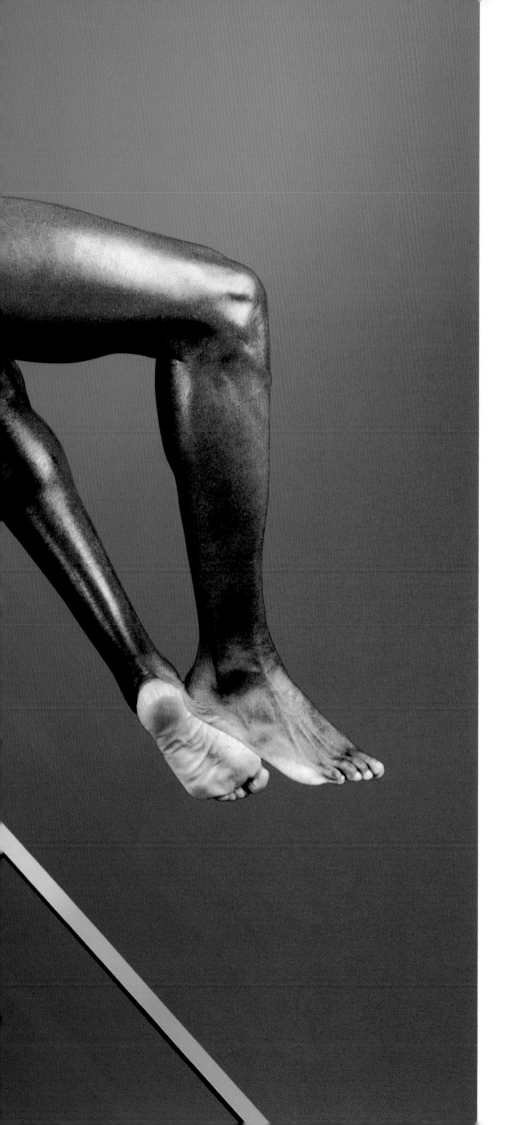

Charles Austin
High Jump

Millrose Games
New York, New York, February 2000

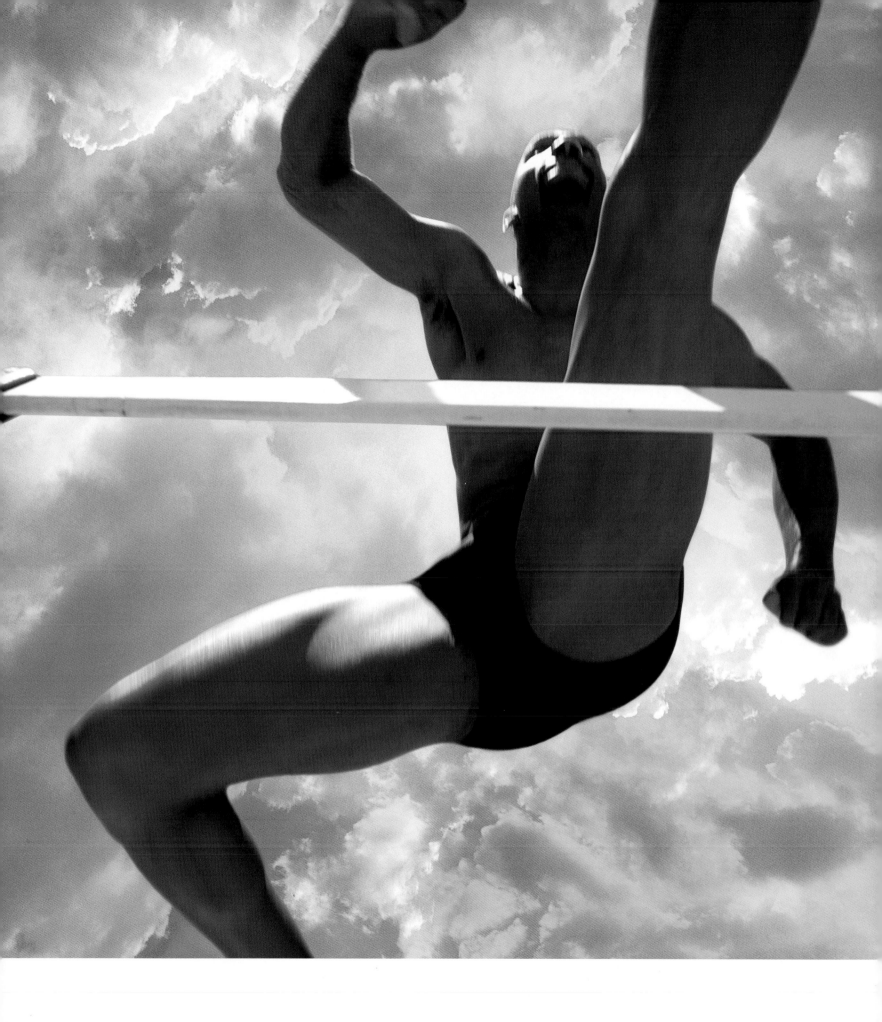

Mark Crear
Hurdles (110m)

Sean Townsend
Gymnastics

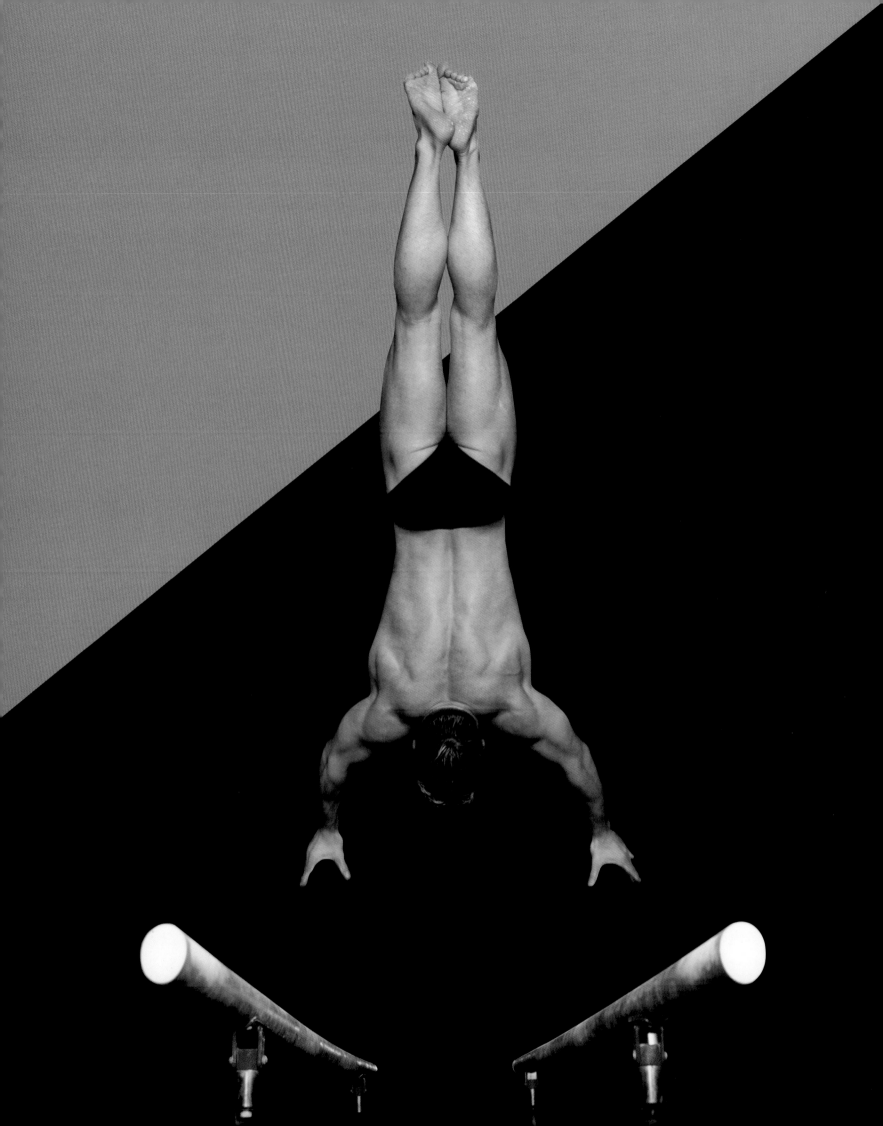

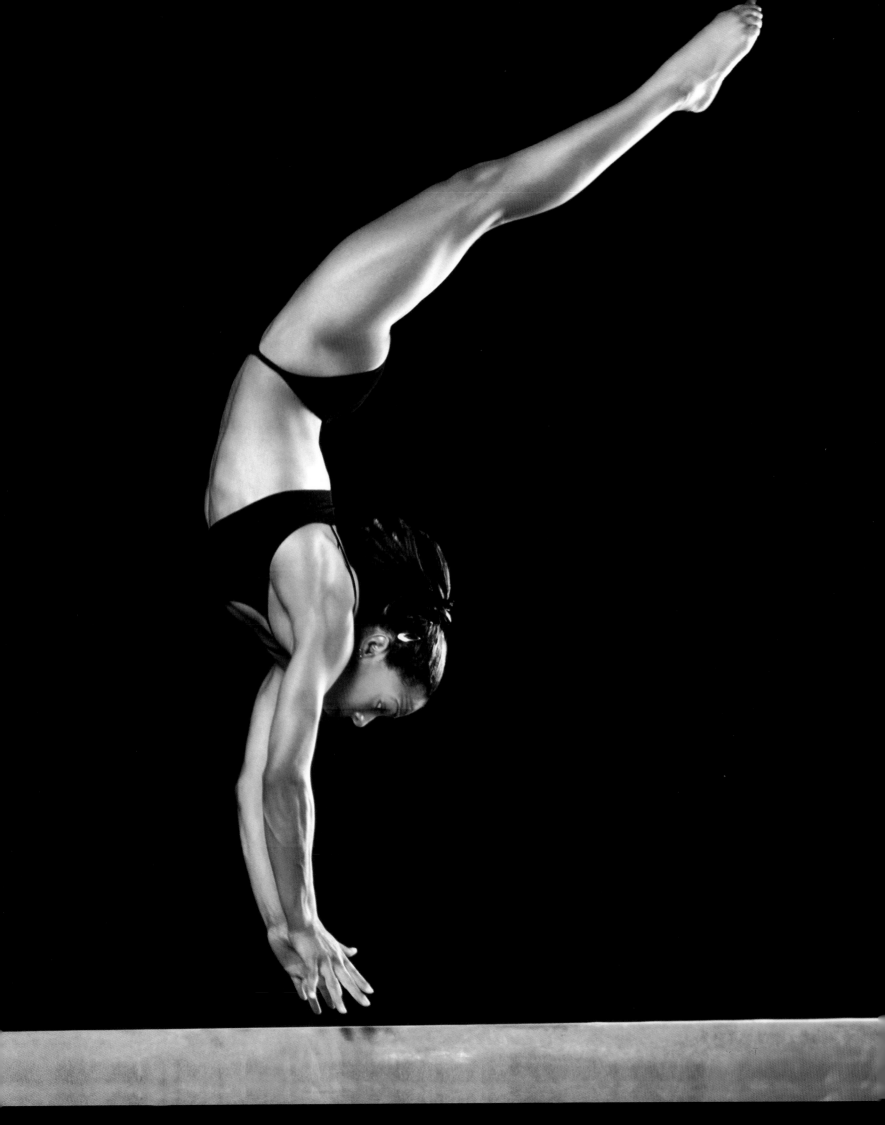

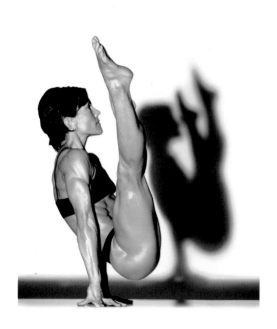

Preceding Pages

Tasha Schwikert
Gymnastics

Tobey Gifford
Sport Aerobics

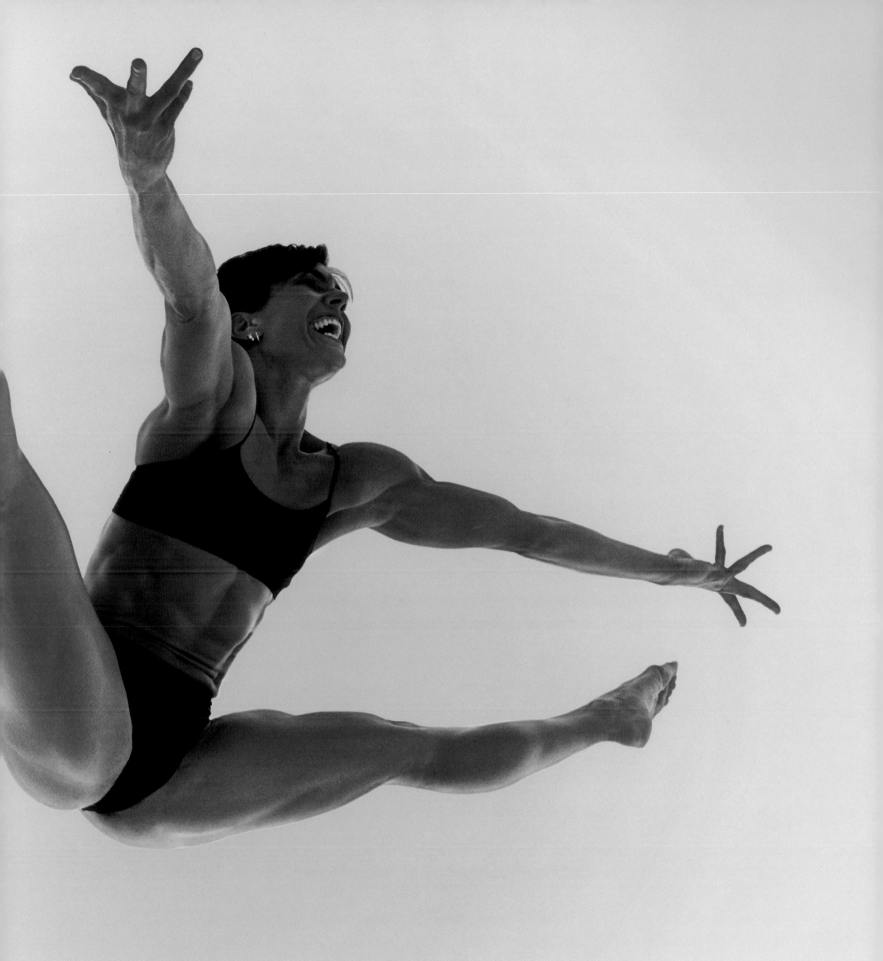

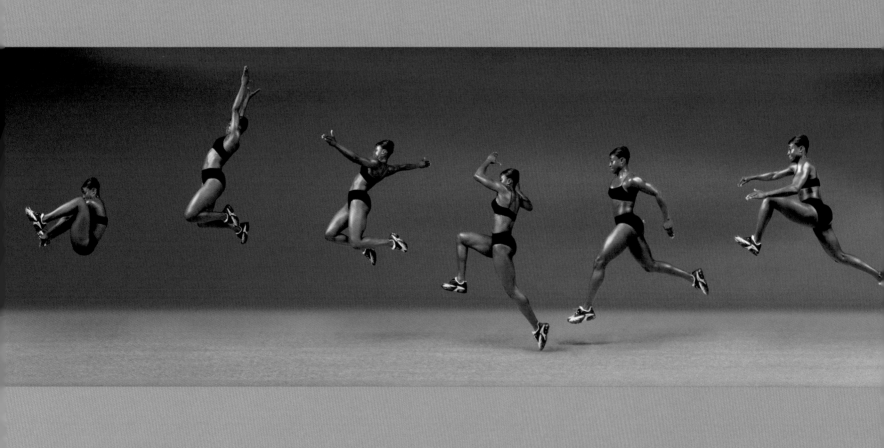

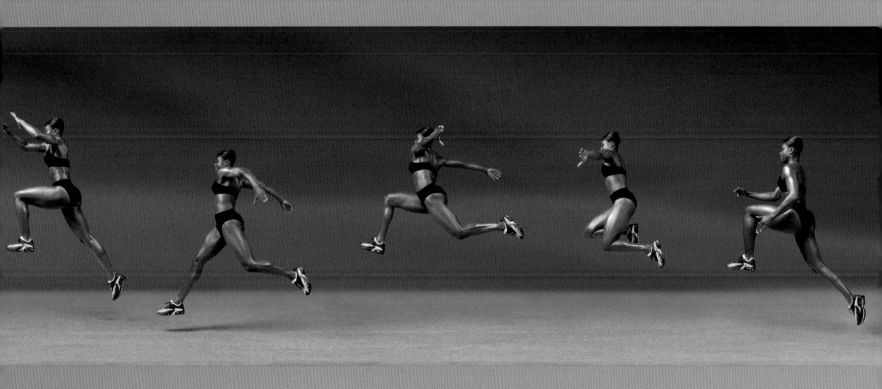

Stacey Bowers
Triple Jump
59

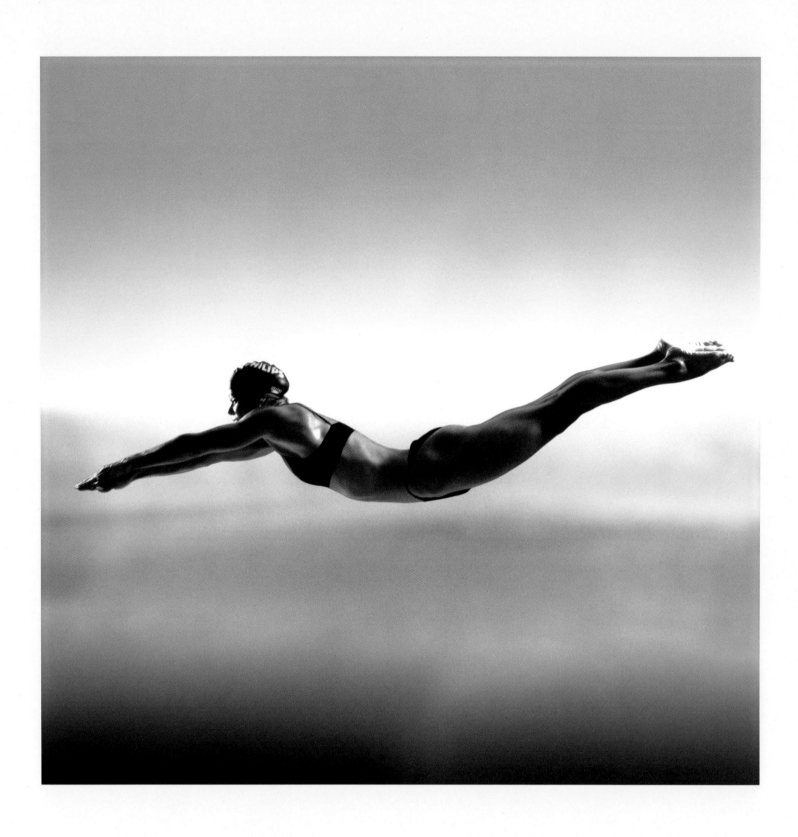

Inge de Bruijn
Swimming (Freestyle & Butterfly)

Wolf Wigo
Water Polo

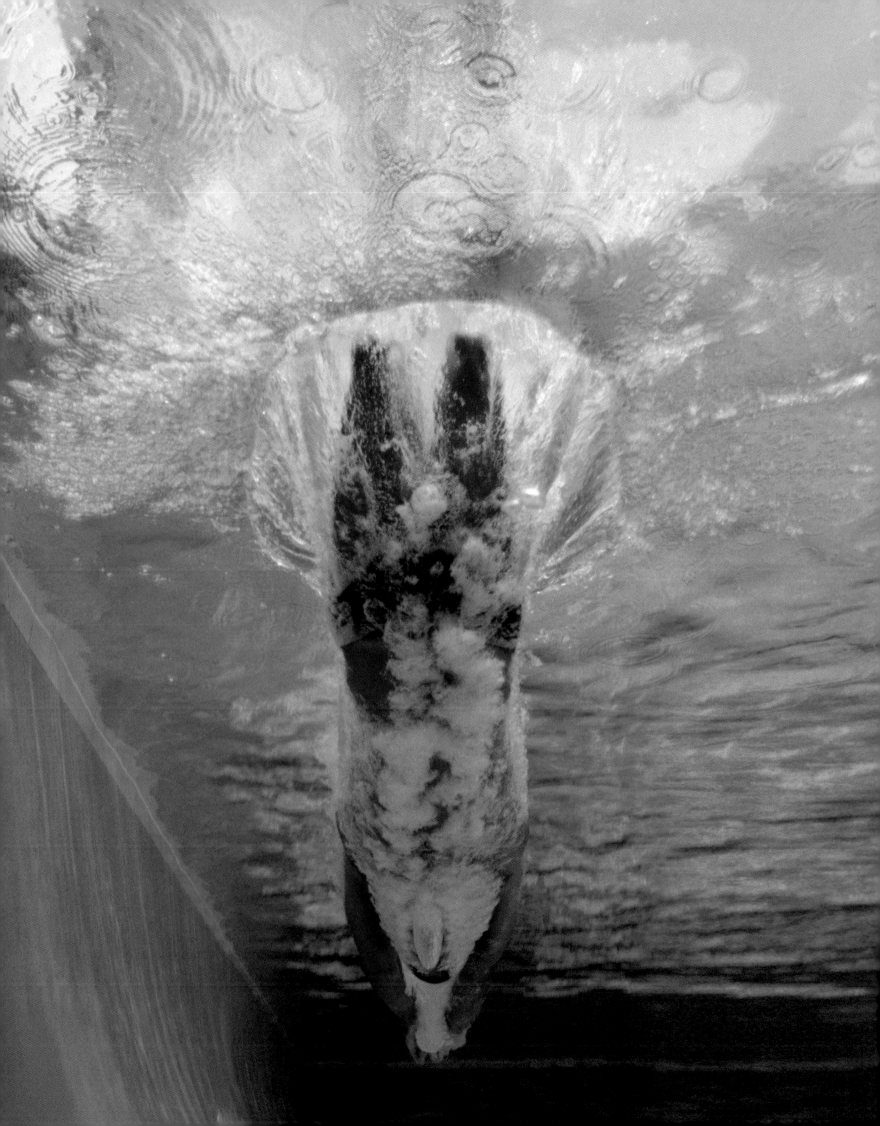

Jennifer Parilla
Trampoline

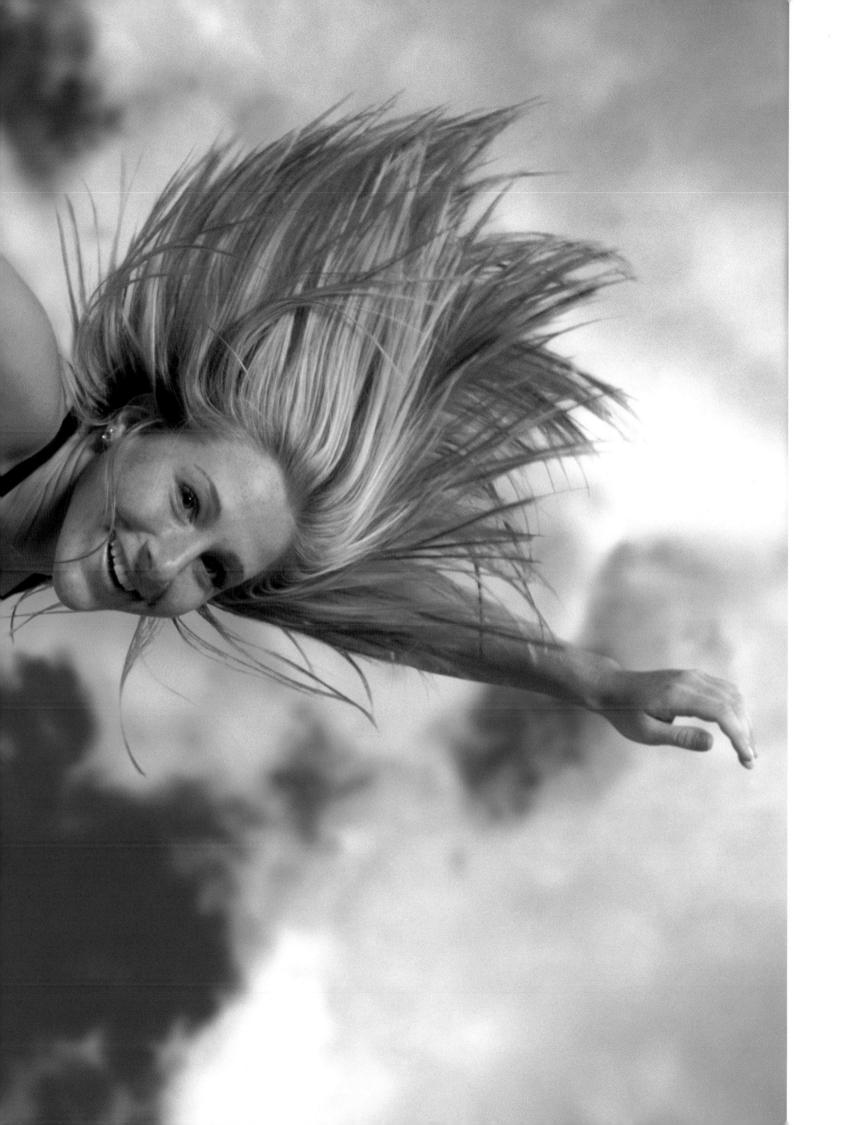

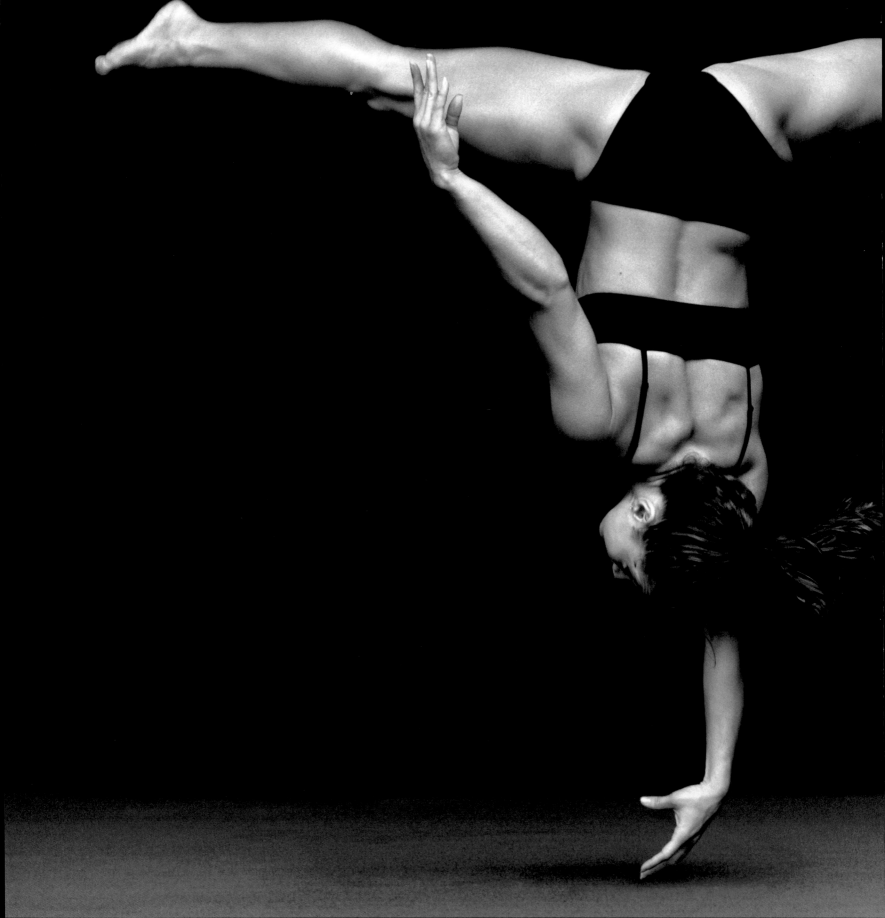

Shannon Miller
Gymnastics

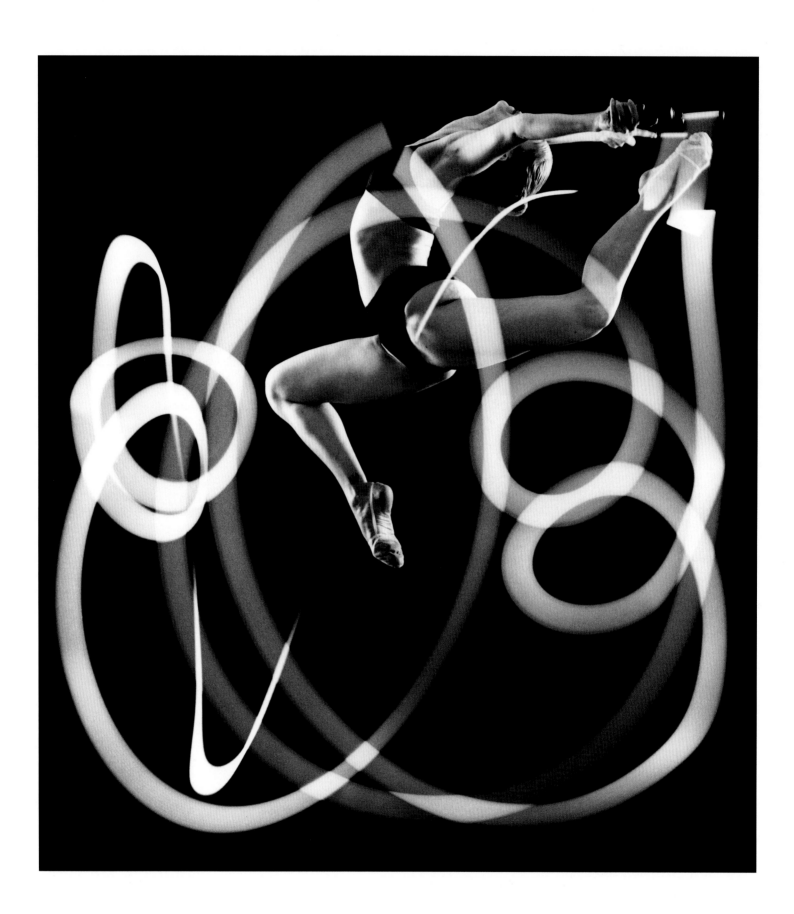

Aliane Baquerot
Rhythmic Gymnastics

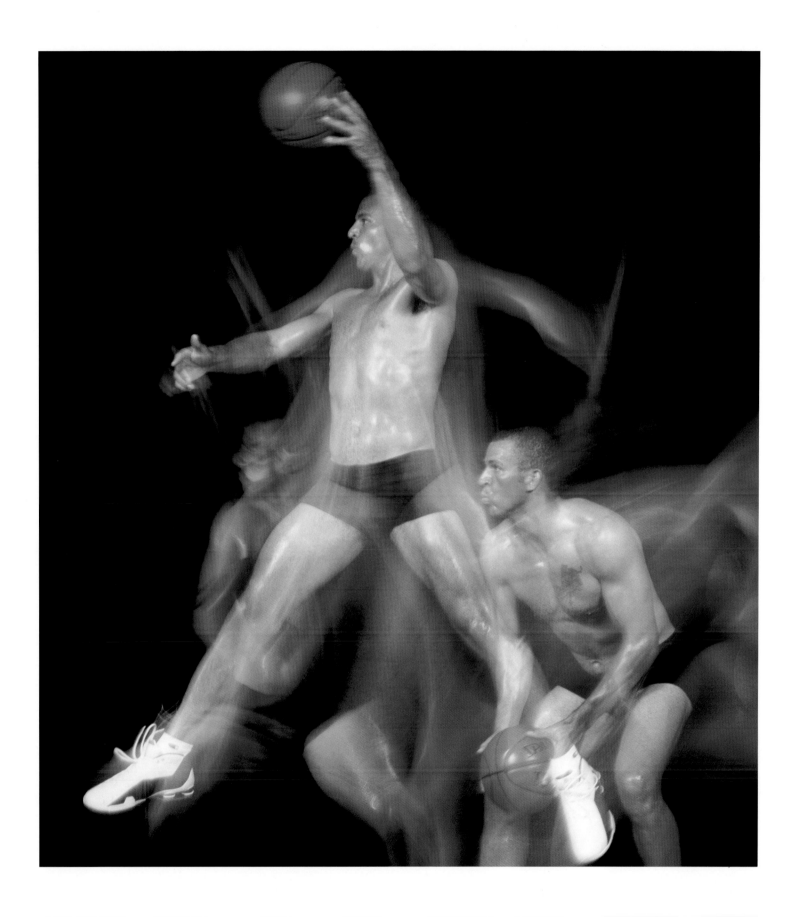

Jason Kidd
Basketball

Following Pages

Allen Johnson
Hurdles (110m)

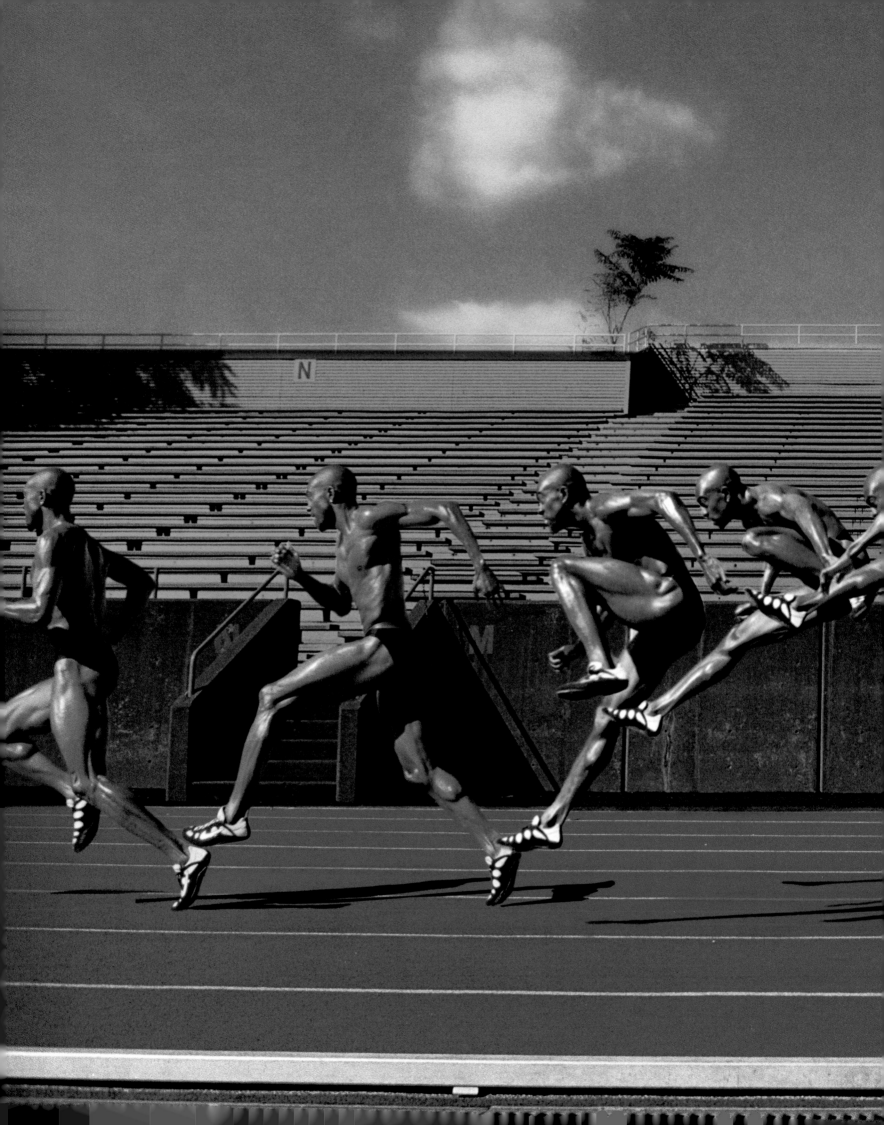

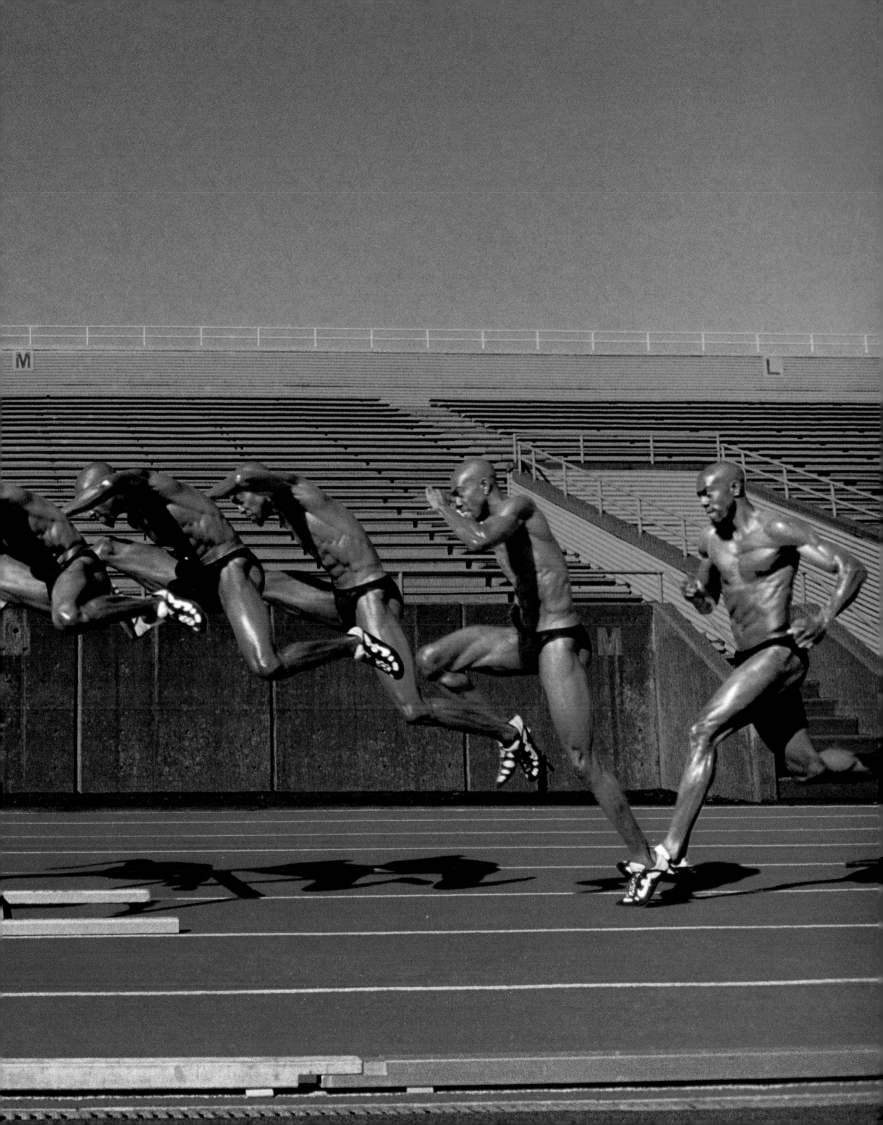

Shawn Crawford
Sprint (200m)

Up Close

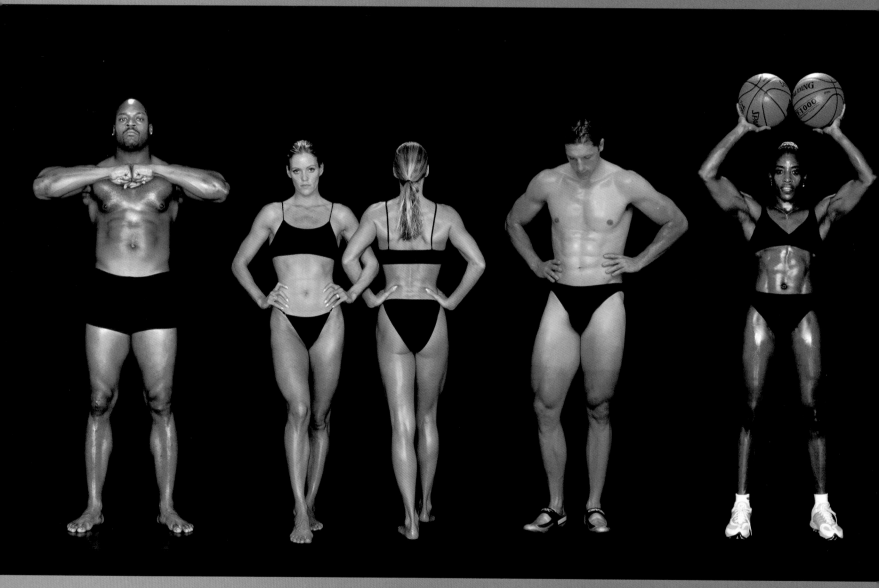

Joe Johnson
Football
6' 4" 270 lbs.

Inge de Bruijn
Swimming (Freestyle & Butterfly)
5' 11" 132 lbs.

Marty Nothstein
Cycling
6' 2" 215 lbs.

Ruthie Bolton-Holifield
Basketball
5' 8" 150 lbs.

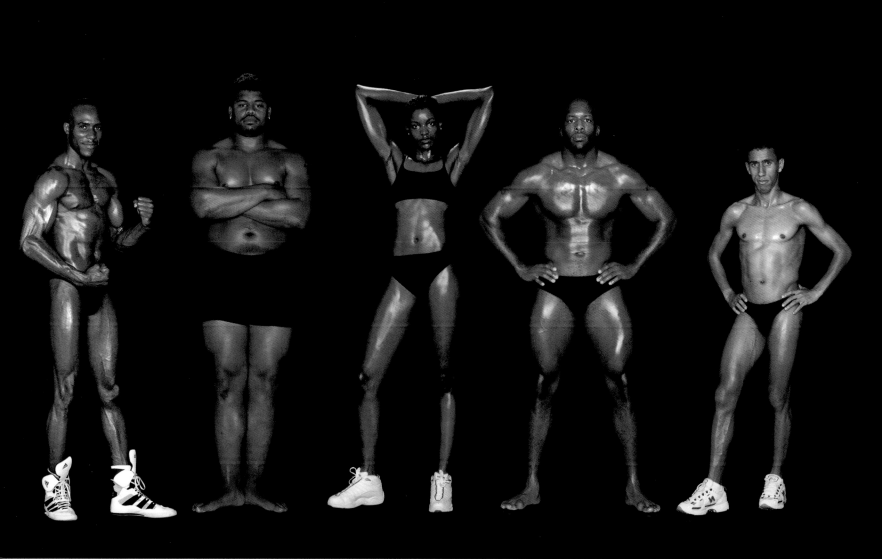

Olanda Anderson
Boxing
6' 2" 178 lbs.

Darrell Russell
Football
6' 5" 325 lbs.

DeLisha Milton
Basketball
6' 1" 172 lbs.

Kerry McCoy
Wrestling
6' 2" 250 lbs.

Khalid Khannouchi
Marathon
5' 5" 125 lbs.

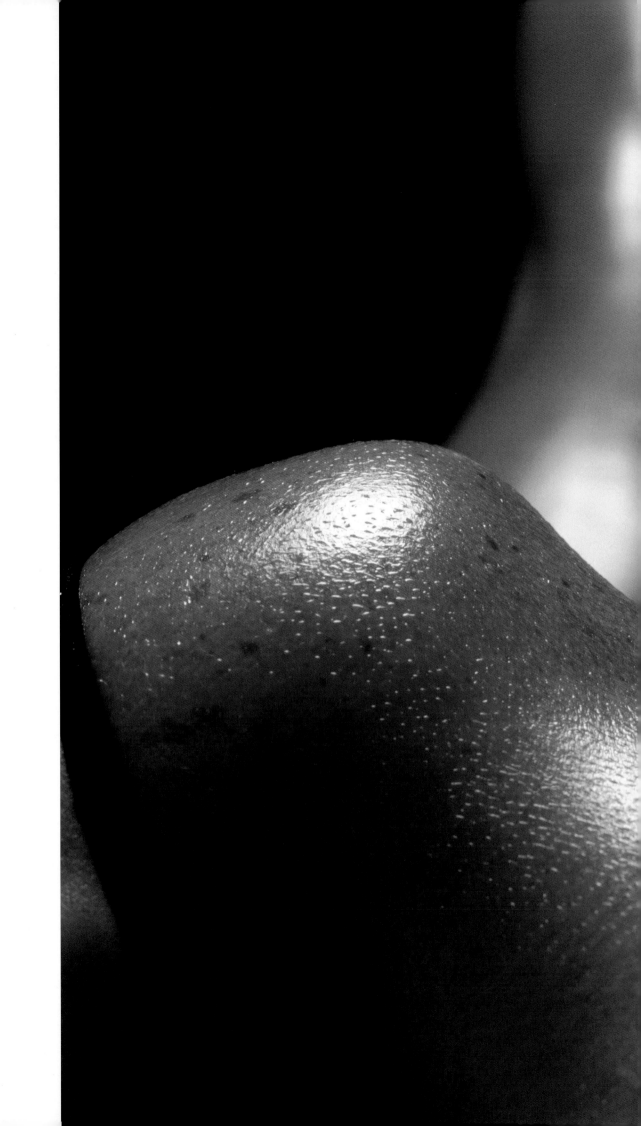

Inge de Bruijn
Swimming (Freestyle & Butterfly)

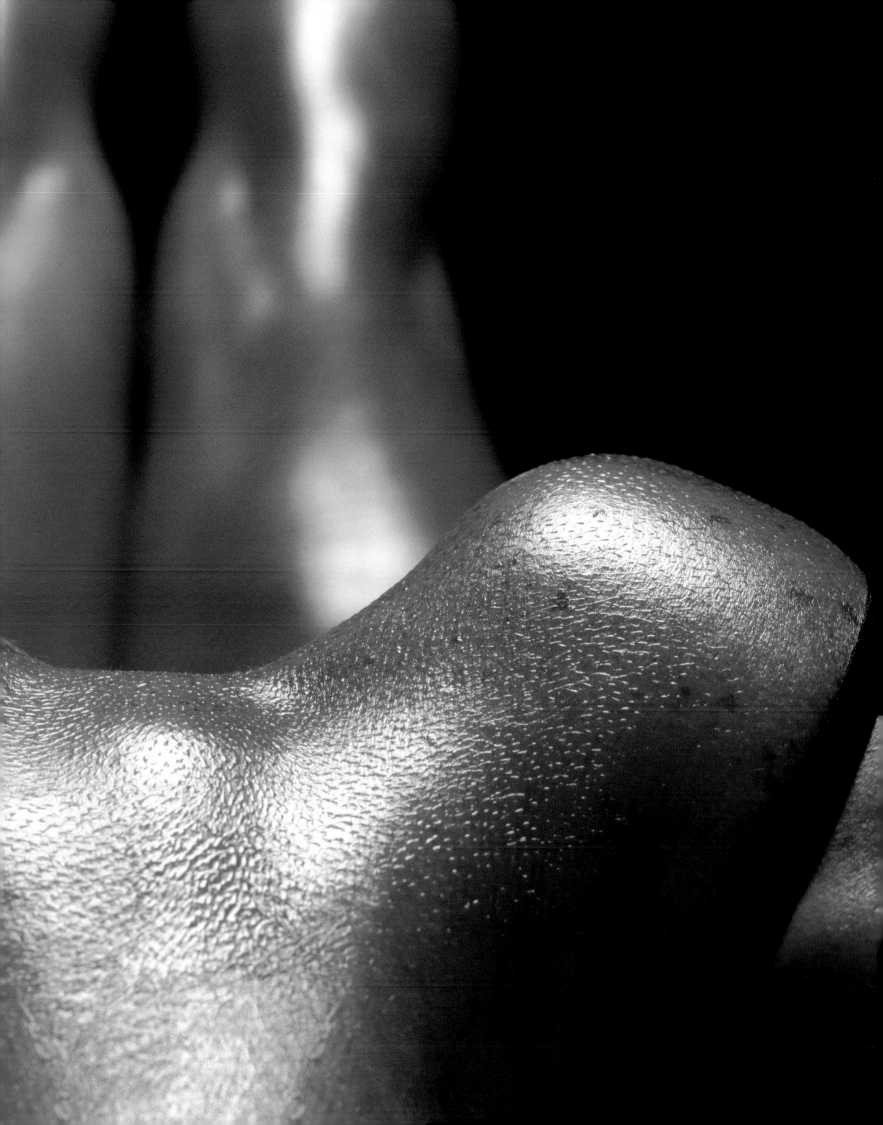

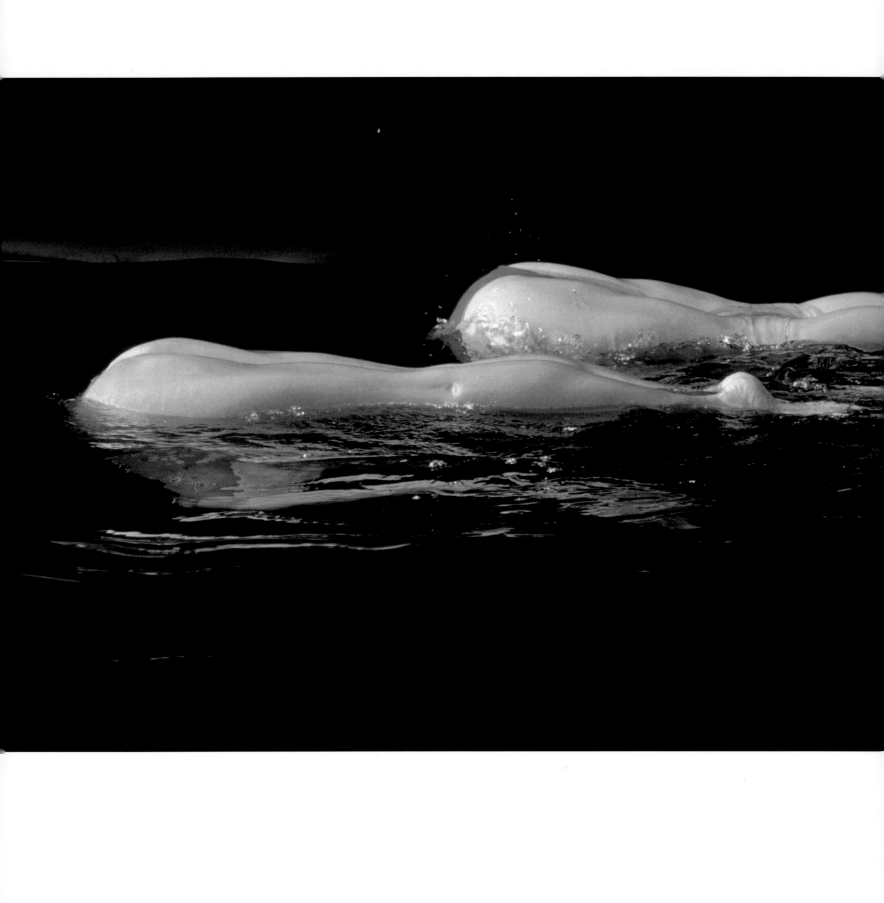

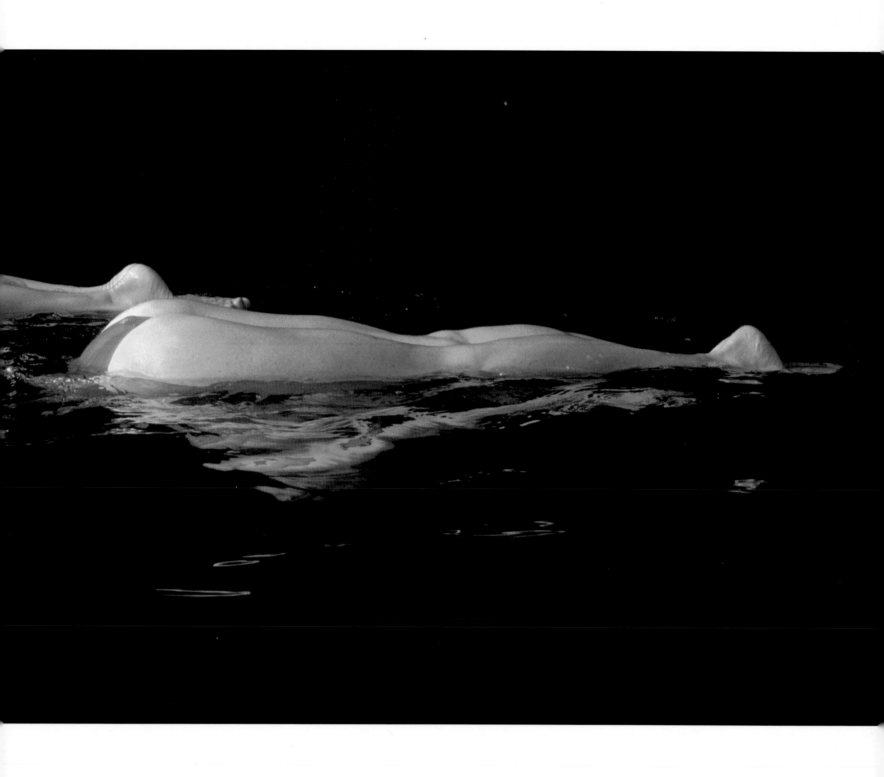

Carrie Barton, Kristina Lum & Bridget Finn
Synchronized Swimming

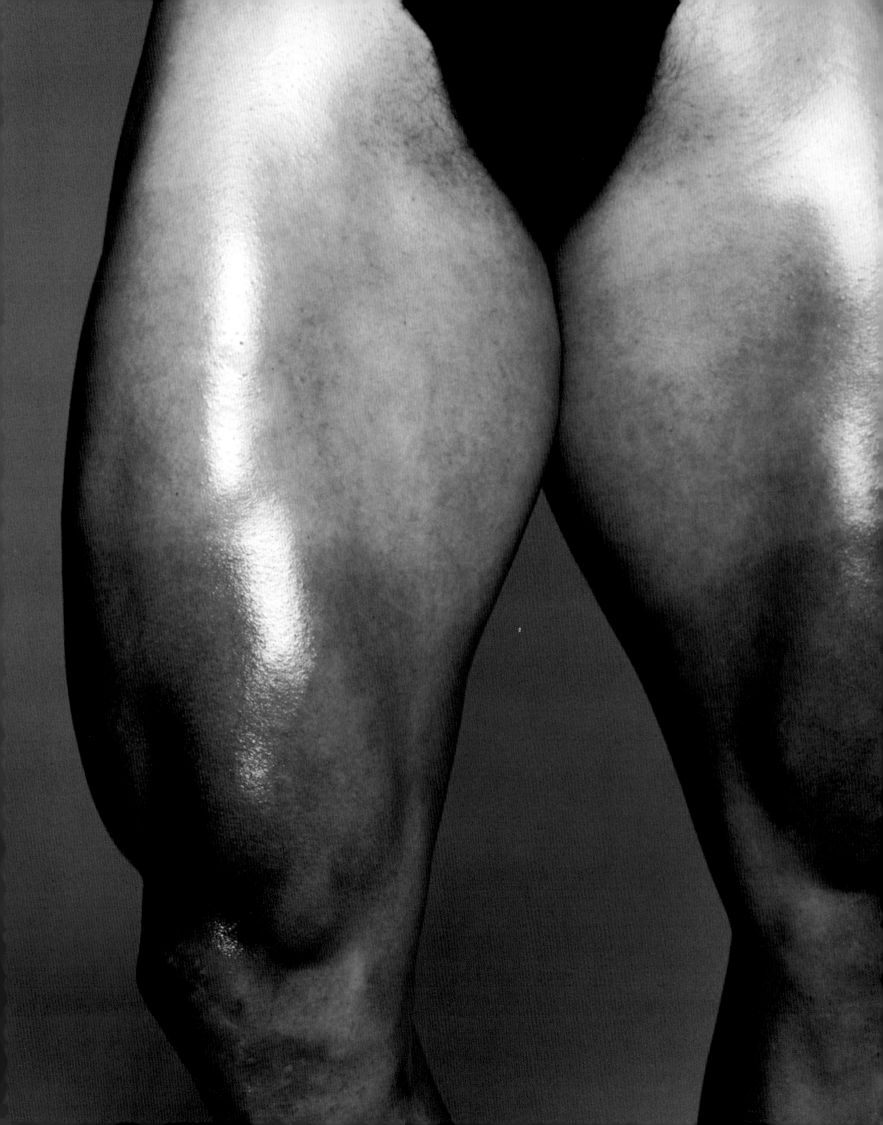

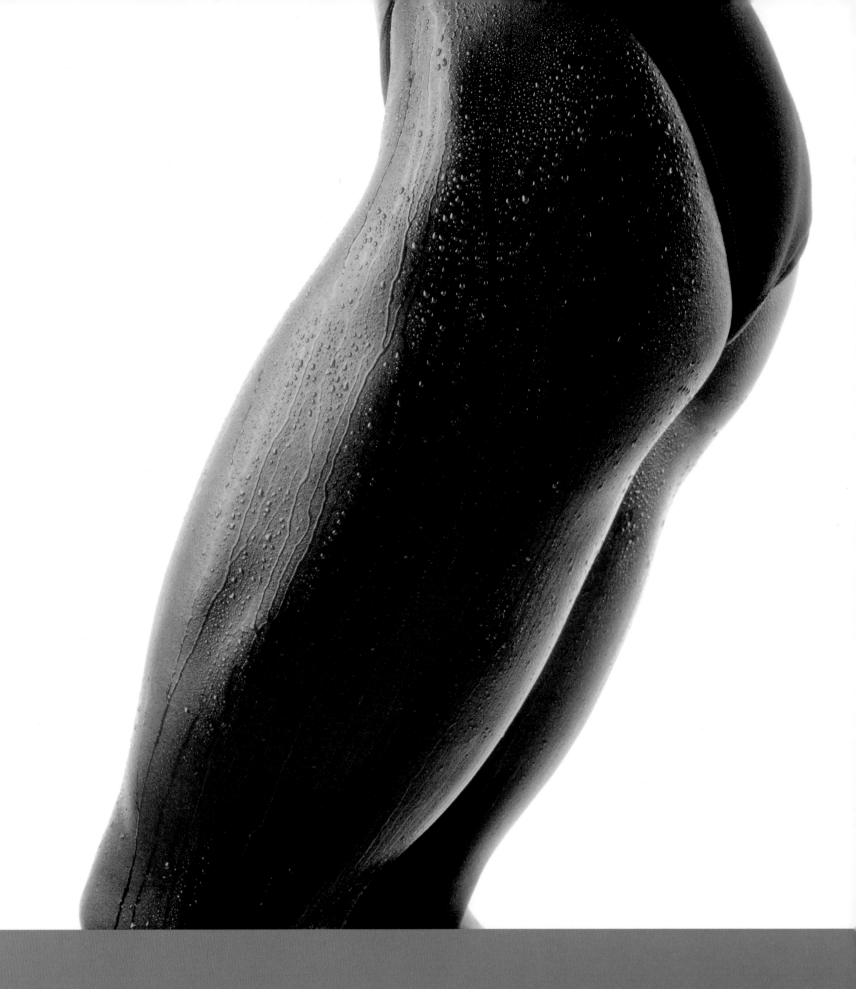

Preceding Pages:

Marty Nothstein
Cycling

Jearl Miles-Clark
Running (400m, 800m)

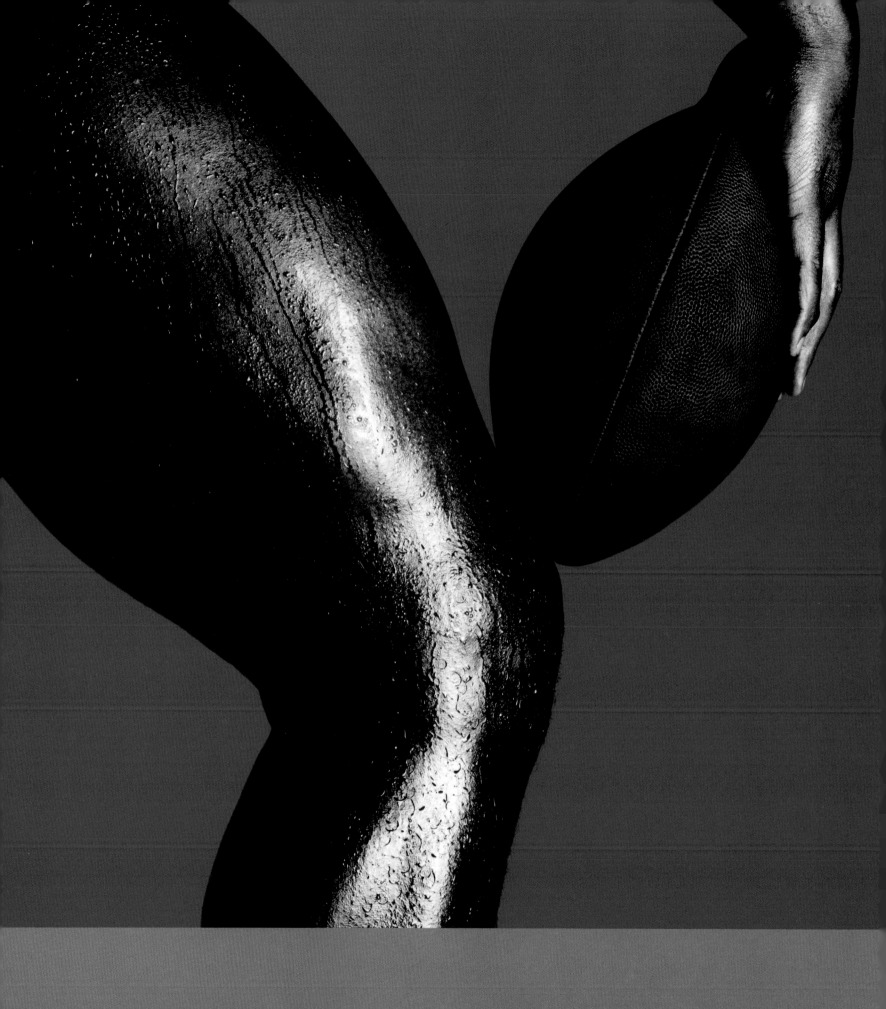

Darrell Russell
Football
81

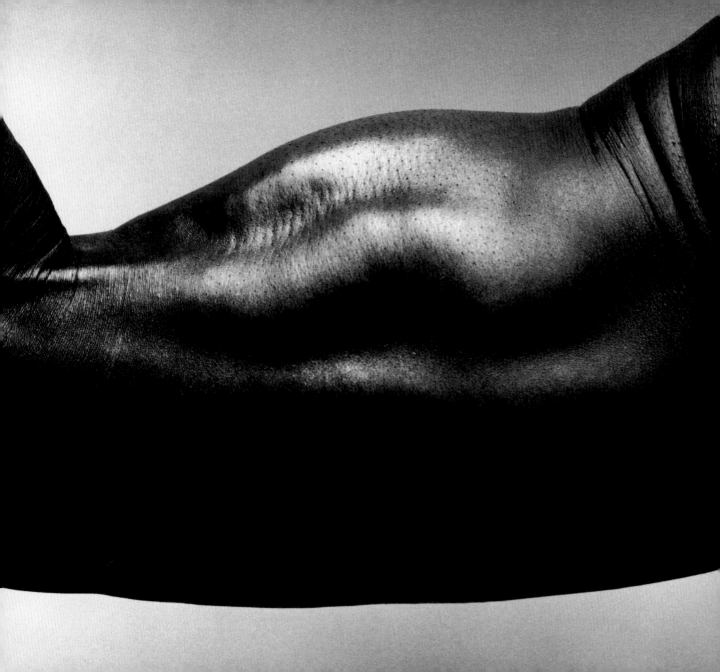

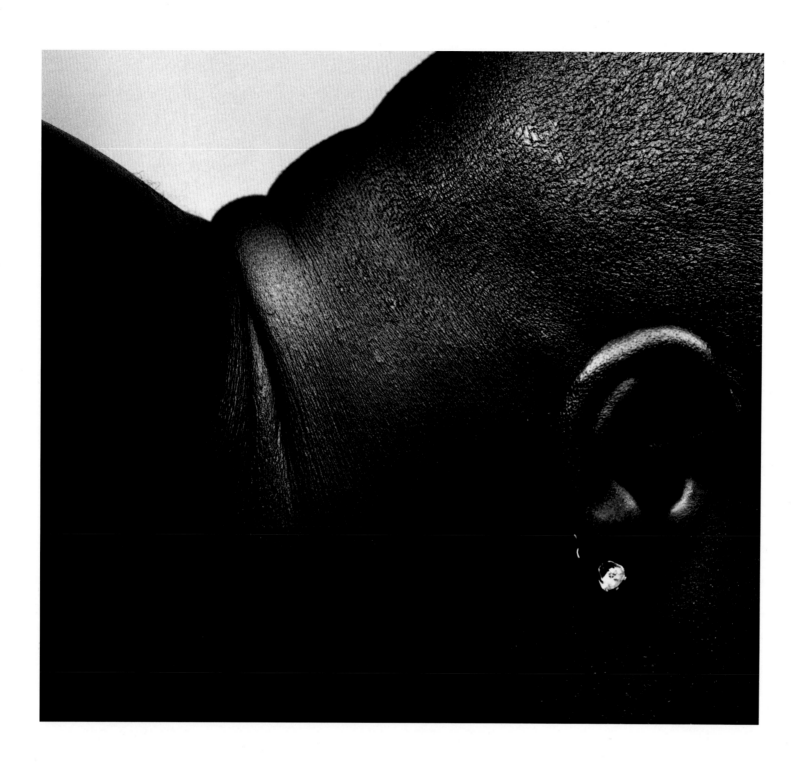

Chris Wheir
Natural Bodybuilding
(Hamstring)

Joe Johnson
Football

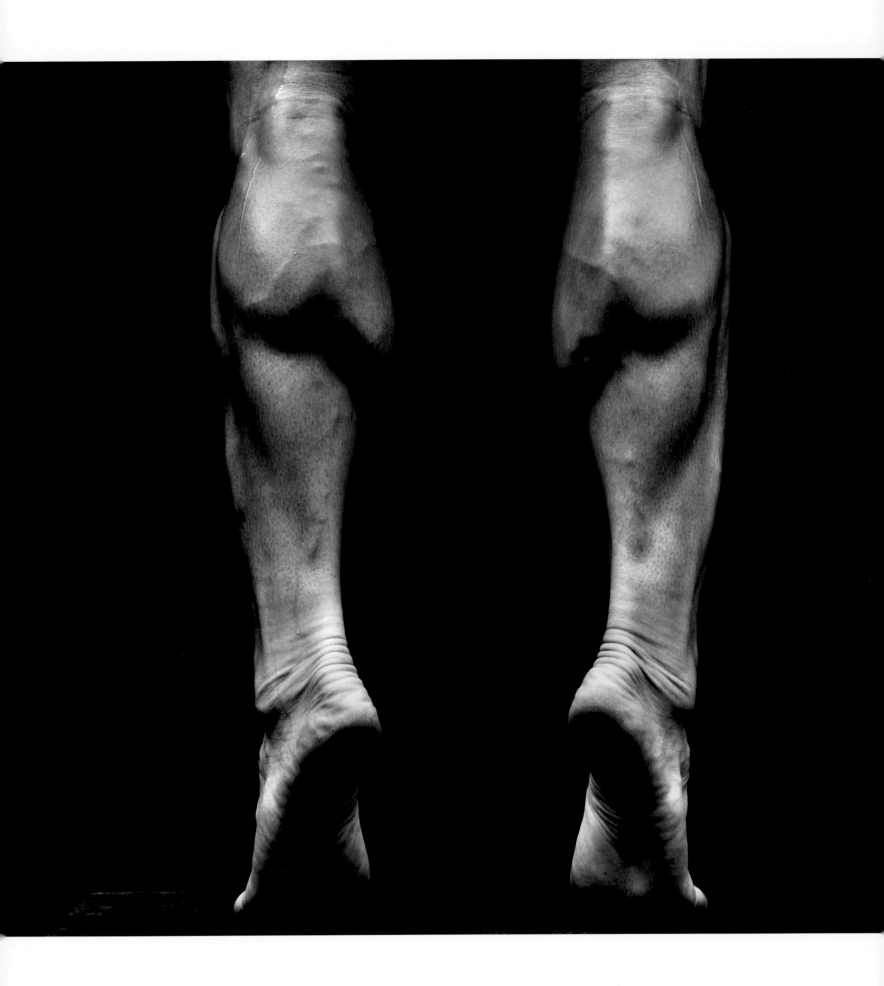

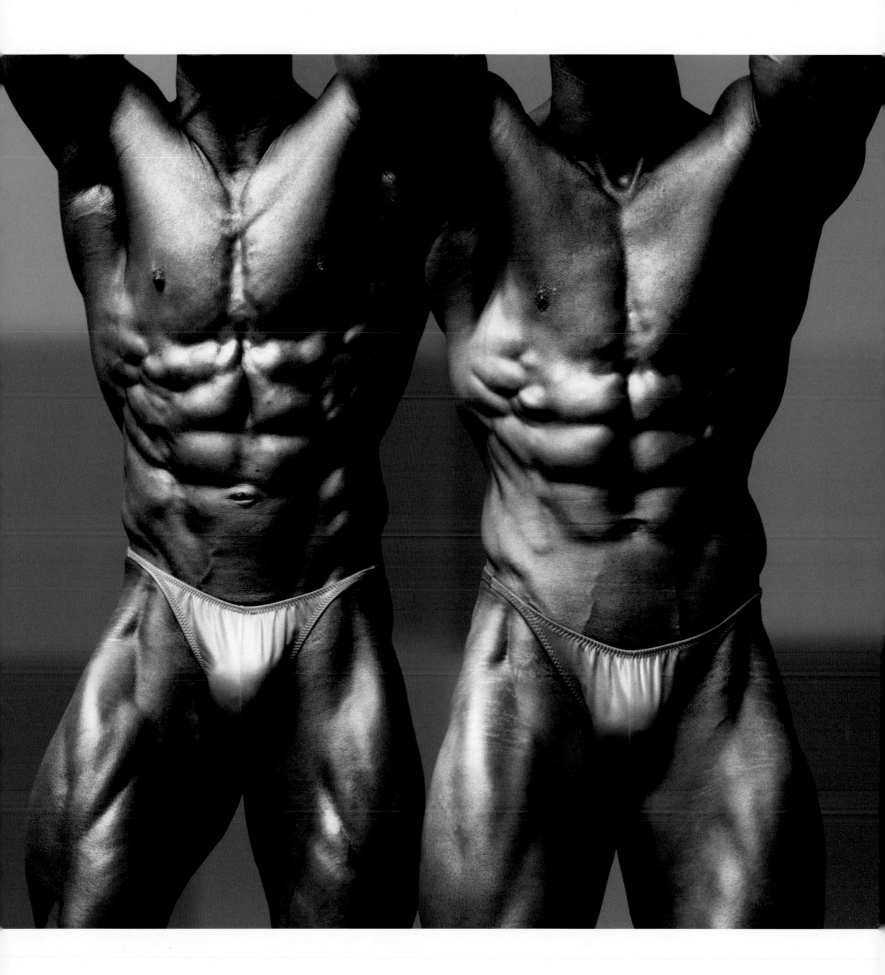

Corey & Chris Wheir
Natural Bodybuilding

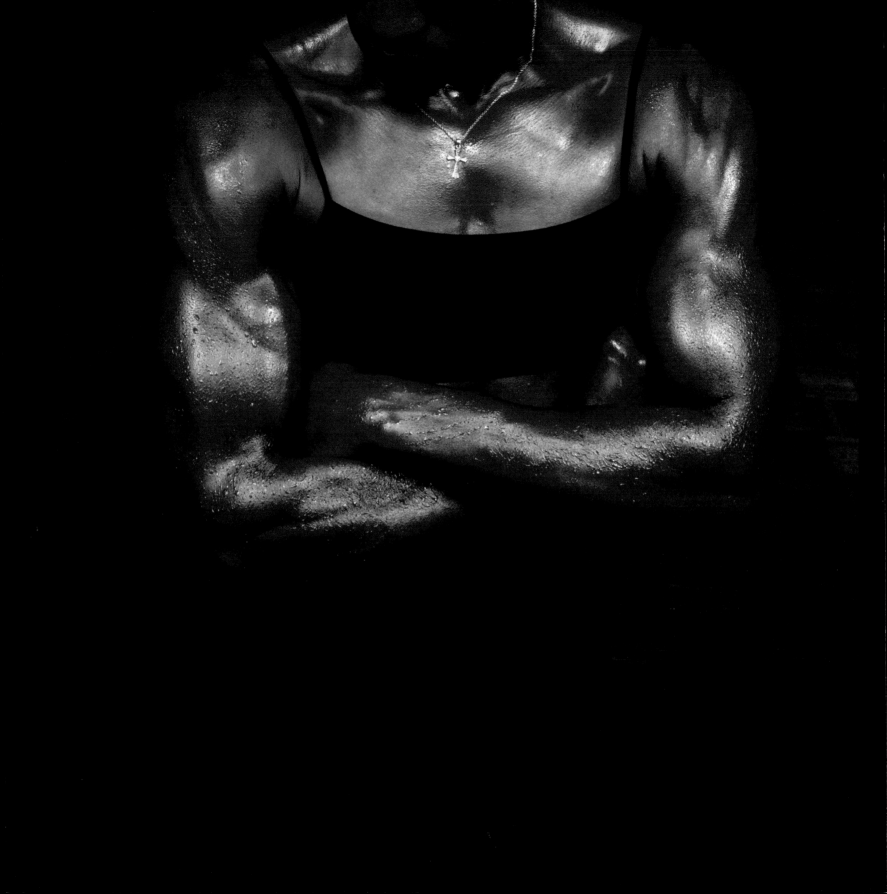

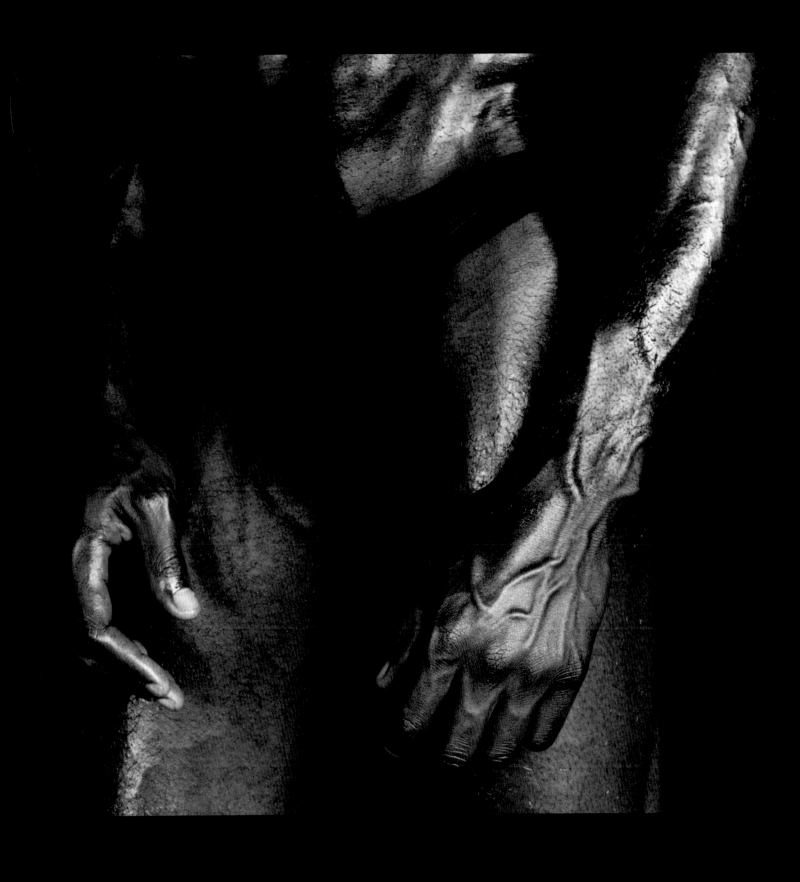

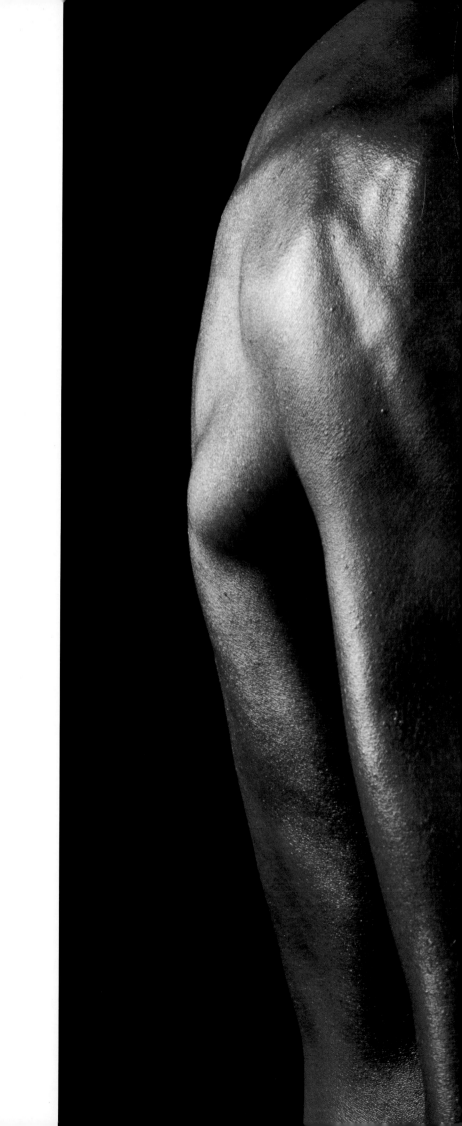

Preceding Pages:

Ruthie Bolton-Holifield
Basketball

Olanda Anderson
Boxing

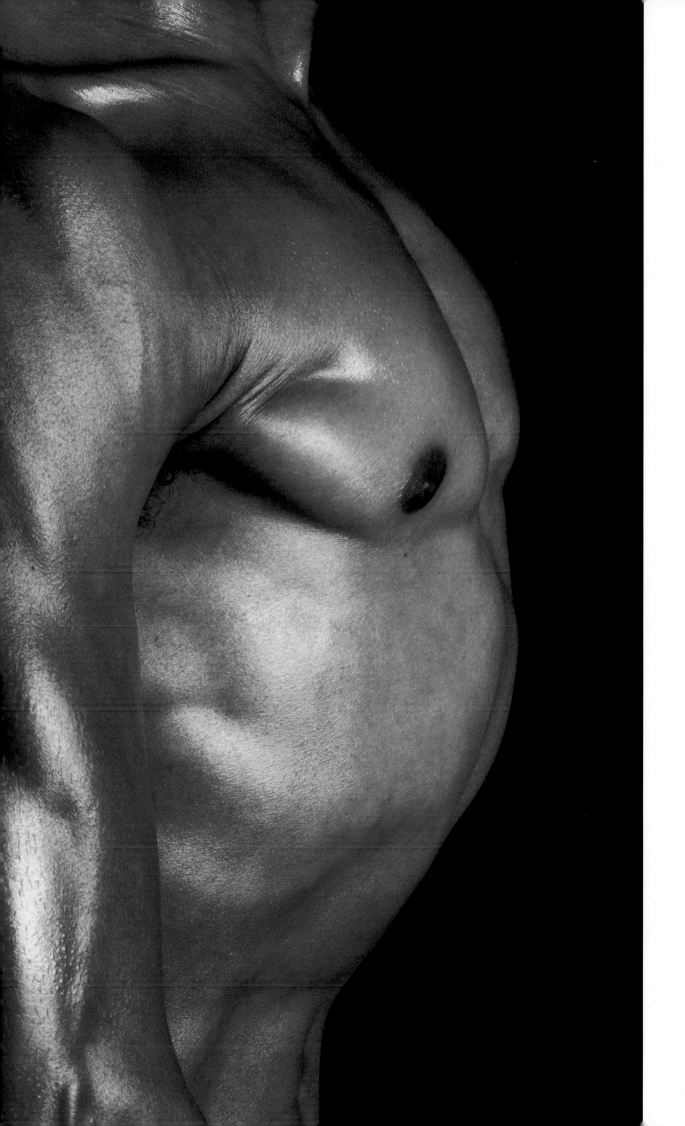

Khalid Khannouchi
Marathon

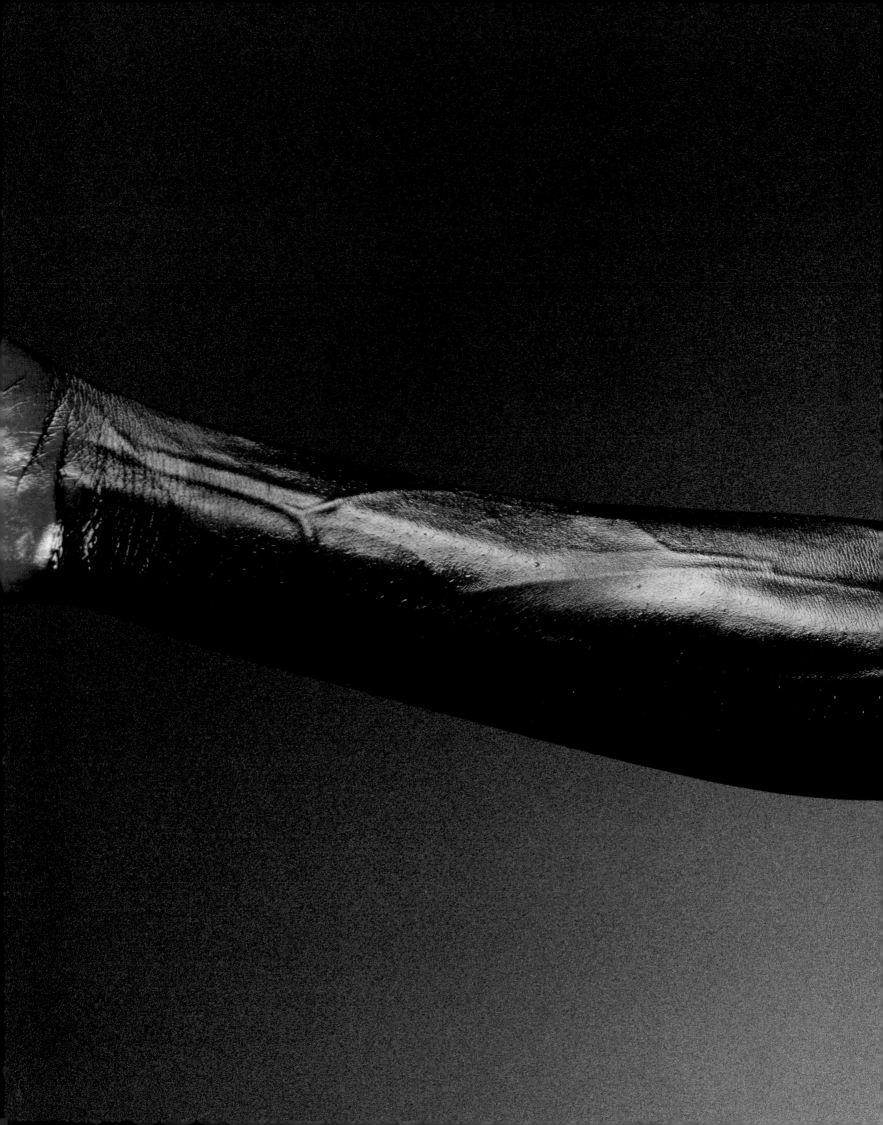

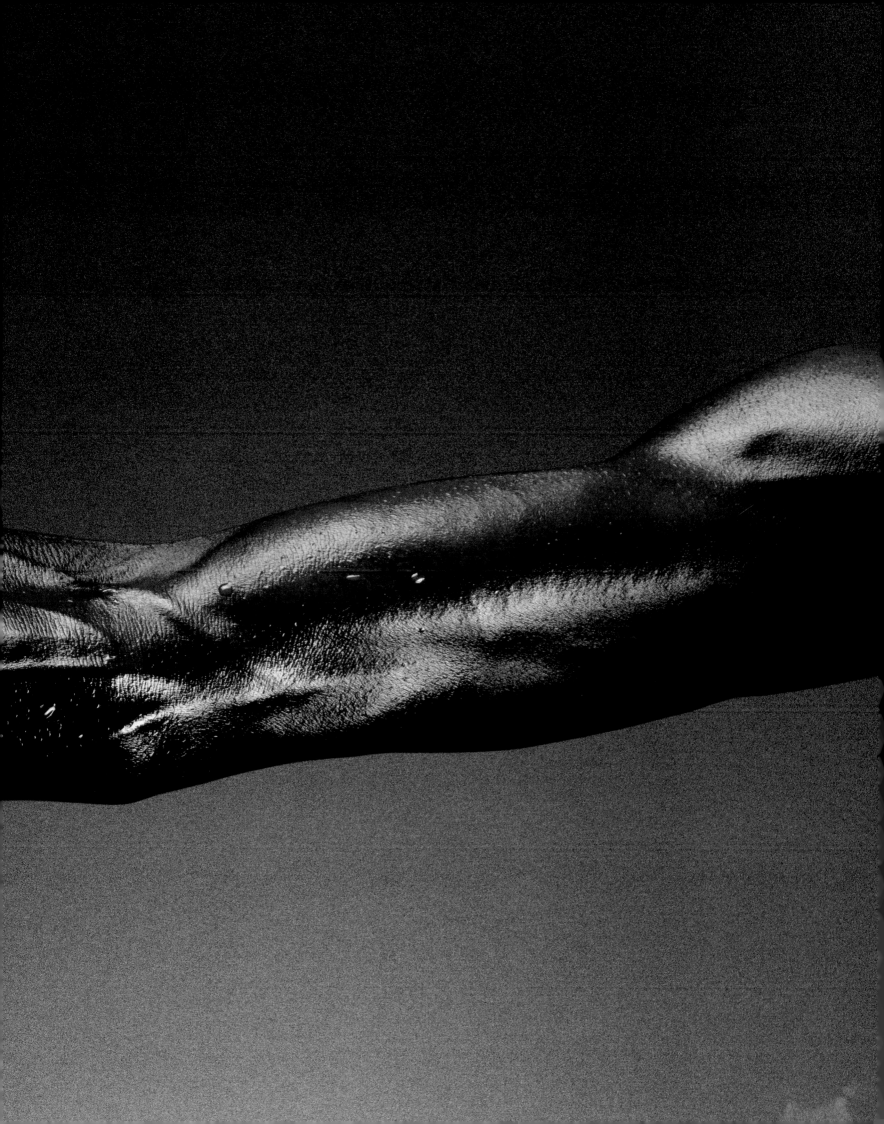

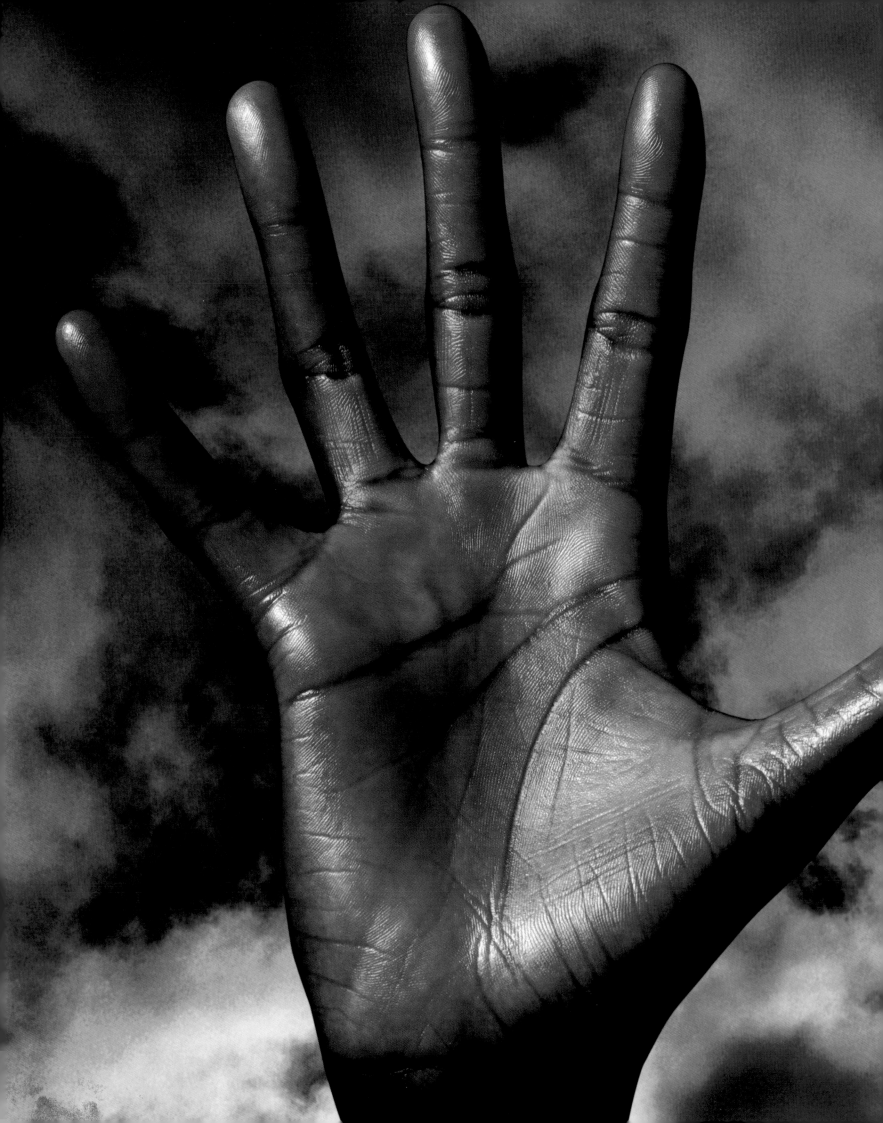

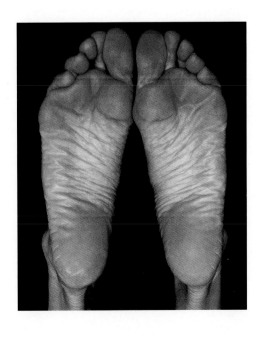

DeLisha Milton
Basketball

Inge de Bruijn
Swimming

Preceding Pages

Joseph Chebet
Marathon

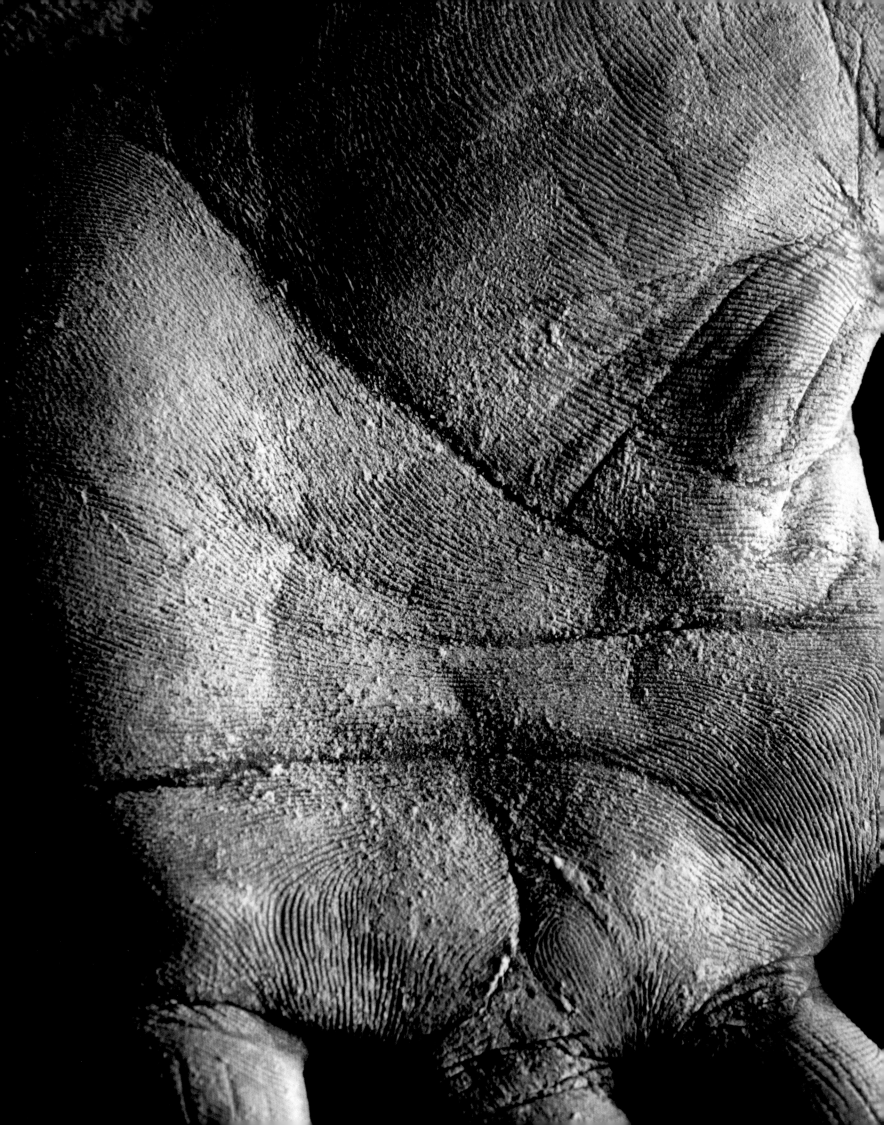

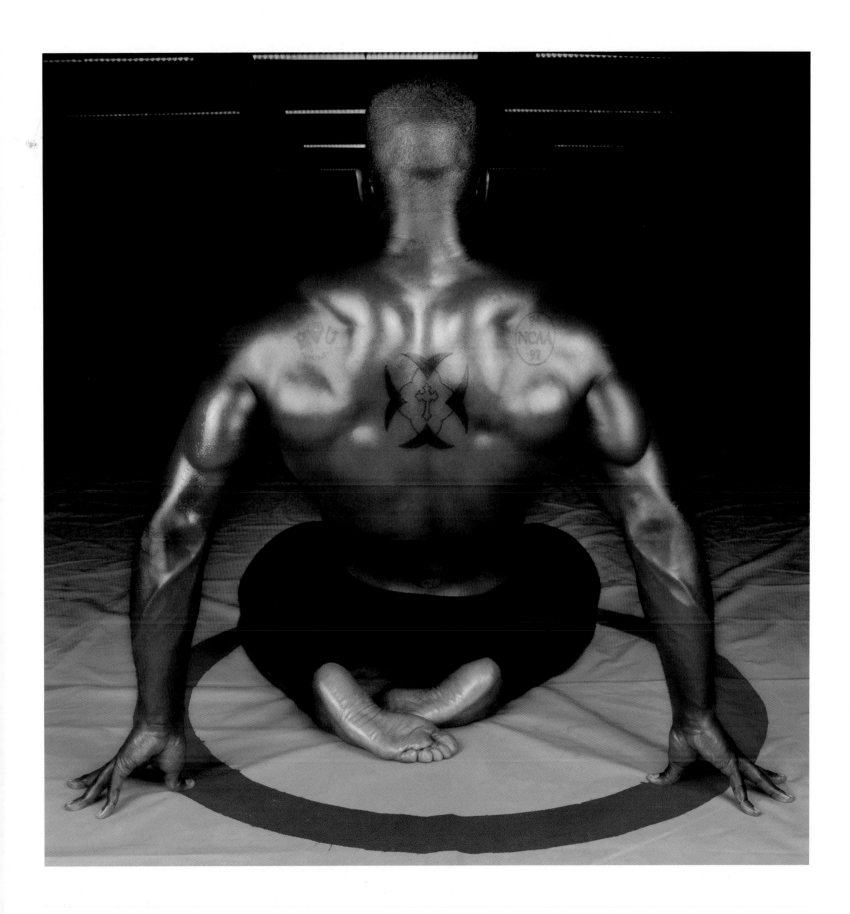

Sean Townsend
Gymnastics

Kerry McCoy
Wrestling

Carlos Delgado
Baseball

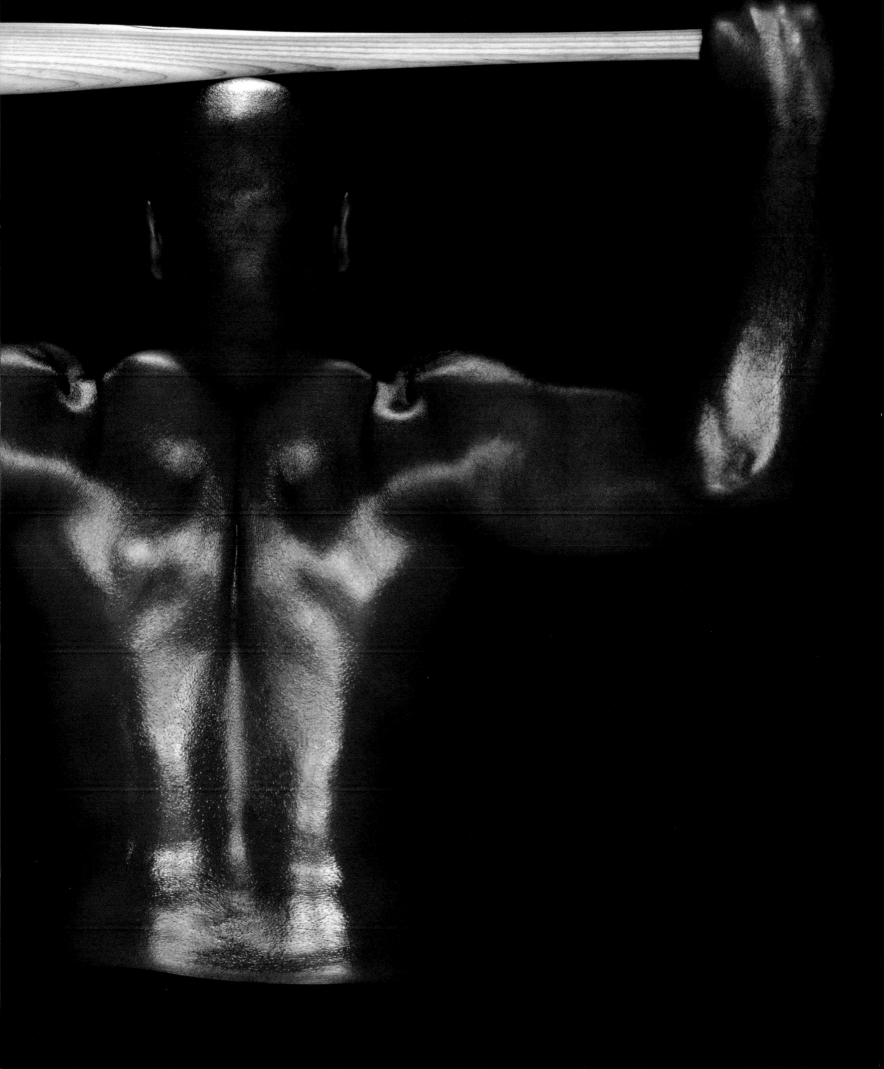

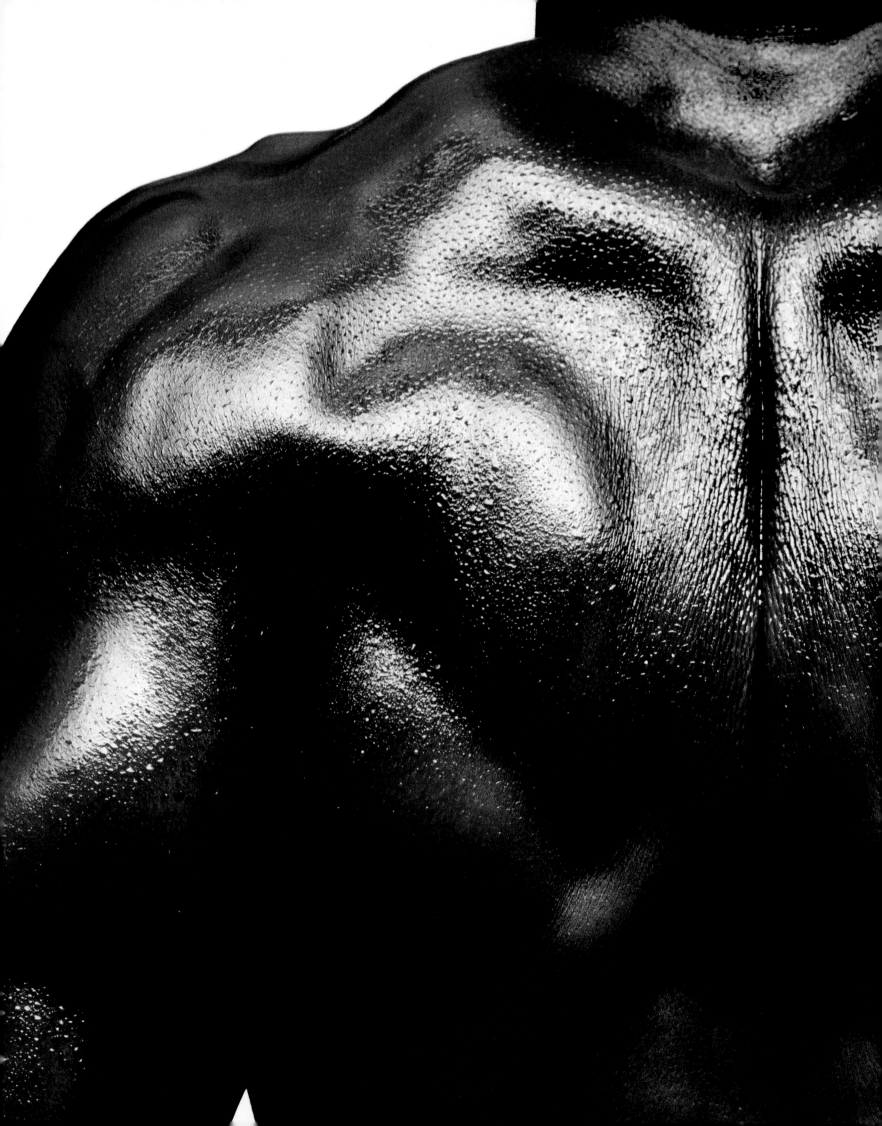

Ray Allen
Basketball

Racing pool, Olympic Training Center
Colorado Springs, Colorado

Ski
Skate
Swim

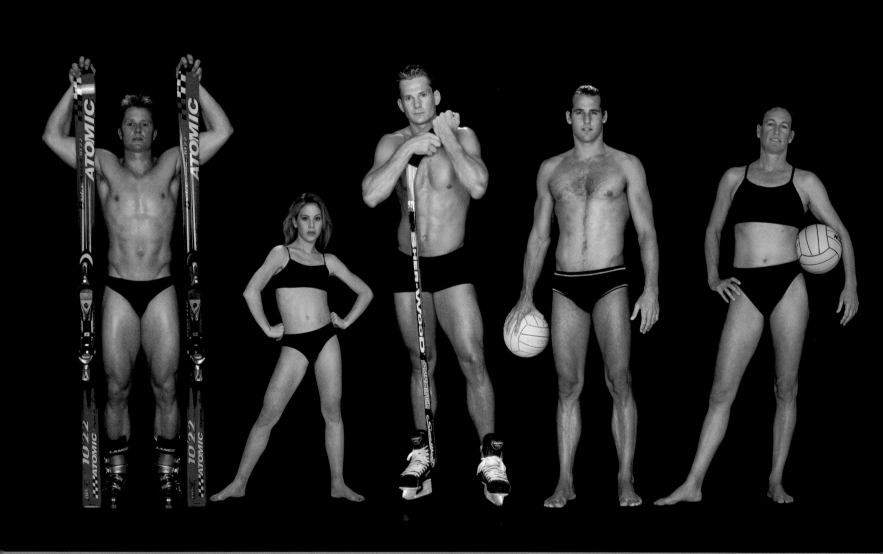

Daron Rahlves
Skiing (Downhill & Super-G)
5' 9" 175 lbs.

Tara Lipinski
Figure Skating
5' 1" 95 lbs.

Patrik Elias
Hockey
6' 1" 200 lbs.

Wolf Wigo
Water Polo
6' 2" 195 lbs.

Maureen O'Toole
Water Polo
5' 11" 140 lbs.

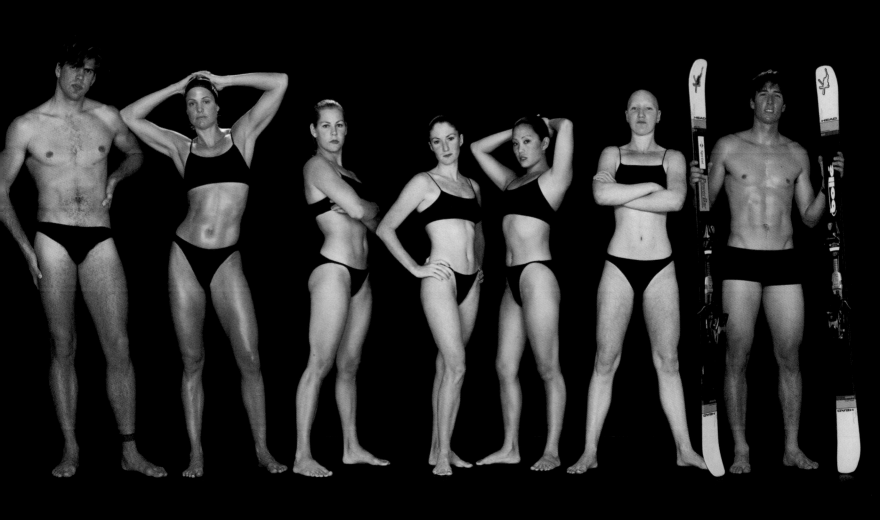

Gary Hall
Swimming (Freestyle)
6' 6" 185 lbs.

Dara Torres
Swimming (Freestyle & Butterfly)
6' 0" 150 lbs.

Carrie Barton, Bridget Finn & Kristina Lum
Synchronized Swimming
5' 7" 135 lbs.; 5' 5" 112 lbs.; 5' 3" 110 lbs.

Staciana Stitts
Swimming (Breaststroke)
5' 10" 140 lbs.

Jonny Moseley
Skiing (Freestyle Moguls)
5' 11" 178 lbs.

Daron Rahlves
Skiing (Downhill & Super G)

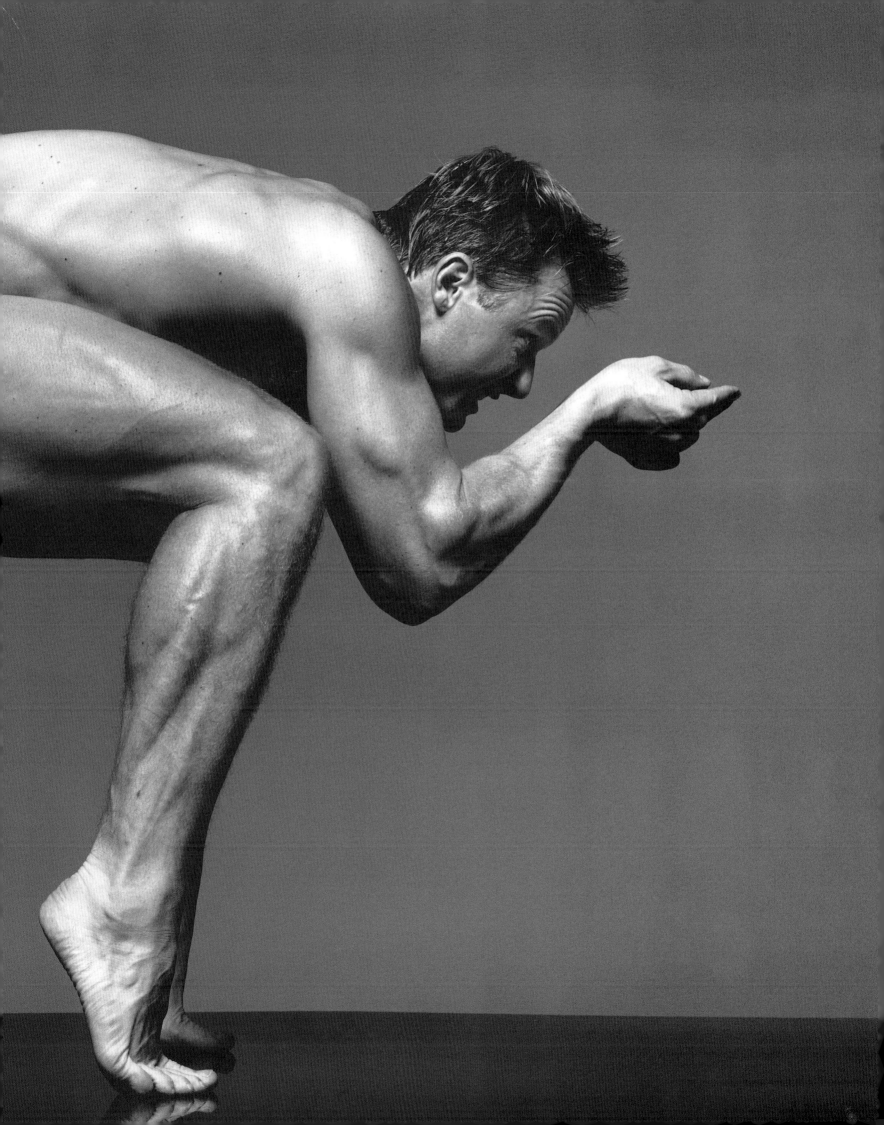

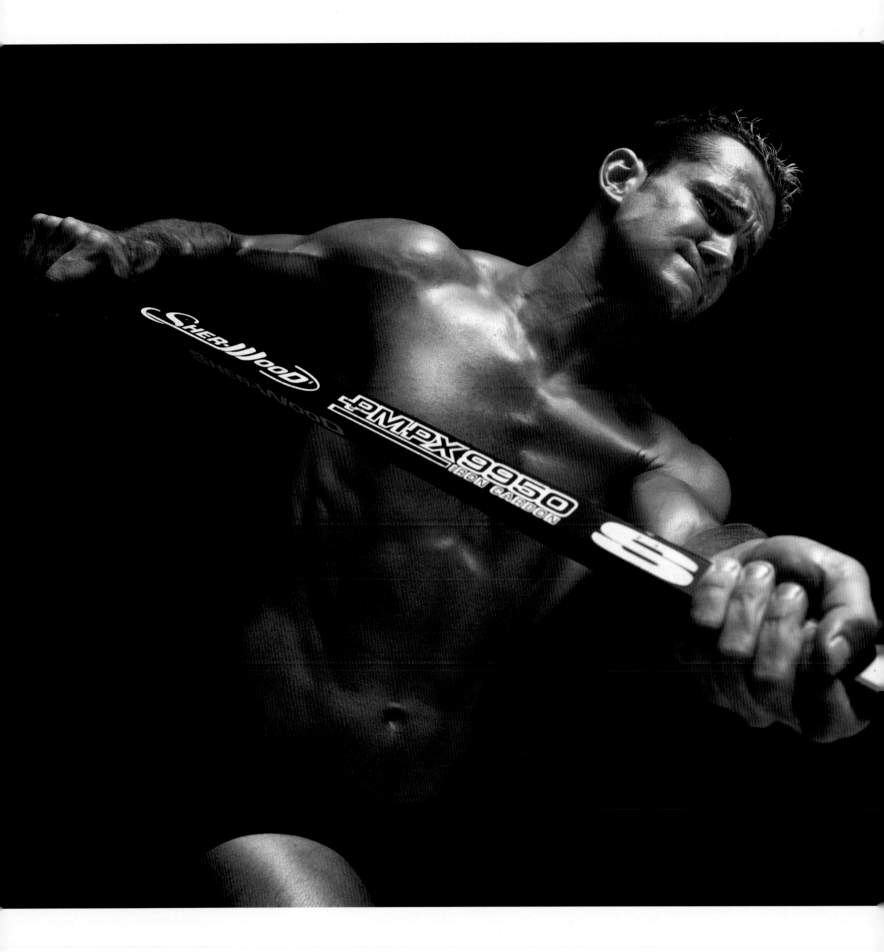

Patrik Elias
Hockey

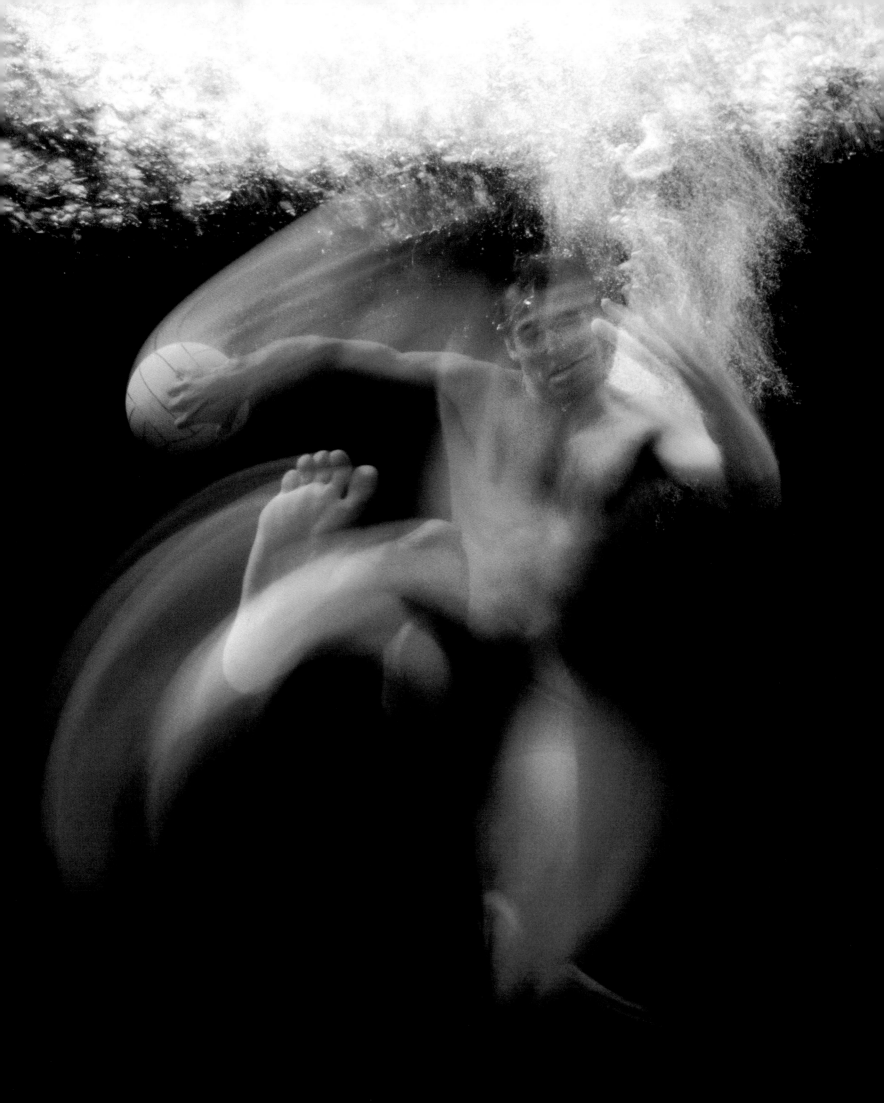

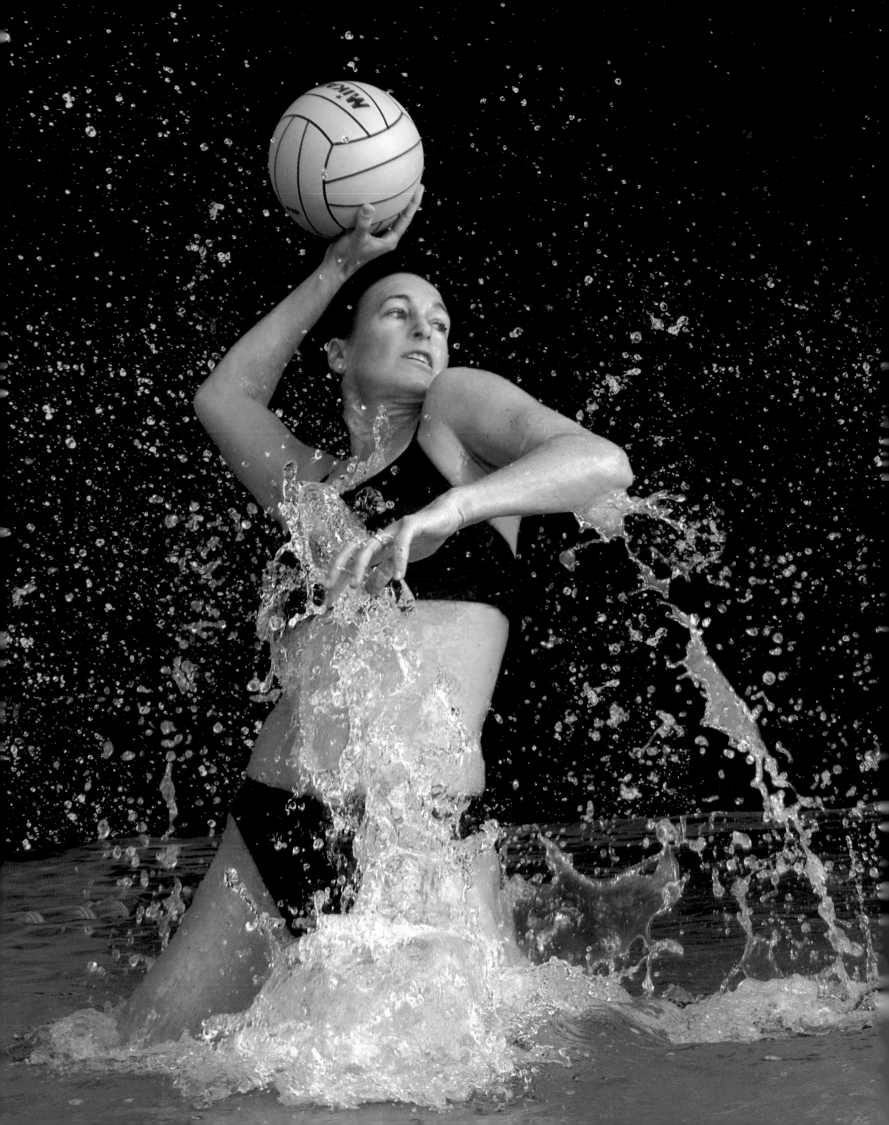

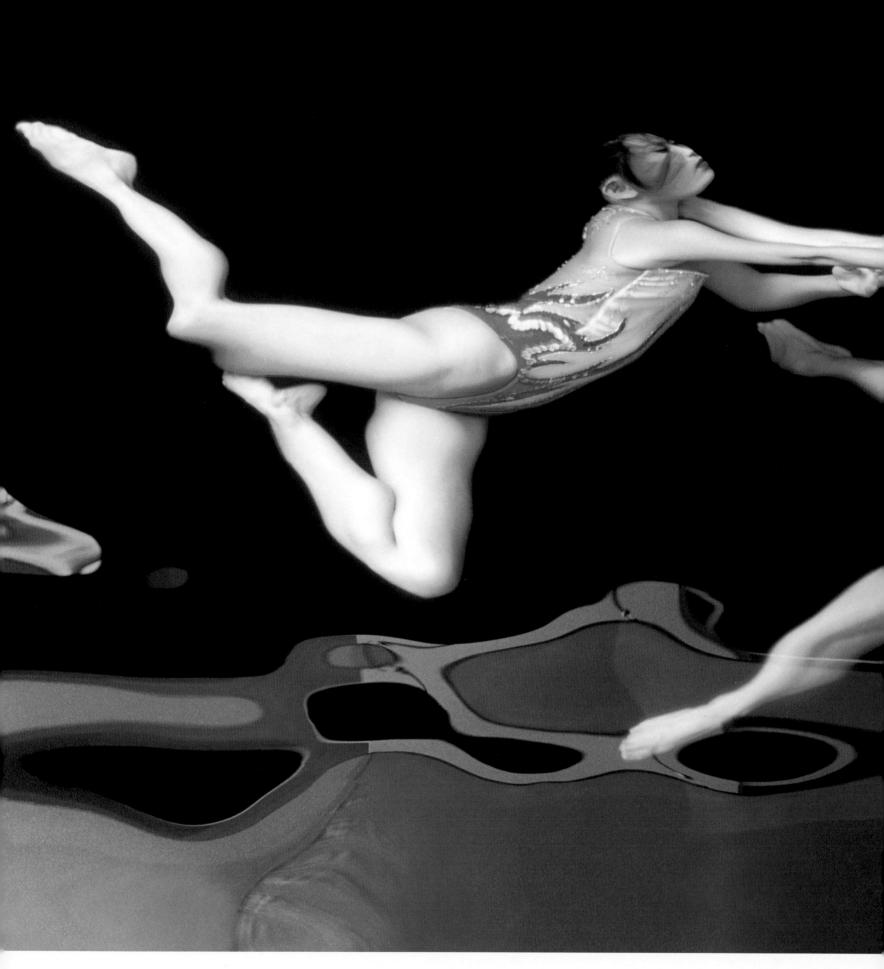

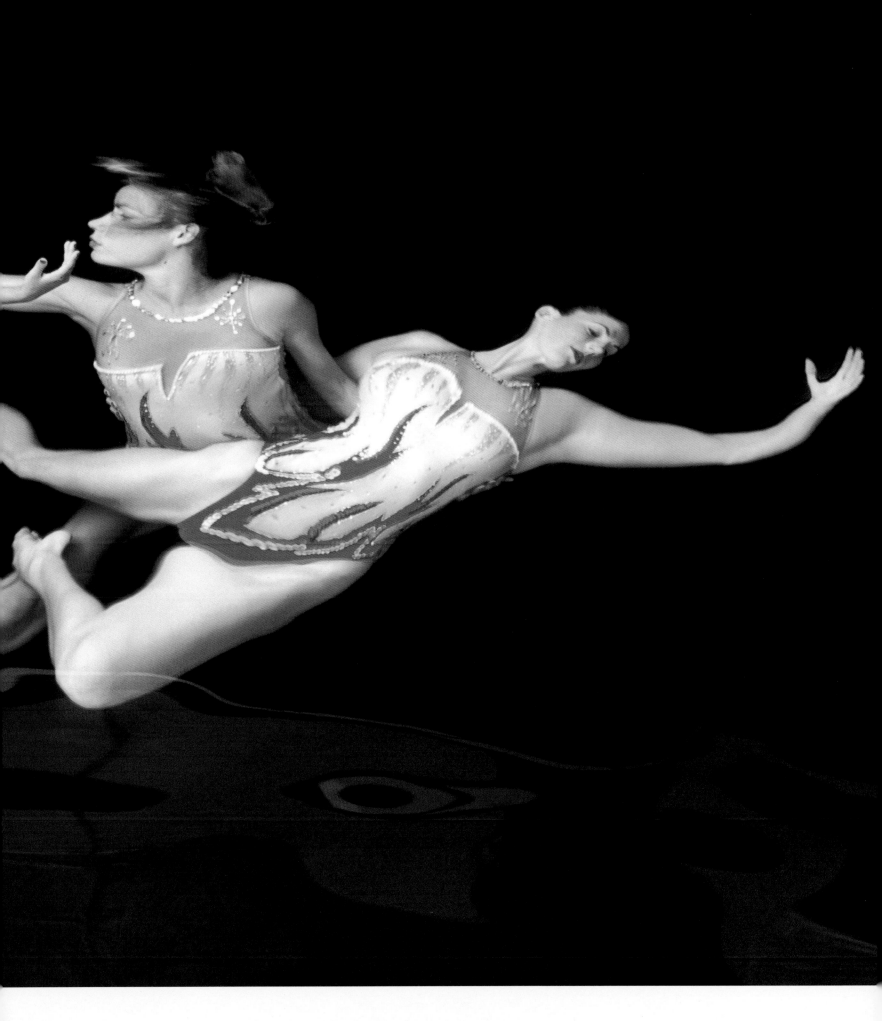

Carrie Barton, Kristina Lum & Bridget Finn
Synchronized Swimming

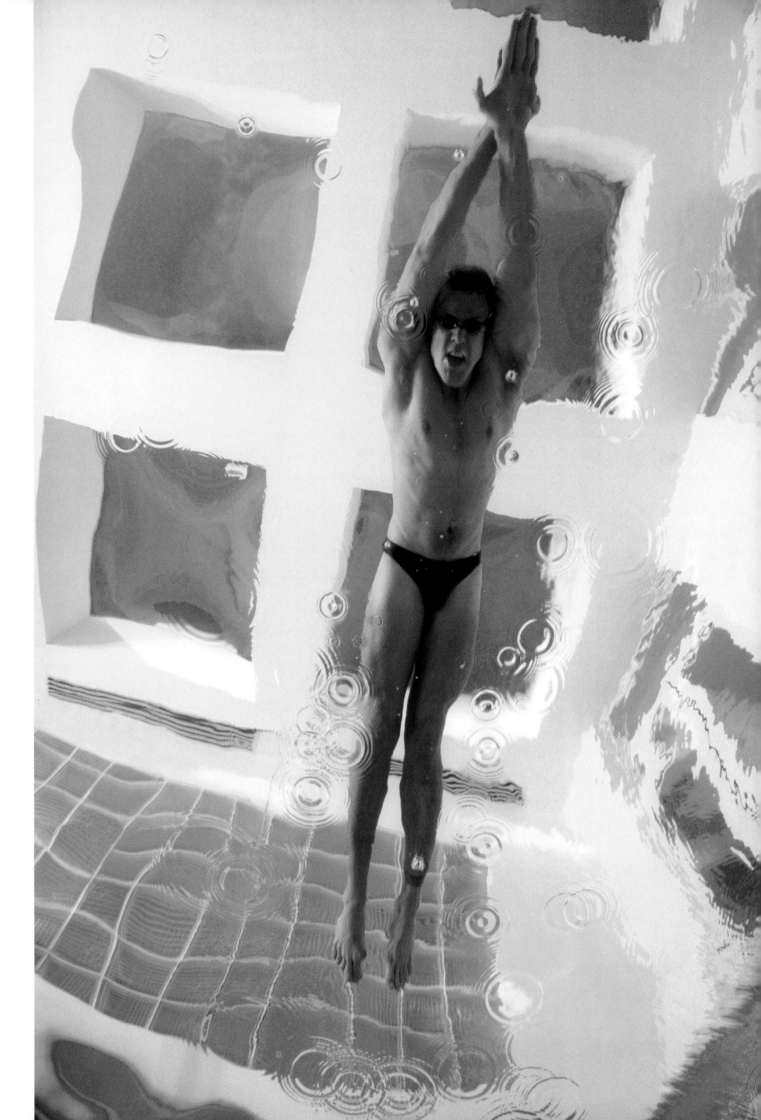

(Photographed from bottom of pool before he hits the water)

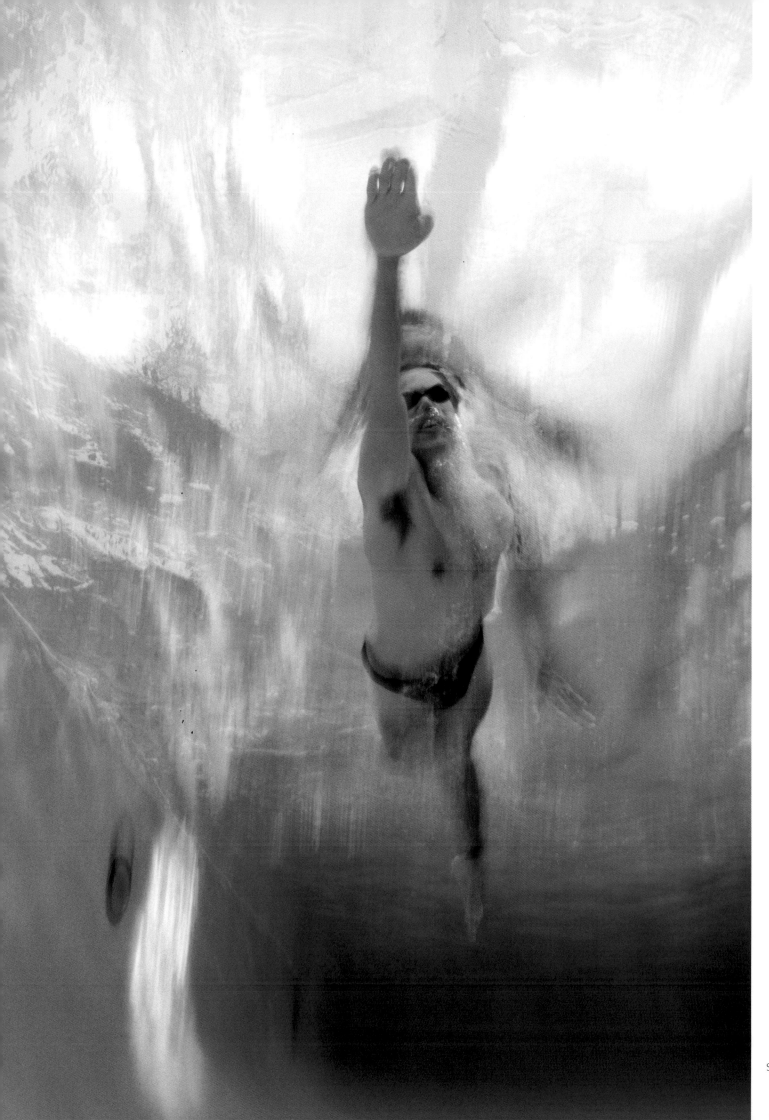

Gary Hall
Swimming (Freestyle)

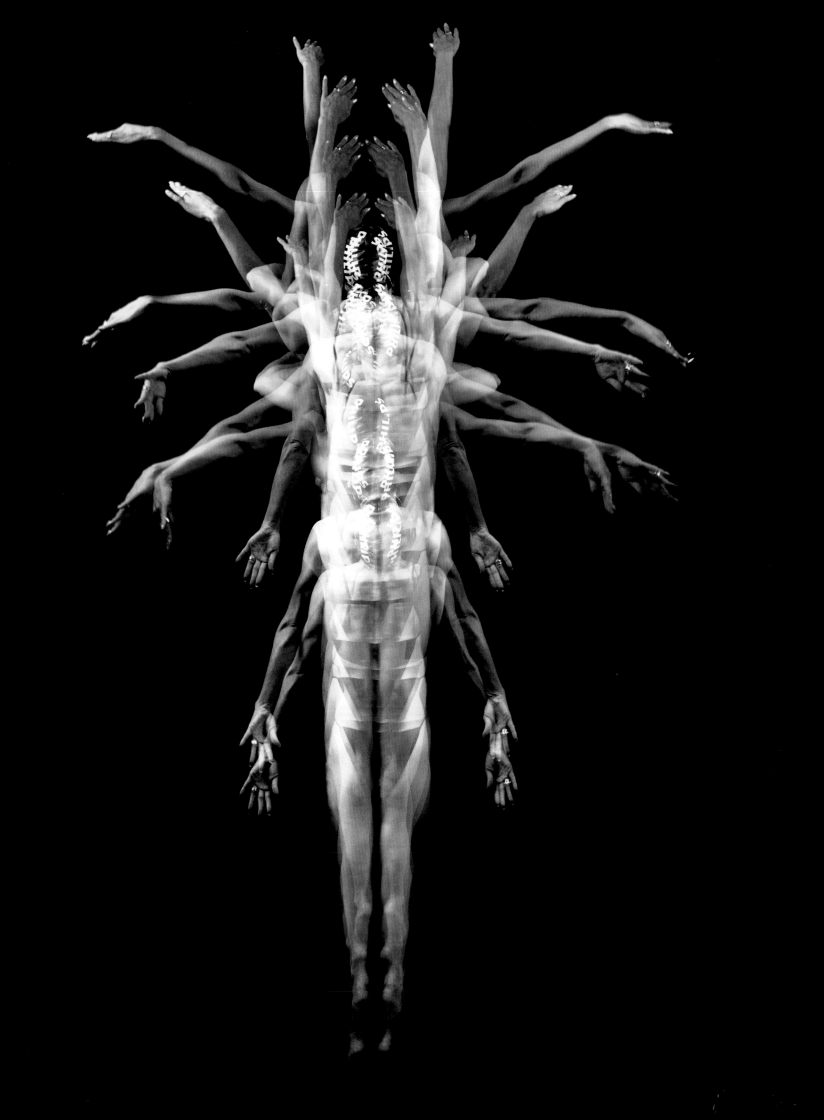

Inge de Bruijn
Swimming (Freestyle & Butterfly)
(Butterfly)

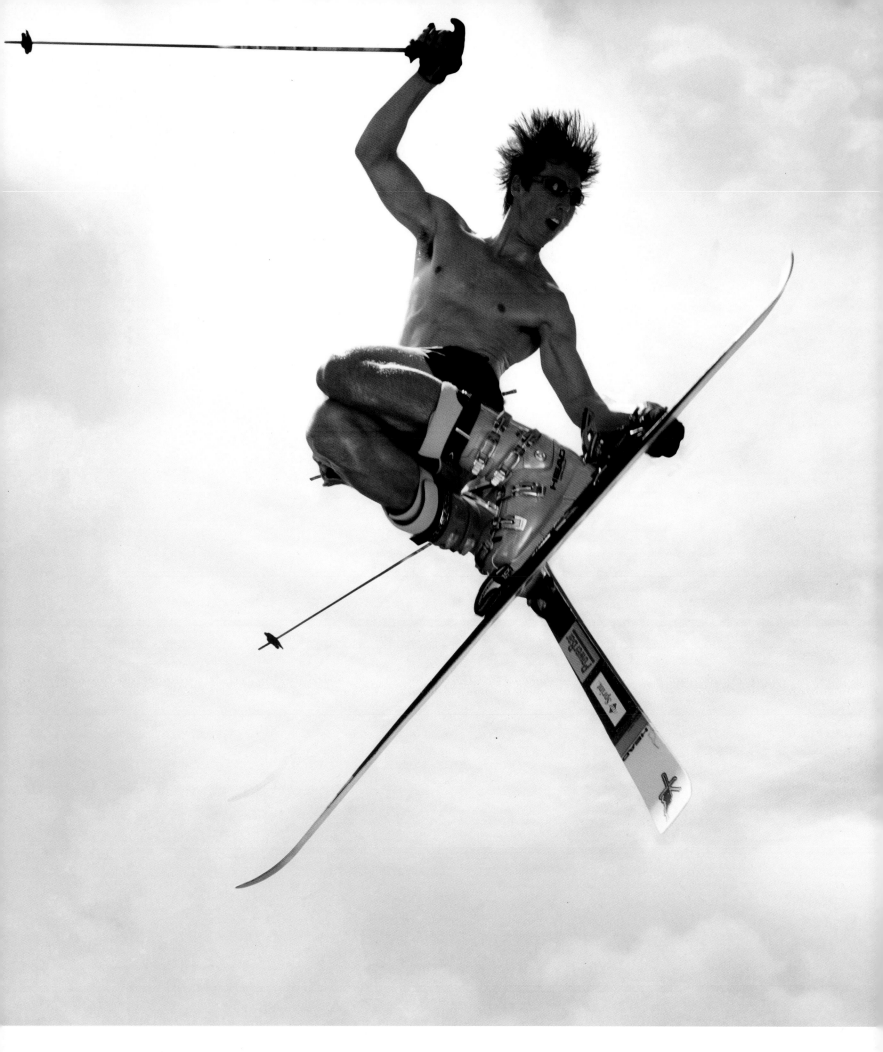

Jonny Moseley
Skiing (Freestyle Moguls)
117

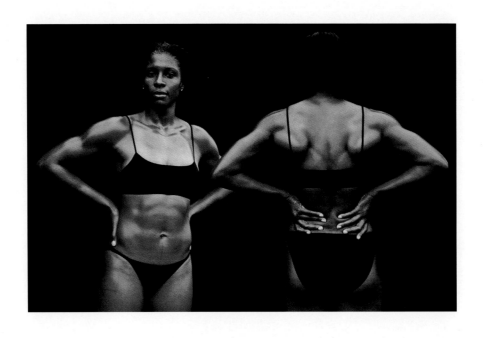

LeShundra Nathan

Heptathlon

Portrait

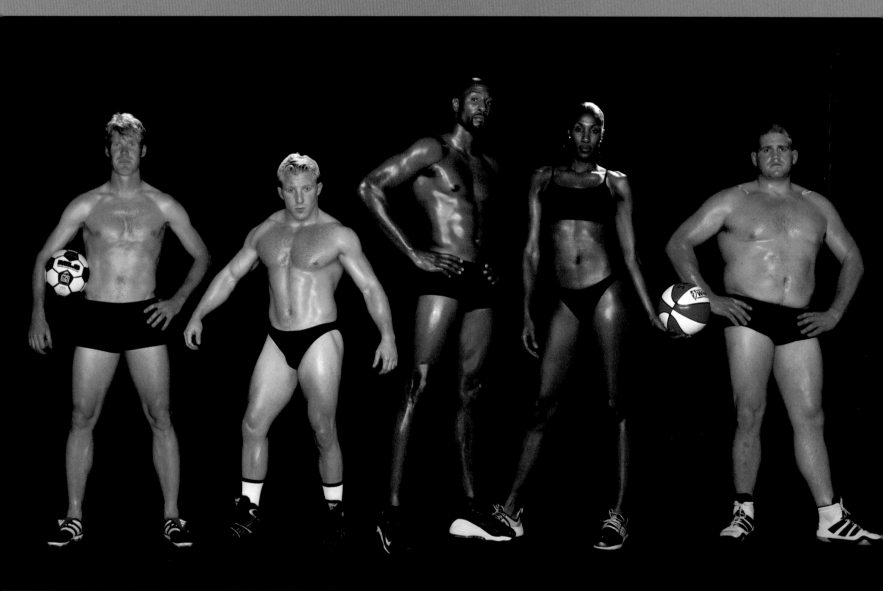

Alexi Lalas
Soccer
6' 3" 195 lbs.

Brandon Slay
Wrestling
5' 8" 167 lbs.

Alonzo Mourning
Basketball
6' 10" 261 lbs.

Lisa Leslie
Basketball
6' 5" 170 lbs.

Rulon Gardner
Wrestling
6' 2" 286 lbs.

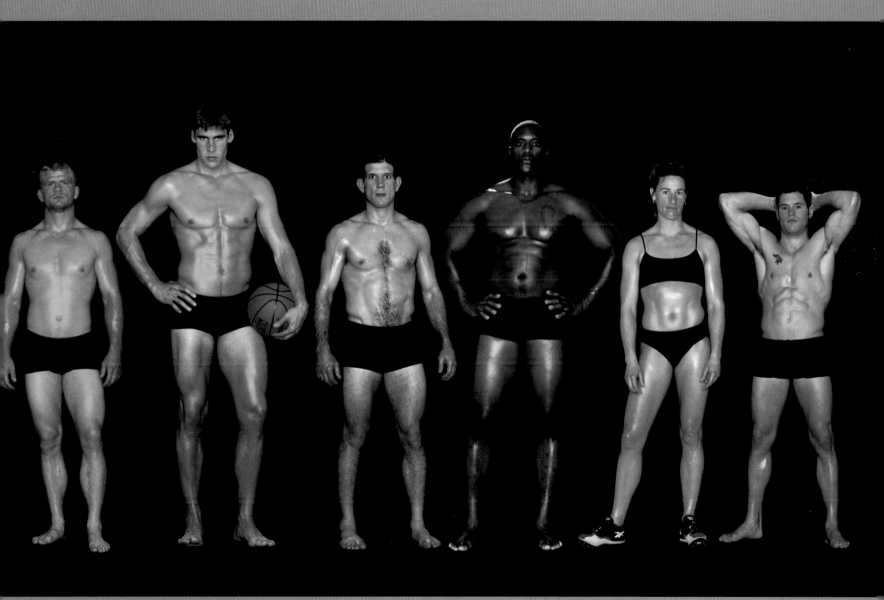

Lincoln McIlravy
Wrestling
5' 8" 152 lbs.

Wally Szczerbiak
Basketball
6' 7" 244 lbs.

Jimmy Pedro
Judo
5' 9" 161 lbs.

Robert Porcher III
Football
6' 3" 282 lbs.

Stacy Dragila
Pole Vault
5' 7.5" 140 lbs.

Blaine Wilson
Gymnastics
5' 4" 135 lbs.

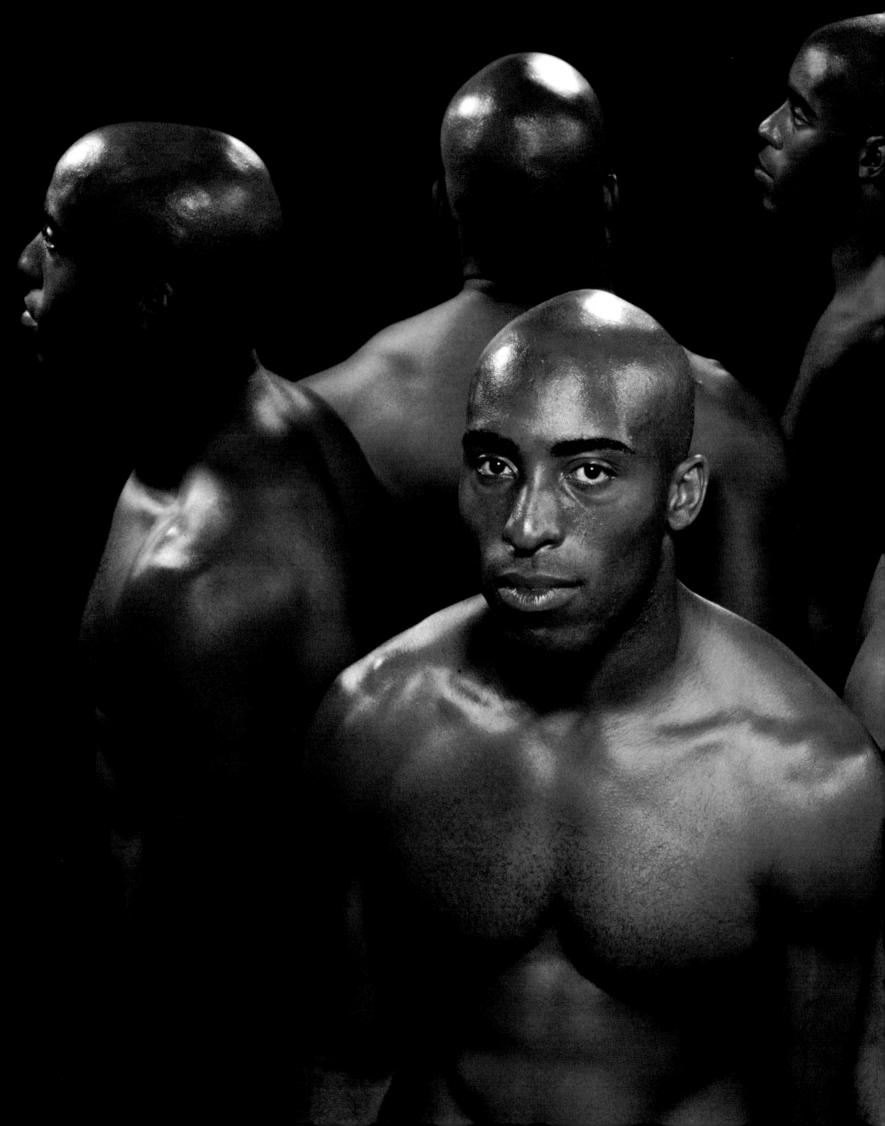

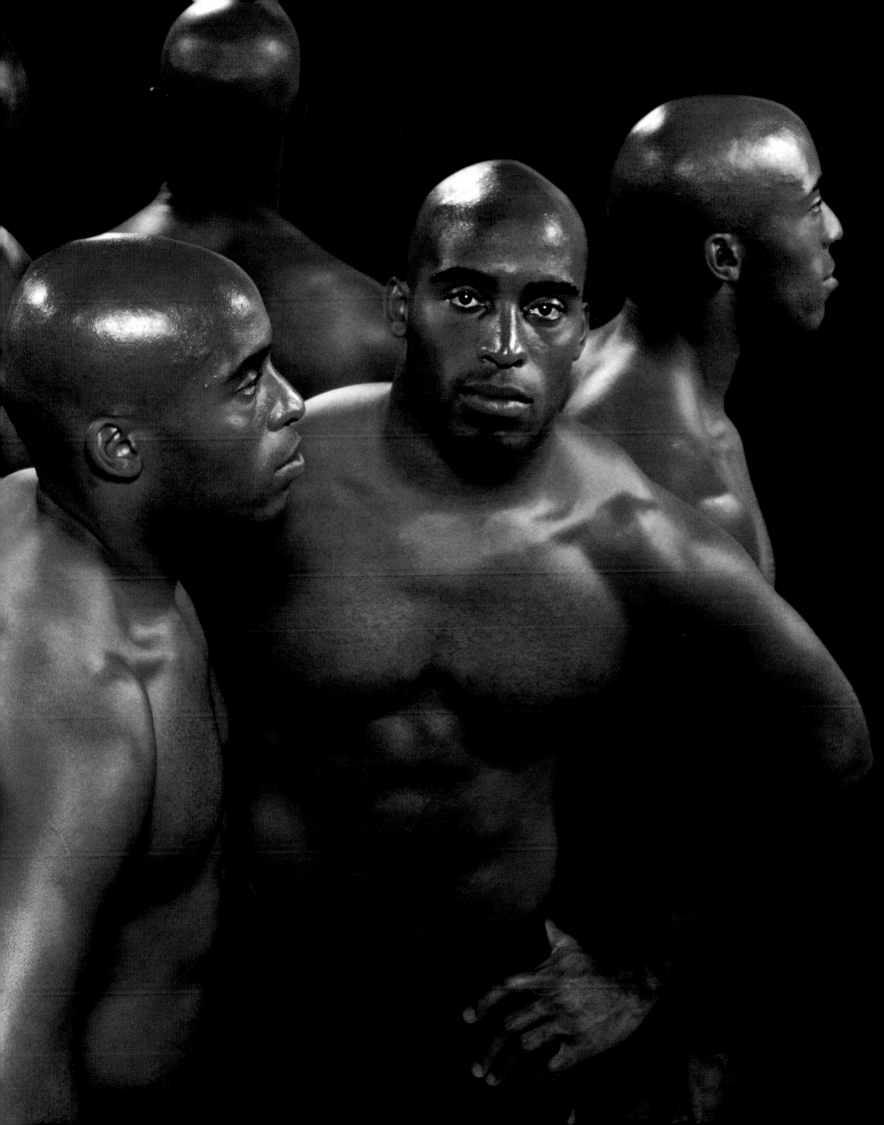

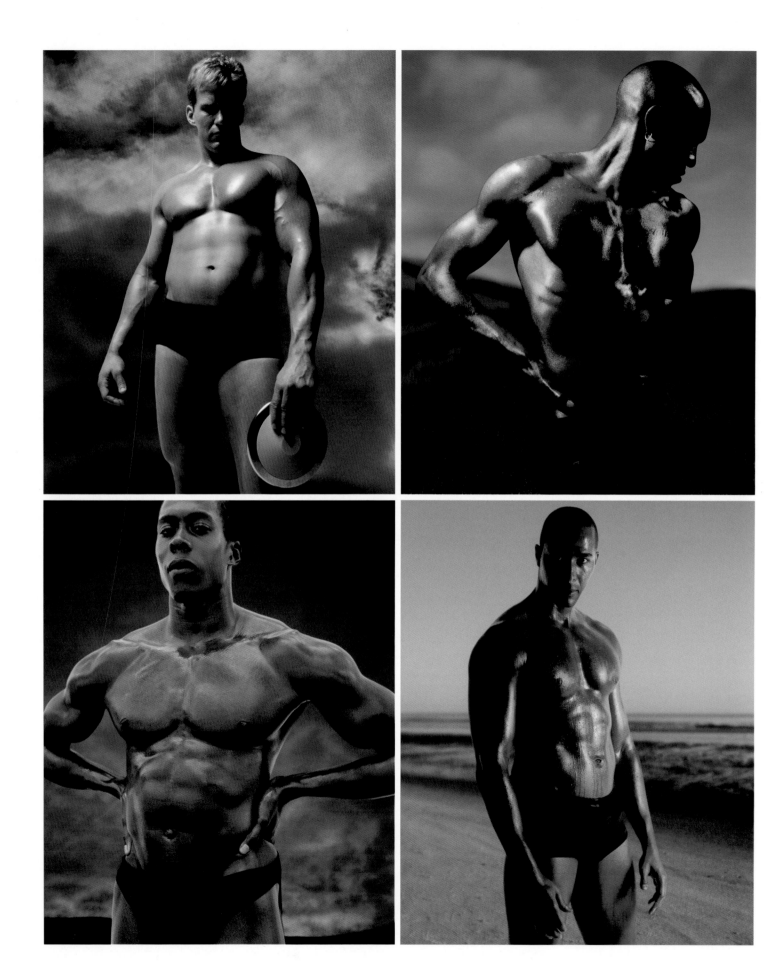

Adam Setliff
Discus

Allen Johnson
Hurdles (110m)

Preceding Pages

Tiki & Rondé Barber
Football

Shawn Crawford
Sprint (200m)

Dain Blanton
Beach Volleyball

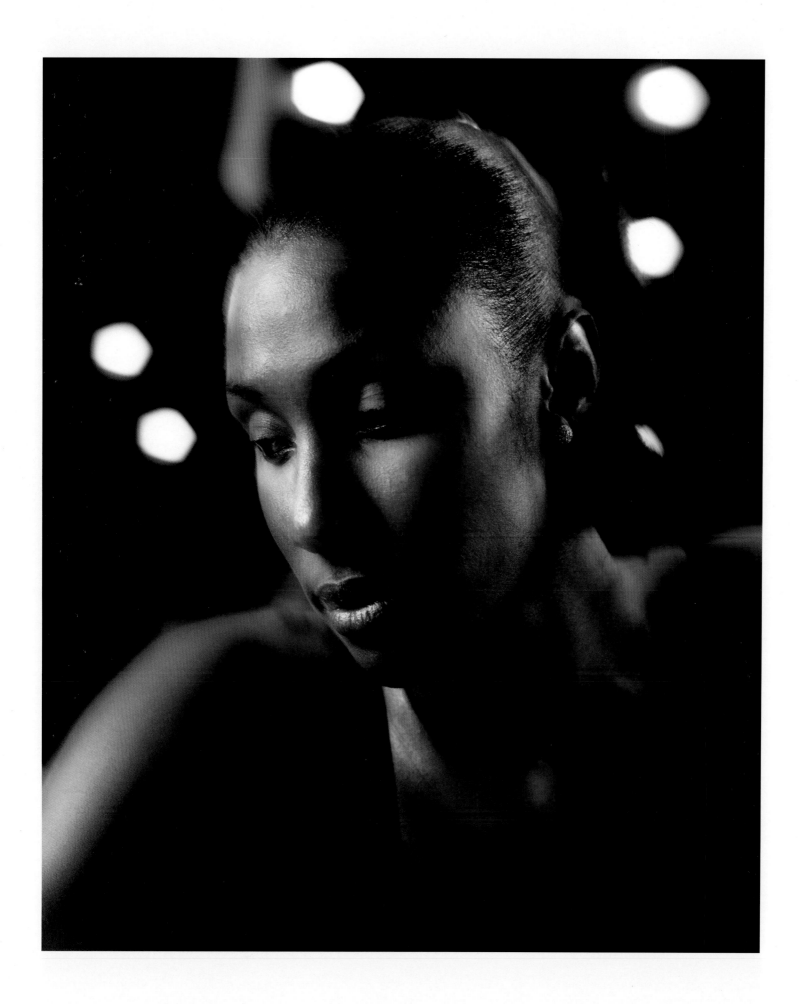

Lisa Leslie
Basketball

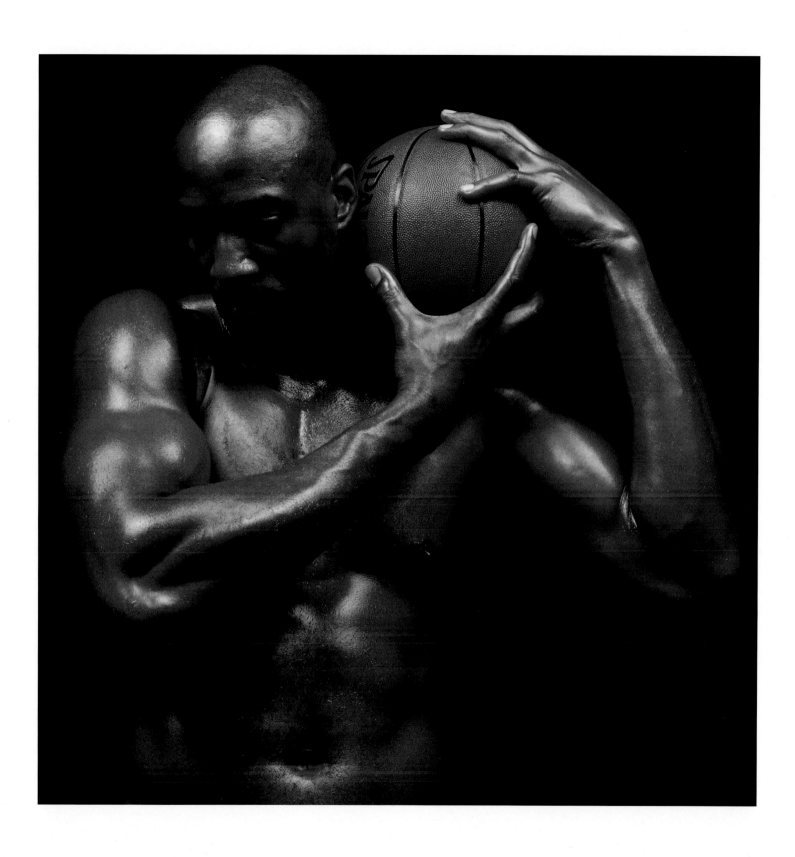

Alonzo Mourning

Basketball

Stacy Dragila
Pole Vault
128

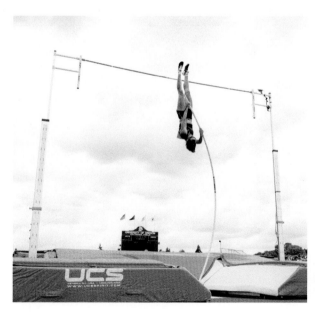

U.S. Outdoor National Track & Field Championships
Eugene, Oregon, June 2001

Rulon Gardner
Wrestling

Brandon Slay
Wrestling

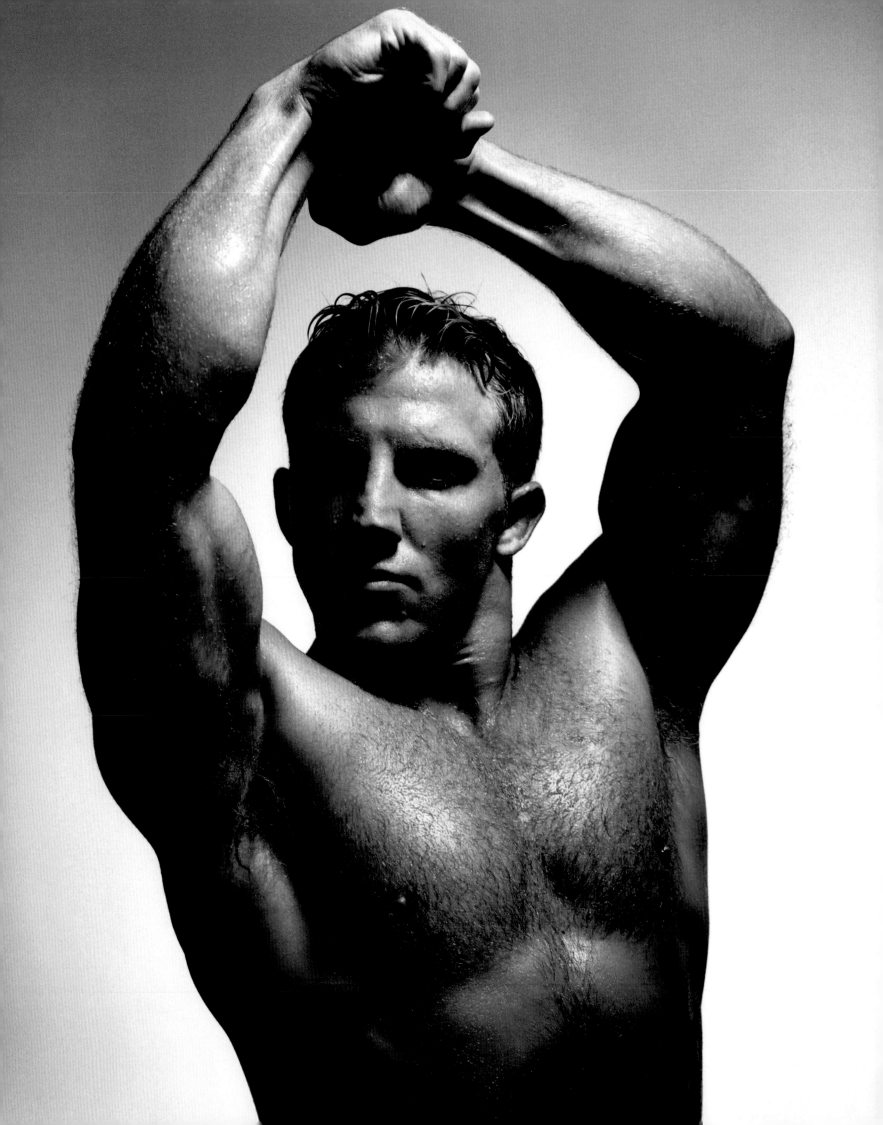

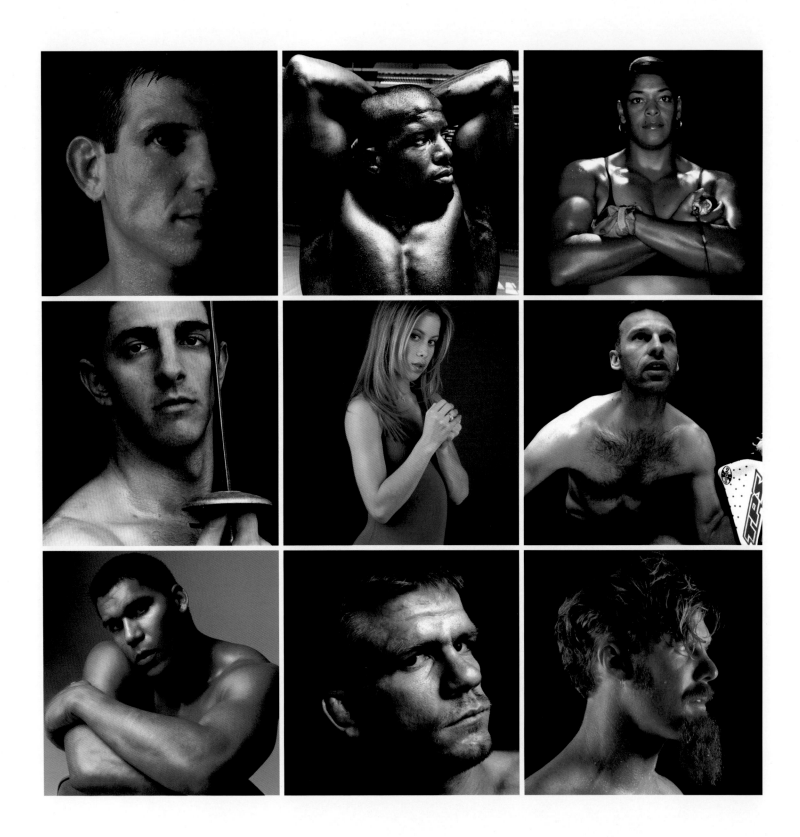

Jimmy Pedro Judo	**Kerry McCoy** Wrestling	**Dawn Ellerbe** Hammer Throw
Cliff Bayer Fencing	**Tara Lipinski** Figure Skating	**Dominik Hasek** Hockey
Donnie Edwards Football	**Lincoln McIlravy** Wrestling	**Alexi Lalas** Soccer

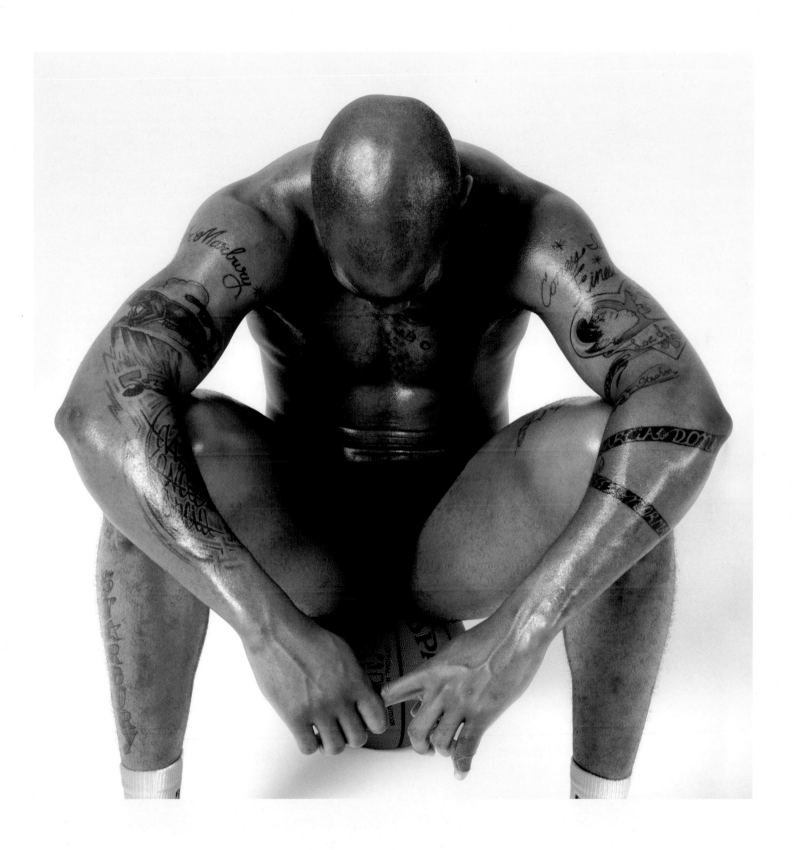

Stephon Marbury
Basketball
133

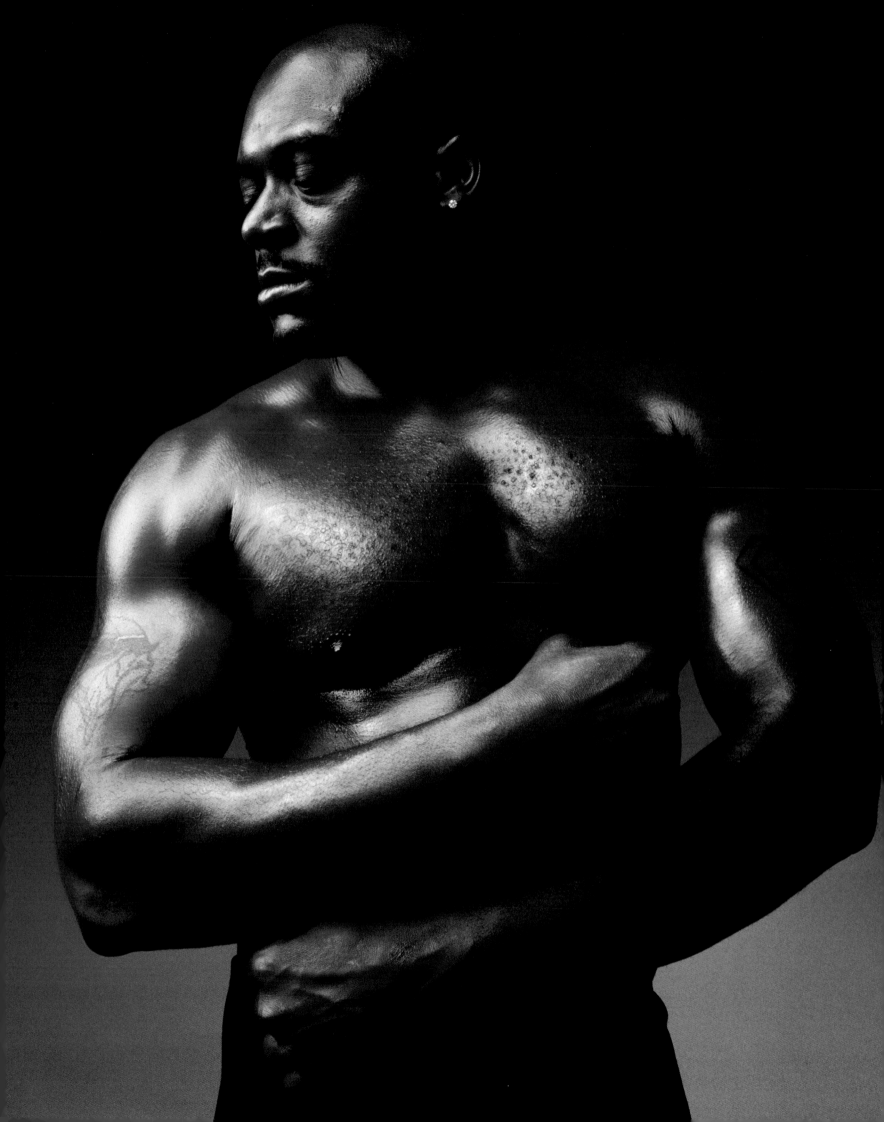

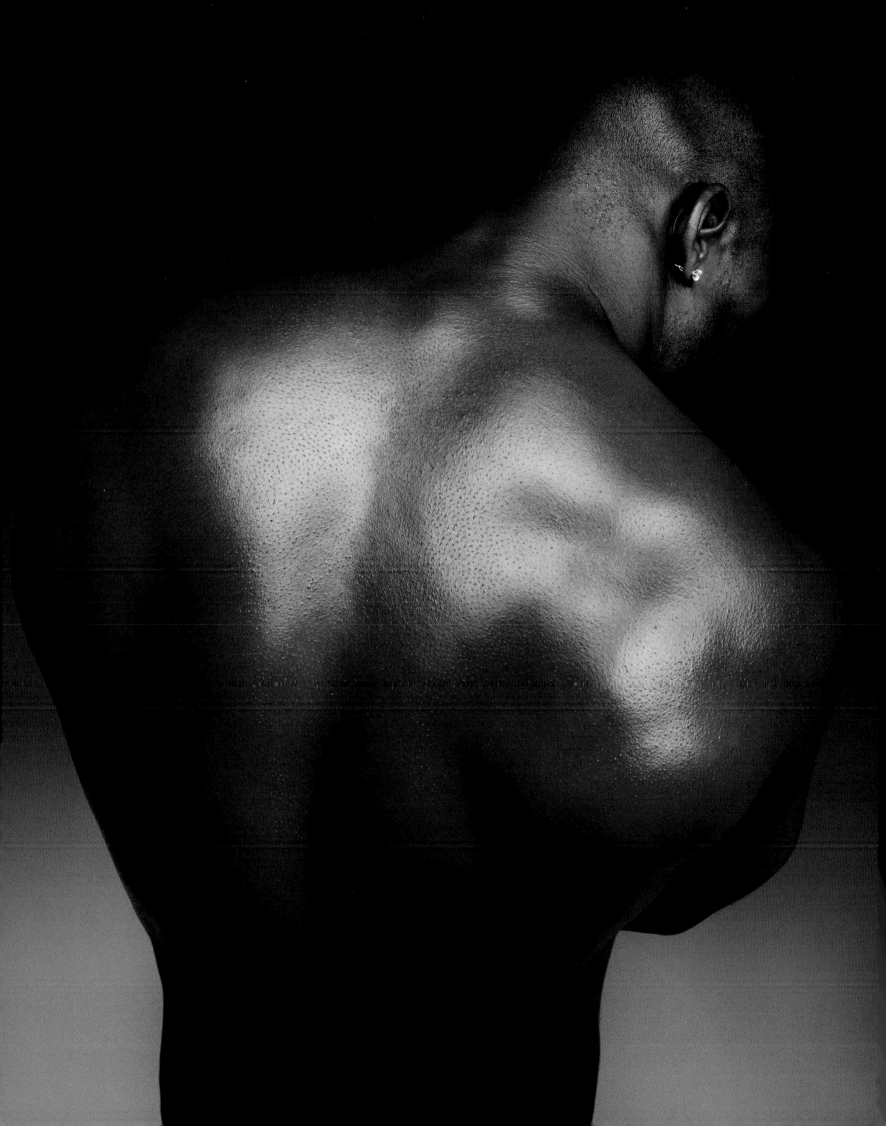

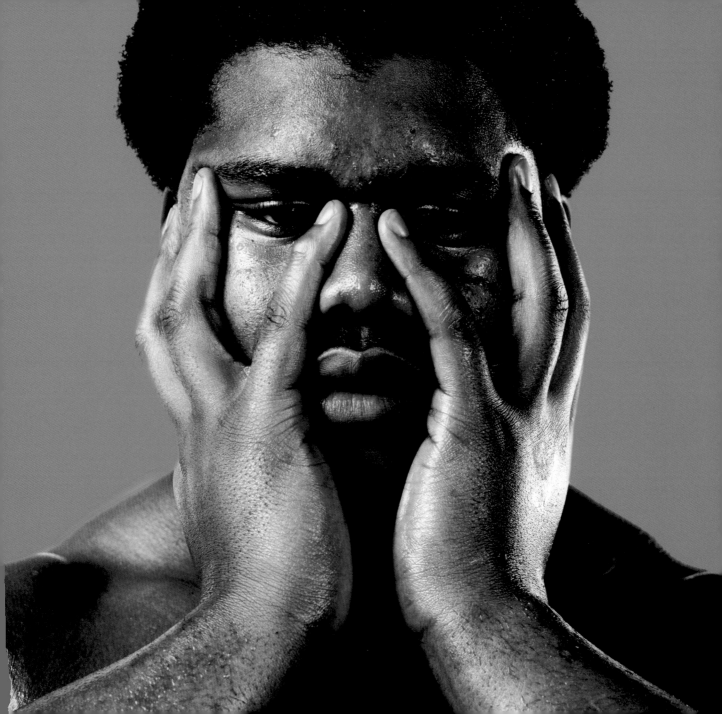

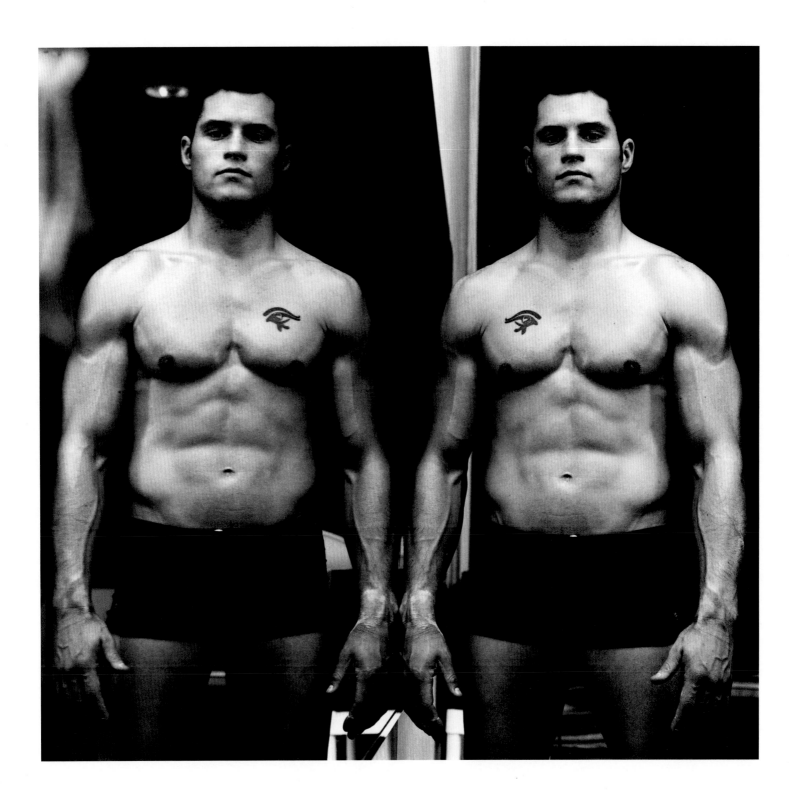

Preceding Pages

Darrell Russell
Football

Blaine Wilson
Gymnast

Joe Johnson
Football

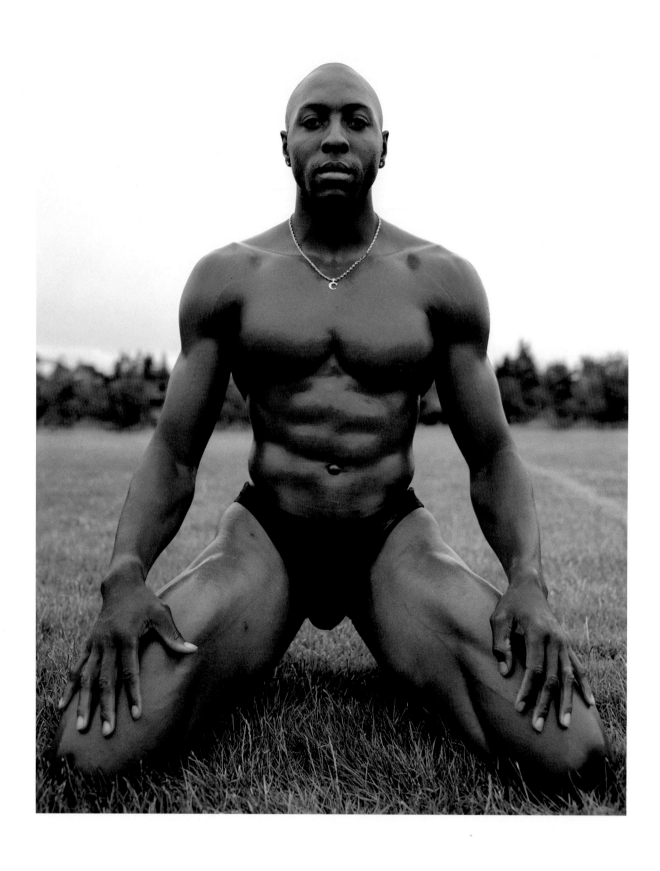

Tyree Washington
Sprint (200m, 400m)

Jearl Miles-Clark
Running (400m, 800m)

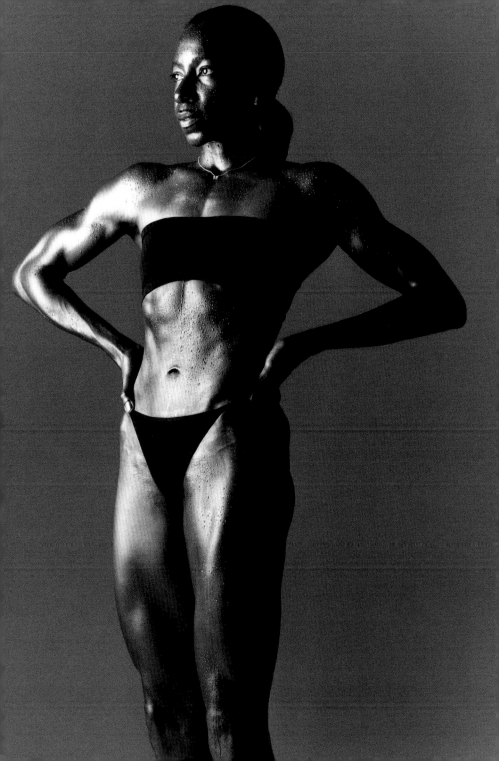

Cheryl Haworth
Weightlifting

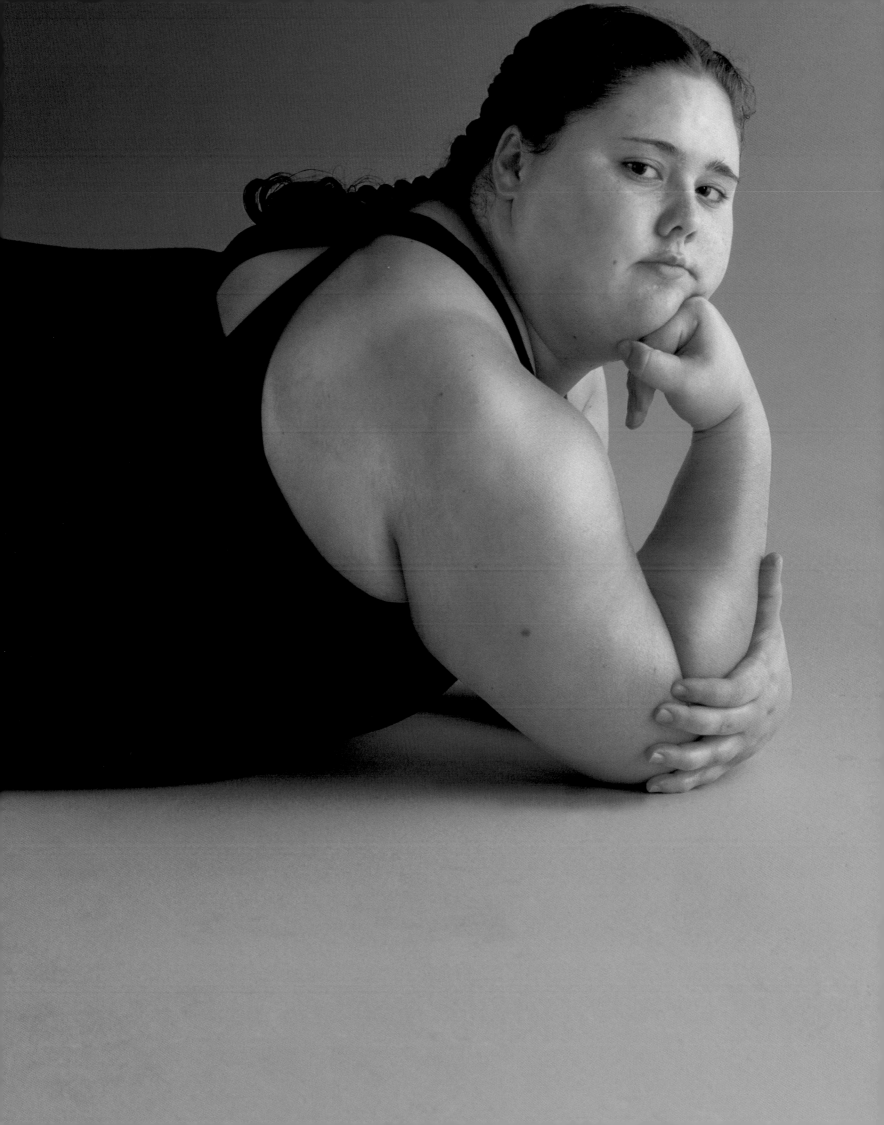

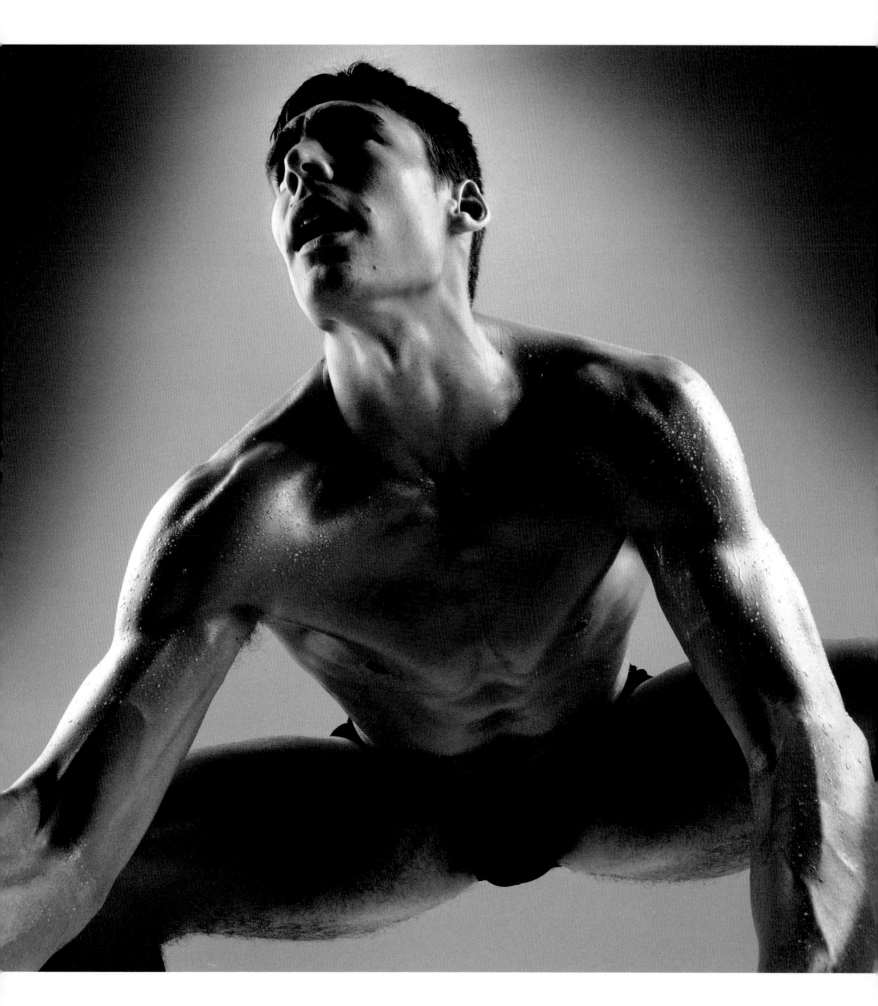

Wally Szczerbiak
Basketball

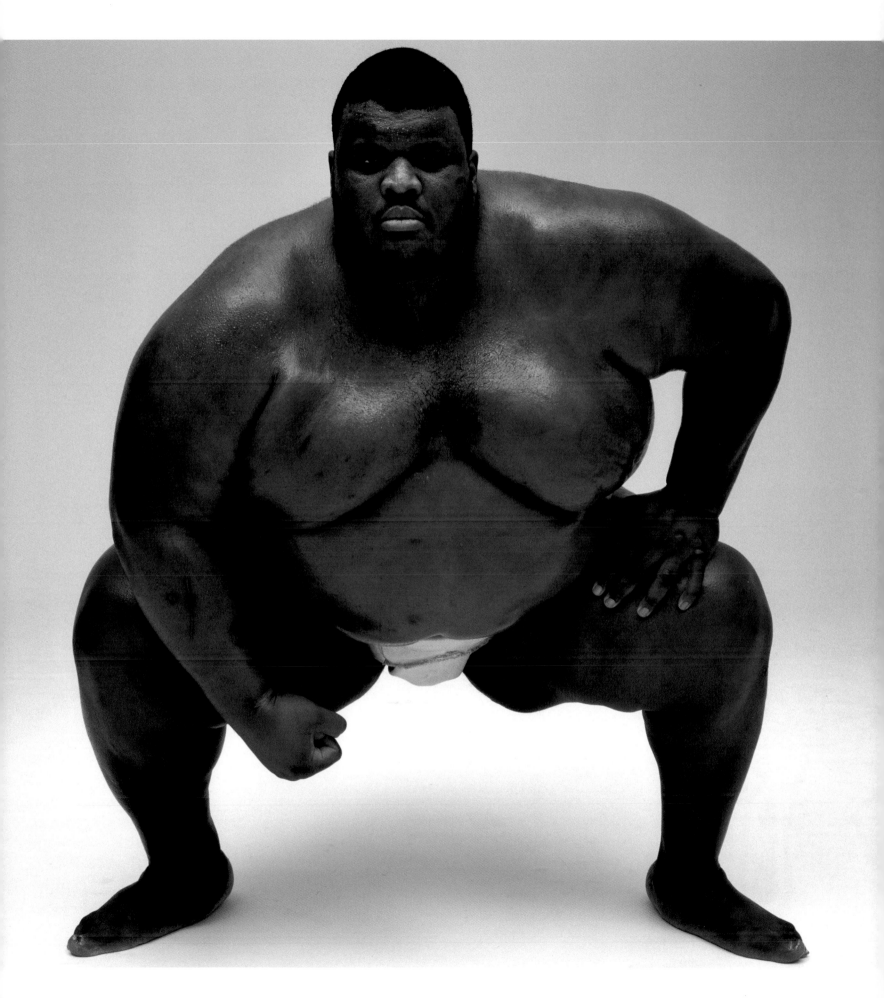

Emanuel Yarbrough
Sumo
143

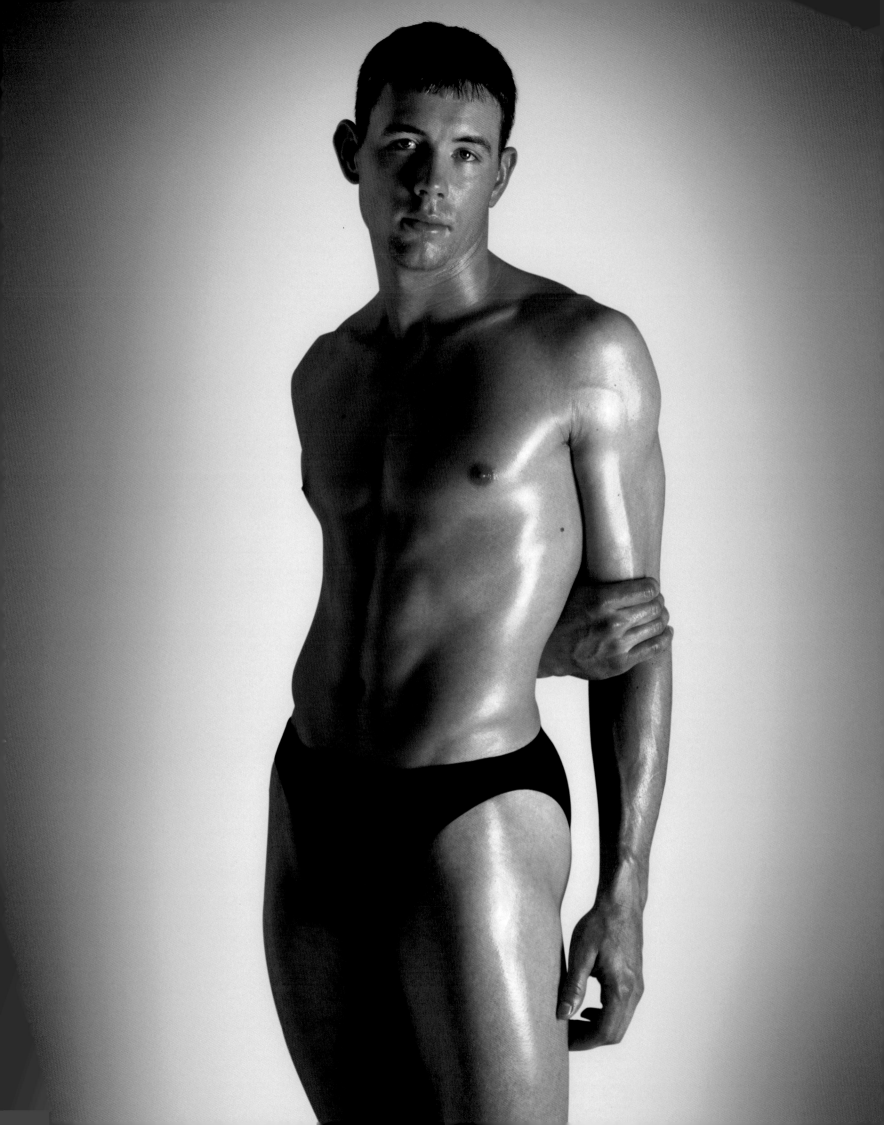

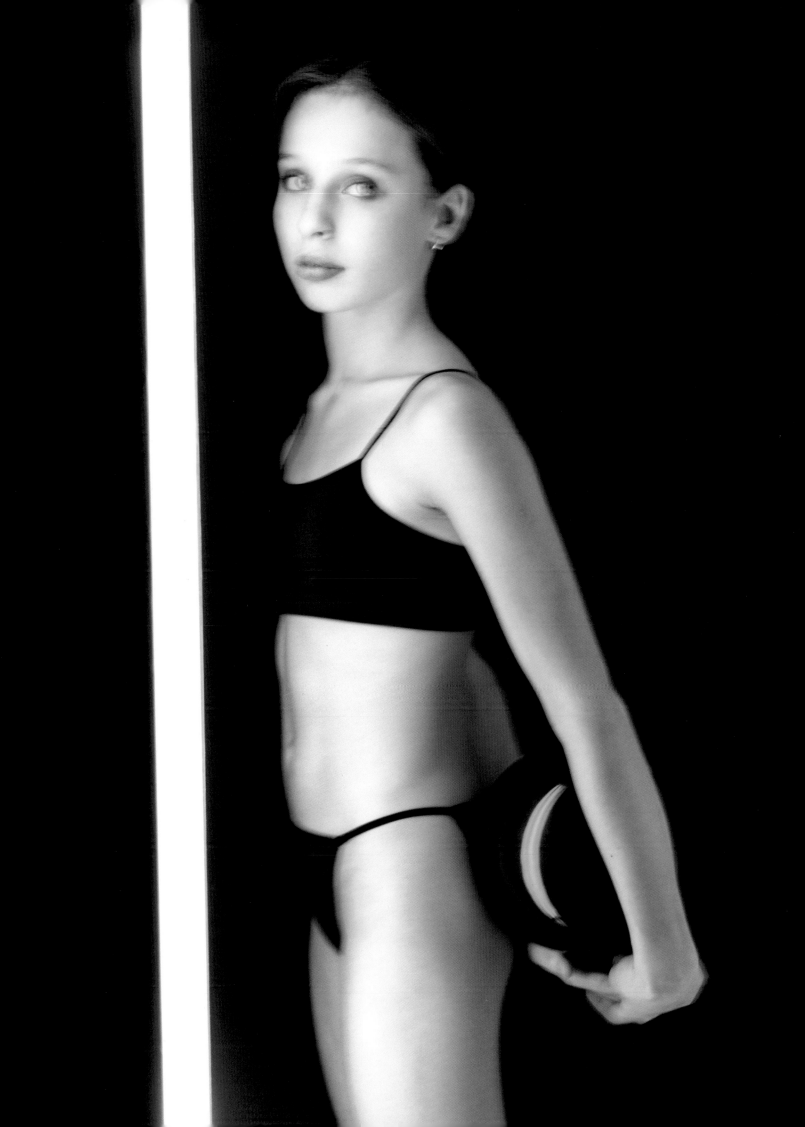

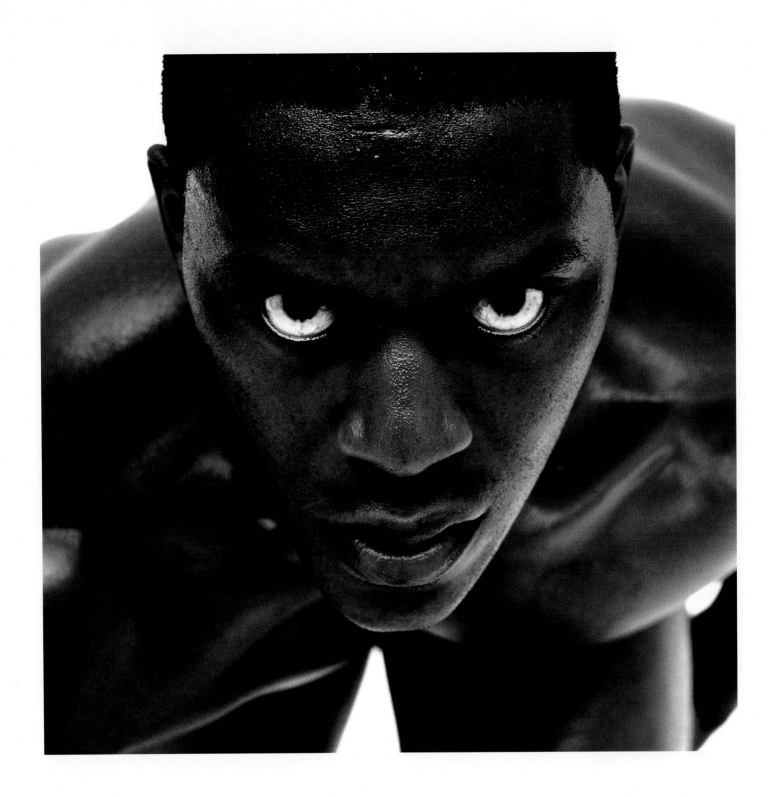

Preceding Pages

Nathan Leeper **Olga Karmansky**

High Jump Rhythmic Gymnastics

Robert Porcher III

Football

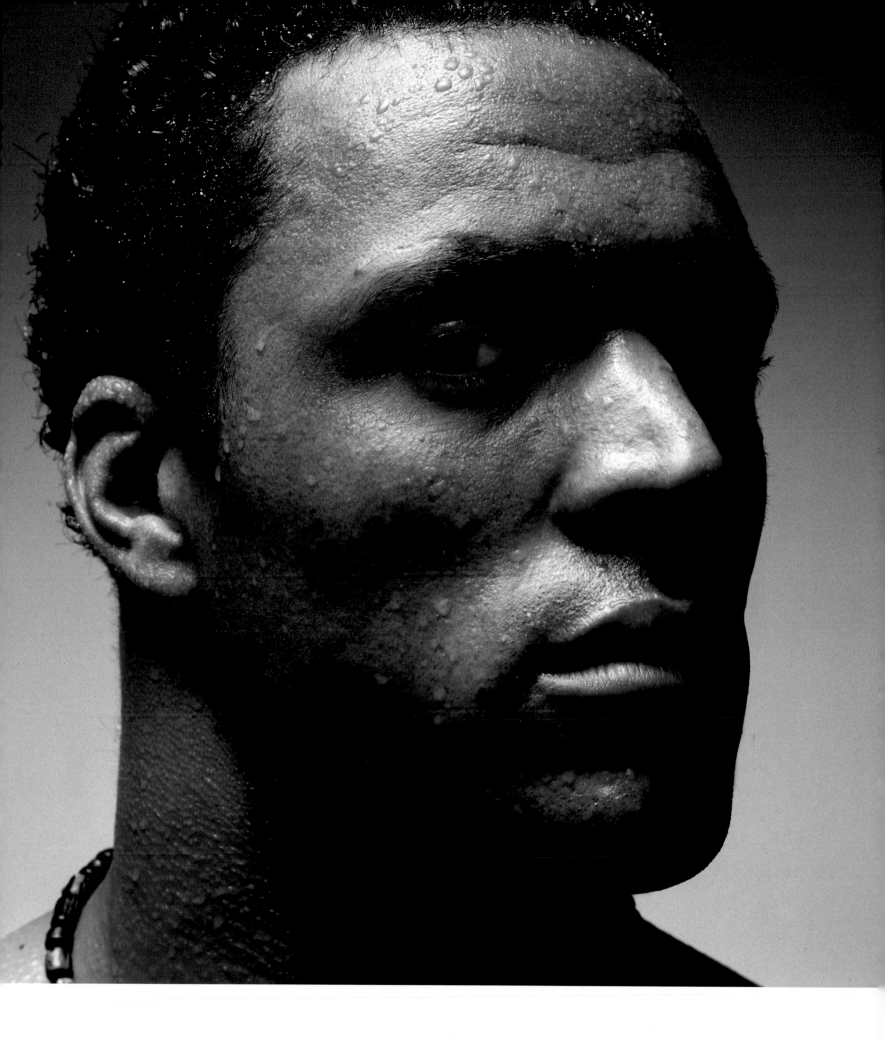

Tony Gonzalez
Football

Pauley Pavilion
UCLA

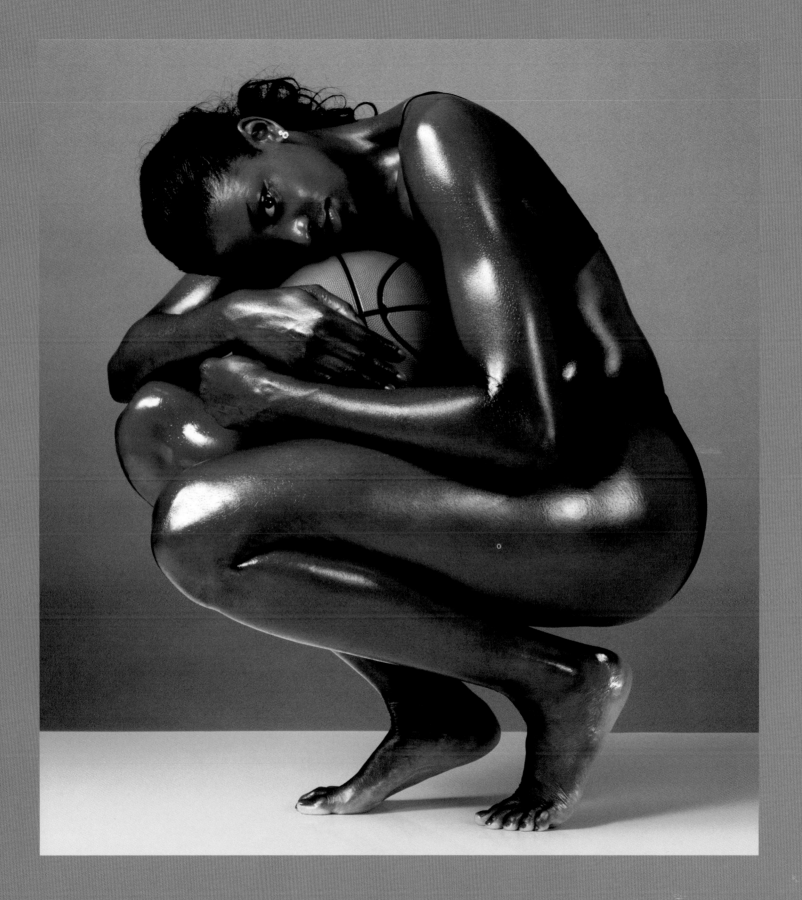

DeLisha Milton
Basketball
149

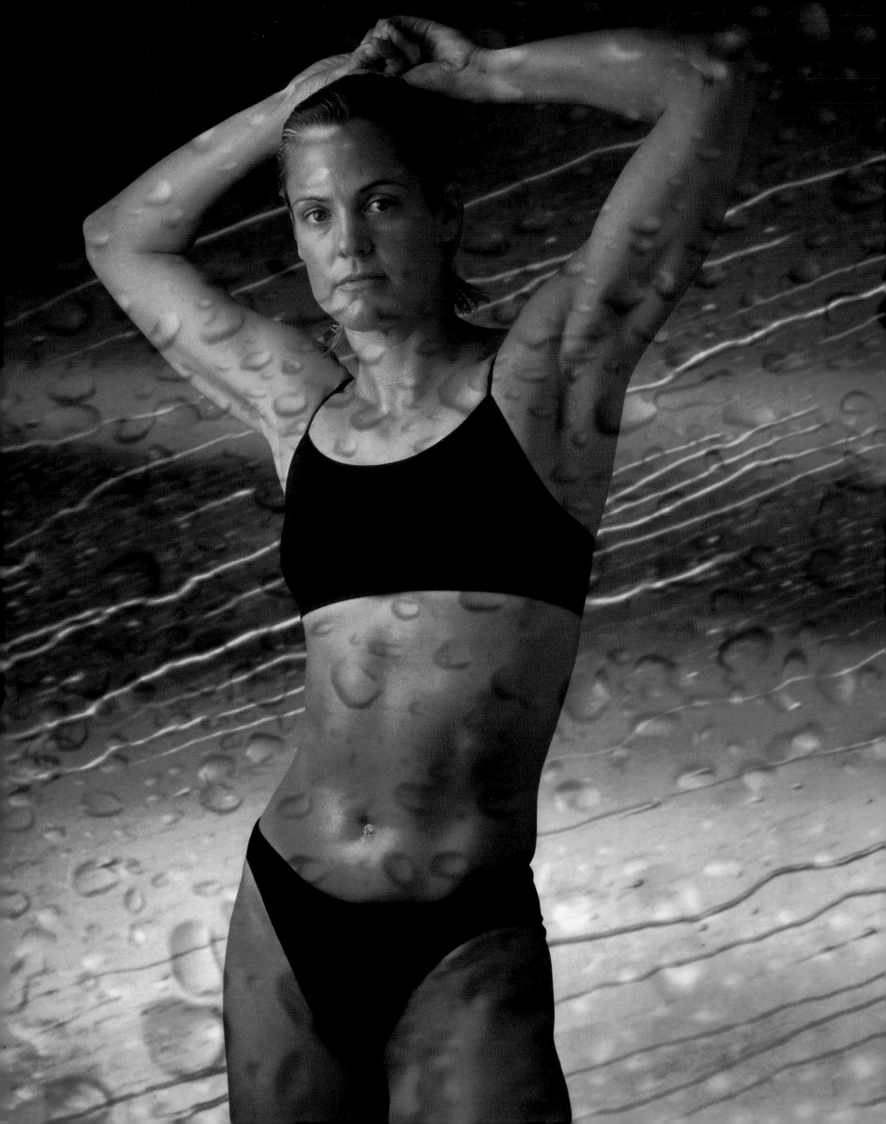

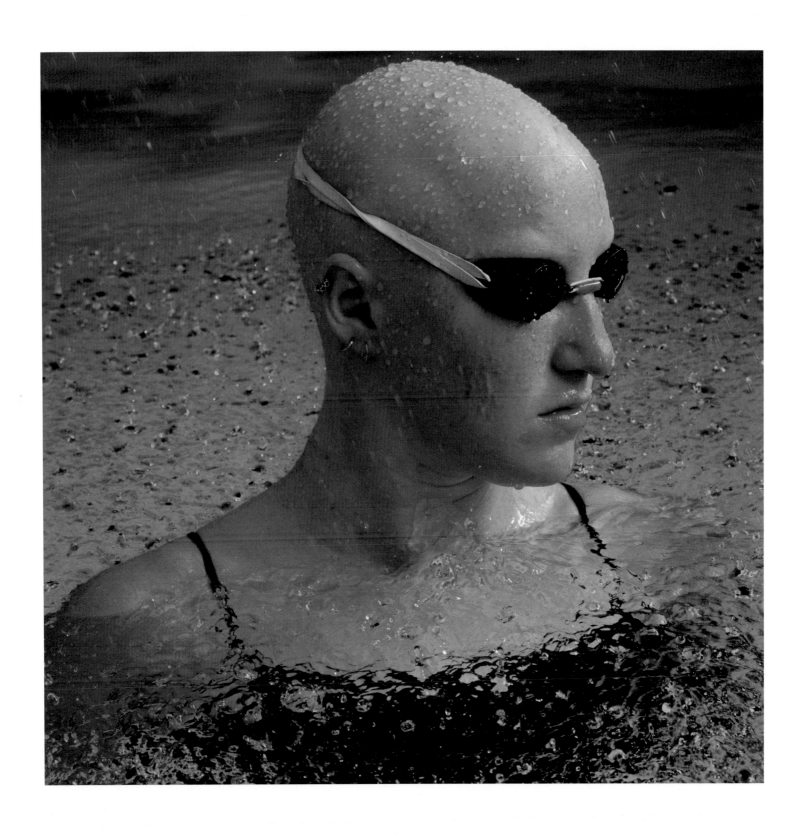

Dara Torres
Swimming (Freestyle & Butterfly)

Staciana Stitts
Swimming (Breaststroke)

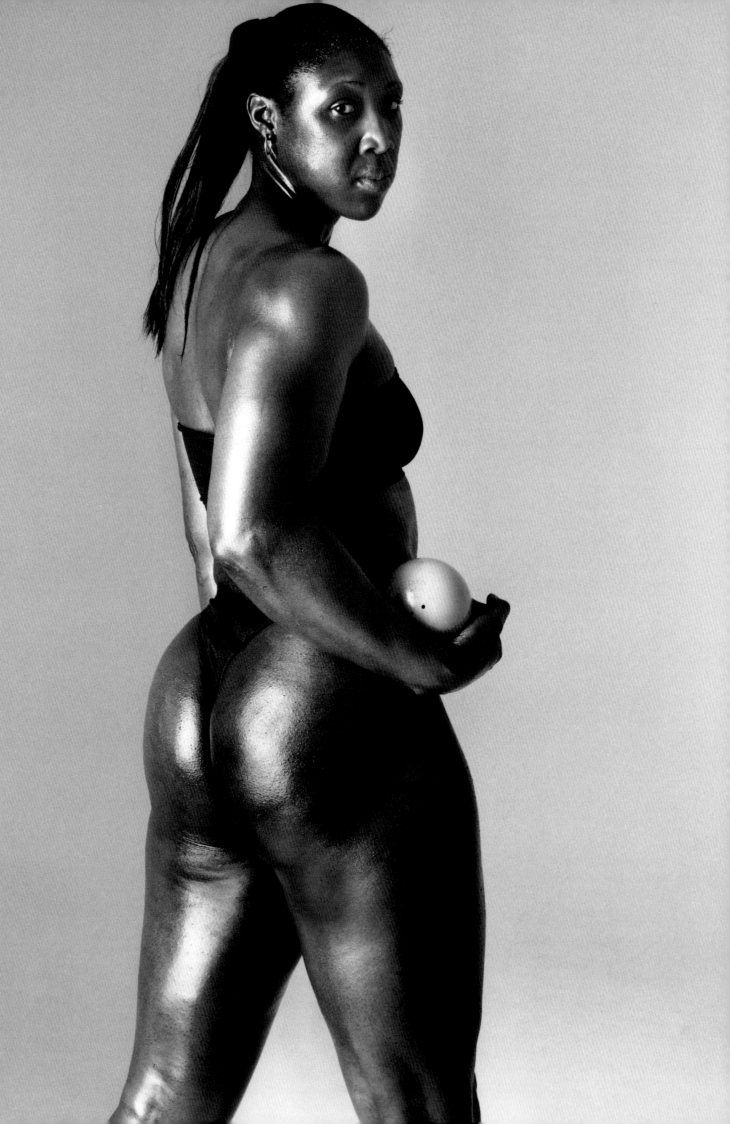

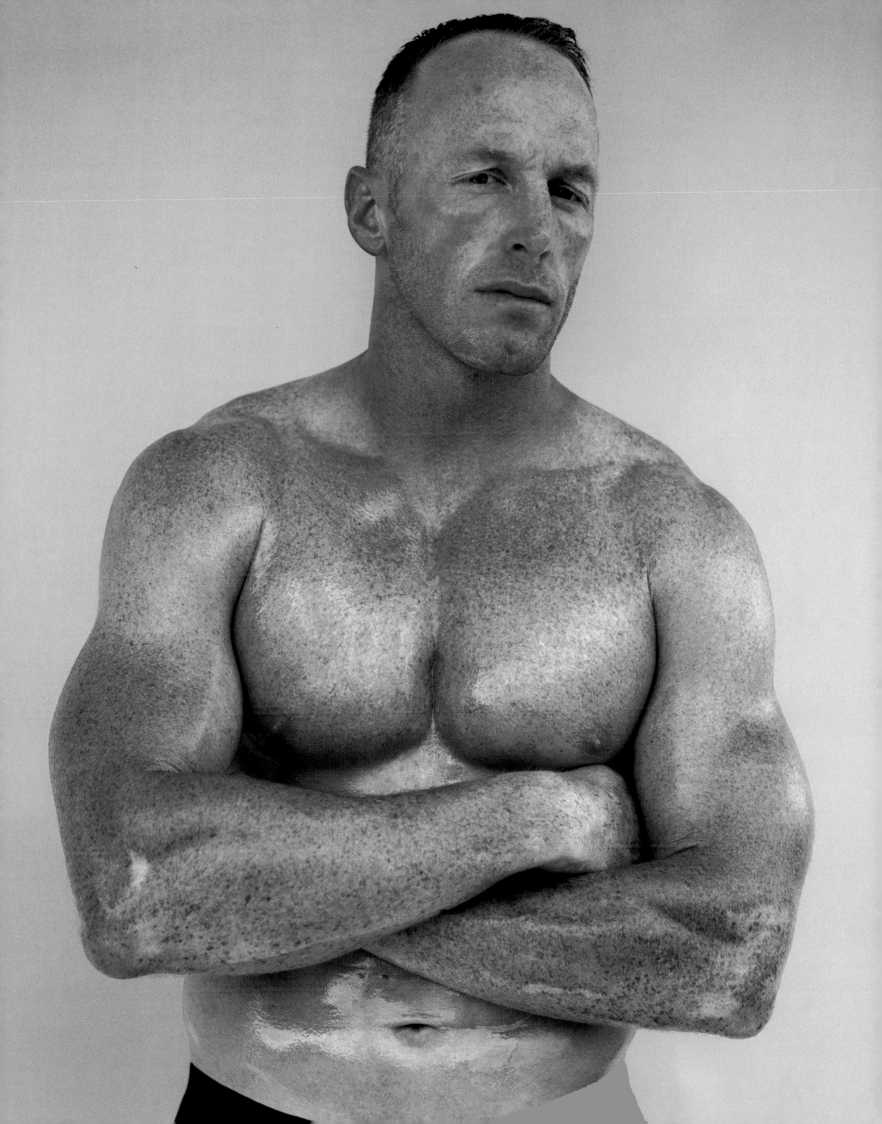

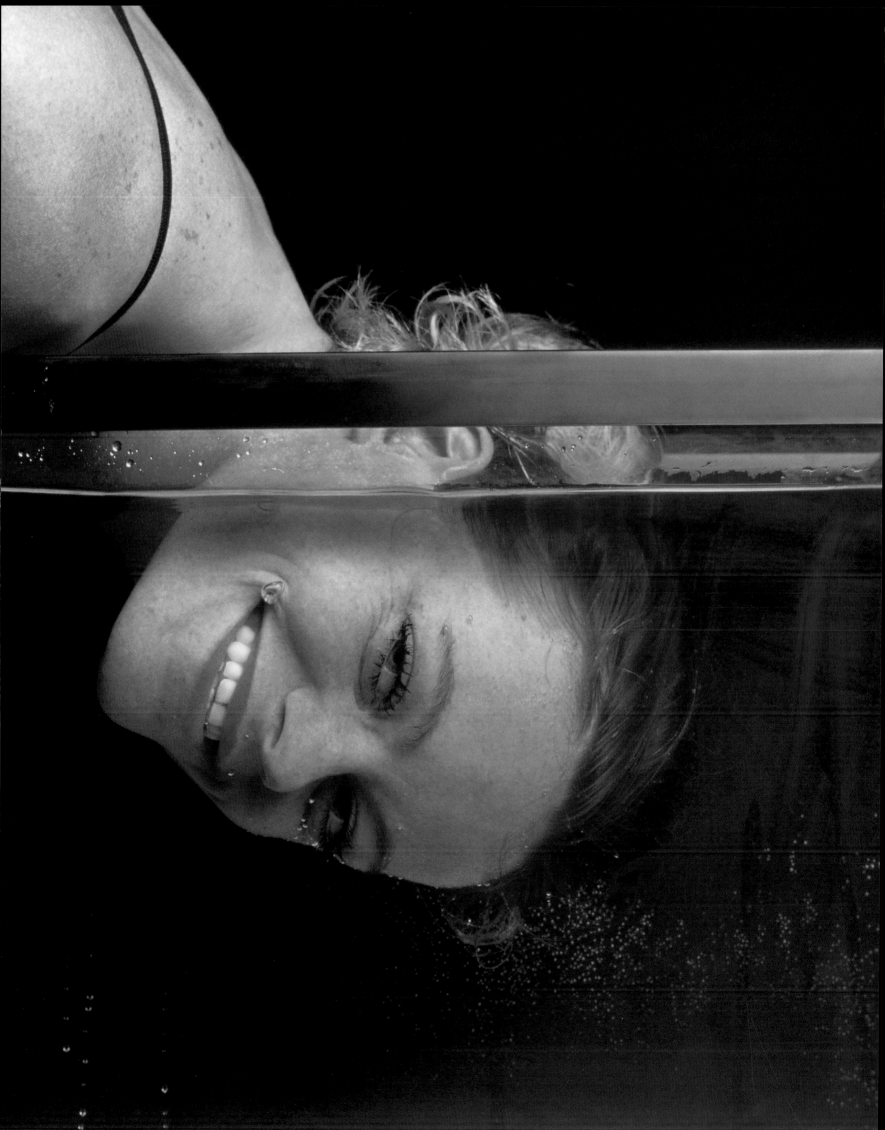

Velodrome, Olympic Training Center
Colorado Springs, Colorado

Climb
Run
Cycle

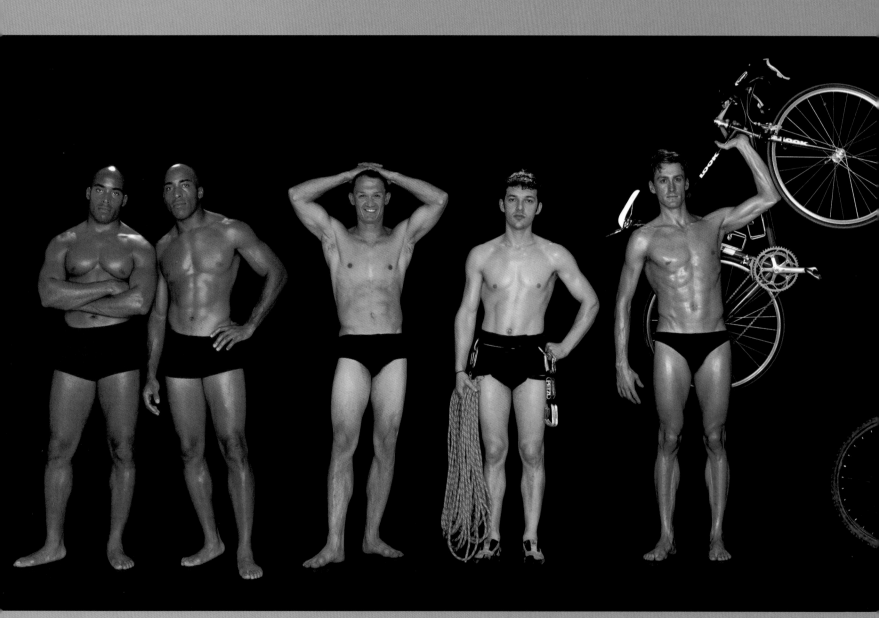

Tiki & Rondé Barber
Football
5' 10" 200 lbs.; 5' 10" 184 lbs.

Chris Bloch
Rock Climbing
5' 9" 150 lbs.

Vadim Vinokur
Rock Climbing
5' 8" 140 lbs.

Michael Smedley
Triathlon
5' 11" 155 lbs.

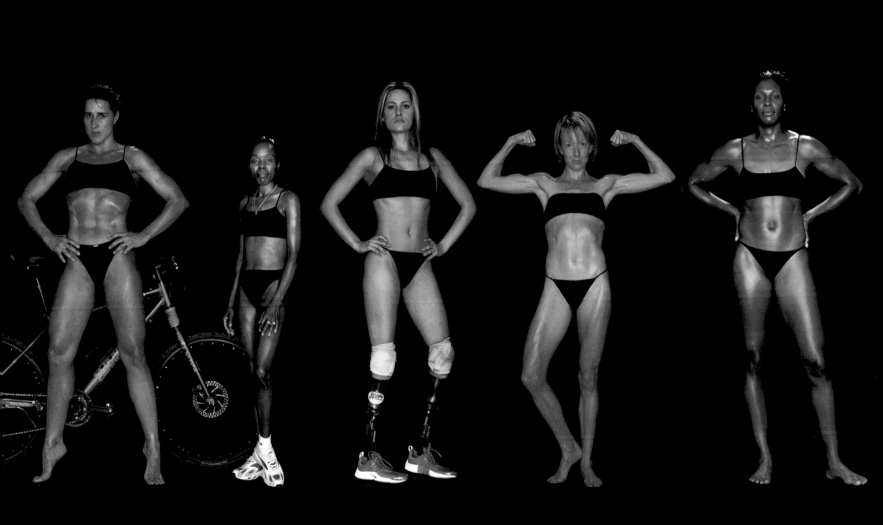

Cathy Sassin
Adventure Racing
5' 6" 138 lbs.

Tegla Loroupe
Long-Distance Running
4' 11" 82 lbs.

Aimee Mullins
Sprint & Long Jump
5' 8" 105 lbs.

Deena Drossin
Long-Distance Running
5' 4" 105 lbs.

LeShundra Nathan
Heptathlon
5' 11" 175 lbs.

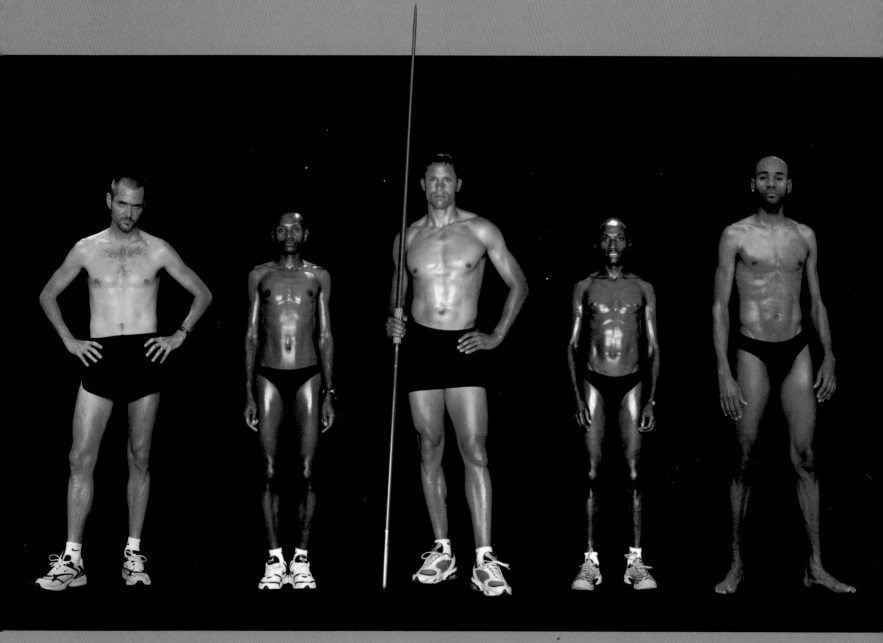

Bob Kennedy	John Kagwe	Dan O'Brien	Joseph Chebet	Johnny Gray
Long-Distance Running	Marathon	Decathlon	Marathon	Running (800m)
6' 0" 146 lbs.	5' 6" 115 lbs.	6' 2" 185 lbs.	5' 4.5" 114 lbs.	6' 4" 175 lbs.

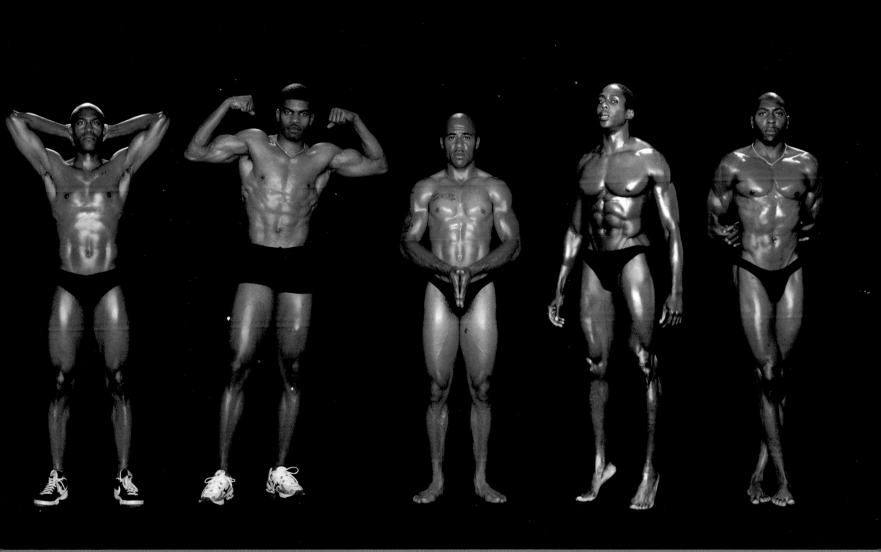

Allen Johnson
Hurdles (110m)
5' 10" 165 lbs.

Terrence Trammell
Hurdles (110m)
6' 2" 175 lbs.

Brian Lewis
Sprint (100m, 200m)
5' 8" 158 lbs.

Shawn Crawford
Sprint (200m)
5' 11" 165 lbs.

Tyree Washington
Sprint (200m, 400m)
6' 0" 180 lbs.

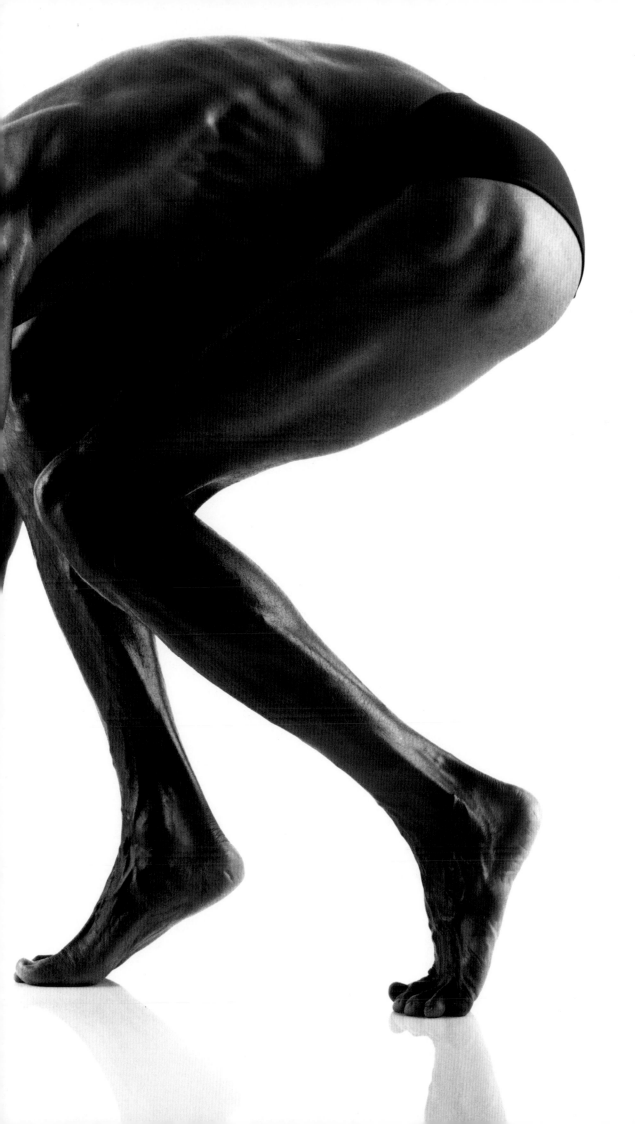

Johnny Gray
Running (800m)

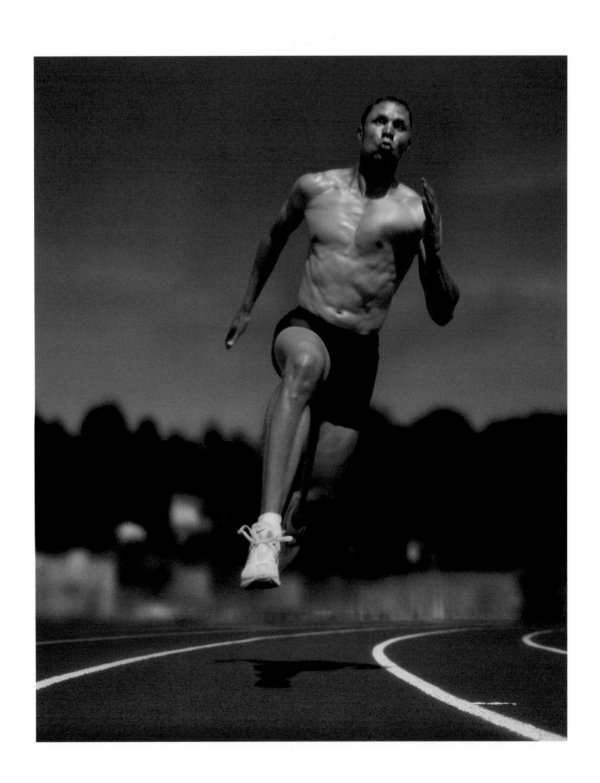

Dan O'Brien
Decathlon

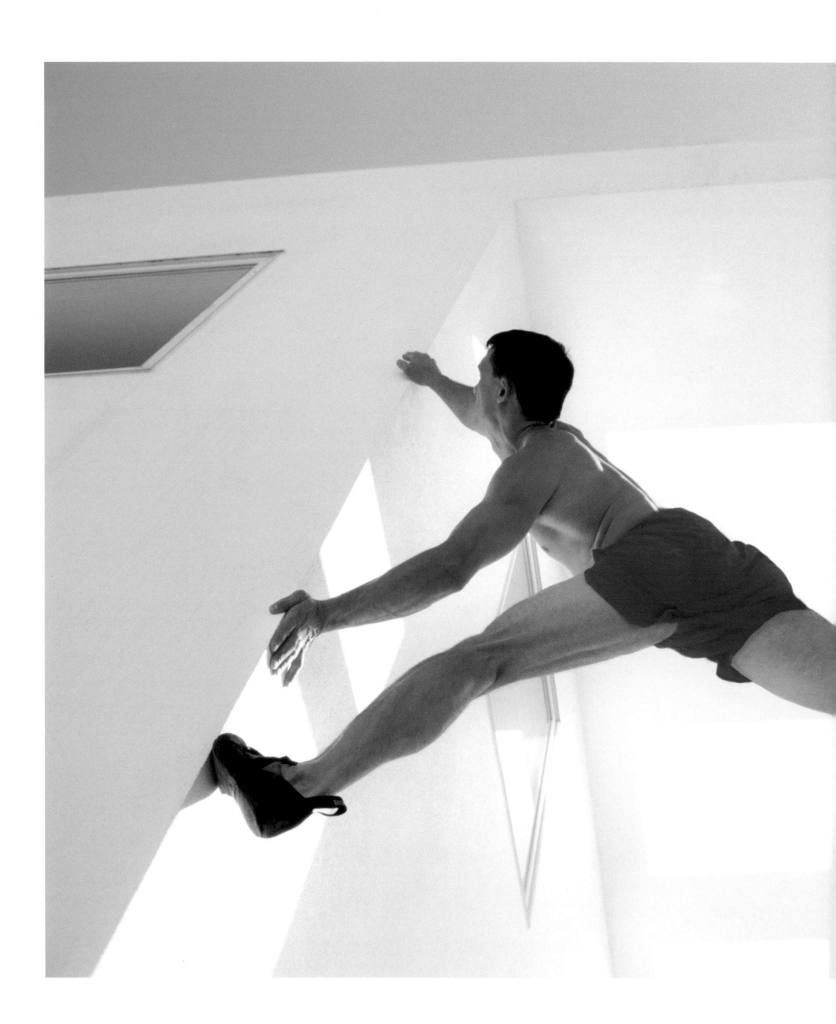

Chris Bloch
Rock Climbing

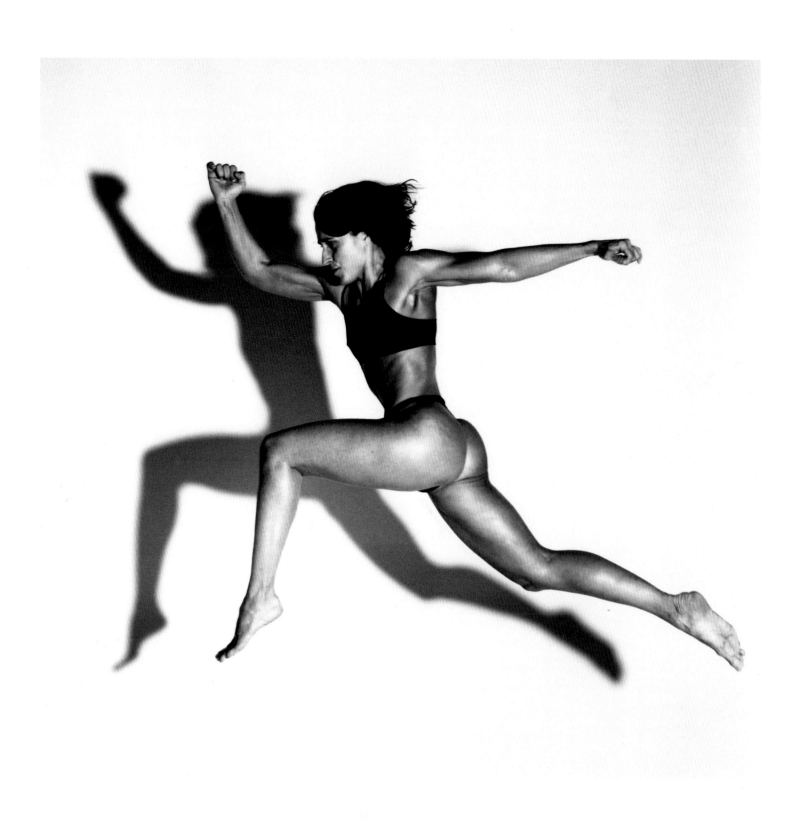

Cathy Sassin

Adventure Racing

(Homage to Helmut Newton)

Jearl Miles-Clark

Running (400m and 800m)

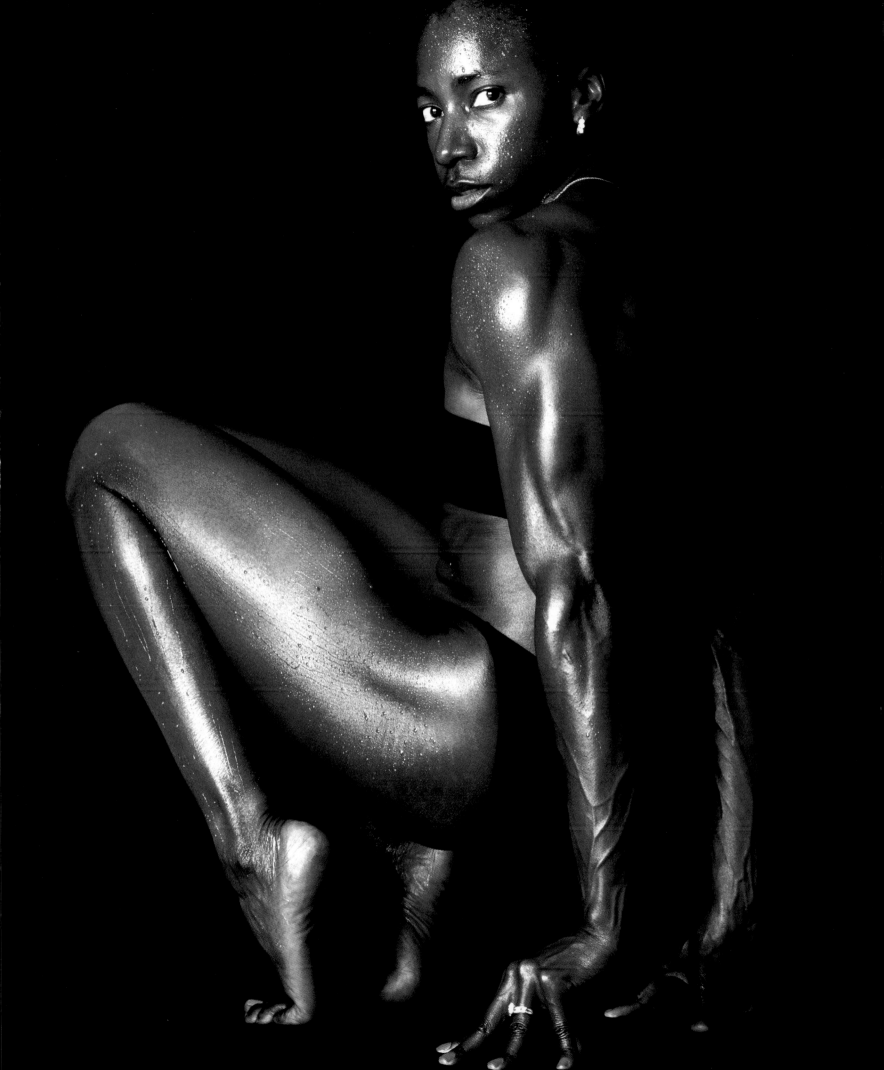

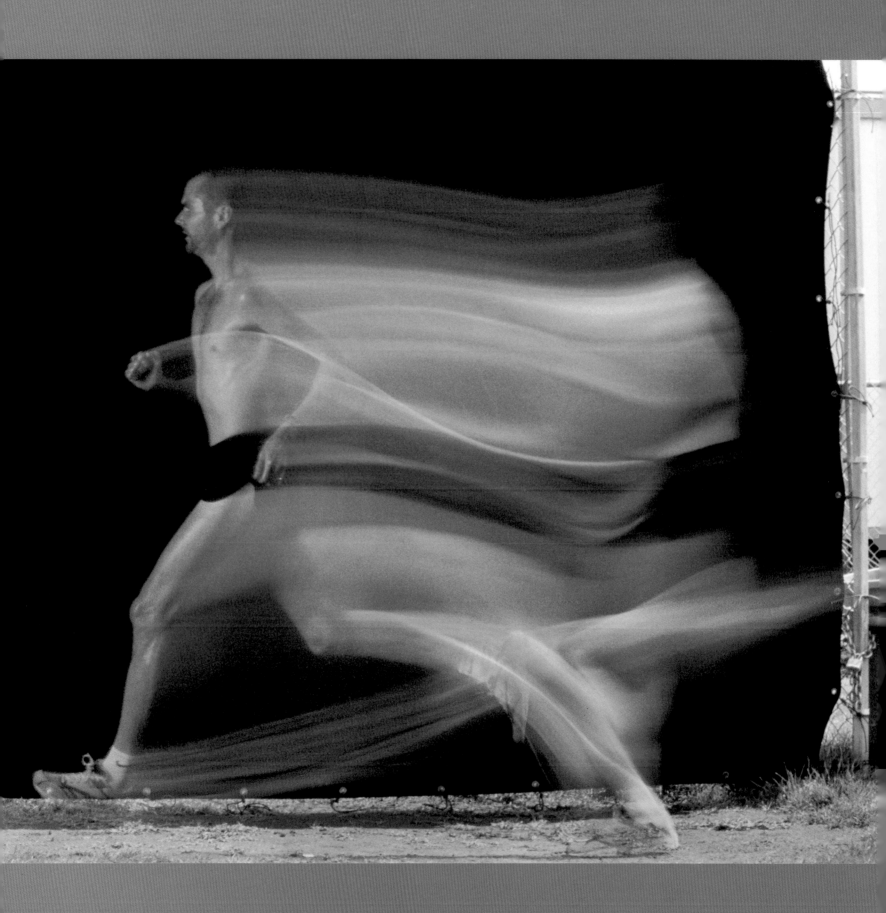

Bob Kennedy
Long-Distance Running
171

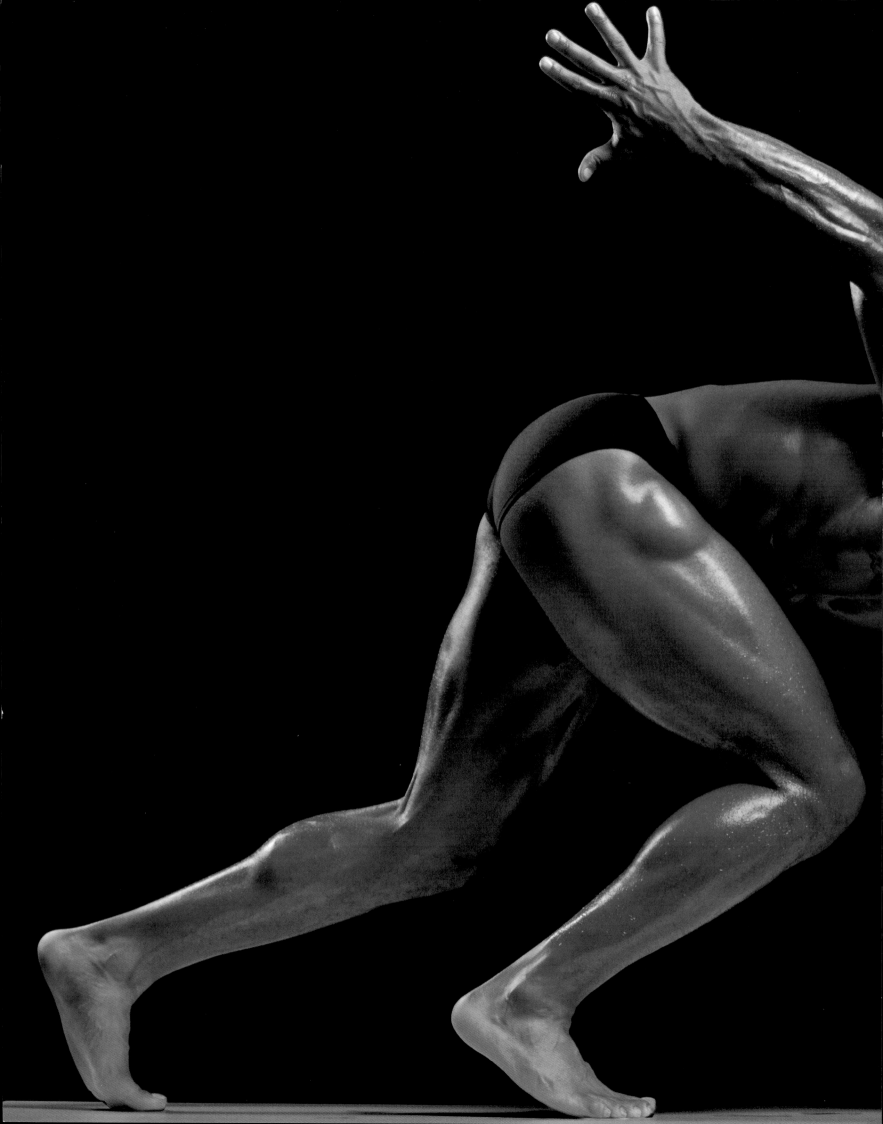

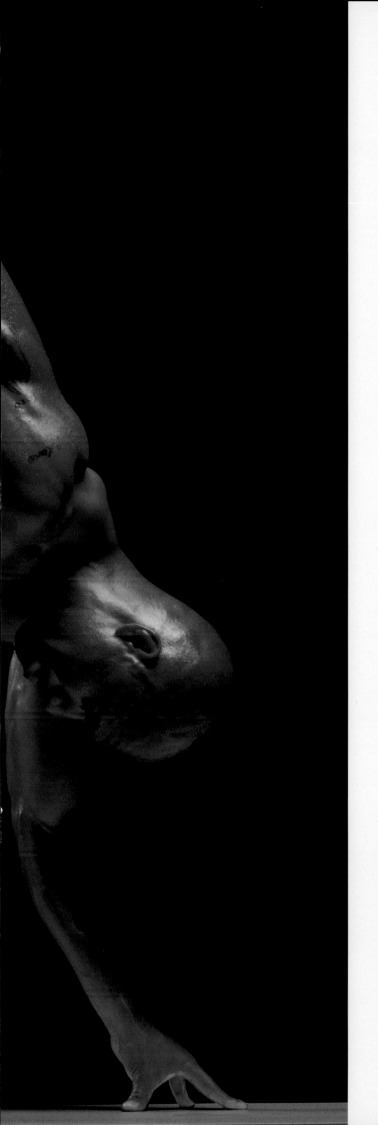

Brian Lewis
Sprint (100m, 200m)

Shawn Crawford
Sprint (200m)

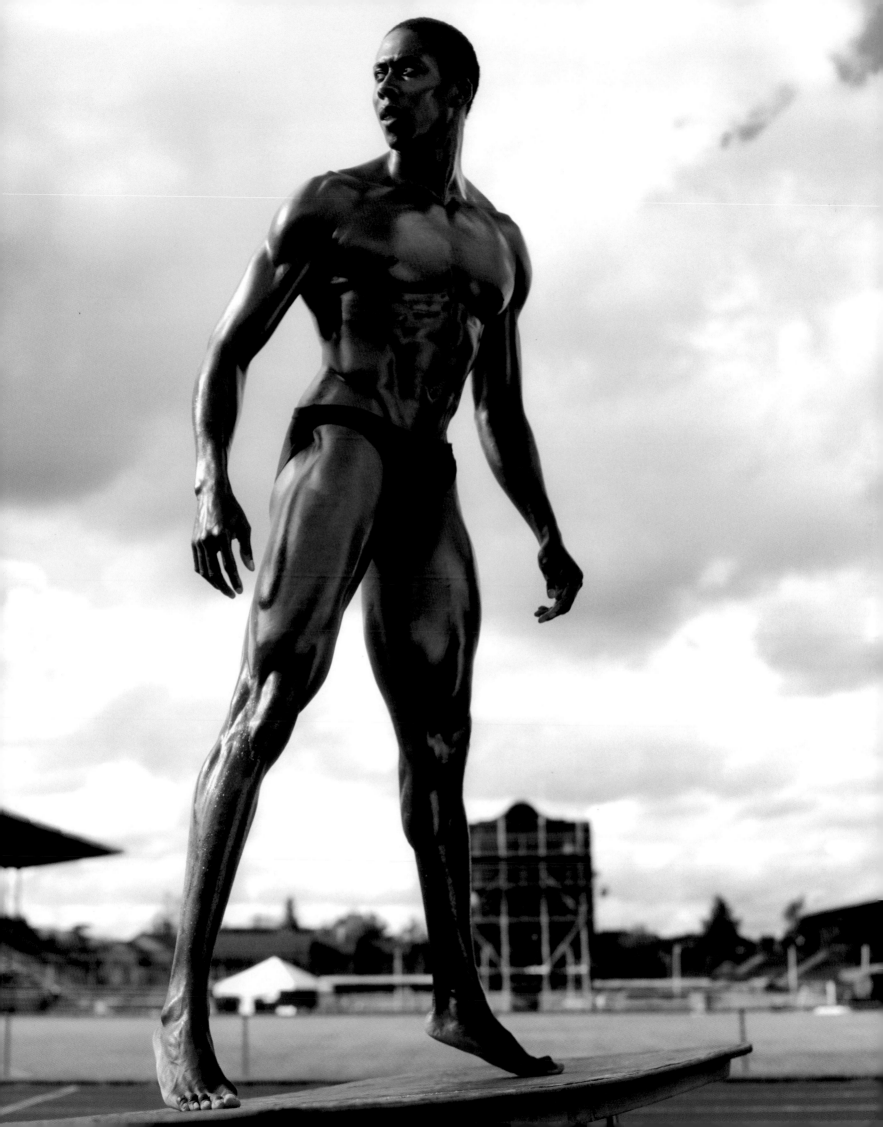

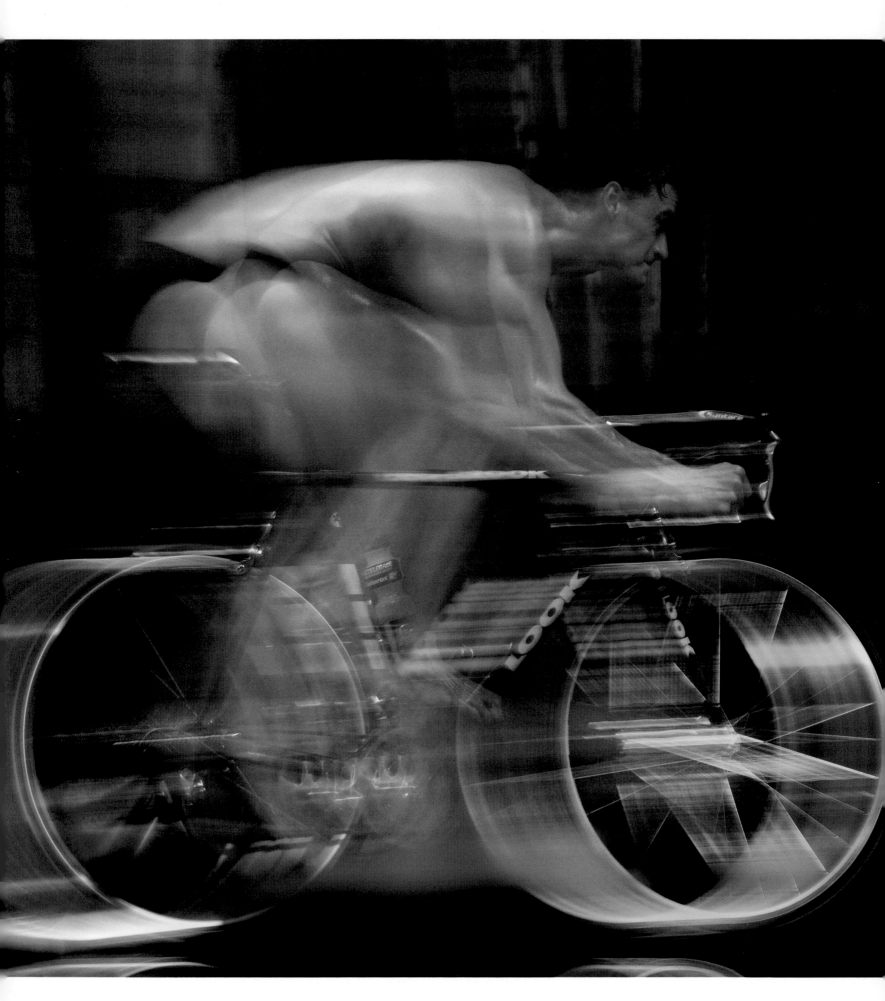

Michael Smedley
Triathlon
176

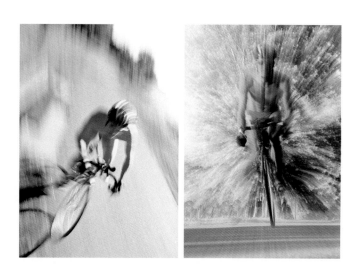
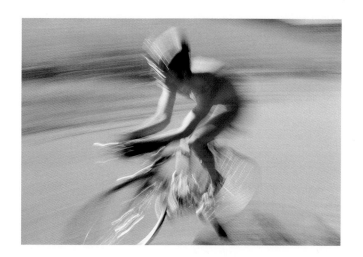

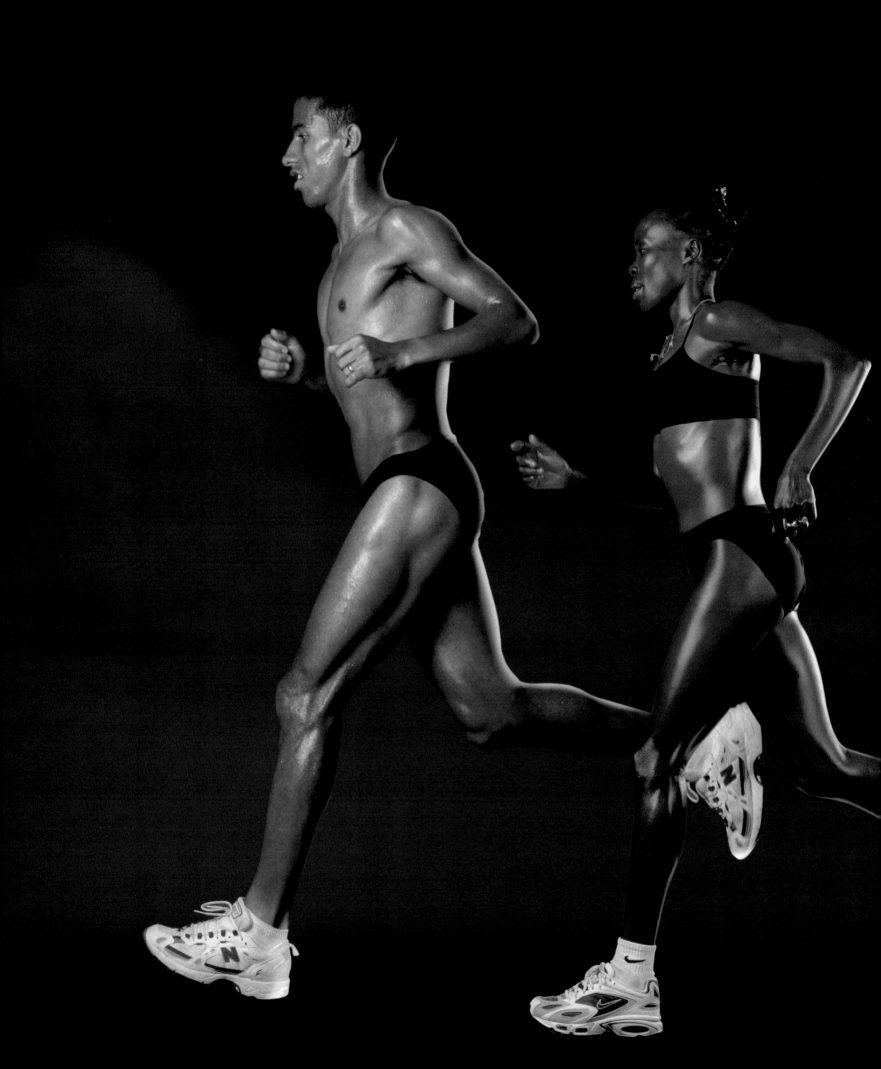

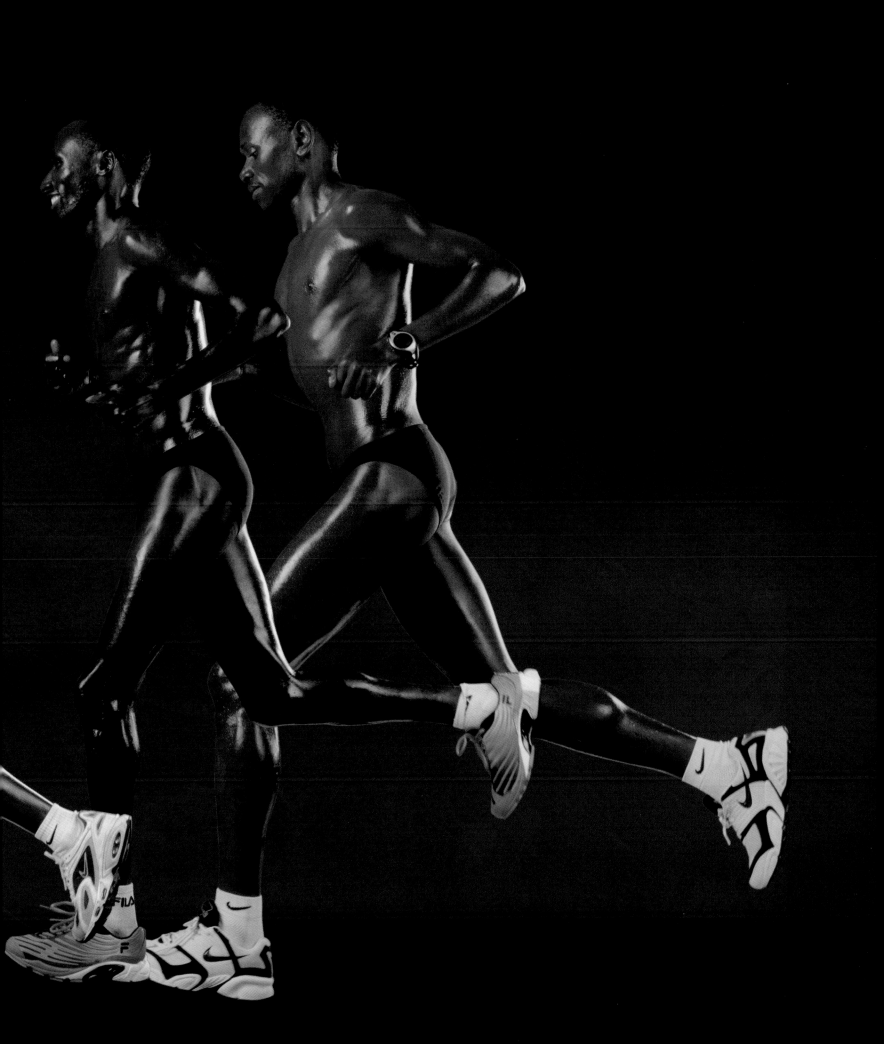

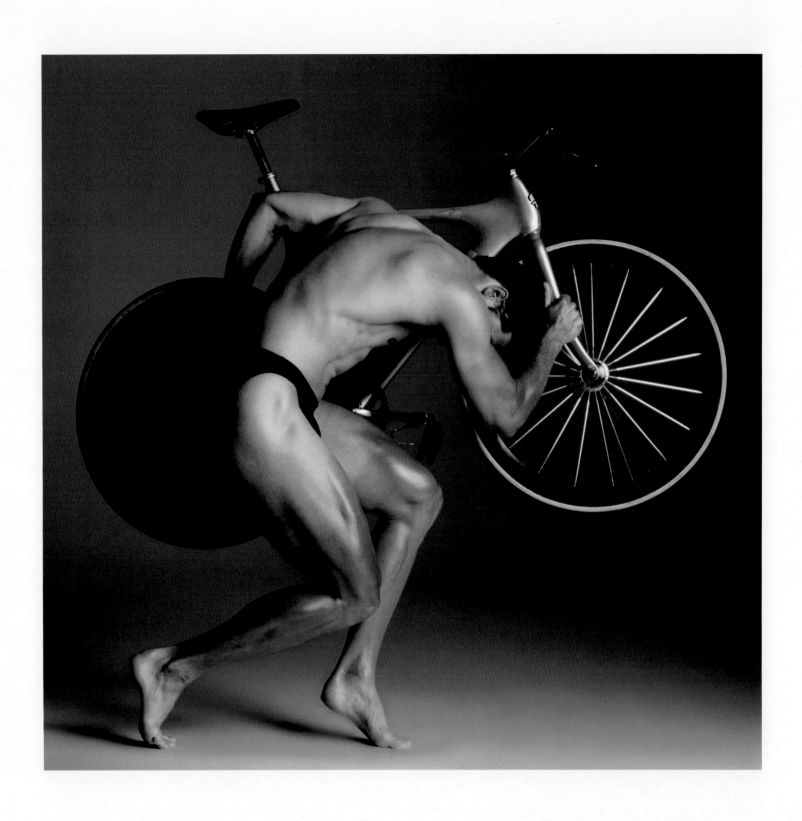

Preceding Pages

Khalid Khannouchi, Tegla Loroupe, Joseph Chebet & John Kagwe
Marathon

180

Marty Nothstein **Cathy Sassin**
Cycling, (Velodrome) Adventure Racer

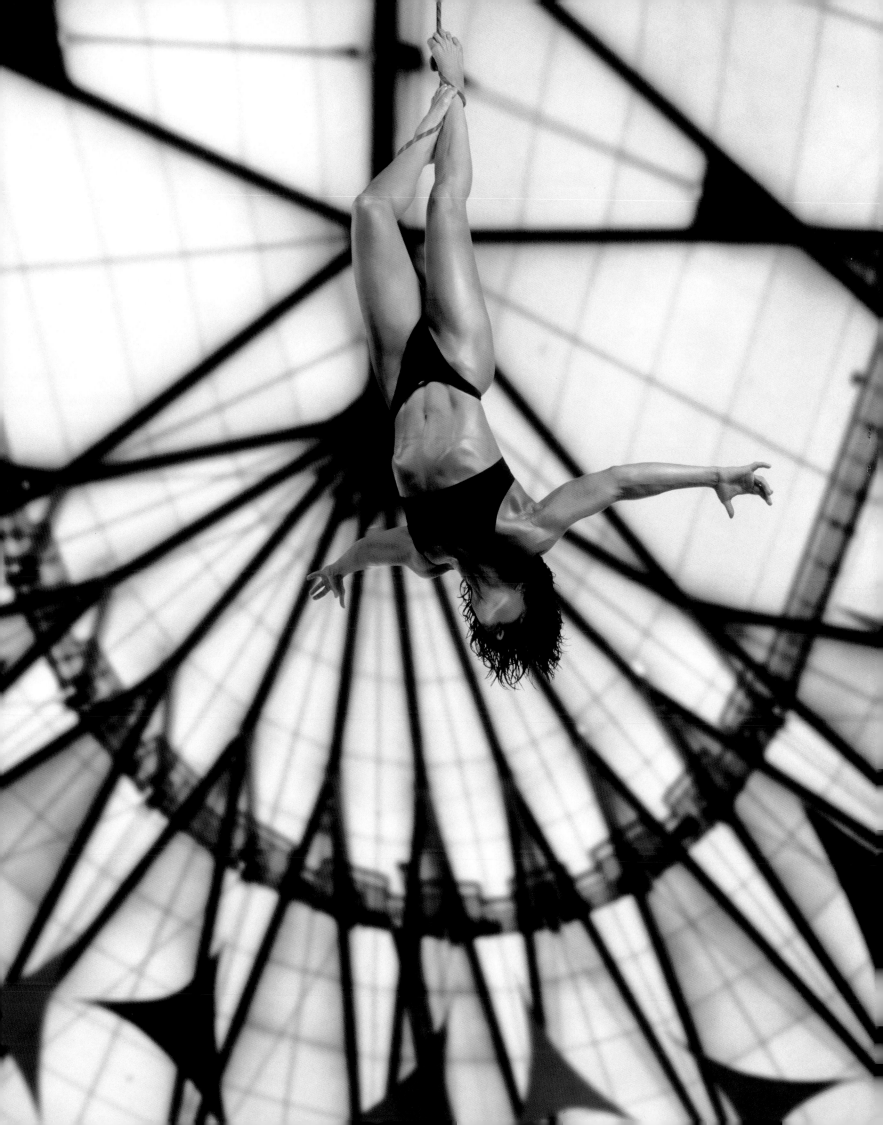

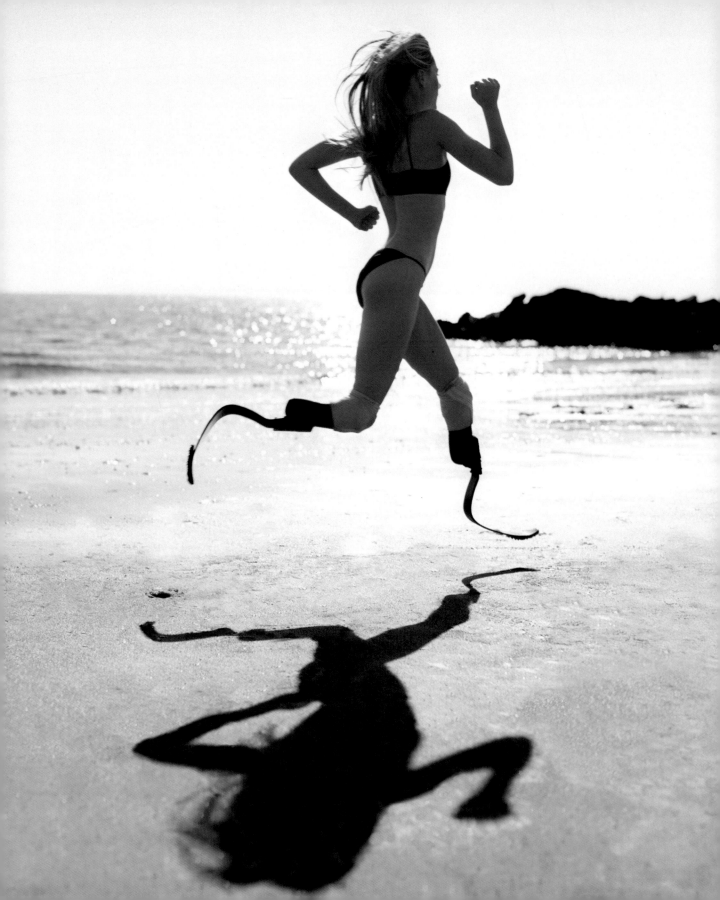

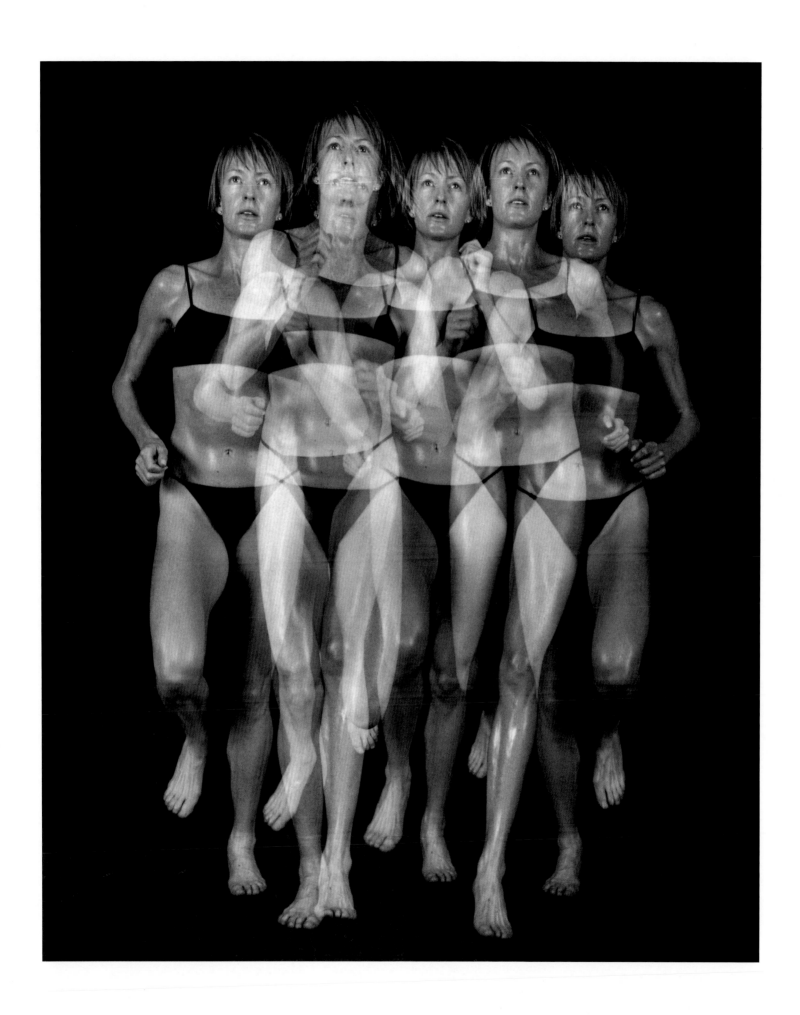

Aimee Mullins
Sprint (100m, 200m) & Long Jump
(Bilateral amputee)

Deena Drossin
Long-Distance Running

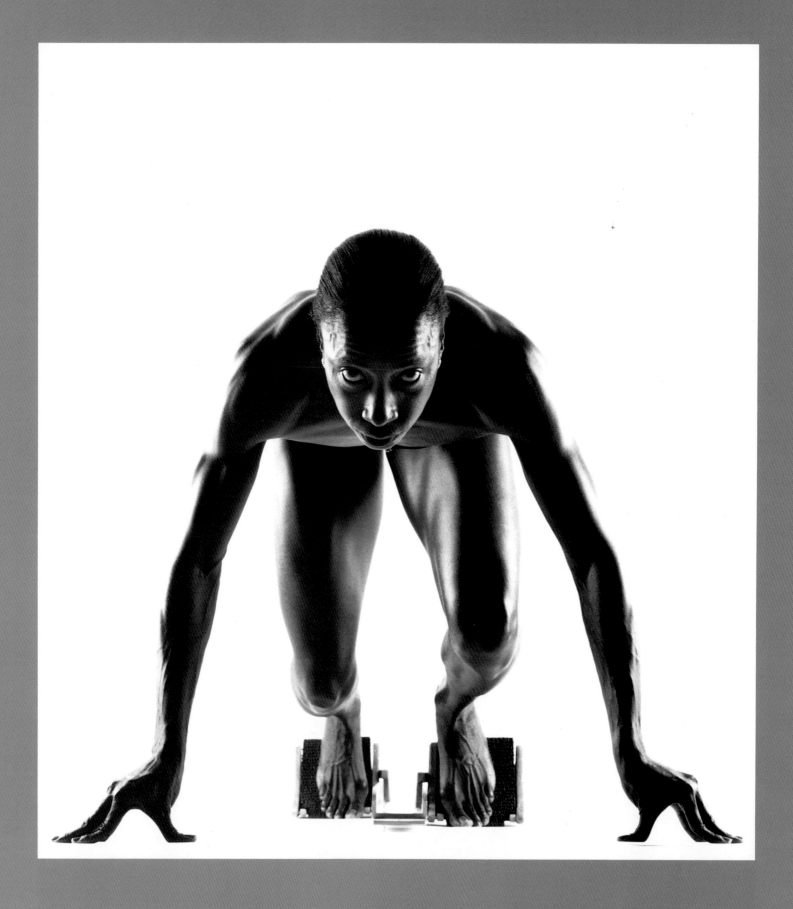

Jearl Miles-Clark
Running (400m, 800m)

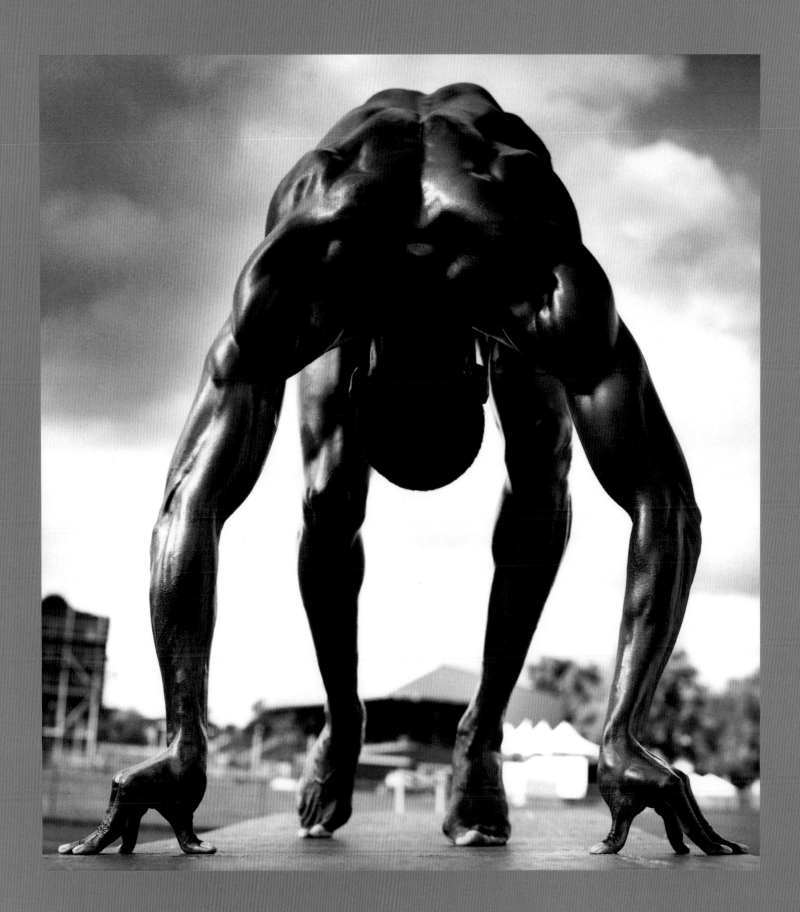

Shawn Crawford
Sprint (200m)
185

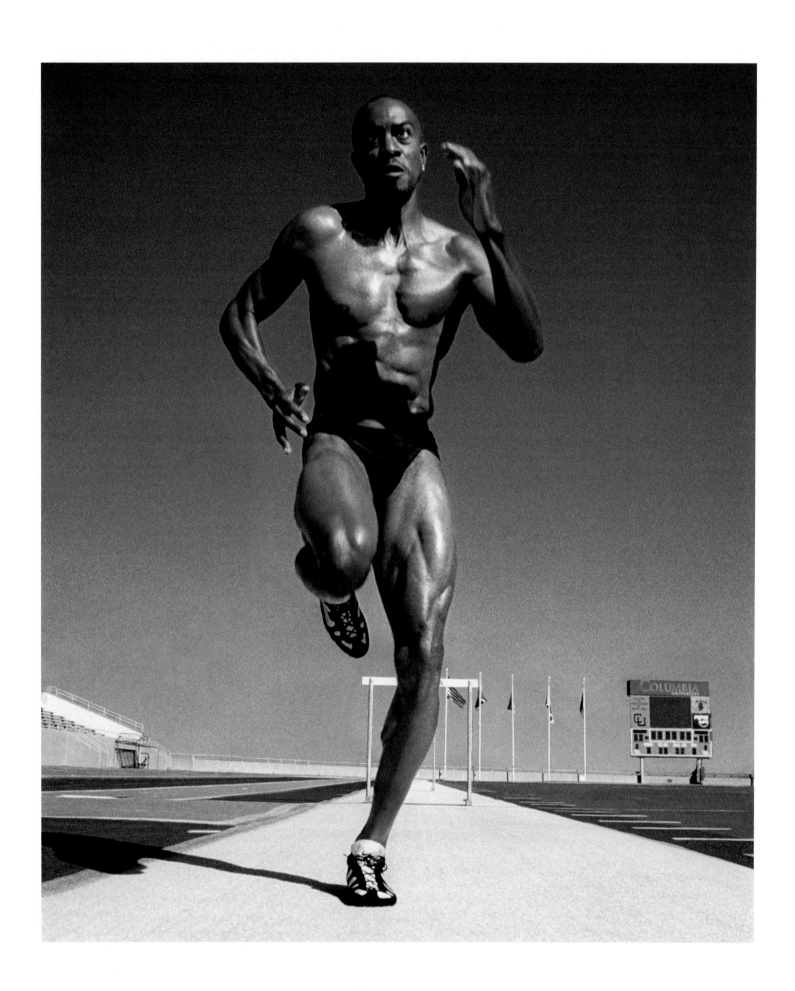

Allen Johnson

Hurdles (110m)

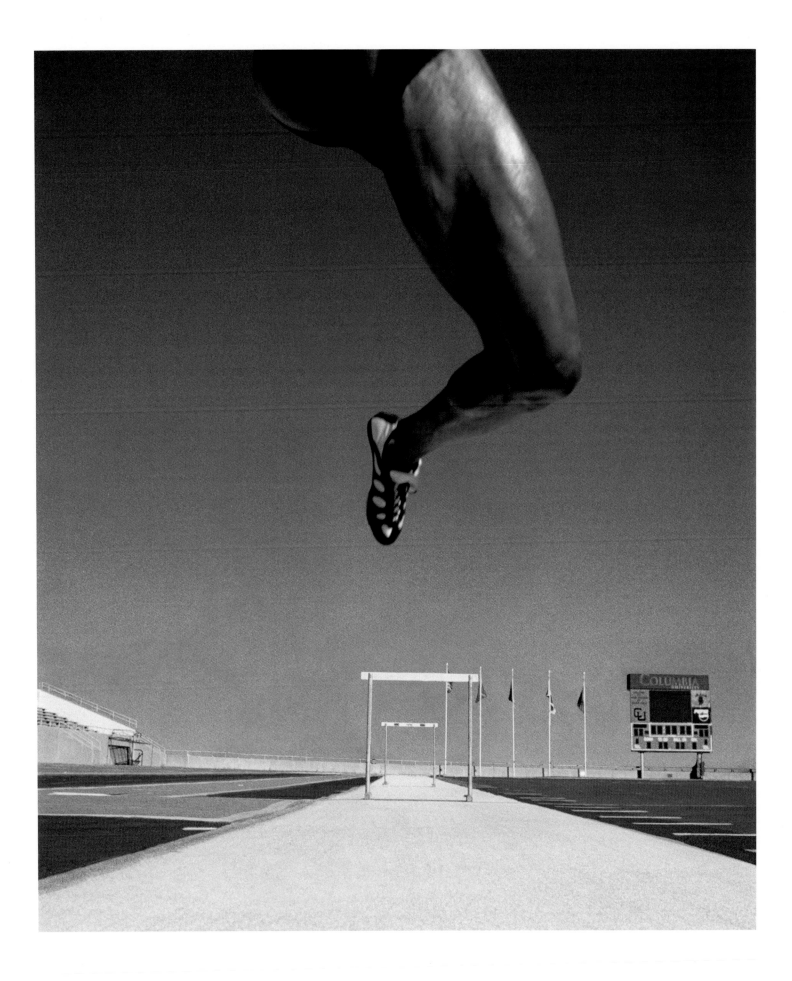

King Kamali
Bodybuilding

Pose Lift

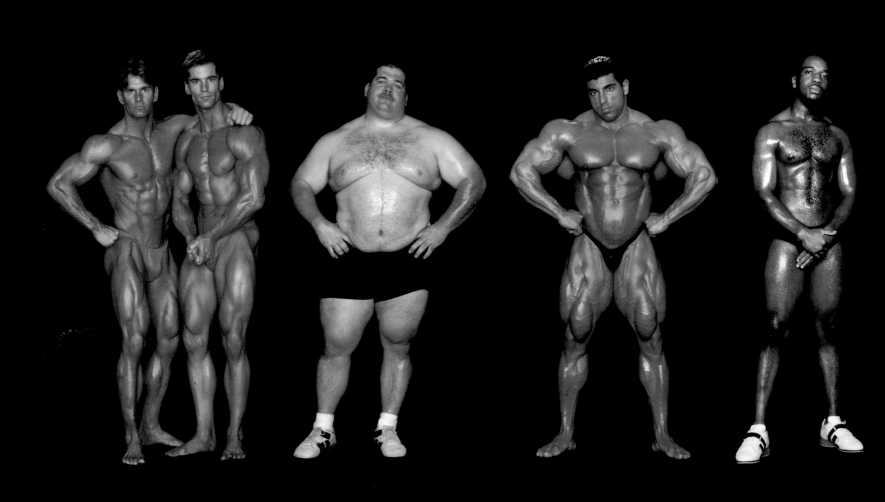

Corey & Chris Wheir
Natural Bodybuilding
5' 10" 205 lbs.; 6' 0" 203 lbs.

Shane Hamman
Weightlifting
5' 9" 370 lbs.

King Kamali
Bodybuilding
5' 10" 248 lbs.

Oscar Chaplin III
Weightlifting
5' 9" 169.5 lbs.

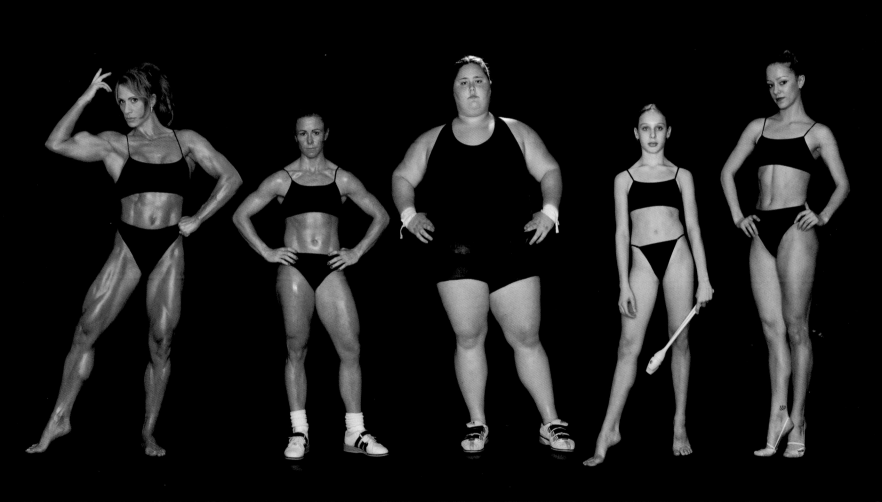

Kim Chizevsky
Bodybuilding
5' 8.5" 135 lbs.

Tara Nott
Weightlifting
5' 1" 105 lbs.

Cheryl Haworth
Weightlifting
5' 9" 297 lbs.

Olga Karmansky
Rhythmic Gymnastics
5' 1" 85 lbs.

Aliane Baquerot
Rhythmic Gymnastics
5' 6" 112 lbs.

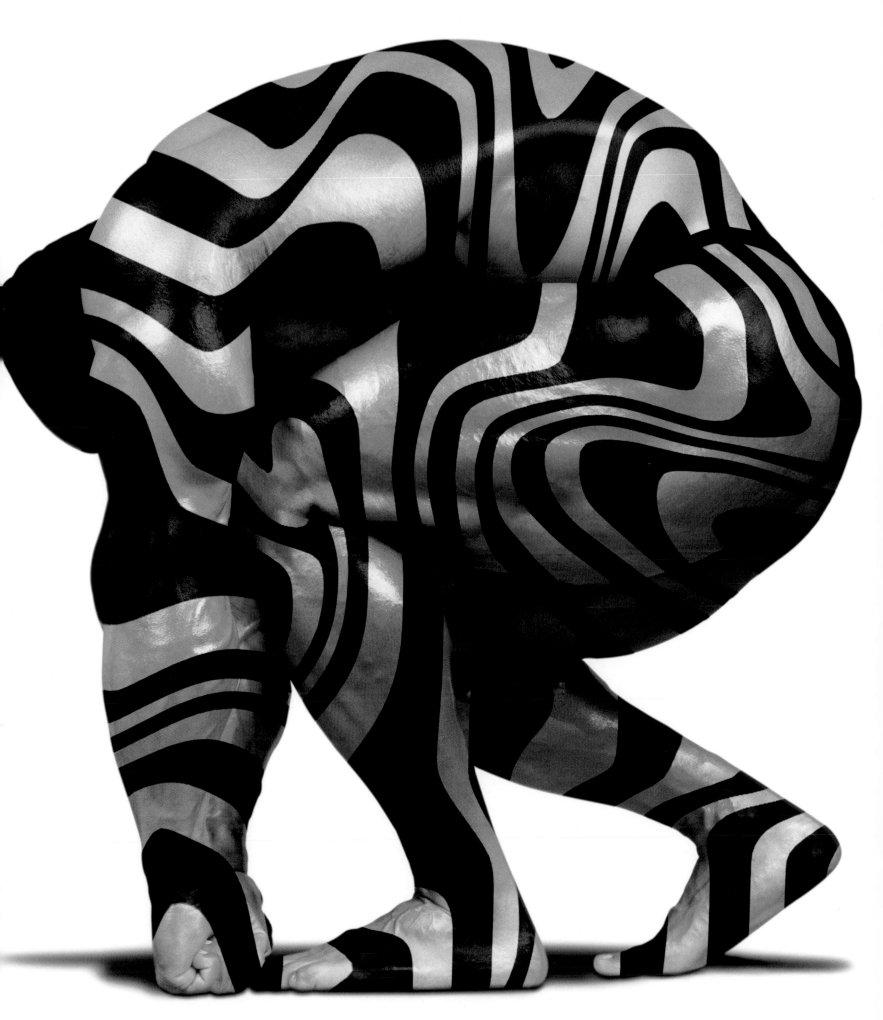

King Kamali
Bodybuilding
193

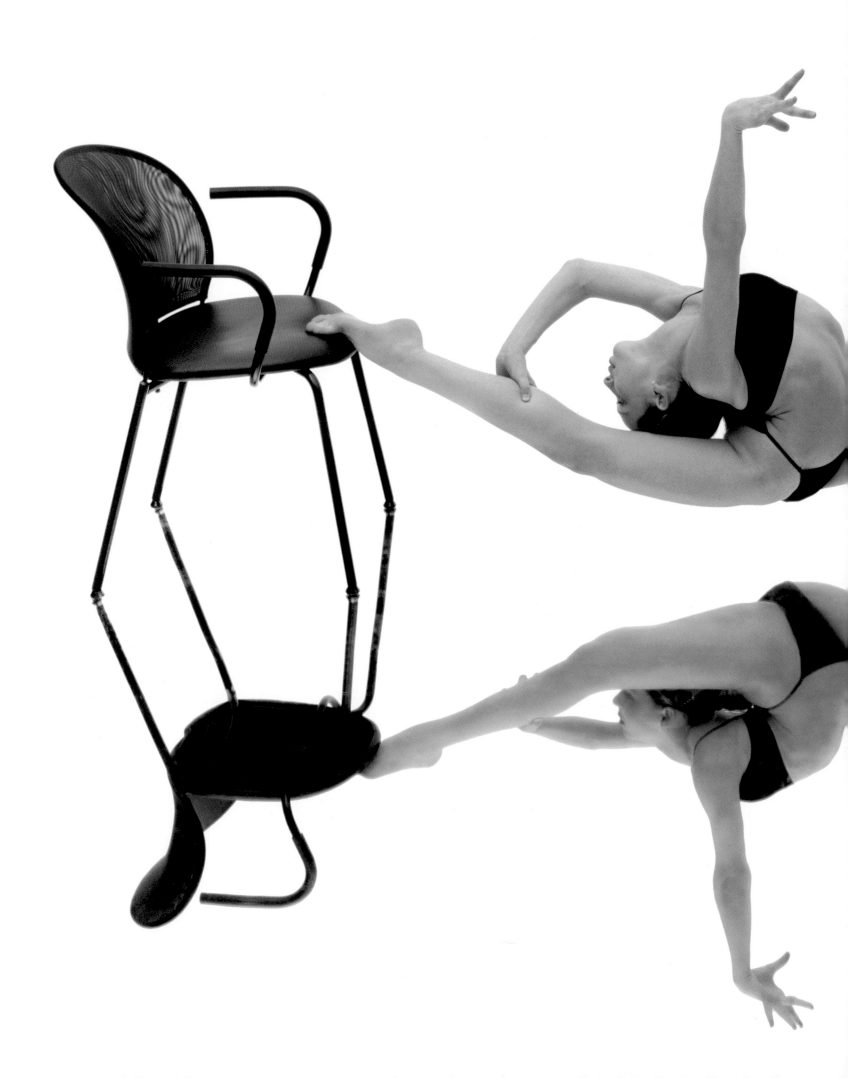

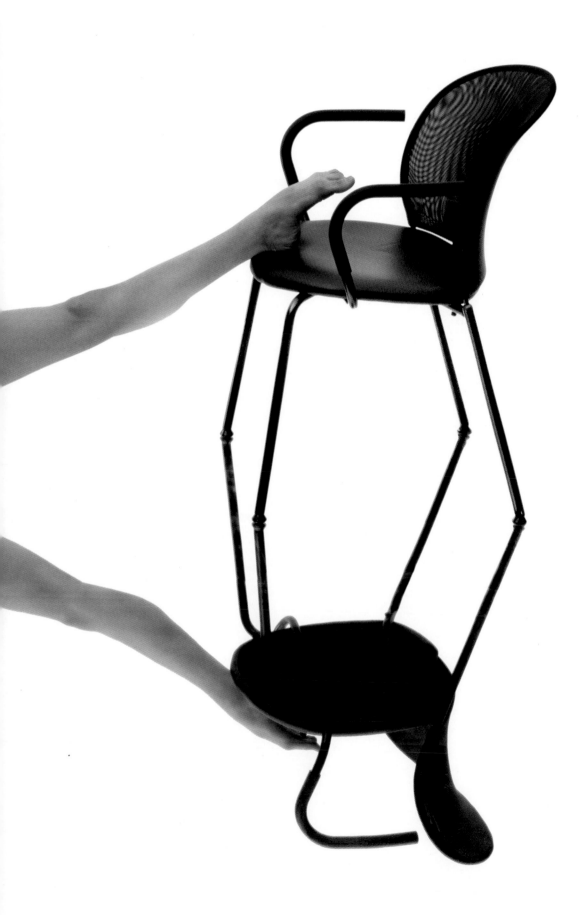

Olga Karmansky
Rhythmic Gymnastics

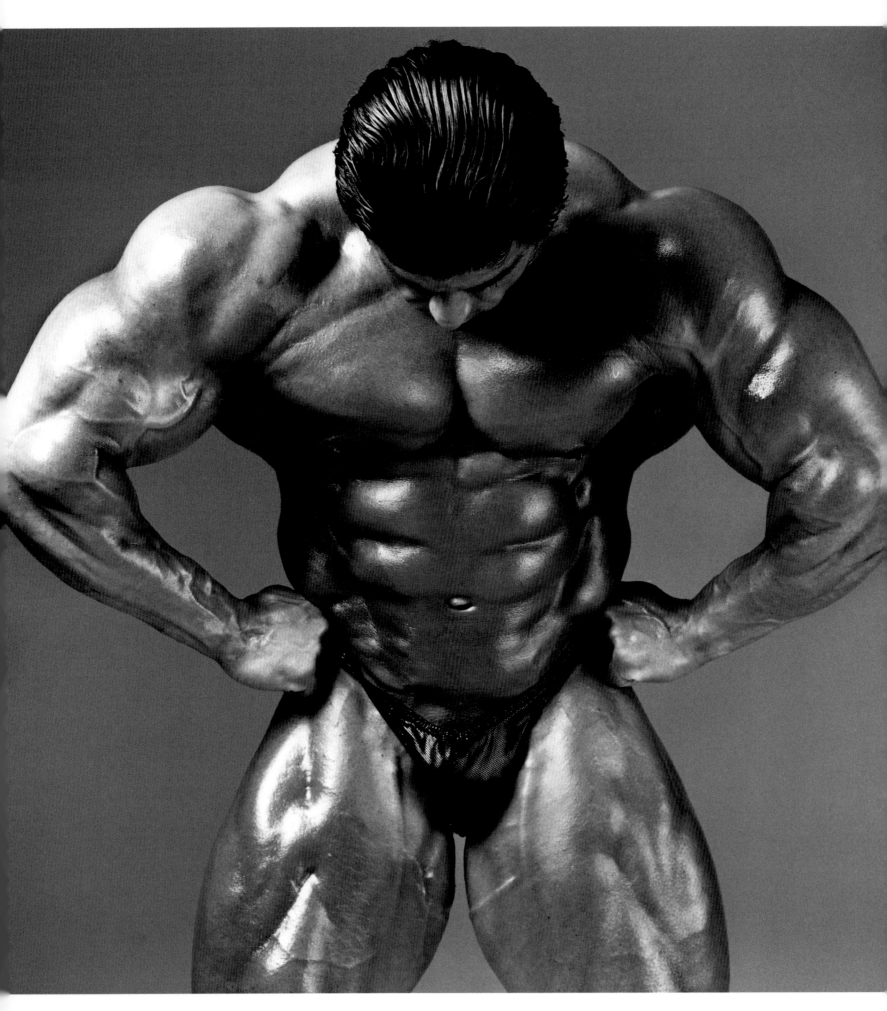

King Kamali
Bodybuilding

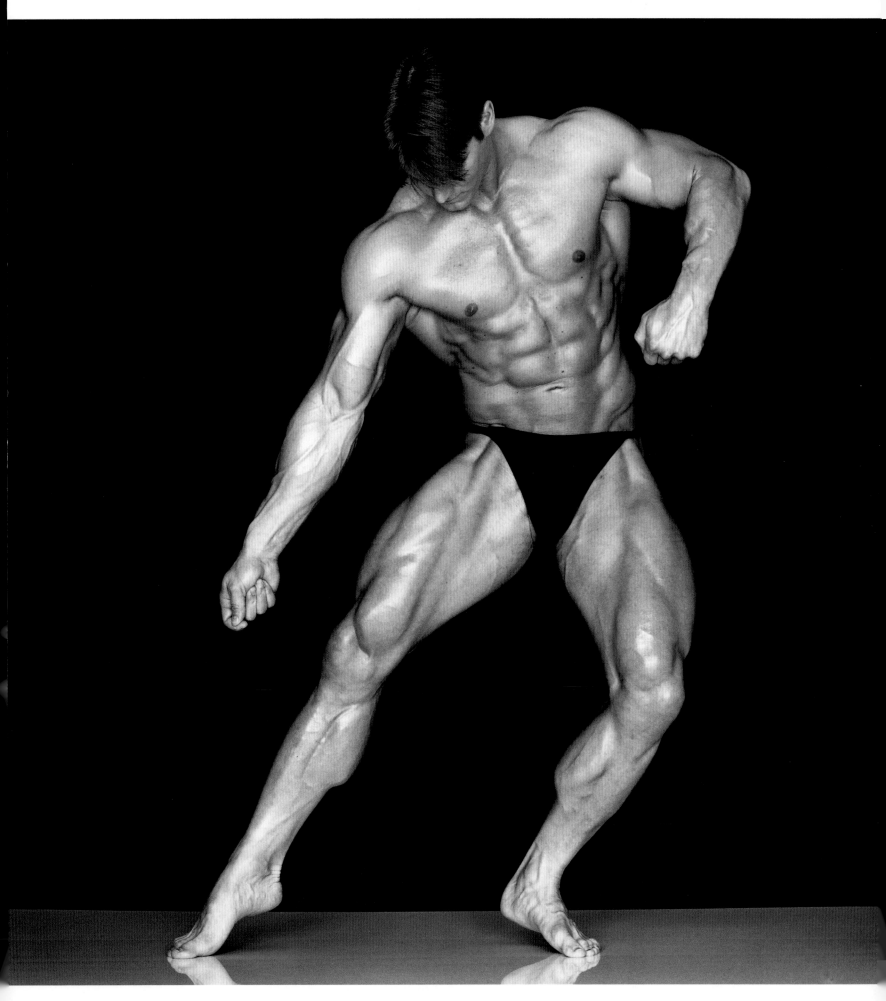

Corey Wheir
Natural Bodybuilding
197

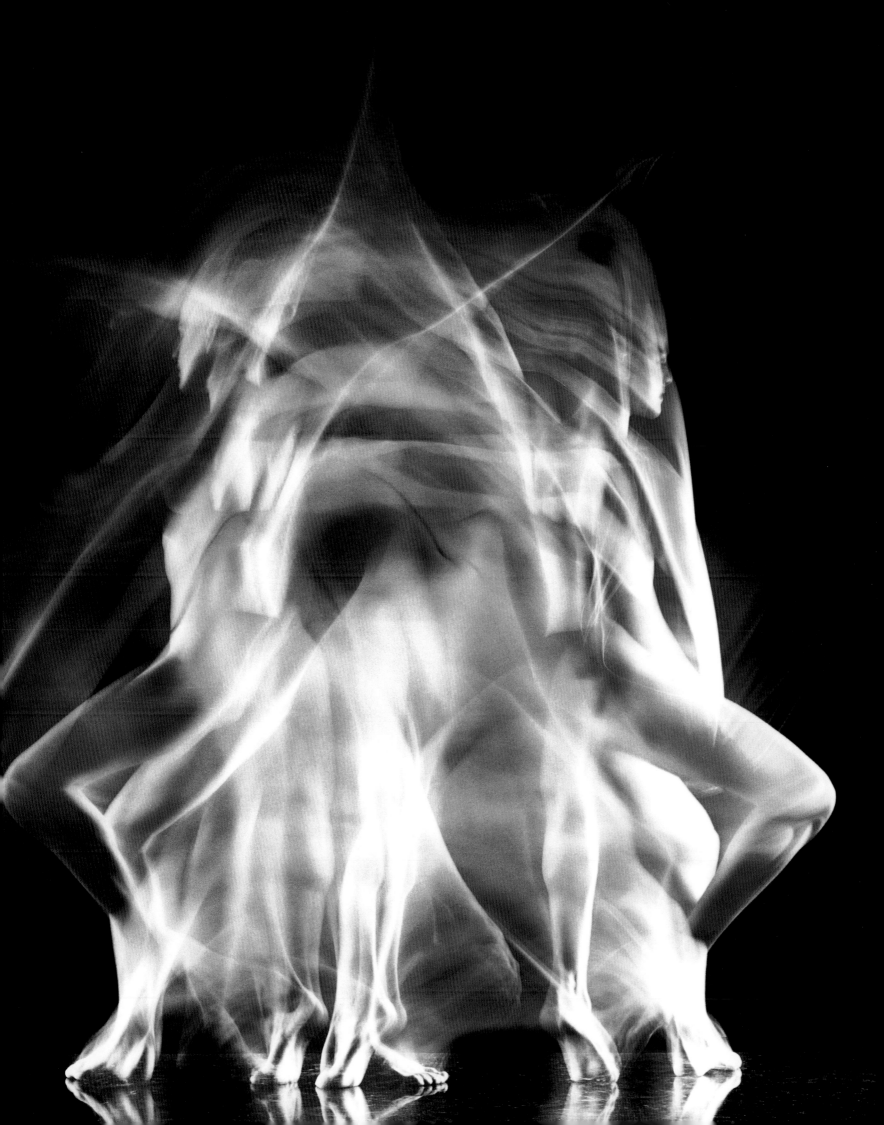

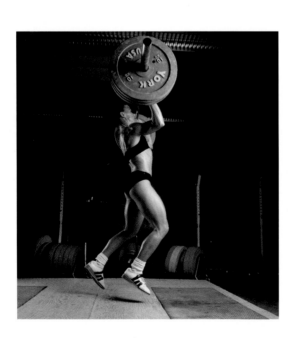

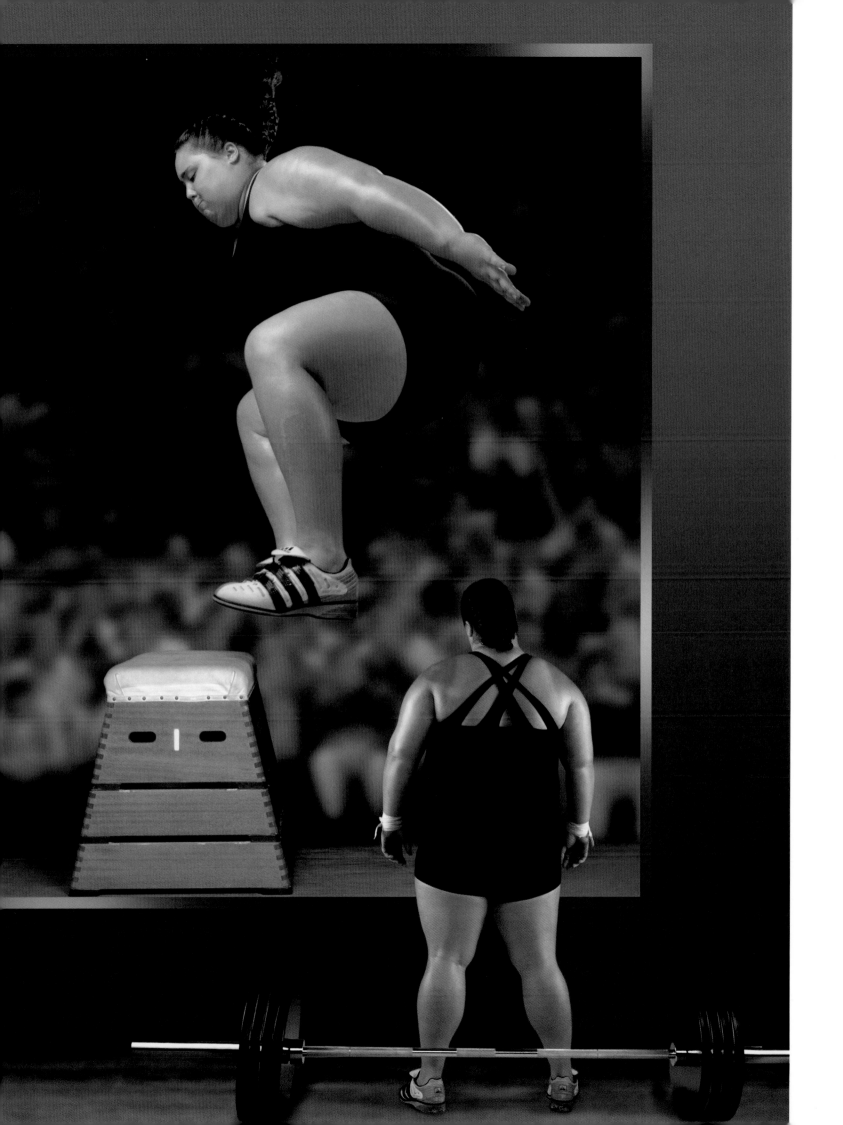

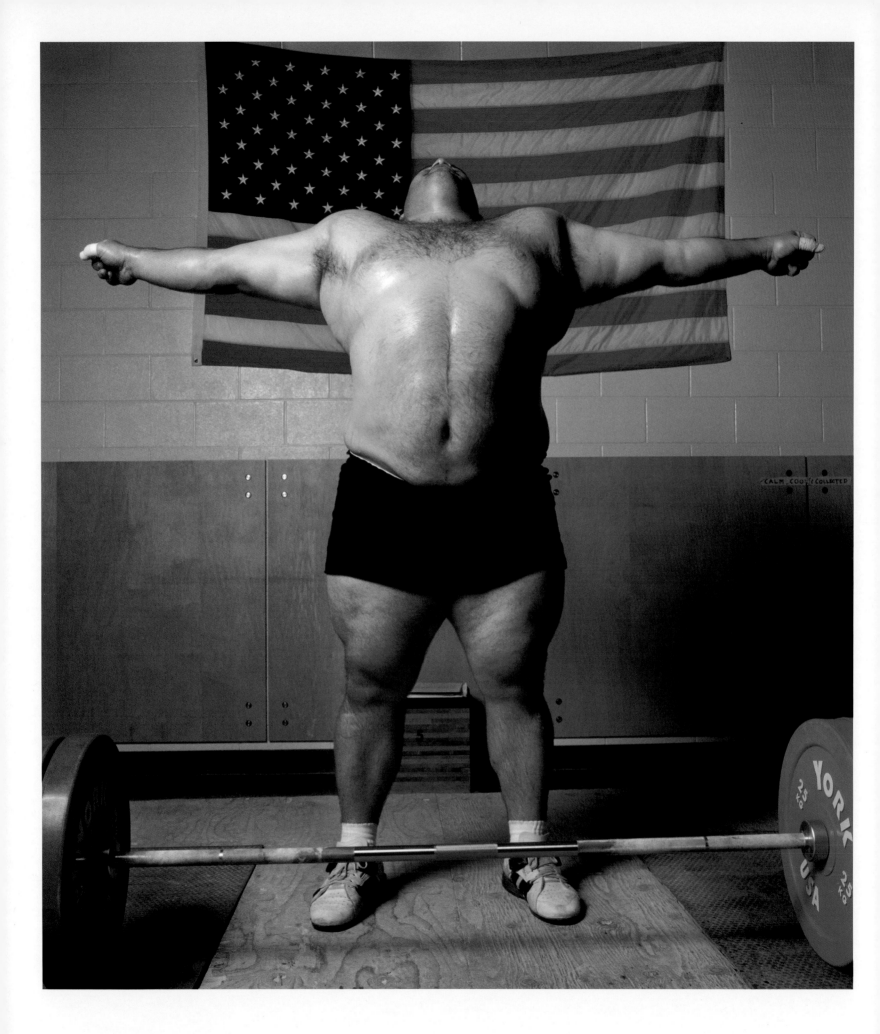

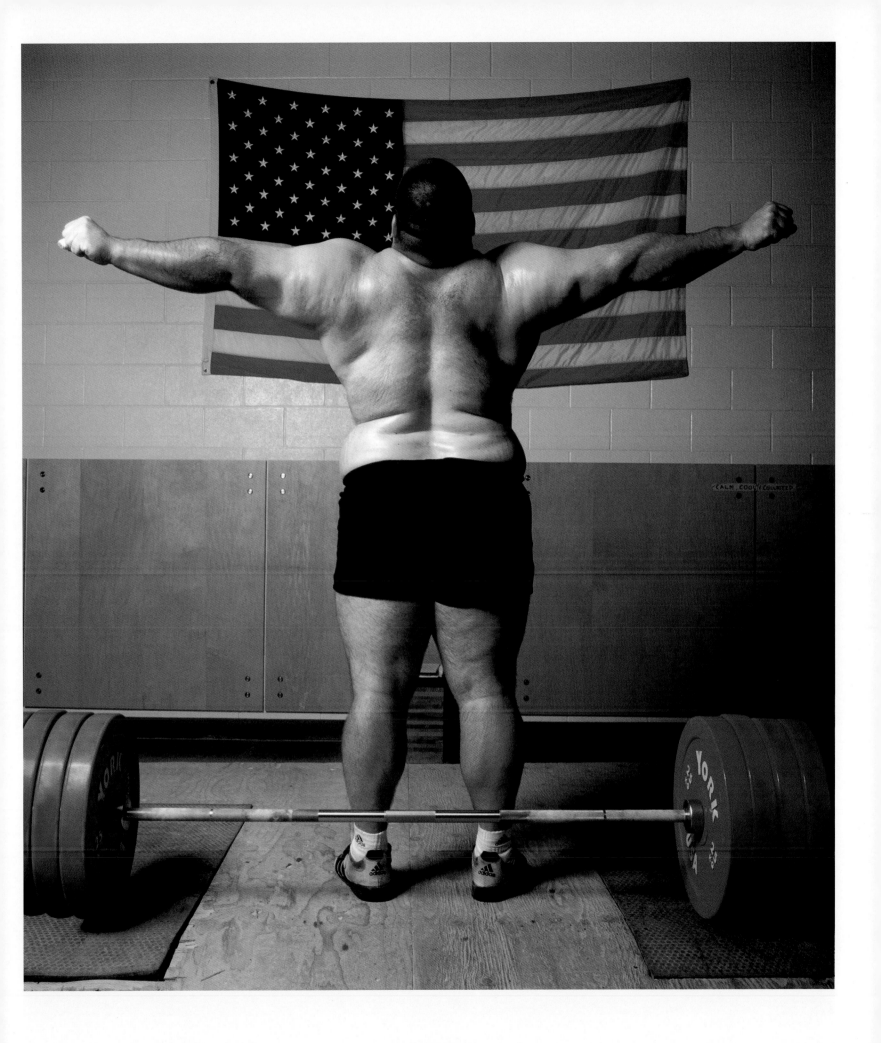

Shane Hamman
Weightlifting
203

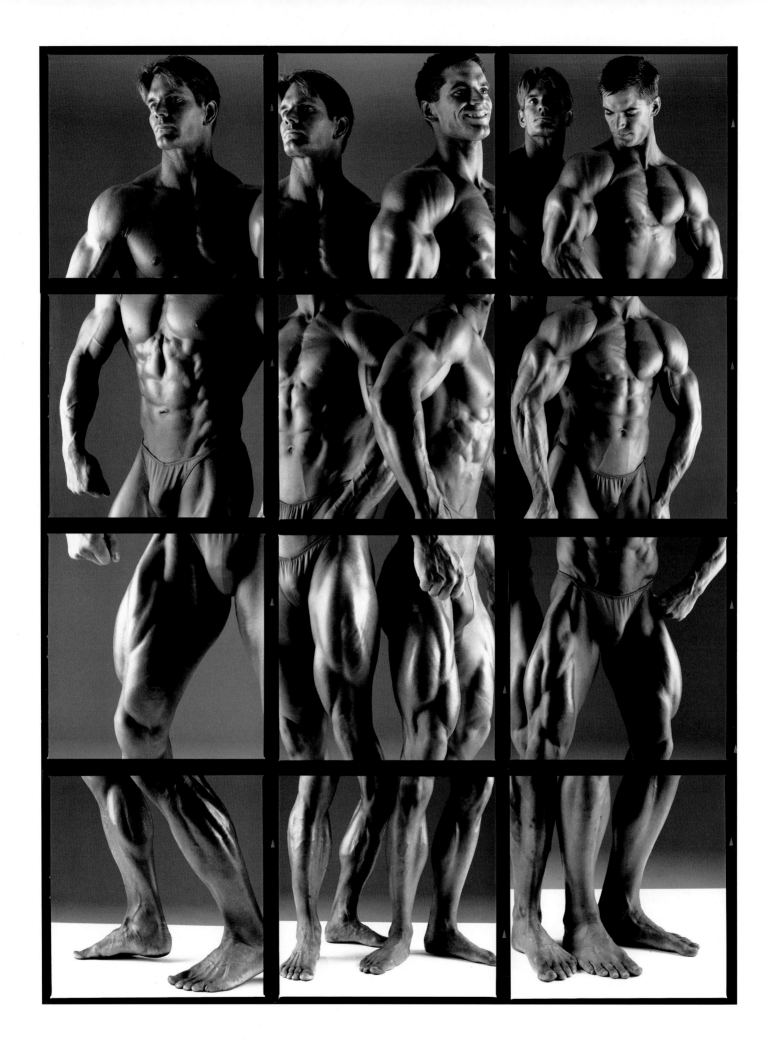

Chris & Corey Wheir
Natural Bodybuilding
206

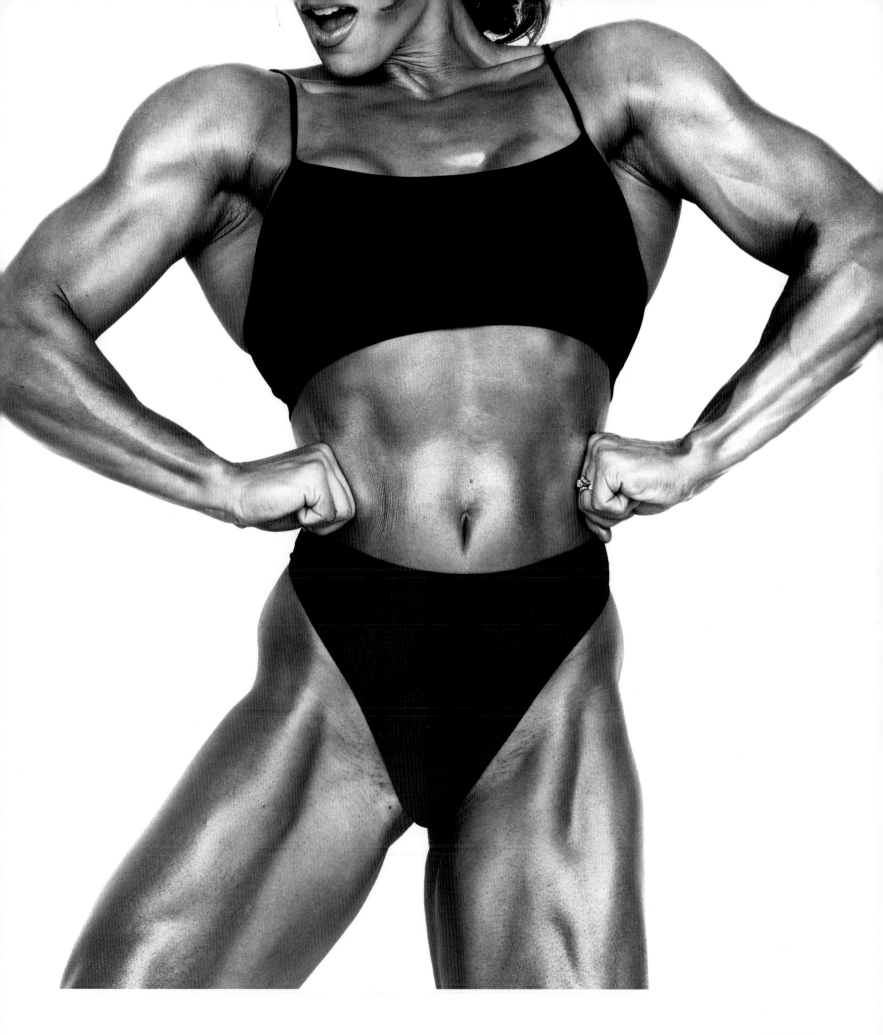

Kim Chizevsky
Bodybuilding

Preceding Pages

Aliane Baquerot
Rhythmic Gymnastics

Throw
Catch

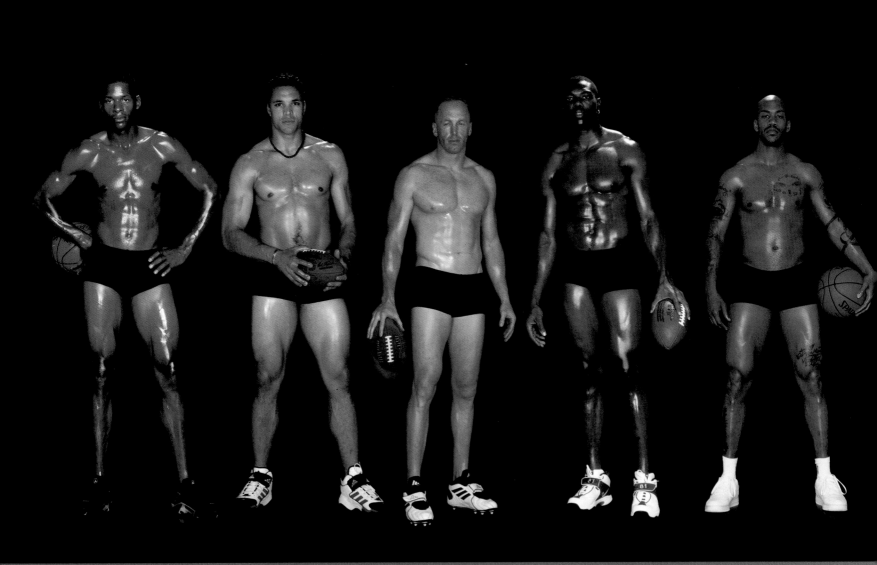

Ray Allen
Basketball
6' 5" 205 lbs.

Tony Gonzalez
Football
6' 4" 248 lbs.

Jeff Garcia
Football
6' 1" 195 lbs.

Terrell Owens
Football
6' 3" 226 lbs.

Stephon Marbury
Basketball
6' 2" 180 lbs.

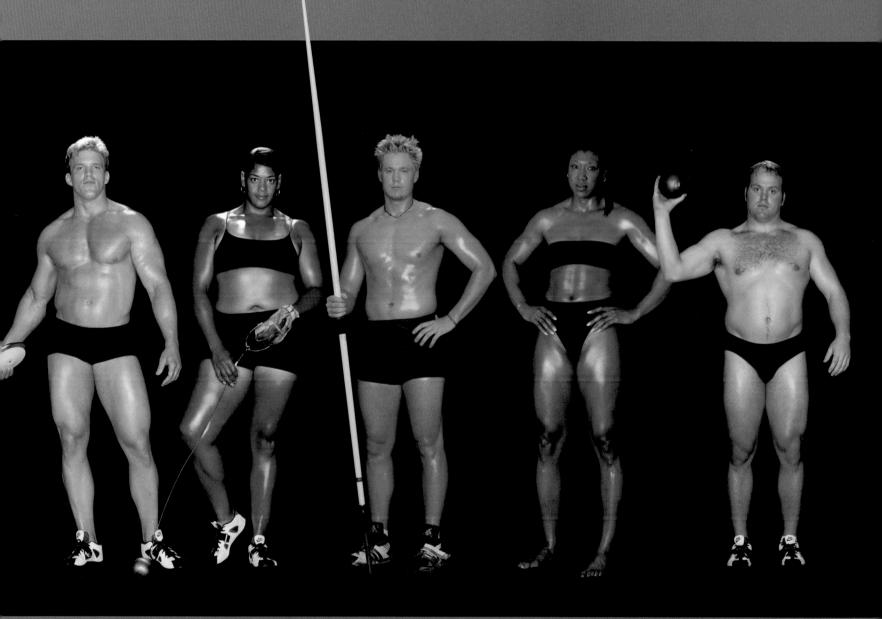

Adam Setliff
Discus
6' 4" 270 lbs.

Dawn Ellerbe
Hammer Throw
6' 2" 240 lbs.

Breaux Greer
Javelin
6' 2" 225 lbs.

Connie Price-Smith
Shot Put
6' 3" 210 lbs.

Adam Nelson
Shot Put
6' 0" 255 lbs.

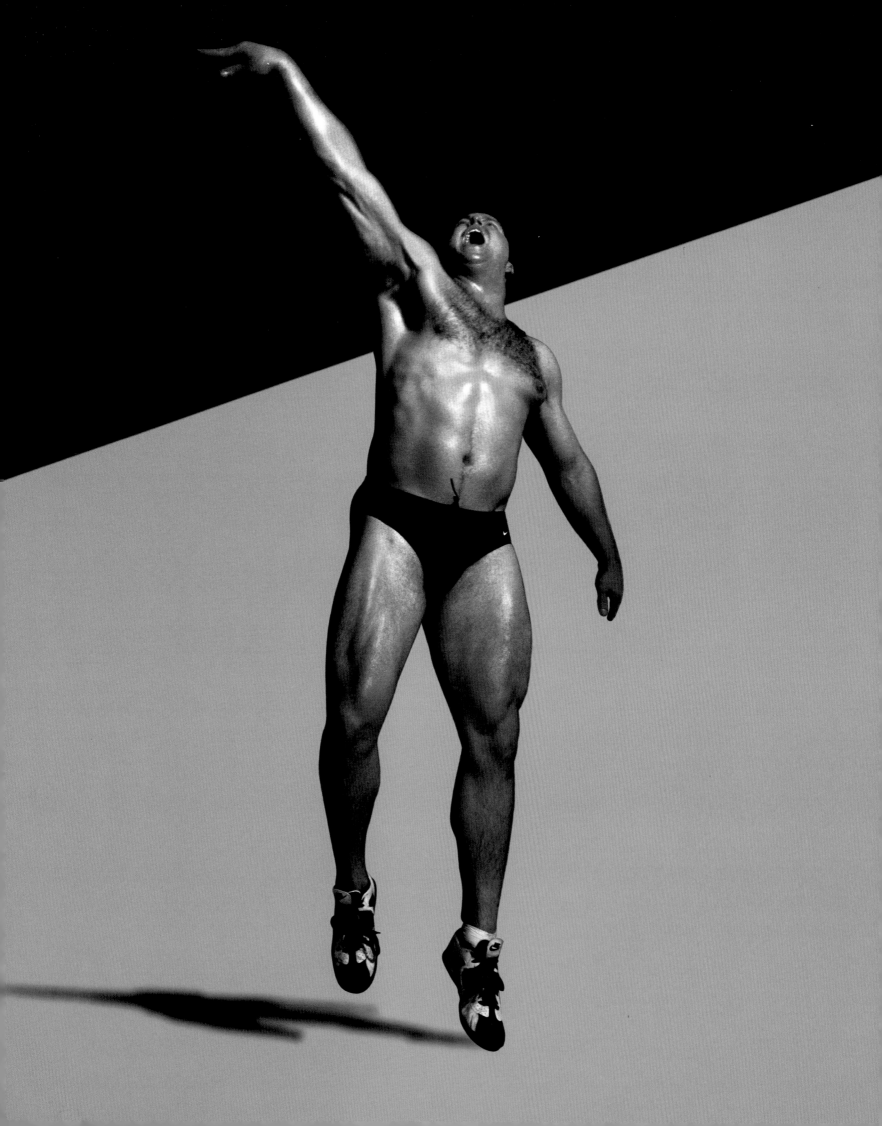

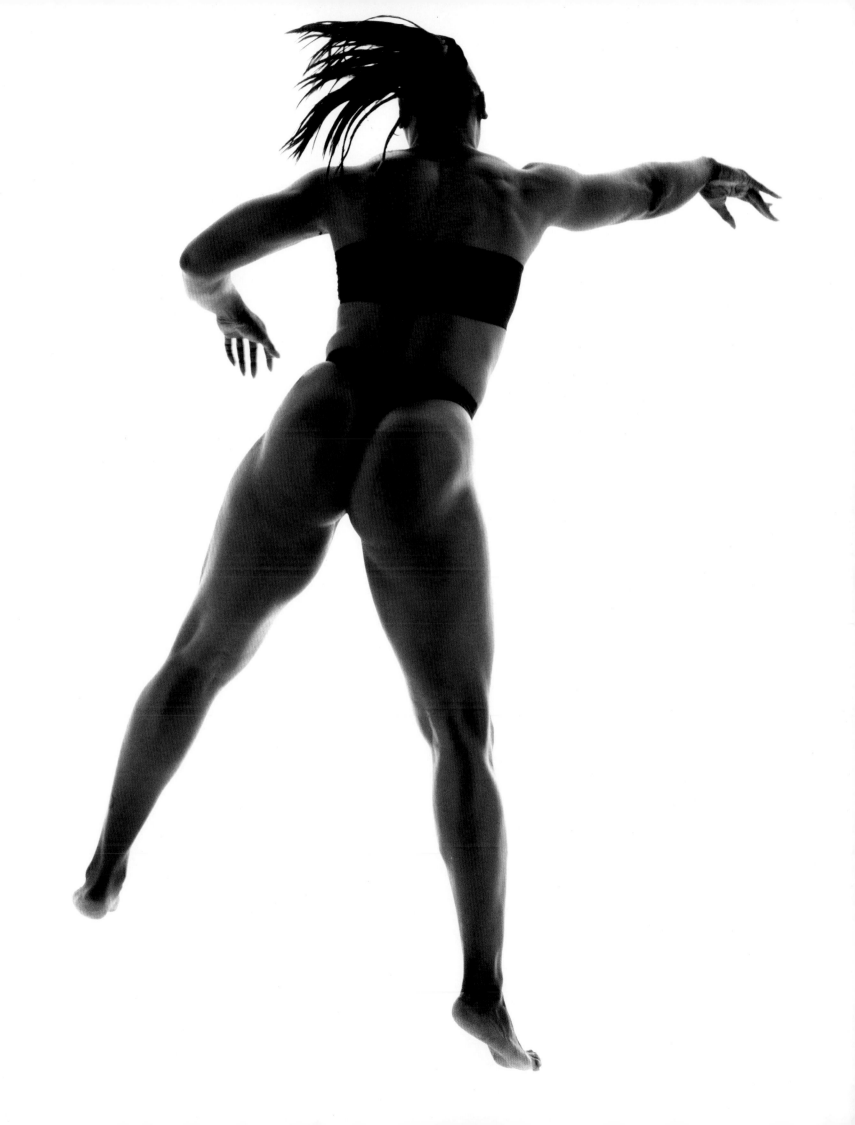

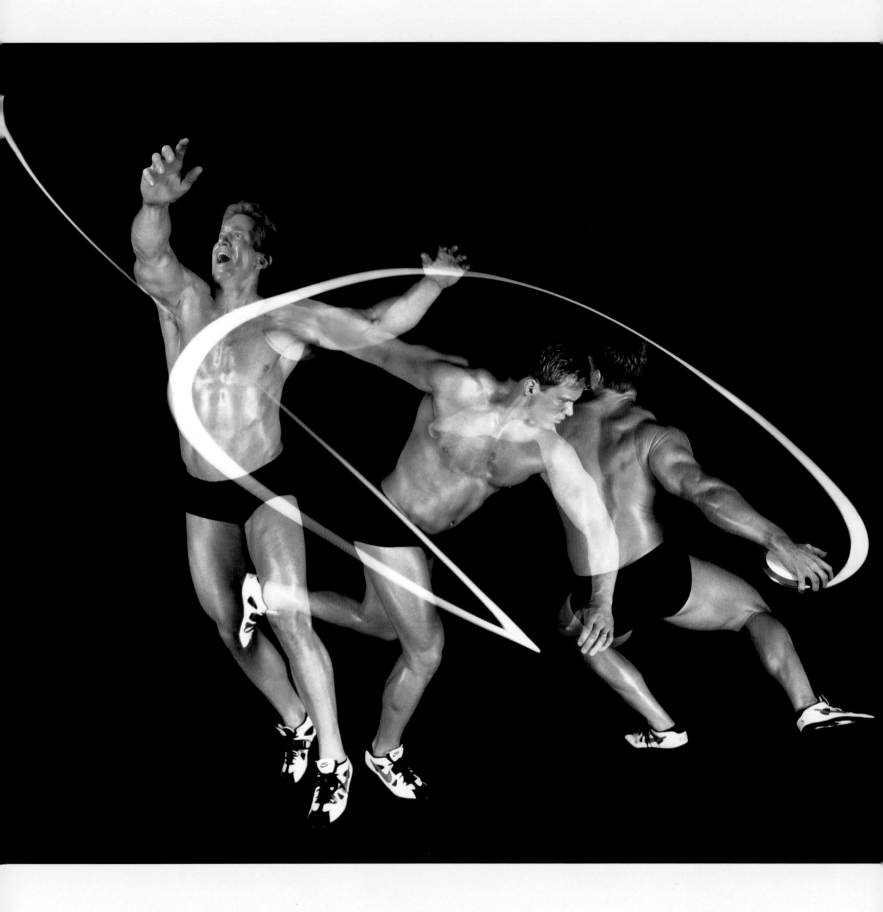

Adam Nelson
Shot Put

Connie Price-Smith
Shot Put

Adam Setliff
Discus
(Path of discus before release)

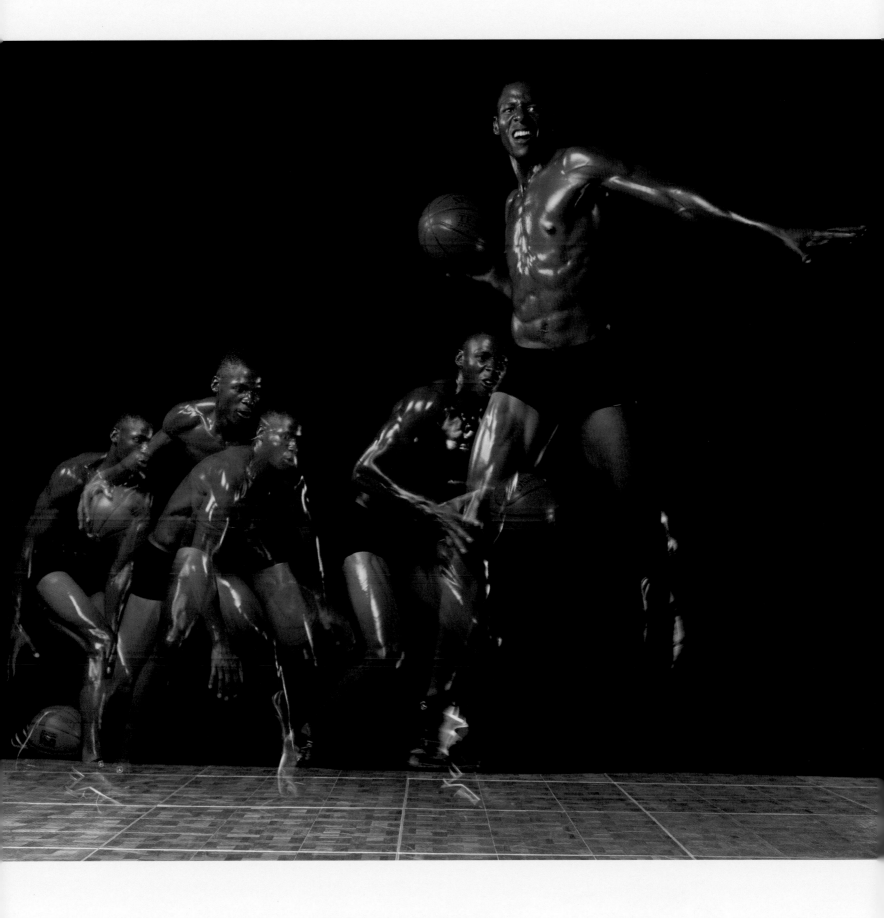

Ray Allen
Basketball

215

Following Pages

Jeff Garcia
Football

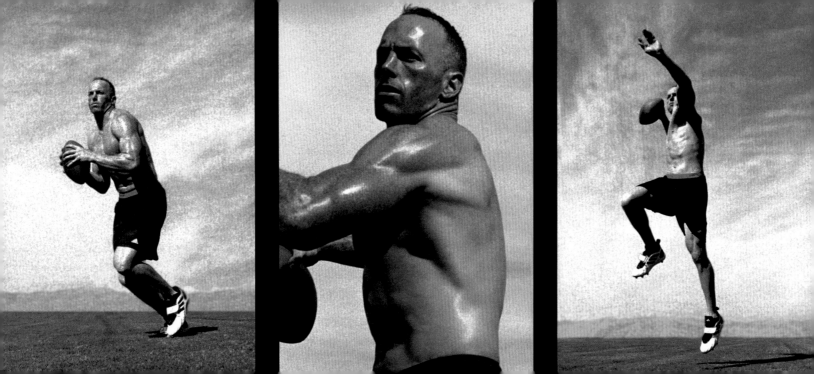

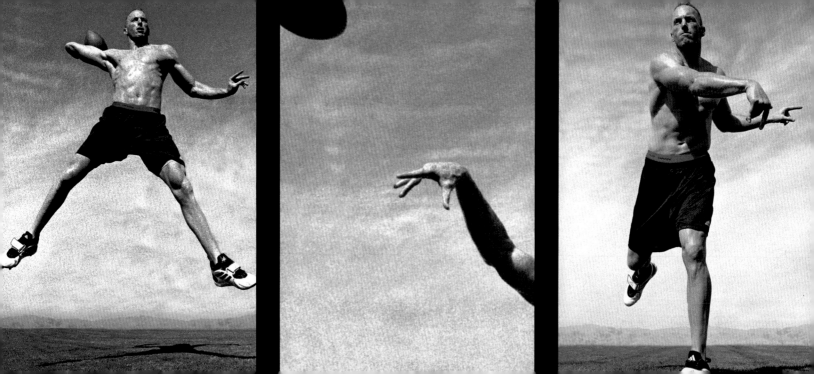

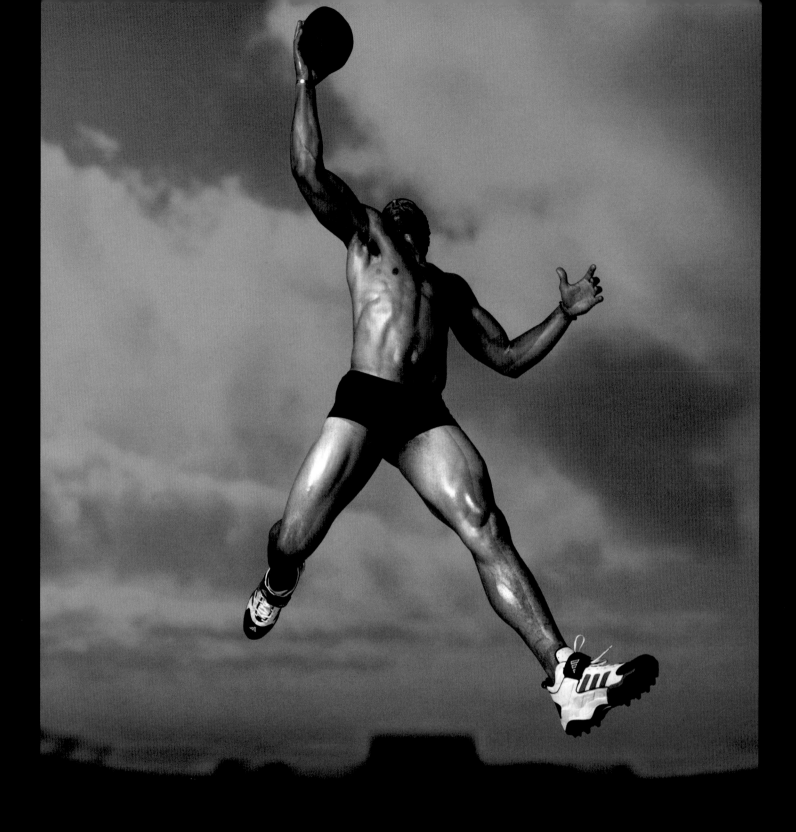

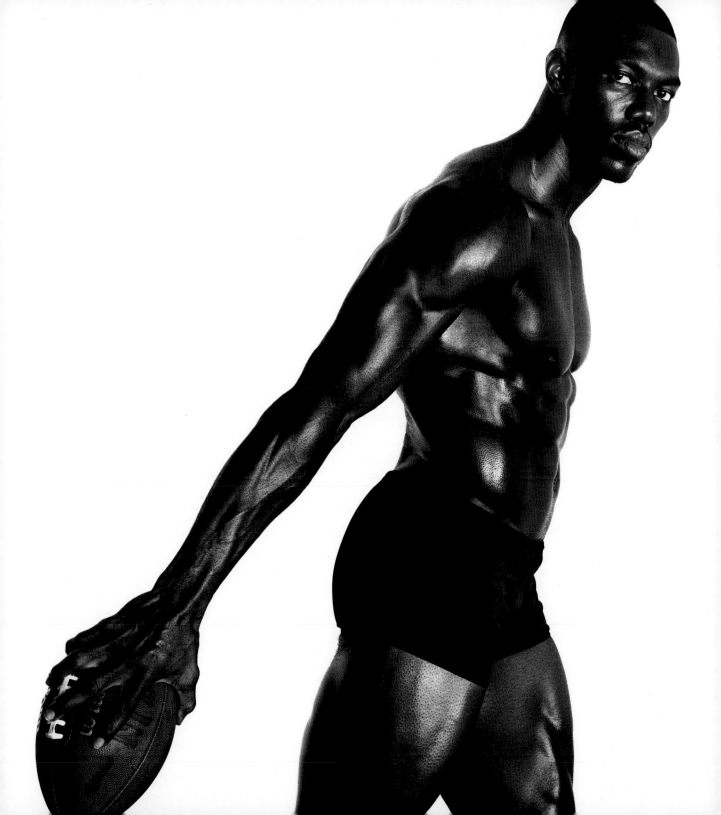

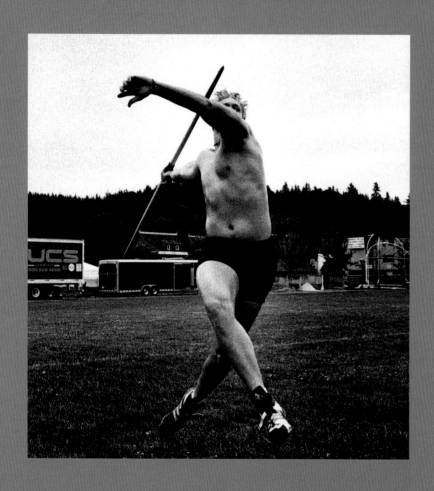

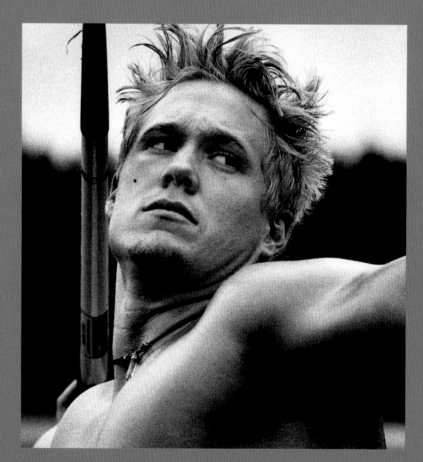

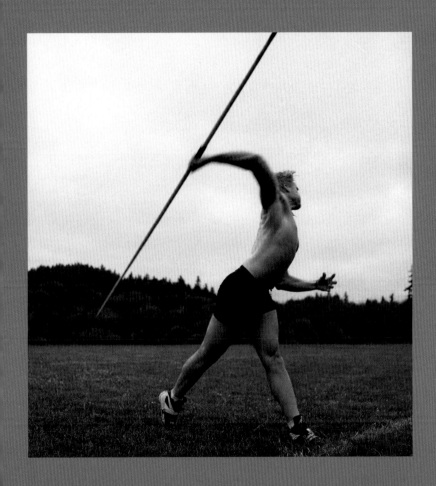
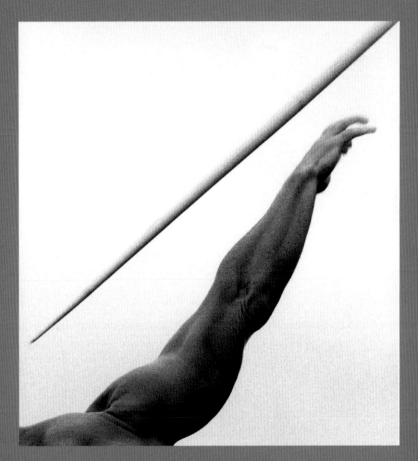

Breaux Greer
Javelin
221

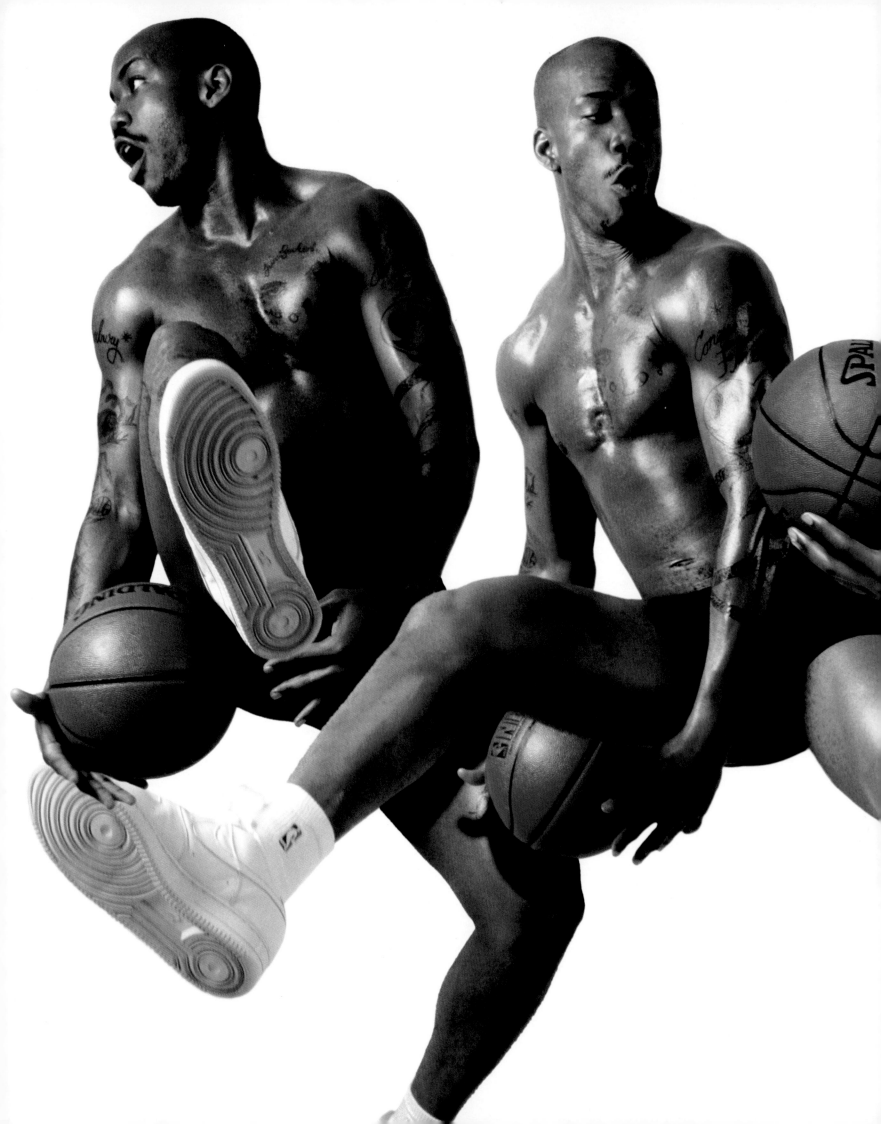

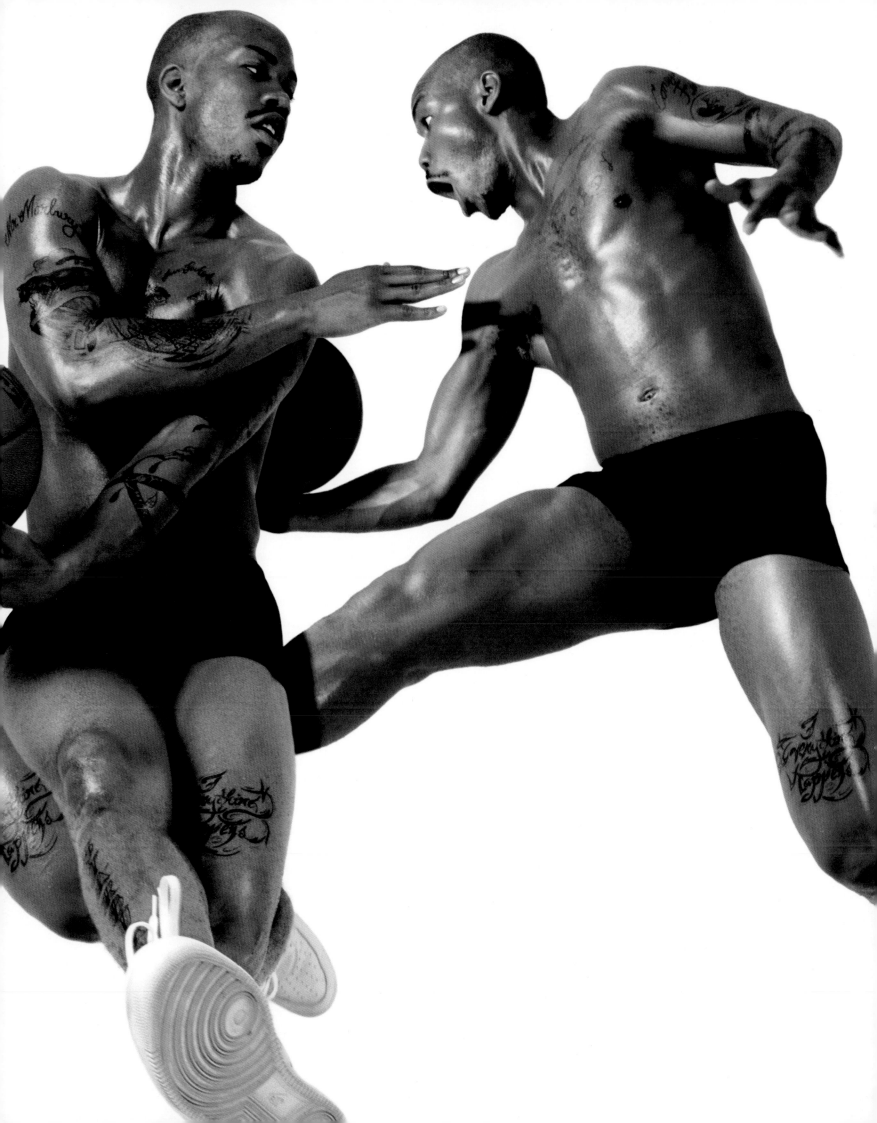

Adam Setliff
Discus

Preceding Pages:

Stephon Marbury
Basketball

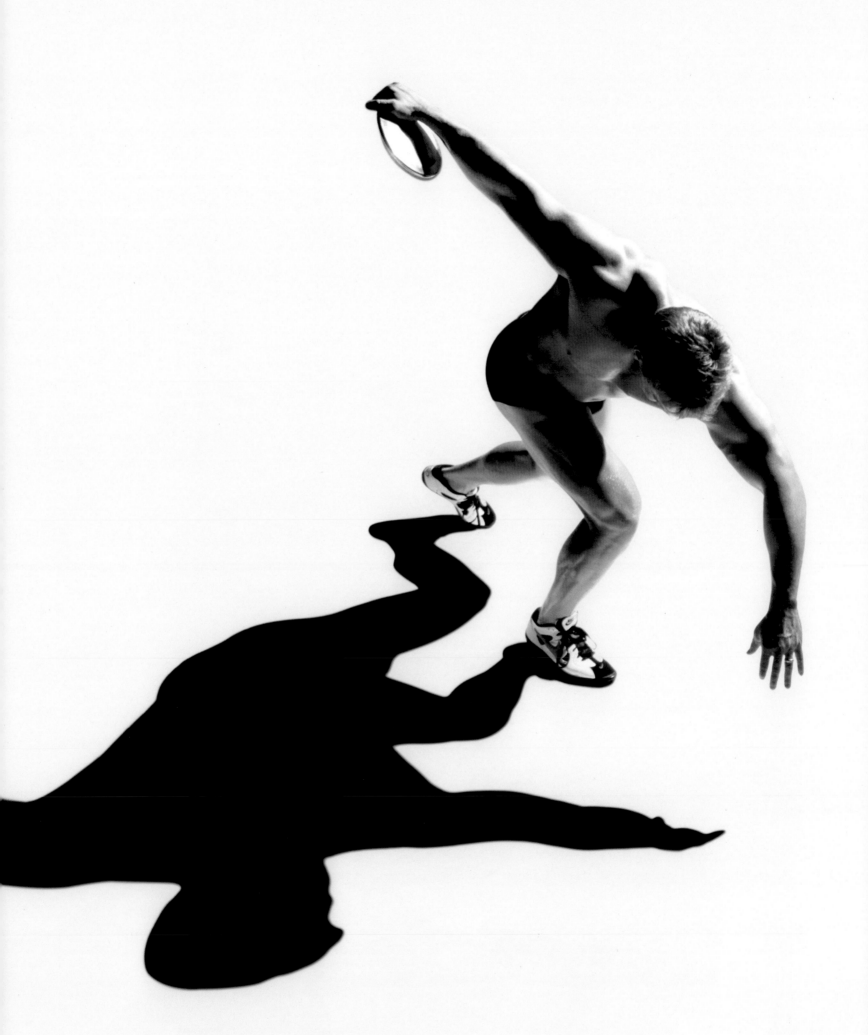

Wrigley Field
Chicago, Illinois

Afterword

Mind Over Muscle

I had the rare journalistic and, to be sure, humbling experience of learning first-hand what it was like to go head-to-head with a world-class champion athlete.

This was in the early 1970s and I was writing a basketball book with Walt ("Clyde") Frazier, then the all-pro guard for the world champion New York Knicks. I had been a high-school and small-college basketball player, had continued playing pickup basketball, and now was in my early 30s. At six feet even, I was about five inches shorter than Frazier and five years younger. Clyde and I played a number of one-on-one basketball games together in the course of the book collaboration.

Frazier's body was beautifully put together. He had the lean build perfect for a hoopster, and he had also discovered, before many athletes, that working with weights did not, as the general notion had it at the time, bunch up the muscles and constrict mobility. Instead, his well-defined muscularity made him stronger and even quicker.

The first game we played, to 11 baskets, saw me hit some outside shots. He won 11–7. But the second game was transforming. He had studied my game — I guess you'd have to say my so-called game — because when I tried to dribble, he took the ball away as easily as if I had handed it to him. It seemed also that he had grown about ten inches and his hands had become the size of scoop shovels. He won 11–0.

It was a demonstration of skill and will, a champion's bread and butter. You can't have one without the other. He wasn't going to let an amateur, or anyone else, get the better of him in his field, and he was going to succeed not only with body, but with brain as well. "Clyde," I said after the second game, "how did you do that?" "I watched you, saw how you played the game, and then reacted," he said. "Each player is different, but each player likes to stay with things he's comfortable with. I try to take them out of their comfort zone. I learned that everyone has a certain rhythm that he dribbles to."

As a sportswriter for more than 35 years, I have enjoyed observing and learning about the mental part of games. I've found that the best athletes are also the most disciplined, the most ferocious and even the most lustful about winning. They are the ones who demonstrate the most patience and determination to practice moves or techniques over and over again and they are brilliant in their endeavor. Someone once said that genius is the ability to take infinite pains, and this holds true for people who pitch and putt and pole-vault as well as those who look through microscopes. Champion athletes are usually as knowledgeable about the intricacies, complexities, and profundities in their arenas as are surgeons and scientists in theirs.

Joe Torre, manager of the New York Yankees, said before a World Series game against the Atlanta Braves that Greg Maddux, Atlanta's great starting pitcher, "is an artist. Every time you swing at one of his pitches, it's a ball, and when you don't, it's a strike."

There is nothing outwardly noteworthy about Maddux, perhaps the best pitcher of our time. He has the demeanor of a bookkeeper. He is in his mid-30s, stands 6 feet tall, and weighs about 175 pounds. He wears glasses off the field, has a physique that would not draw attention at the beach, rarely shows emotion, and frustrates batters to such a degree that they nearly weep.

His fastball is generally clocked in the rather pedestrian mid-to-upper 80s, and he uses breaking balls sparingly. "I found that velocity can be misleading," he once told me. "I rely on location of my fastball and on change-ups. If you stand by a highway and watch cars go by, you can't really tell which one is going 80 miles an hour and which is going 90. And if you throw real hard every pitch, hitters will eventually time them."

In a word, Maddux exemplifies what is meant when a manager says that one of his mound operatives "has gone from a thrower to a pitcher." A "thrower" relies strictly on innate ability, while a "pitcher" has learned that combining thinking with a hurling arsenal makes the champion. A supreme example is Sandy Koufax, who had six mediocre years and six fabulous years — the latter coming when he understood not to throw as hard as he could and to finesse his pitches just a little more.

I once asked Ted Williams, one of baseball's greatest hitters, if it's true that, as many people had said, he was as good as he was at the plate because of his extraordinary reflexes and eyesight (it was said he could read a license plate a block away). In his typically forthright fashion, Williams replied, "Bullshit. It was all trial and fucking error, trial and fucking error, trial and fucking error, trial and fucking error."

One of the most exciting and intriguing prize fights I've ever seen was the middleweight championship bout in 1987 between the champion, Marvelous Marvin Hagler, and the former champion, Sugar Ray Leonard. For all 12 rounds, Hagler doggedly pursued the challenger, who danced, dodged, and twirled — and when Hagler finally located him, he discovered what appeared to be a dozen or so red boxing gloves working his bald head and spare abdomen. Leonard won the decision. "It was," said the long-time trainer Ray Arcel, "a case of brains over brawn. Leonard had too much mental energy for Marvin. He outsmarted him and out-punched him."

Arthur Ashe Stadium
Flushing Meadows, New York

I was reminded of the famous "Rope-a-Dope" heavyweight championship fight in Zaire in 1974, in which the underdog, an aging Ali, beat the stronger and younger George Foreman by laying back on the ropes, covering his head and body with his arms, and allowing Foreman to punch harmlessly and wear himself out. At that point, Ali knocked Foreman out.

The 1975 Wimbledon men's final between Arthur Ashe and defending champion Jimmy Connors is another example. Connors was clearly the superior athlete at this time, and a 10–1 favorite. Ashe, slick and cerebral, had to devise a strategy, and he decided that he couldn't out-hit or out-run Connors, but if he could tire Connors out, he would have a chance. So with an attack that featured changing pace and spins, and startling Connors with a sliced serve wide to the two-fisted backhand, Ashe won, 6–1, 6–1, 5–7, 6–4.

In June of 1987, a huge controversy erupted in sports. After the Celtics and their star, Larry Bird, had beaten the Pistons in a playoff game, Isaiah Thomas, the star of the Pistons, said after the game that "If Larry Bird was black, he'd be just another good guy." The next day, Thomas told me, "What I was referring to was not so much Larry Bird, but the perpetuation of stereotypes about blacks. All we do is run and jump. We never practice or give a thought to how we play. It's like we came dribbling out of our mothers' wombs. You hear it on television, you see it in the papers. The announcer says at a substitution, 'Here come the athletes into the game.' And they're black, never white. Magic Johnson and Michael Jordan and me, for example, we're playing on God-given talent, like we're lions and tigers, animals who run around wild in a jungle, while Larry's success is due to intelligence and hard work. The fact is, Bird is a great athlete, who uses his intelligence. Just like Magic and Michael."

If ever there has been a more extraordinary athlete than the Olympic discus thrower Al Oerter, I have not heard of him, or her. Oerter won four Olympic gold medals in four consecutive Olympics, over a period of 12 years, the first Olympic athlete to win four gold medals in the same event. No Olympic athlete had ever matched Oerter's combination of achievement and longevity.

And in each Olympics, to compound the accomplishment, he was not favored to win, being neither the American champion nor the world record holder. But in each Olympics, he used his abilities, poise, ever-improving technique, and capacity to unnerve his opponents to achieve his goal.

In the Melbourne Olympics in 1956, the 19-year-old, 6'4", 235 lbs. Oerter was practicing with the favorite and world record holder Fortune Gordien. Oerter began to hurry his throws because he was aware of Gordien pacing about. "I got so shook up I finally threw one backwards," said Oerter. "It was an accident, but it whistled right past his ear and slammed into the net. It could have taken his head off. He was shaking. He didn't hurry me anymore after that." Gordien began to think more about his weird young opponent, and less about the task at hand, while Oerter took advantage of the "psyche" and gained in confidence. Part of the athletic endeavor, Oerter learned, was the psyching or "zonking," as he called it — trash-talking is the modern expression and outgrowth — that goes on in the pits, in all sports.

In Rome, in 1960, Oerter approached a tough Czech thrower and asked how Poland was. "Zonk! The guy was walking around like King Kong," recalled Oerter. "Now he was shrunk to size."

In Tokyo, in 1964, Oerter would tell one of his opponents in practice that he was throwing well and to keep throwing, hoping the guy would tire himself out. Meanwhile, Oerter watched from a prone position on the grass. When another opponent bragged that he had just thrown 225 feet, Oerter with feigned comradely interest would insist on seeing him do it again. "If he didn't," said Oerter, "it was all downhill for him from then on."

In 1968, in Mexico City, Jay Silvester, the American champion, world record holder and the Olympic favorite, showed Oerter a good-luck telegram from Utah. "It's signed by almost everybody in my hometown of Orem," said Silvester. "All 400 of them." "Four hundred?" said Oerter. "Can't be much of a town." Zonk.

In the finals, Oerter, now 31 and weighing 285 after a regimen of weight-lifting and having changed his technique by throwing more with his body, uncorked the best throw of his life — 212 feet 6 inches, five feet farther than he'd ever thrown before. Silvester, demoralized, fouled three times in a row, and finished fifth.

Oerter, like all great champions, rose to the occasion with the indispensable amalgam of the physical and the mental. And like all great champions, he did what had to be done to win, from hours of toil in practice; to enhancing strength, mobility, and endurance; to developing new methods when needed; to assiduously studying his opponent and applying, when called for, the unexpected but deft, straight-as-an-arrow zonk.

Ira Berkow

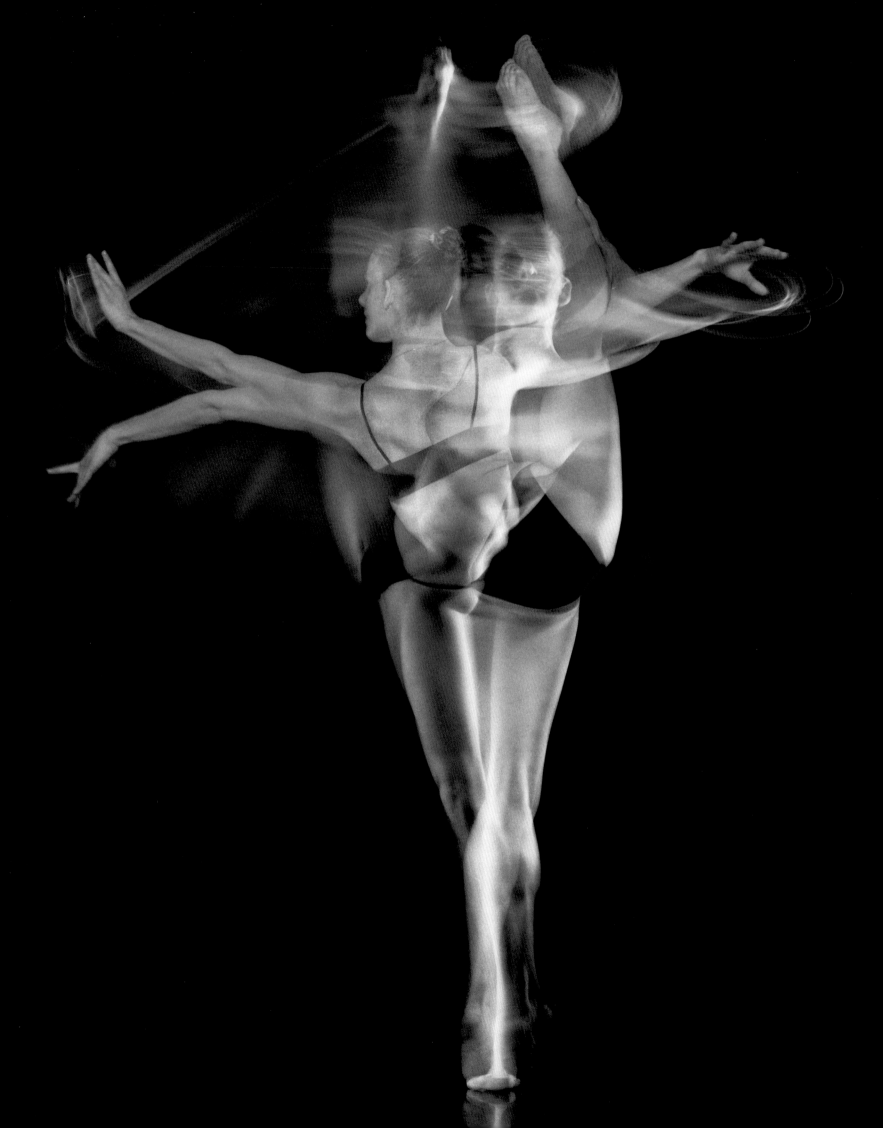

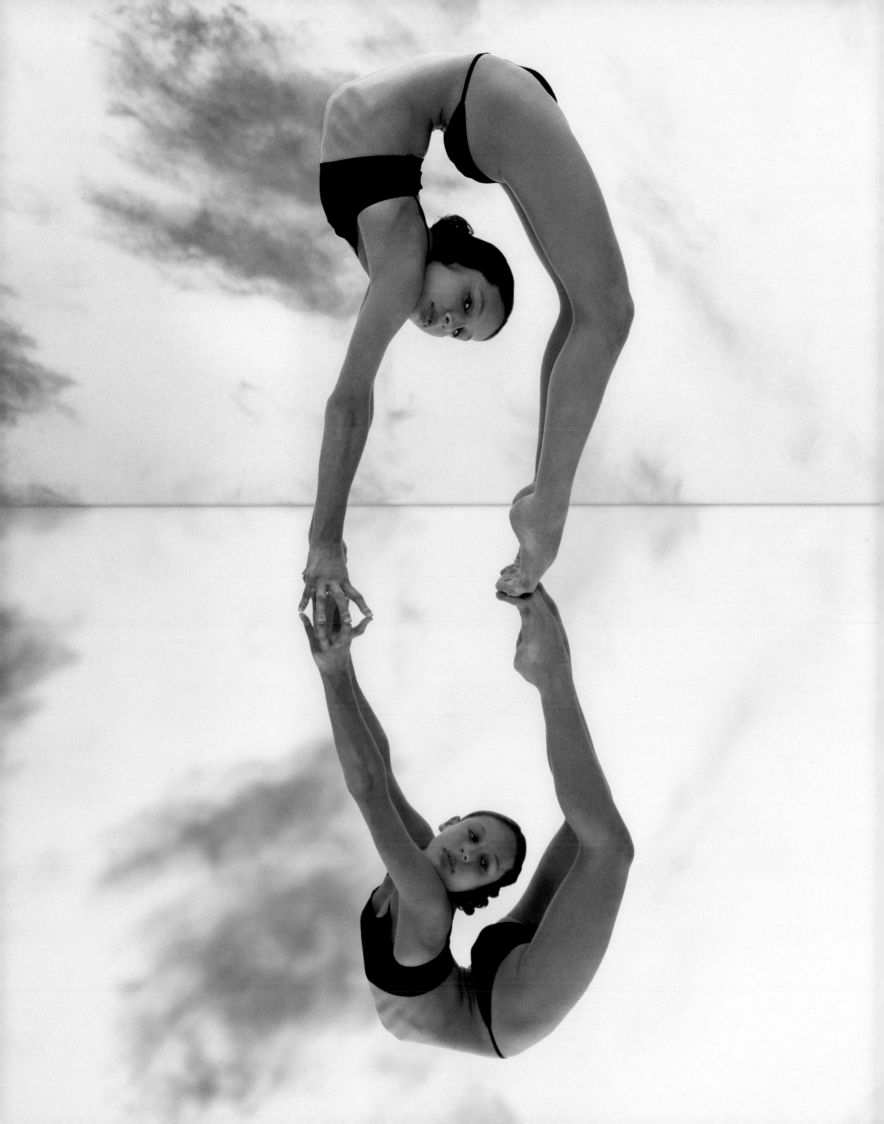

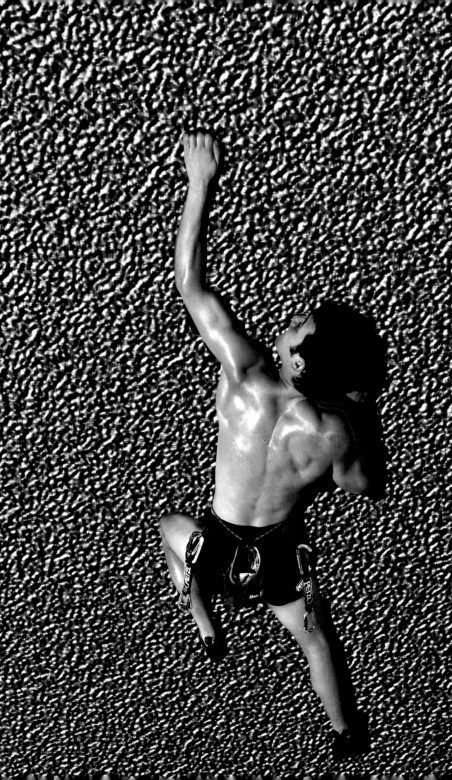

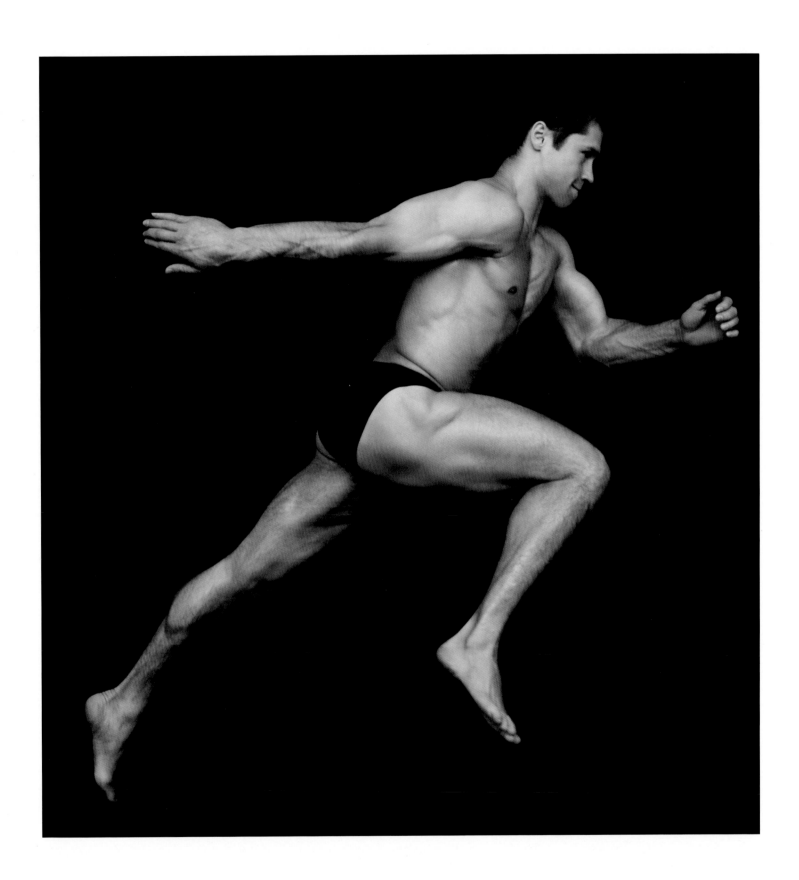

Vadim Vinokur
Rock Climbing

Alexei Nemov
Gymnastics

Jessica Howard
Rhythmic Gymnastics

Olga Karmansky
Rhythmic Gymnastics

Biographies

Amy Acuff 6' 2", 145 lbs. (b. July 14, 1975 in Port Arthur, Texas).
High jumper with a personal best of 6' 6.75". She is a two-time Olympian,
four-time U.S. champion, and five-time NCAA champion. At the end of her high
school career, she held national high school records for freshman, sophomore,
junior, and senior levels.
 Photographed on March 31, 2000 and January 12, 2001 in Los Angeles, California

Erin Aldrich 6' 1", 143 lbs. (b. December 27, 1977 in Dallas, Texas).
High jumper with a personal best of 6' 5.5". She was a member of the Sydney
2000 Olympic Track and Field Team. As a high jumper, she won four NCAA
championships and is co-holder of the national collegiate indoor record of
6' 5.5". A seven-time track and field All-American and First team American
Volleyball Coaches Association (AVCA) All-American, she was the 1999–2000
Big 12 Conference Female Athlete of the Year. She is also currently playing with
the USA Volleyball National Team.
 Photographed on June 24, 2001 in Eugene, Oregon

Ray Allen 6' 5", 205 lbs. (b. July 20, 1975 in Merced, California).
Shooting guard with the Milwaukee Bucks basketball team. He averaged 13.4
points per game in his first year with the Bucks and made the NBA All-Rookie
Team. In the 1999–2000 season, he averaged 22.1 points per game, his career
high. In 2000, he was a member of the NBA All-Star Team and a member of the
gold medal-winning U.S. team in the 2000 Olympics in Sydney.
 Photographed on August 27, 2000 in Maui, Hawaii

Jason Allison 6' 3", 223 lbs. (b. May 29, 1975 in North York, Ontario, Canada).
Center for the Los Angeles Kings National Hockey League team. In the 1997–
1998 season he was his team's leader in goals (33), assists (50) and points (83),
ninth place in NHL. He led the Boston Bruins to the playoffs that season. In the
1998 and 1999 seasons, he led the Bruins in scoring. In 2000–2001, as the Bruins'
team captain, he scored 59 assists, 95 points, three short-handed goals and six
game-winning goals. In February 2001, he played in the NHL All-Star Game.
 Photographed on August 14, 2001 in New York, New York

Olanda Anderson 6' 2", 178 lbs. (b. November 16, 1972 in Sumter, South
Carolina). Light-heavyweight boxer, 2000 Olympian, two-time U.S. champion,
and five-time Armed Forces champion. He joined the Army in 1992 and
began boxing the following year as a member of the U.S. Army World Class
Athlete Program.
 Photographed July 26, 2000 at the Olympic Training Center, Colorado Springs

Charles Austin 6' 0.5", 170 lbs. (b. December 19, 1967 in Bay City, Texas).
High jumper with a personal best of 7' 10.5"— the American record as of 2001.
He is a three-time Olympian, winning the gold medal in 1996 with an Olympic
record of 7'10" at Atlanta; he's a two-time world champion, a World Cup
champion, and a six-time U.S. Outdoor champion with consecutive victories
from 1995 through 2000. While at Southwest Texas State, he won the NCAA
championship in 1990.
 Photographed February 3, 2000 in New York, New York

Lloy Ball 6' 8", 258 lbs. (b. February 17, 1972 in Ft. Wayne, Indiana).
Volleyball player who was named Best Setter at the 2000 World League and the
America Cup. Ball came to the U.S. National Team in 1994 after graduating from
Indiana-Purdue, Fort Wayne, where he finished with school records for career
assists, block assists and service aces. He helped the National Team win a silver
medal at the 1995 Pan American Games and led the team to a second-place
finish at the1999 Americas' Cup. He was a member of the 1996 Olympic Team
and captain of the 2000 Olympic Team.
 Photographed on August 1, 2000 at the Olympic Training Center in Colorado

Aliane Baquerot 5' 6", 112 lbs. (b. November 23, 1978 in New York, New York).
Rhythmic gymnast. As a member of the U. S. Rhythmic Gymnastic National team,

she competed in the 1994 and 1996 World Championships. The team finished
second in the Pan American Games of 1995 and ninth in the 1996 Olympics.
Since then she has appeared in *Saturday Night Fever* on Broadway and is currently
on tour with the musical *Contact*.
 Photographed on January 19, 2001 in New York, New York

Rondé Barber 5' 10", 184 lbs. (b. April 7, 1975 in Roanoke, Virginia).
Defensive corner back with the Tampa Bay Buccaneers football team. In his first
four years with the Buccaneers, Rondé recorded 213 tackles, nine sacks, and six
interceptions returned for 173 yards.
 Photographed with his twin, Tiki, on June 15, 2001 in New York, New York

Tiki Barber 5' 10", 200 lbs. (b. April 7, 1975 in Roanoke, Virginia).
Running back with the New York Giants football team. In his first four years with
the Giants, Tiki had 1,941 yards rushing in 463 carries and 1,975 yards receiving
with seven touchdowns. In 1999, Barber set a Giants record for most receptions
by a running back in a season with 66 and broke that record in 2000 with 70
receptions. He holds the University of Virginia's all-time record with 651 carries
and 3,389 yards.
 Photographed on June 15, 2001 in New York, New York

Carrie E. Barton 5' 7", 135 lbs. (b. May 19, 1976 in Dallas, Texas).
Synchronized swimmer with the Santa Clara Aquamaids. She has competed on
the U.S. National Team since 1997, when she competed in all three synchronized
swimming events — solo, duet, and team — at the World Cup and was voted
Synchronized Swimming Athlete of the Year. She was part of the National Team
which won a silver medal at the 1998 Goodwill Games, bronze at the 1998
World Championships, and fifth place at the 2000 Olympics.
 Photographed on August 31, 2001 in Marin County, California

Cliff Bayer 6' 1", 170 lbs. (b. June 24, 1977 in New York, New York).
Fencer who competes in the foil event. In 1995, he became the first American
men's foil fencer to win the Junior "A" World Cup. In 1999, he won his first World
Cup event in senior competition and a silver medal in the Pan Am Games. In
2000, he won a second World Cup event and competed in the Sydney Olympics
finishing tenth, the best result of an American men's fencer since 1984.
 Photographed on May 25, 2000 and April 21, 2001 in New York, New York

Elena Berezhnaya / Anton Sikharulidze
Elena 5' 0", 92 lbs. (b. October 20, 1977 in Nevinnomyssk, Russia);
Anton 6' 0", 167 lbs. (b. October 25, 1976 in St. Petersburg, Russia).
Pairs skaters who began skating together in 1996. Together they were third at the
1997 European Championships, won the silver medal at the 1998 Olympics and
gold in the 1998 and 1999 World Championships. In the 2001 World Championships
they won the silver medal. They won the gold medal at the 2002 Olympics.
 Photographed on July 18, 2000 in New York, New York

Dain Blanton 6' 2", 205 lbs. (b. November 28, 1971 in Laguna Beach,
California). Beach volleyball player who, together with his partner, Eric Fonoimoana,
won the gold medal at the 2000 Olympics. In June of 1997 Blanton was the first
African-American to win a major beach volleyball tournament, the Hermosa Beach
Grand Slam. As a high school senior in 1990, Blanton was named the Orange
County Player of the Year, Most Valuable Player of the Pacific Coast League and
earned All-American honors at the Junior Olympics.
 Photographed on February 26, 2001 in Santa Monica, California

Christopher Bloch 5' 9", 150 lbs. (b. August 12, 1971 in Stockton, California).
Rock climber, six-time medal winner in speed climbing. From 1996 through
2001, he won four silver and two bronze medals at the ESPN X-Games.
He was U.S. national champion from 1995 through 1997 and North American
champion in 1996.
 Photographed on May 31, 2001 in Marin County, California

Ruthie Bolton-Holifield 5' 8", 150 lbs. (b. May 25, 1967 in McClain, Mississippi). Guard with the Sacramento Monarchs basketball team. She was a member of the U.S. Olympic teams that won gold medals in 1996 and 2000. She was named to the 1997 All-WNBA Team after leading the Monarchs in scoring, three-pointers, three-point percentage, and steals.

Photographed on August 31, 2000 in Honolulu, Hawaii

Stacey Bowers 5' 6", 130 lbs. (b. August 22, 1977 in Waco, Texas). Track and field athlete, specializing in the triple jump. She was ranked #1 in the United States in 1999, when she won the NCAA Outdoor Championships and the USA National Outdoor Championships.

Photographed on March 3, 2001 in Atlanta, Georgia

James Carter 5' 11", 185 lbs. (b. May 7, 1978 in Baltimore, Maryland). 400m hurdler with a personal best of 48.04 sec. recorded when he finished fourth at the 2000 Olympics. In 2001, he won the 400m at the indoor Millrose Games and was third in the 400m hurdles at the U.S. Outdoor National Championships.

Photographed on June 23, 2001 in Eugene, Oregon

Oscar Chaplin III 5' 9", 169.5 lbs. (b. February 22, 1980 in Savannah, Georgia). Weightlifter. Since 1998, he has won all national junior and senior championships in his class. In July 2000, he became the first U.S. lifter to win a gold medal at the World Junior Championships in the clean and jerk, setting an American record; he also won the silver medal in the snatch. His total of 342.5 kg was another American record. In 2001, he moved up to the 85-kg weight class and won bronze at the Goodwill Games, setting four American records in this class.

Photographed on August 1, 2000 at the Olympic Training Center, Colorado

Joseph Chebet 5' 4.5", 114 lbs. (b. August 23, 1970 in Kenya). Marathon runner who won the first two marathons he entered: Amsterdam in 1996 and Turin in 1997. He finished his next three marathons in second place. In 1999 he won the Boston Marathon and the New York City Marathon.

Photographed on November 2, 2000 in New York, New York

Kim Chizevsky 5' 8.5", 135 lbs. (b. April 23, 1968 in Mattoon, Illinois). She has been called "the best female bodybuilder of all time." A four-time Ms. Olympia, from 1996 through 1999, she has competed as a professional bodybuilder since 1992. After she had won her fourth Ms. Olympia title, she began to train for Fitness and Aerobic competitions. In her first 2001 Fitness International competition she finished sixth.

Photographed on May 17, 2001 in New York, New York

Kathy "Wild Cat" Collins 5' 5", 137 lbs. (b. March 23, 1971 at Fort Meade, Maryland). In 1997, she won the IFBA (International Female Boxers Association) Welterweight World Championship title and the IWBF (International Women's Boxing Federation) Junior Welterweight title. In 1998, she won the WIBF (Women's International Boxing Federation) Lightweight title and in 2000 the IBA (International Boxing Association — Women's Division) Junior Welterweight Championship, her fourth world title.

Photographed on August 15, 2001 in New York, New York

Shawn Crawford 5' 11", 165 lbs. (b. January 14, 1978 in Van Wyck, South Carolina). Sprinter who holds the American indoor record of 20.26 in the 200m distance. He is a two-time NCAA champion and the gold medal winner at the 2001 U.S. Outdoor Championships. He won the 200m in the 2001 World Indoor Championships, the Goodwill Games, and tied for third in the 2001 World Outdoor Championships.

Photographed on June 24, 2001 in Eugene, Oregon

Mark Crear 6' 1", 189 lbs. (b. October 2, 1968 in San Francisco, California). 110-meter hurdler with a personal best of 12.98. In 1995, 1998 and 1999, he was ranked #1 in the world by *Track & Field News*. In 1996, he broke his arm two weeks before he won the silver medal at the Atlanta Olympics. In 2000, he won a bronze medal at the Sydney Olympics. He was the 1992 NCAA Outdoor Champion and the 1994 and 1999 U. S. Outdoor National Champion, as well as a three-time Grand Prix Final winner.

Photographed on March 30, 2000 in Los Angeles, California

Inge de Bruijn 5' 11", 132 lbs. (b. August 24, 1973 in Barendrecht, The Netherlands). Swims freestyle and butterfly with world record times of 24.13 for 50m freestyle, 53.77 for 100m freestyle, 25.64 for 50m butterfly, and 56.61 for 100m butterfly. In 2000, before the Olympic Games, she set eight world records. At the Sydney Olympics, she won the gold medals in the 50m and 100m freestyle events, both in world record time, and the 100m butterfly, setting another world record. She was a member of the team which won the silver medal in the 4 × 100m freestyle relay. At the 2001 Long Course World Championships, she again won three events, the 50m and 100m freestyle and the 50m butterfly.

Photographed on October 21, 2001 in New York, New York

Carlos Delgado 6' 3", 225 lbs. (b. June 25, 1972 in Aguadilla, Puerto Rico). Plays first base for the Toronto Blue Jays baseball team. In 2000, he was an All-Star and led the league in total bases, doubles, extra-base hits and times on base. He was named the American League Hank Aaron Award winner as the league's best offensive player. In 2000, he was named by *The Sporting News* as the Major League Baseball Player of the Year and received the Silver Slugger Award.

Photographed on July 16, 2001 in New York, New York

Dede Demet Barry 5' 9", 135 lbs. (b. October 8, 1972 in Milwaukee, Wisconsin). Cyclist who specializes in road racing. She was a member of the U.S. national team from 1990 through 2000. She was national road cycling champion in 1991 and 1993 in team time trial races, and in 1996 and 1998 in time trial and the three-stage criterium race, that includes flat and climbing courses, as well as a time-trial. At the World Road Cycling Championships in 1993, she won a silver medal in the team time trial and in 1994 she won a bronze medal in the same team event. She also won a team time trial gold medal in the 1991 Pan American Games. She began cycling in 1987 as cross training for speed skating and was also a member of the U.S. speed-skating team from 1987 through 1991.

Photographed on June 5, 2000 in New York, New York

Stacy Dragila 5' 7.5", 140 lbs. (b. March 25, 1971 in Auburn, California). Pole vaulter with a personal best of 15' 9.25", a world record. Since 1997, she has equaled or broken the world record fifteen times. An eleven-time national champion, three-time world champion, she won the gold medal in the first Olympic pole vault competition for women in the 2000 Sydney Games. She also was Grand Prix Finals Champion in 2001.

Photographed on March 3, 2001 in Atlanta, Georgia

Deena Drossin 5' 4", 105 lbs. (b. February 14, 1973 in Waltham, Massachusetts). Long-distance runner with a personal best of 14:45.62 in the 5,000m and 31:51.05 in the 10,000m. As the fastest American woman in the 2001 New York City Marathon (her marathon debut at 2:26:58), she won the title of U.S. national woman's marathon champion. She won the 2000 U.S. Olympic Trials and the 2001 U.S. National Championship at 10,000m. She is a four-time U.S. 8,000m cross-country champion and the 1999 4,000m cross-country champion. She won the 10,000m gold medal at the 1997 World University Games. She is also an eight-time NCAA All-American.

Photographed November 7, 2001 in New York, New York

Jon Drummond 5' 9", 160 lbs . (b. September 9, 1968 in Philadelphia, Pennsylvania). 100/200m sprinter with personal bests of 9.92 and 20.03. He won a gold medal in the 4 × 100m relay at the 2000 Olympics and a silver medal in the 4 × 100m relay at the 1996 Olympics. He was on the winning 4 × 100m relay team in the World Championships of 1993 and 1999. In 1997, he was U.S. Outdoor 200m Champion and twice won the 60m at the U.S. Indoor Nationals.

Photographed on January 10, 2001 in Los Angeles, California

Donnie Edwards 6' 2", 227 lbs. (b. April 6, 1973 in San Diego, California). Linebacker for the Kansas City Chiefs. In his first career start in 1996, he had a team-high eight tackles, half a sack, and an interception. In 1998, 1999 and 2000 he led his team in tackles. In his first three pro seasons, he produced 301 tackles (194 solo). He had a career-best six sacks in the 1998 season and a career-best five interceptions in 1999.

Photographed on February 27, 2001 in Santa Monica, California

Patrik Elias 6' 1", 200 lbs. (b. April 13, 1976 in Trebic, Czech Republic). Left wing with the New Jersey Devils hockey team. After playing for the Poldi Kladno Club in the Czech Republic, he was drafted by New Jersey. In the 1997–1998 season, he was on the NHL All-Rookie Team; in 2000 he won the Stanley Cup with the Devils. He was an NHL All-Star in the 1999–2000 and 2000–2001 seasons.

Photographed on June 27, 2001 in New York, New York

Pan American Games. She also won a bronze medal with the team at the 1998 World Championships and placed fifth at the 2000 Olympics.

Photographed August 31, 2001 in Marin County, California

Eric Fonoimoana 6' 3", 205 lbs. (b. June 7, 1969 in Torrance, California). Beach volleyball player who, together with his partner Dain Blanton, won the gold medal at the 2000 Olympics. He won a gold medal at the 1989 U.S. Olympic Festival. From 1989 through 1992, he competed at the University of California, Santa Barbara; he was named Most Valuable Player for the UCSB men's volleyball team in 1991 and 1992. In 1992, he was named captain of the team and earned All-American honors.

Photographed February 26, 2001 in Santa Monica, California

Dallas Friday 5' 1", 113 lbs. (b. September 6, 1986 in Orlando, Florida). Professional wake-boarder who switched from gymnastics to wake-boarding and won the America's Cup title as well as silver at the X-Games in 2000 before she

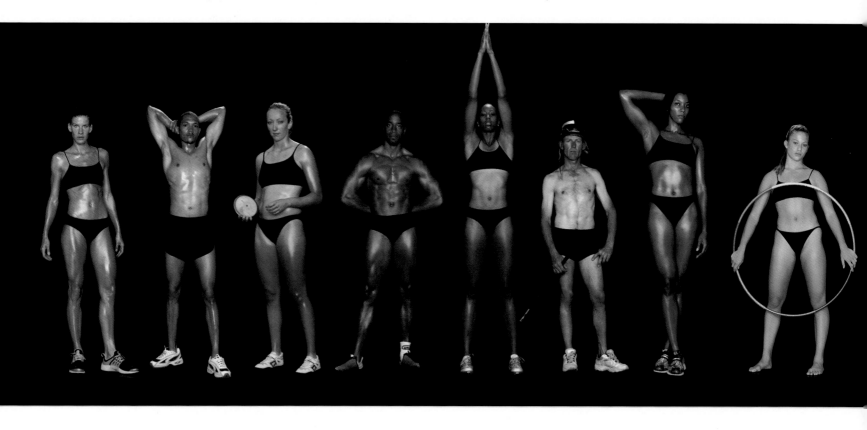

Dawn Ellerbe 6' 2", 240 lbs. (b. April 3, 1974 in Brooklyn, New York). Hammer thrower with a personal best of 231' 2", the American record. She also holds the world indoor record for the 20-pound weight throw. She is a six-time national indoor champion, a five-time national outdoor champion and a four-time NCAA champion. At the 2000 Sydney Games, where the women's hammer throw made its debut, Ellerbe finished seventh. She won her first U.S. hammer throw outdoor title in 1995.

Photographed June 22, 2001 in Eugene, Oregon

Bridget Finn 5' 5", 112 lbs. (b. February 25, 1974 in Buffalo, New York). Synchronized swimmer competing with the Santa Clara Aquamaids. She has been named to the U.S. National Team seven times. The Aquamaids team finished first at the 1998 and 1999 German Opens and the 1996 Swiss Open. With the U.S. National Team, she won silver medal at the 1998 Goodwill Games and the 1999

turned 14. In 2001, in her first year as a professional, she won a gold medal at the ESPN X-Games and the NBC Gravity Games in addition to six other first-place finishes; she also won the 2001 World Cup, and was ranked #1 woman in the world in wake-boarding

Photographed May 31, 2001 in Marin County, California

Jeff Garcia 6' 1", 195 lbs. (b. February 24, 1970 in Gilroy, California). Quarterback, San Francisco 49ers football team. In 2000, he threw 4,278 yards, a team record (breaking the records of Joe Montana and Steve Young). He had a streak of 150 passes without interception. He was named to the Pro Bowl for the 2000–2001 season as the second highest rated quarterback in the NFL that year. Prior to joining the 49ers in 1999, he played in the Canadian Football League and led the Calgary Stampeders to the 1998 Grey Cup Championship and won the Most Valuable Player award. He finished his Canadian Football League career with

Stacy Sykora	Seneca Lassiter	Suzy Powell	Jon Drummond	Donica Merriman	Ron Warren Jr.	Danielle Scott	Jacquelyn Jampolsky
Volleyball	Running (1500m)	Discus	Sprint (100m, 200m)	Hurdles & Sprint	Jockey	Basketball	Rhythmic Gymnastics
5' 10", 135 lbs.	5' 8", 132 lbs.	5' 11" 170 lbs.	5' 9" 160 lbs.	5' 10.5" 135 lbs.	5' 4", 115 lbs.	6' 2", 185 lbs.	5' 6", 110 lbs.

16,449 passing yards and 111 touchdowns. In college, at San Jose State, he ranked first in the school's history with 7,274 yards of total offense and was an All-American.

Photographed on June 1, 2001 in Redwood City, California

Rulon Gardner 6' 2", 286 lbs. (b. August 16, 1971 in Afton, Wyoming). Wrestler who stunned the world when he defeated Alexandr Karelin of Russia in the 2000 Sydney Olympics for the gold medal. He won the gold medal at the 2001 Greco-Roman World Wrestling Championships. He was U.S. national Greco-Roman champion four times, and the Greco-Roman champion twice at the Pan American Games. He was U.S. national heavyweight Greco-Roman champion in 2000 and 2001. In 2001, he won the ESPY Award for Male U.S. Olympic Athlete, the James E. Sullivan Amateur Athlete of the Year, the USOC Sportsman of the Year, the Jesse Owens Award and was the Wyoming Sports Hall of Fame Athlete of the Year.

Photographed October 8, 2000 in New York, New York

by a tight end with seventy-six. He bested his own record in 2000 with ninety-three receptions.

Photographed January 12, 2001 in Los Angeles, California

Johnny Gray 6' 4", 175 lbs. (b. June 19, 1960 in Los Angeles, California). 800m runner who holds the American record at 1:42.60, set in 1985. He is the American indoor record holder at 1:45.00. Gray is a four-time Olympian who competed in the Games between 1984 and 1996. He won a bronze medal in 1992 and the gold medal at the 1999 Pan American Games; he is a seven-time outdoor national champion and a three-time Olympic Trials champion. In 2000, at age 39, he won the 800m at the Millrose Games in New York.

Photographed February 3, 2000 in New York, New York

Breaux Greer 6' 2", 225 lbs. (b. October 19, 1976 in Houston, Texas). Javelin thrower with a personal best of 285' 5". He won at the U.S. Olympic Trials

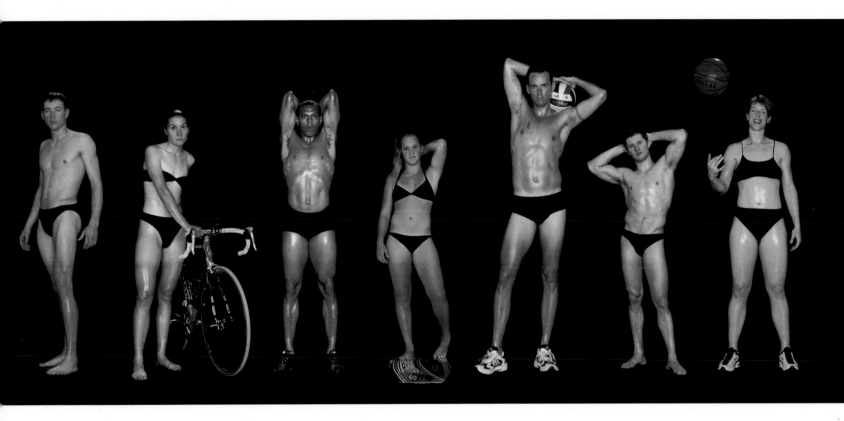

Tobey Gifford 5' 3", 118 lbs. (b. October 23, 1963 in Fort Dix, New Jersey). Sport aerobic competitor who since 1995 has won the U.S. National Aerobic Championships three times, and placed second twice and third once. At the World Aerobic Championships she finished sixth in 1997 and fourth in 1998. She finished 6th at the 2001 Suzuki World Cup.

Photographed February 9, 2001 in New York, New York

Tony Gonzalez 6' 4", 248 lbs. (b. February 27, 1976 in Torrance, California). Tight end for the Kansas City Chiefs. He was a first-round pick, 13th overall, in the 1997 NFL draft. In 1996 while at University of California, Berkeley, he was named to *The Sporting News* College All-America first team. He also played basketball for UCB, averaging seventeen points during his final year of college, leading the Bears to the Sweet Sixteen of the NCAA Tournament. He played in the Pro Bowls of 1999 and 2000. In 1999, he set the Chiefs' single-season record for receptions

in 2000, making the Olympic team. He placed 12th at the Sydney Olympics. In 2001 he finished fourth in the World Championships. In 2000 and 2001, he was ranked #1 in the U.S.

Photographed June 22, 2001 in Eugene, Oregon

Jennifer Gutierrez 5' 3", 115 lbs. (b. April 28, 1967 in San Antonio, Texas). Triathlete who is ranked 12th in the world. In the 2000 Olympic Games, she led the bicycle stage and finished 13th. She finished third in 2000 World Cup in Toronto. She was the first U.S. finisher at the 1999 World Championships, placing seventh. In the Pan American Games of 1999, she was the first U.S. finisher and fourth overall. Gutierrez won Sportswoman of Colorado awards in 1999 and 2000, and Latina Sportswoman of the Year 2000.

Photographed July 25, 2000 at the Olympic Training Center, Colorado

Nathan Leeper	Dede Demet-Barry	James Carter	Dallas Friday	Lloy Ball	Alexei Nemov	Katie Smith
High Jump	Cycling	Hurdles (400m)	Wake Boarding	Volleyball	Gymnastics	Basketball
6' 2", 180 lbs.	5' 9" 135 lbs.	5' 11" 185 lbs.	5' 1" 113 lbs.	6' 8" 258 lbs.	5' 4" 141 lbs.	5' 11" 173 lbs.

Gary Hall, Jr. 6' 6", 185 lbs. (b. September 26, 1974 in Paradise Valley, Arizona). Freestyle swimmer who won a total of eight medals in the 1996 and 2000 Olympic Games and a total of six medals in the 1994 and 1998 World Championships. In the 50m freestyle, the event in which he won a gold medal at the 2000 Olympics, he holds the U.S. record of 21.76, also the second-fastest time in history. Between 1994 and 1999, he won four U.S. national swimming titles.

Photographed January 4, 2001 in Marin County, California

Shane Hamman 5' 9", 370 lbs. (b. June 20, 1972 in Mustang, Oklahoma). Weightlifter in the super-heavyweight (231+ lbs.) class. He holds all the American men's records for his weight class. A five-time U.S. national champion from 1997 to 2001, he was also the Pan American Games champion in 1999. At the 2000 Olympic Games in Sydney, he broke his own national records in the snatch and total lift by lifting 429.75 lbs. and 925.75 lbs. respectively.

Photographed August 1, 2000 at the Olympic Training Center, Colorado

Dominik Hasek 6' 1", 174 lbs. (b. January 29, 1965 in Pardubice, Czech Republic). Ice hockey goalie with the Detroit Red Wings. He won the Vezina Trophy an unprecedented six times and the Hart Memorial Trophy, as the National Hockey League's Most Valuable Player, twice. He has participated in multiple All-Star Games for the Eastern Conference and the World All-Stars. He won a gold medal with his team from the Czech Republic at the 1998 Winter Olympic Games in Nagano, Japan and was named the tournament's "Outstanding Goaltender," allowing only five goals. From 1992–2001, Hasek played for the Buffalo Sabres of the National Hockey League; he led the league for six seasons with a .937 save percentage.

Photographed June 7, 2000 in New York, New York

Cheryl Haworth 5' 9", 297 lbs. (b. March 19, 1983 in Savannah, Georgia). Weightlifter in the 75+ kg. (over 165.25 lbs.) weight class. She is a four-time national champion. In 1999 at the World Championships and in 2000 at the Sydney Olympic Games, she won the bronze medal. In 2001, she won three gold medals at the Junior World Championships and three gold medals at the Goodwill Games. She holds every U.S. record in her weight class: 127.5 kg in the snatch, 155 kg in the clean and jerk, 282.5 kg in the total. Haworth began lifting when she was 13 years old. Despite being in the women's super heavyweight category, she is runs the 40-yard dash in 5.5 seconds, and has a 30" vertical leap.

Photographed March 2, 2001 in Atlanta, Georgia

Allan Houston 6' 6", 200 lbs. (b. April 20, 1971 in Louisville, Kentucky). Guard for the New York Knicks basketball team. He was chosen in the first round by the Detroit Pistons in the 1993 draft, and joined the Knicks for the 1996–1997 season. In 2000, he was named to the NBA All-Star team and he competed in the Summer Olympics in Sydney with the gold medal-winning United States team.

Photographed June 13, 2001 in Purchase, New York

Jessica Howard 5' 7", 100 lbs. (b. February 4, 1984 in Jacksonville, Florida). Rhythmic gymnast who, in 2001, won her third consecutive U.S. National Championship after winning her first national title at the age of 15 in 1999. At the 1999 Pan American Games, she won the silver medal in the all-around. She won silver medals with the team and in the individual all-around at the 2000 Senior Pacific Alliance Games. She was third all-around in the 2001 Shishmanova Cup in Bulgaria.

Photographed on November 26, 2001 in New York, New York

Jacquelyn Jampolsky 5' 6", 110 lbs. (b. August 4, 1986 in San Francisco, California). Rhythmic gymnast who was on the U.S. national team in 1999 and 2000. She won a gold medal with the team in the 2000 Junior International Pan American Games and was fourth in individual competition.

Photographed August 29, 2001 in Marin County, California

Allen Johnson 5' 10", 165 lbs. (b. March 1, 1971 in Washington, D.C.). 110m hurdler who holds the American record of 12.92, set in 1996. He won the gold medal at the 1996 Olympics and the World Outdoor Championships in 1995, 1997, and 2001. He won the gold medal at the 2001 Goodwill Games. He has won at the U.S. Outdoor National Championships four times between 1995 and 2001. In 1996, 1997, and 2001, he was ranked #1 in the world.

Photographed March 4, 2001 in New York, New York

Joe Johnson 6' 4", 270 lbs. (b. July 11, 1972 in Cleveland, Ohio). Defensive end for the New Orleans Saints football team. He attended Louisville University and was a first-round pick by the Saints in 1994. He had a career high 12 sacks in 2000 and played in the 2001 Pro Bowl.

Photographed July 17, 2001 in New York, New York

John Kagwe 5' 6", 115 lbs. (b. January 9, 1969 in Kenya). Marathon runner with a personal best of 2:08:12, with which he won the 1997 New York City Marathon. Between 1995 and 2001 he won five marathons, including two successive victories in New York City. In 2001, he won the Suzuki Rock 'n' Roll Marathon in San Diego.

Photographed November 2, 2000 in New York, New York

King Kamali 5' 10", 248 lbs. (b. March 29, 1972 in Tehran, Iran). Bodybuilder who was NPC (National Physique Committee) Heavyweight national champion in 1999. He joined the professional IFBB (International Federation of Body Builders) early in 2000.

Photographed January 30, 2001 in New York, New York

Olga Karmansky 5' 1", 85 lbs. (b. July 1, 1986 in the Ukraine). Rhythmic gymnast who won the silver medal in the all-around in 2001 in the U.S. National Championships. She placed first in the ball event, second in rope and clubs, and third in hoop. In 2001, she won medals in the international Coupe D'Opale at Calais, France with a second place in rope, a third in ball and a third in the all-around.

Photographed November 12, 2001 in New York, New York

Kasey Keller 6' 2", 180 lbs. (b. November 29, 1969 in Lacey, Washington). Goalkeeper with Tottenham Hotspur soccer team of the English Premier League. He was the goalie for the U. S. National Team with a 6-1-0 record in 1996; he also played with the U.S. Olympic team in 1996. He was named Male Athlete of the Year for 1997 by the U.S. Soccer Federation.

Photographed June 22, 2001 in Eugene, Oregon

Bob Kennedy 6' 0", 146 lbs. (b. August 18, 1970 in Bloomington, Indiana). Long-distance runner who competes in the 3,000m, 5,000m, and 10,000m distances specializing in the 5,000m. He holds the American record in the 3,000m with a time of 7:30.84 and in the 5,000m at 12:58.2; he is the only American ever to run the 5,000m in less than 13 minutes. He is a two-time Olympian who finished 12th in the 5,000m in 1992 and 6th in 1996. He is a four-time U.S. national 5,000m champion. While at Indiana University, he won twenty Big Ten titles.

Photographed June 23, 2001 in Eugene, Oregon

Khalid Khannouchi 5' 5", 125 lbs. (b. January 1, 1971 in Meknes, Morocco). Marathon runner who holds the world record of 2:05:38, set at the 2002 London Marathon. He also held the previous world record of 2:05.42, set at the 1999 Chicago Marathon. Khannouchi immigrated to the United States in 1993 and became a U.S. citizen in May 2000. He has also won the 1997 and 2000 Chicago Marathons.

Photographed July 1, 2000 in New York, New York

Svetlana Khorkina 5' 5", 105 lbs. (b. January 19, 1979 in Belgorod, Russia). Gymnast who won a total of five medals in the 1996 and 2000 Olympics: two gold and three silver. She is a six-time gold medal winner at the World Championships (1995, 1996, 1997, 1999 and 2001) including a second all-around

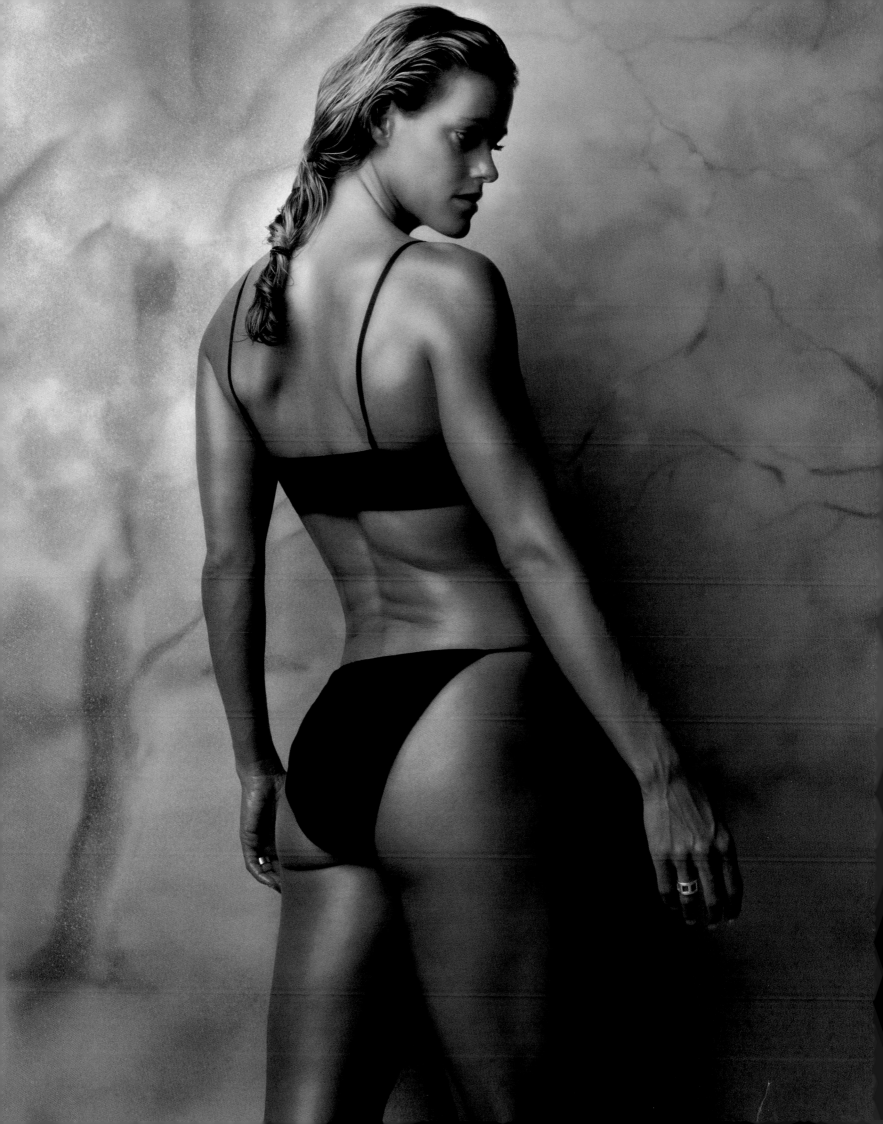

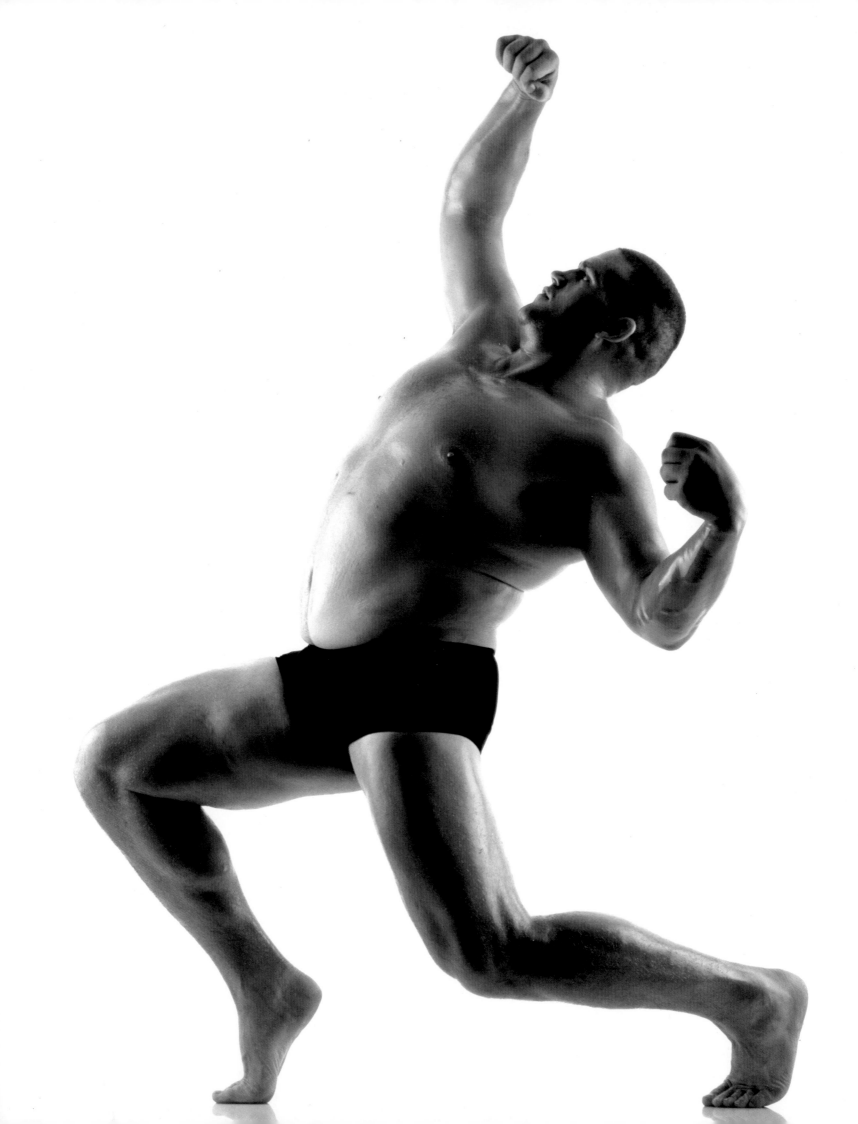

world championship title with gold medals on the uneven bars and the vault in 2001. She also won a gold and two silver medals in the 2001 Goodwill Games.

Photographed on November 21, 2000 on Long Island, New York

Jason Kidd 6' 4", 212 lbs. (b. March 23, 1973 in San Francisco, California). Point guard with the New Jersey Nets basketball team. In 1994 he was selected second overall in the NBA draft, chosen by the Dallas Mavericks. He shared Rookie of the Year honors in 1995 with the Pistons' Grant Hill, and was an All-Star in 1996. He was named to the NBA First Team and NBA Defensive First Team in 1999, 2000, and 2001. He was the NBA Assist leader in 1999, 2000 and 2001. He was a member of the U.S. Olympic Team that won a gold medal in the 2000 Games.

Photographed August 28, 2000 in Maui, Hawaii

Cary Kolat 5' 5", 138 lbs. (b. May 19, 1973 in Alabaster, Alabama). Freestyle wrestler in the 63 kg weight class. He won the Cadet World Championship in 1989 in the 55-kg weight class. He has won the World Cup in the 63-kg class three times and finished second in 2001. He is a three-time U.S. national champion, and the Goodwill Games champion of 1998. He won the gold medal at the Pan American Games in 1999 and 2000. He competed at the 2000 Olympic Games, finishing ninth.

Photographed July 27, 2000 at the Olympic Training Center, Colorado

Jeff Lacy 5' 11", 168 lbs. (b. May 12, 1977 in St. Petersburg, Florida). Super middleweight boxer. He finished sixth at the Sydney Olympics in 2000. He has an overall amateur record of 209–12. Lacy turned pro on January 13, 2001 and won his first six fights by knockout.

Photographed July 26, 2000 at the Olympic Training Center in Colorado

Alexi Lalas 6' 3", 195 lbs. (b. June 1, 1970 in Detroit, Michigan). Defender for the Los Angeles Galaxy soccer team and a four-time All-Star. In January of 2001, after two years in retirement, he played with the Galaxy which won the Football Confederation Champions Cup. He played on the 1992 and 1996 U.S. Olympic teams and on Team USA in the 1994 and 1998 World Cups. In 1995, he won the U.S. Soccer Athlete of the Year Award. In 1994, he became the first American to play in Italy's famed Serie A soccer league.

Photographed February 12, 2000 in New York, New York
and February 28, 2001 in Los Angeles, California

Barry Larkin 6' 0", 185 lbs. (b. April 28, 1964 in Cincinnati, Ohio). Shortstop with the Cincinnati Reds baseball team. In his 16 years with Cincinnati, Larkin has been an All-Star 11 times. He won the Gold Glove three times, the Silver Slugger Award nine times, and the Roberto Clemente Award. In 1995, he was voted Most Valuable Player. In 2000, he hit .300 for the ninth time in his career. In 1996 he was the first shortstop in Major League Baseball history to join the exclusive 30/30 club with 33 home runs and 36 stolen bases. He was on the U.S. Olympic team that won the silver medal in 1984.

Photographed March 25, 2000 in Sarasota, Florida

Seneca Lassiter 5' 8", 132 lbs. (b. March 12, 1977 in Williamsburg, Virginia). 1,500m runner with a personal best of 3:33.72. In 2001, he ran the fastest American indoor mile in 16 years with a time of 3:54.21 at the Tyson Invitational in Fayetteville, Arkansas. He won the U.S. Outdoor Championships in 1997 and NCAA Outdoor Championship in 1997, and 1998, competing for the University of Arkansas.

Photographed June 23, 2001 at Eugene, Oregon

Nathan Leeper 6' 2", 180 lbs. (b. June 13, 1977 in Greensburg, Kansas). High jumper with a personal best of 7' 8.5". In 1998 he was the NCAA outdoor champion. In 2001 he was U.S. indoor and outdoor champion; he placed fourth in the World Indoor Championships and sixth in the Goodwill Games. He finished eleventh in the 2000 Olympics.

Photographed February 3, 2001 in New York, New York

Lisa Leslie 6' 5", 170 lbs. (b. September 7, 1972 in Hawthorn, California). Center/forward with the Los Angeles Sparks basketball team. In an outstanding 2001 season, she earned three Most Valuable Player (MVP) awards. She led her team to their first WNBA Championship, averaging 19.5 points per game. She also won All-WNBA First Team for the third time and was named Top Sportswoman of the Year by the Women's Sports Foundation. She was MVP in the 1999 WNBA All-Star Game. She was the leading scorer as center of the U.S. Olympic teams that won the gold medal in 1996 and 2000. In 1998, she was named USA Basketball Female Athlete of the Year.

Photographed January 10, 2001 in Los Angeles, California

Brian Lewis 5' 8", 158 lbs. (b. December 5, 1974 in Sacramento, California). 100m and 200m sprinter with a personal best of 10.00 and 20.26 respectively. He won two gold medals as a member of the U.S. 4 x 100m relay teams, running the third leg, in the 1999 World Championships and the 2000 Olympics. He was runner-up in the 100m at the 1998 and 1999 U.S. National Outdoor Championships and runner-up in the 200m at the U.S. National Indoor Championships in 2000.

Photographed July 7, 2000 in New York, New York

Tara Lipinski 5'1", 95 lbs. (b. June 10, 1982 in Philadelphia, Pennsylvania). Professional figure skater who currently stars in the annual 60-city U.S. Stars on Ice tour. At the age of 16, she won the gold medal in the 1998 Nagano, Japan Olympic Games, becoming the youngest figure skater ever to do so.

Photographed November 28, 2000 in New York, New York

Tegla Loroupe 4' 11", 82 lbs. (b. May 9, 1973 in Kenya). Long-distance runner, specializing in the marathon, with a personal best of 2:20:43, a world mark set in 1999. In 1994 and 1995 she won the New York City Marathon. She won the Rotterdam Marathon twice, in 1997 and 1998, the Berlin Marathon in 1999, and the London Marathon in 2000. In 1998, she won the gold medal in the 10,000m at the Goodwill Games.

Photographed November 2, 2000 in New York, New York

Kristina Lum 5' 3", 110 lbs. (b. October 18, 1976 in Santa Clara, California). Synchronized swimmer with the Santa Clara Aquamaids. She was on the 2000 Olympic team that finished fifth and was named United States Synchronized Swimming Athlete of the Year 2000. Between 1996 and 1999, she was United States team champion with the Aquamaids and in 1998 and 1999 national solo silver medalist. At the 1998 World Swimming Championships, she won bronze medals in the solo and the team competitions, and a silver medalist at the 1999 Pan American Games. In duet competition, Lum has a male partner, Bill May — they are the first and only mixed pair in the sport. They won the gold medal in the 1998 and 2000 national duet championships, and silver medals at the Goodwill Games of 1998, the French Open and Swiss Open in 1999.

Photographed August 31, 2001 in Marin County, California

Stephon Marbury 6' 2", 180 lbs. (b. February 20, 1977 in Brooklyn, New York). Guard for the Phoenix Suns basketball team. In 1996, his first year in the National Basketball League (NBA), he averaged 15.8 points per game, led all NBA rookies with 7.8 assists per game, and was a member of the All-Rookie team. He was an NBA All-Star in 2001.

Photographed May 4, 2001 in New York, New York

Clint Mathis 5' 10", 170 lbs. (b. November 25, 1976 in Conyers, Georgia). Forward with the New York/New Jersey MetroStars of Major League Soccer. In 2001 he was chosen for the U.S. National Team. At the beginning of the 2001 season, he led the league in scoring and assists and will play for the U.S. National Team competing in the 2002 World Cup finals.

Photographed May 7, 2001 in New York, New York

Rulon Gardner
Wrestling

Kerry McCoy 6' 2", 250 lbs. (b. August 2, 1974 in Riverhead, New York). Freestyle wrestler in the 130 kg (286 lbs.) heavyweight class. He was the U.S. national champion in 2000 and 2001, Olympic Trials champion in 2000, and World Team Trials champion in 2001. He finished fifth in the Sydney Olympics. At the 2001 World Championships he finished fourth. At Penn State University, he was 1994 and 1997 NCAA heavyweight champion.

Photographed July 27, 2000 at the Olympic Training Center, Colorado

Lincoln McIlravy 5' 8", 152 lbs. (b. July 17, 1974 in Rapid City, South Dakota). Freestyle wrestler in the 69 kg (152 lbs.) lightweight class. He was U.S. national champion from 1997 through 2000, Olympic Trials champion in 2000 and World Team Trials champion from 1997 through 1999. At the Sydney Olympics in 2000 he won a bronze medal. He was a three-time NCAA champion between 1993 and 1997, competing for the University of Iowa.

Photographed July 27, 2000 at the Olympic Training Center, Colorado

and the bronze in 1995 and 1997. In 1997, she was world indoor champion. She is a three-time U.S. outdoor 400m champion and a two-time U.S. outdoor 800m champion. In 2001, she was U.S. indoor 800m champion.

Photographed February 5, 2000 in New York, New York

Inger Miller 5' 4", 120 lbs. (b. June 12, 1972 in Los Angeles, California). 100m and 200m sprinter with personal bests of 10.79 and 21.77. In 1999 she won the 200m and was runner-up in the 100m at the World Championships. At the 1996 Olympics she was fourth in the 200 and won a gold medal with the 4 x 100m relay team. She was a member of the gold-medal U.S. 4 x 100m relay team in the 2001 World Championships.

Photographed January 10, 2001 in Los Angeles, California

Shannon Miller 5' 0", 97 lbs. (b. March 10, 1977 in Rolla, Missouri). Gymnast who has won more Olympic and World Championship medals than any

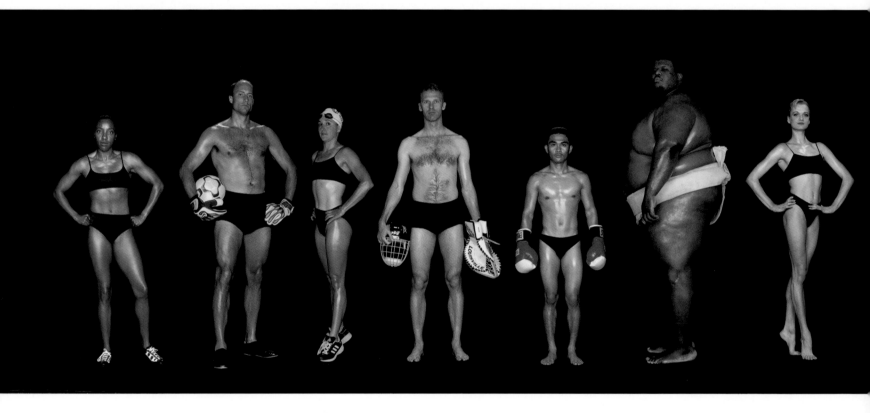

Donica Merriman 5' 10.", 135 lbs. (b. January 24, 1979 in Dayton, Ohio). 100m hurdler. While at Ohio State University, she was a five-time NCAA All-American. She is the Ohio State record holder in four events, the 100m hurdles, 100m and 200m sprints and the 4 x 100m relay. In 2000 and 2001, she was Ohio State Female Athlete of the Year. She was Big Ten Athlete of the Year in 2000 and NCAA 100m hurdles champion in 2001. She was a member of the 2001 U.S. World Championship team.

Photographed June 22, 2001 in Eugene, Oregon

Jearl Miles-Clark 5' 7", 127 lbs. (b. September 4, 1966 in Gainesville, Florida). 400m and 800m runner. Her 800m personal best (1:56.40) is the American record. She is a three-time Olympian, competing in 1992, 1996 and 2000. She won a gold medal with the 4 x 400m relay team in 1996 and 2000, and a silver medal in 1992. She won the gold medal in the 400m in the 1993 World Championships

other American gymnast, male or female. She won two gold medals at the 1996 Olympics, and two silver and three bronze medals at the 1992 Olympics. She is the only American to win two all-around world championships with two gold medals in 1994 and three gold medals in 1993.

Photographed November 20, 2000 in New York, New York

Delisha Milton 6' 1", 172 lbs. (b. September 11, 1974 in Riceboro, Georgia). Forward with the Los Angeles Sparks basketball team. She was a member of the gold medal-winning team at the 2000 Olympics and the 1998 World Championships as well as Sparks 2001 WNBA Championship team. She ranks third among all-time World Championship competitors from the U.S. for field goal percentage (64.3 percent).

Photographed August 29, 2000 in Honolulu, Hawaii and October 16, 2000 in New York, New York

Inger Miller	Kasey Keller	Jennifer Gutierrez	Dominik Hasek	Brian Viloria	Emanuel Yarbrough	Svetlana Khorkina
Sprint (100m, 200m)	Soccer	Triathlon	Hockey	Boxing	Sumo	Gymnastics
5' 4" 120 lbs.	6' 2" 180 lbs.	5' 3", 115 lbs.	6' 1", 174 lbs.	5' 2", 106 lbs.	6' 8", 700 lbs.	5' 5", 105 lbs.

Jonny Moseley 5' 11", 178 lbs. (b. August 27, 1975 in San Juan, Puerto Rico). Skier who specializes in the freestyle moguls event. He won the gold medal in the 1998 winter Olympics. He also won the gold medal in moguls at the 1998 World Cup. He has a total of 17 World Cup wins in his career.

Photographed on June 2, 2001 in Marin County, California

"Sugar" Shane Mosley 5' 9", 147 lbs. (b. September 7, 1971 in Los Angeles, California). He was the International Boxing Federation lightweight (137 lbs.) world boxing champion, successfully defending his title five times in 1998 — all by knockout. He was named "Fighter of the Year" by the Boxing Writers Association of America. In 1999, he became a welterweight (147 lbs.) and on June 17, 2000, he defeated Oscar De La Hoya for the World Boxing Council welterweight championship. He has successfully defended his title three times, winning all by knockout. His career record as professional is 38–0, with 35 by knockout.

Photographed August 14, 2001 in Brooklyn, New York

Vincent Muñoz 5' 9", 165 lbs. (b. July 19, 1969 in Zacatecaz, Mexico). Handball player. He is the 2001 national three-wall and four-wall champion, ranked #3 on the U.S. Handball Association (USHA) Pro Tour. Muñoz has won the singles event at the last six U.S. National Championships (1996 through 2001).

Photographed August 23, 2001 in Commerce, California

LeShundra Dedee Nathan 5' 11", 175 lbs. (b. April 20, 1968 in Birmingham, Alabama). Heptathlete who competes in seven track and field events — the 100m hurdles, high jump, shot put, long jump, javelin throw, and the 200m and 800m runs. In 2000 and 2001 she was the United States champion; and in 1999 she won the gold medal at the World Indoor Championships in the five-event pentathlon. She won the gold medal at the Pan American Games in 1991 and a silver medal in the Goodwill Games in 1998. She was ranked #1 in the United States in 1999 and 2000.

Photographed June 23, 2001 in Eugene, Oregon

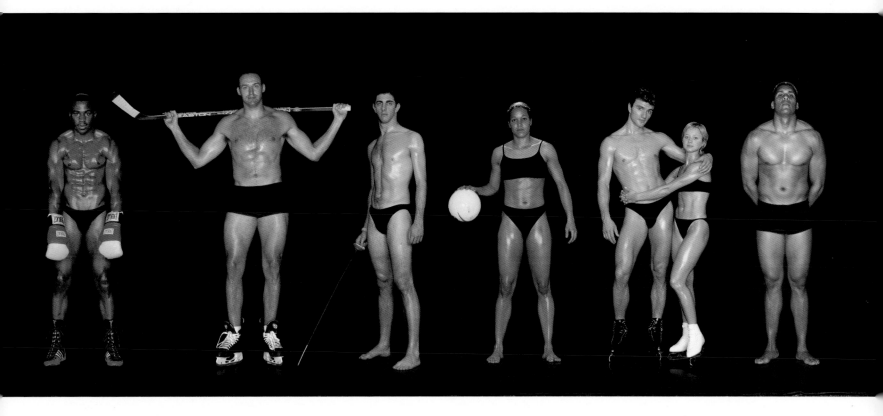

Alonzo Mourning 6' 10", 261 lbs. (b. February 8, 1970 in Chesapeake, Virginia). Center for the Miami Heat basketball team. He is among the National Basketball League's leaders in blocked shots, field goal percentage, and rebounds per game. He has been an NBA All-Star five times and he was a member of the gold medal USA Basketball team in the 2000 Olympics in Sydney.

Photographed July 10, 2000 in Miami, Florida

Aimee Mullins 5' 8", 105 lbs. (b. July 20, 1975 in Allentown, Pennsylvania). Disabled sprinter and long jumper (below the knee, bilateral amputee) with personal bests of 14.81 in the 100m, 30.02 in the 200m, and 4.36m in the long jump. She set world records in all three events. While in college, she was the first-ever disabled member of the NCAA Division One track team.

Photographed November 14, 2001 on Coney Island, New York

Adam Nelson 6' 0", 255 lbs. (b. July 7, 1975 in Atlanta, Georgia). Shot putter whose personal best of 72' 7" won the U.S. Olympic Trials for the 2000 Games. It was the longest throw in the world in ten years. That year he also won five international meets and the silver medal in the Sydney Olympics. In 2001, he won the gold medal at the U.S. Indoor Championships and a silver medal in the World Indoor Championships; and he placed second in the U.S. National Outdoor Championships and in the World Outdoor Championships.

Photographed March 28, 2001 in New York, New York

Alexei Nemov 5' 4", 141 lbs. (b. May 28, 1976 in Barashevo, Russia). The most decorated male gymnast of the last two Olympics; in 1996, he won two gold, one silver and three bronze medals; in Sydney, in 2000, he won two gold medals including the all-around title, and one silver and three bronze medals.

Photographed November 21, 2000 on Long Island, New York

Jeff Lacy	Jason Allison	Cliff Bayer	Saskia Webber	Anton Sikharulidze & Elena Berezhnaya	Donnie Edwards
Boxing	Hockey	Fencing	Soccer	Figure Skating	Football
5' 11", 168 lbs.	6' 3" 223 lbs.	6' 1", 170 lbs.	5' 9", 145 lbs.	6' 0" 167 lbs.; 5' 0" 92 lbs.	6' 2" 227 lbs.

Marty Nothstein 6' 2", 215 lbs. (b. February 10, 1971 in Allentown, Pennsylvania). Cyclist who specializes in sprint races on the velodrome track. He won a silver medal in the match sprint in the 1996 Olympics, and a gold medal in the 2000 Olympics, the first American cyclist in 16 years to do so. He has won the gold medal three times at the World Track Cycling Championships, the silver medal twice, and the bronze twice. He has been U.S. national track cycling champion 22 times. In 1996, he was the #1 male cycling sprinter in the world. He holds the world record for 500m. He won three gold medals at the 1999 Pan American Games.

Photographed May 3, 2000 in New York, New York

Tara Nott 5' 1", 105 lbs. (b. May 10, 1972 in Stilwell, Kansas). Weightlifter competing in the 48 kg (105.6 lbs.) weight class, the lightest for women. She won a gold medal at the 2000 Olympics when women's weightlifting made its Olympic debut, equaling her American record with a total of 185.0 kg (407 lbs.). Her American record in the snatch is 82.5 kg (181.5 lbs.) and in the clean and jerk 102.5 kg (225.5 lbs.). She is a four-time U.S. champion, the Pan American Games champion of 1999, and she placed in the top ten in World Championships three times. She is only the second American woman to lift twice her body weight.

Photographed August 1, 2000 at the Olympic Training Center, Colorado

Dan O'Brien 6' 2", 185 lbs. (b. July 18, 1966 in Portland, Oregon). Decathlete competing in ten track and field events. He won the Olympic gold medal in 1996; he was ranked #1 in the world six times between 1991 and 1998. He was world champion three times, U.S. national champion five times between 1991 and 1995, and Goodwill Games champion twice. He is currently in training for the 2004 Olympics in Greece.

Photographed May 28, 2001 in Marin County, California

Maureen O'Toole 5' 11", 140 lbs. (b. March 24, 1961 in Long Beach, California). Water polo player. She won a silver medal in the 2000 Olympic Games, when women's water polo was included for the first time. She is a six-time Most Valuable Player in the World Championships and a five-time U.S. Water Polo Female Athlete of the Year. She joined the U.S. national team in 1978 at age 17 and was a member of the first place World Cup team in 1978, and second-place teams in 1980, 1983, 1984, and 1989.

Photographed December 20, 2000 in Marin County, California

Terrell Owens 6' 3", 226 lbs. (b. December 7, 1973 in Alexander City, Alabama). Wide receiver for the San Francisco 49ers football team. He set an NFL record with 20 receptions against Chicago (12–17) on December 17, 2000, which broke a 50-year-old record. He established career highs with 67 catches for 1,097 yards and 14 touchdowns, in 1998 and 97 catches for 1,451 yards and 13 touchdowns in 2000. Owens was a member of the Pro Bowl team in the 2000 season. He has scored 58 touchdowns since 1996.

Photographed December 19, 2000 in San Francisco, California

Jennifer Parilla 5' 1", 120 lbs. (b. January 9, 1981 in Newport Beach, California). Trampolinist who is an eight-time U.S. national champion in the trampoline, the double-mini and the synchronized trampoline events. She was the only U.S. Olympian for the trampoline event at the 2000 Olympic Games, finishing ninth. She is a three-time World Championships medalist.

Photographed January 11, 2001 at Rancho Santa Margarita, California

Jimmy Pedro 5' 9", 161 lbs. (b. October 30, 1970 in Danvers, Massachusetts). Judo champion in the 73 kg weight class. He is a Fifth Degree Black Belt, a five-time U.S. national champion, a four-time gold medal winner in the U.S. Olympic Festival, a gold medal winner at the Pan American Games in 1995 and 1999, and the 1999 World Judo champion. In 1991 and 1995, he won bronze medals at the World Championships. He also won a bronze medal at the 1996 Olympics and finished fifth in the 2000 Olympic Games.

Photographed June 12, 2000 in New York, New York

Robert Porcher III 6' 3", 282 lbs. (b. July 30, 1969 in Wando, South Carolina). Defensive end with the Detroit Lions football team. He was voted to his first Pro Bowl following the 1997 season. He had double-digit sack totals from 1996 through 1999. In 1999, he had a career-high 15 sacks.

Photographed May 18, 2001 in New York, New York

Suzy Powell 5' 11", 170 lbs. (b. September 3, 1976 in Modesto, California). Discus thrower with a personal best of 214' 3" (65.30m) — her winning throw at the Modesto Relays in 2000. In 2001, she finished second in the U.S. National Championships. She still holds the national high school record for the discus and was the 1994 *Track & Field News* High School Athlete of the Year. She was U.S. junior champion in 1993, 1994, and 1995. In 1995, she won the gold medal at the Pan American Junior Championships; in 1996 she was the Olympic Trials champion. While she was a student at UCLA, she won both the discus and the javelin throw at the 1997 Pac-10 meet.

Photographed June 22, 2001 in Eugene, Oregon

Connie Price-Smith 6' 3", 210 lbs. (b. June 3, 1962 in St. Charles, Missouri). Shot putter with a personal best of 64' 3.75". She is a four-time Olympian, an eleven-time U.S. outdoor national champion, a seven-time U.S. indoor national champion and a two-time Pan American Games champion. She won the Olympic shot put trials three times. She won a silver medal in the 1995 World Indoor Championships and a bronze medal in the 1998 World Cup. Through 1994, she was also a six-time national outdoor title winner in the discus and two-time winner of the Olympic discus trials. She took fifth place in the shot put in the 1996 Olympics. Price-Smith's silver medal in the shot put at the World Indoor Championships in 1995 is the best performance by an American woman in the event at an Olympics or World Championship. Price-Smith is the head track coach at Southern Illinois University.

Photographed February 5, 2000 in New York, New York

Daron Rahlves 5' 9", 175 lbs. (b. June 12, 1973 in Walnut Creek, California). Ski racer who specializes in the downhill and super-G speed events. In 2000, Rahlves won his first two World Cup downhills within 24 hours. In 2001 he won the super-G at the World Championships in St. Anton, Austria. He is a two-time U.S. giant slalom champion, a U.S. super-G champion, and the 2001 downhill champion. He was also a world jet-ski champion in 1993 before he began to concentrate on ski racing full-time.

Photographed October 17, 2001 in New York, New York

Darrell Russell 6' 5", 325 lbs. (b. May 27, 1976 in Pensacola, Florida). Defensive tackle for the Oakland Raiders football team, named to the Pro Bowl in 1998 and 1999. In 1998, he had 64 tackles. In college, he was a *USA Today* All-American, Gatorade State Player of the Year, *Parade* and Blue Chip All-American, and CIF Defensive Player of the Year. He also lettered four years in basketball and track.

Photographed February 27, 2001 in Santa Monica, California

Cathy Sassin 5' 6", 138 lbs. (b. November 25, 1962 in Syracuse, New York). Adventure racer who has trekked across the deserts of Utah and South Africa, the volcanoes of Ecuador, and the glaciers of British Columbia and Patagonia. She has bushwhacked through Maine and New Zealand, explored caves in Borneo and the Philippines, and raced through Brazil and Australia in canoes and on horseback. The objective of adventure racing is to get teams to race nonstop across more than 500 miles of jungles, deserts, and glaciers. Each competitor is required to mountain bike, kayak, canoe, climb, rappel, and trek to conquer challenging terrain. Sassin has scored five victories in team adventure racing.

Photographed February 26, 2001 in Santa Monica, California

Tasha Schwikert 5' 1.5", 110 lbs. (b. November 21, 1984 in Las Vegas, Nevada). Gymnast who started competing with the U.S. national team at age 12. She became the top female gymnast in the United States when she won the all-around title at the 2001 U.S. National Championships. In the 2001 World Championships,

she placed fifth all-around and won the bronze medal in the team competition. In 2000, she was a member of the U.S. team at the Olympics in Sydney.

Photographed August 25, 2001 in Las Vegas, Nevada

Danielle Scott 6' 2", 185 lbs. (b. October 1, 1972 in Baton Rouge, Louisiana). Volleyball player. Middle blocker on U.S. Olympic team in 1996 and 2000. She was a member of the bronze medal-winning U.S. team at the Pan American Games in 1999. In January of 2000, the team qualified for the 2000 Olympics by winning the North American/Central American/Caribbean (NORCECA) Championships where she was named Most Valuable Player. In 2001 the U.S. team won first place in the World Championships qualifying round, the Grand Prix and the NORCECA Championships.

Photographed July 28, 2000 at the Olympic Training Center, Colorado

Adam Setliff 6' 4", 270 lbs. (b. December 15, 1969 in El Dorado, Arkansas). Discus thrower with a personal best of 227' 10", set in 2001. He is a two-time U.S. champion and a two-time Olympian. He finished fifth at the 2000 Olympics and at the 2001 World Championships. He was ranked #1 in the United States in discus in 2000 and 2001.

Photographed February 28, 2001 in Los Angeles, California

Brandon Slay 5' 8", 167 lbs. (b. October 14, 1975 in Amarillo, Texas). Freestyle wrestler in the 76 kg (167.5 lbs.) weight class. Slay won the gold medal in freestyle wrestling at the 2000 Olympics in Sydney. He won the gold medal at the 2000 U.S. National Championships. He was a two-time NCAA finalist for the University of Pennsylvania.

Photographed December 12, 2000, in New York, New York

Michael Smedley 5' 11", 155 lbs. (b. October 6, 1973 in Niles, Michigan). Triathlete in his fourth year as a professional. Smedley has finished in the top three on the international triathlon circuit 11 times between 1997 and 2001, taking first place 3 times. He won a silver medal in the 1999 Pan American Games.

Photographed October 8 and 15, 2001 in New York, New York

Katie Smith 5' 11", 173 lbs. (b. June 4, 1974 in Logan, Ohio). Guard with the Minnesota Lynx basketball team. She is ranked first in the WNBA in points per game, three-point field goals, and minutes played per game. She was a WNBA All-Star Game western conference team member in 2000. Competing on the U.S. national team, she won gold medals in the 1994 Goodwill Games, 1998 World Championships, 1999 U.S. Olympic Cup, and the 2000 Olympics. While at Ohio State University she was named 1996 Big Ten Conference Player of the Year.

Photographed August 30, 2000, in Honolulu, Hawaii

Annika Sorenstam 5' 5", 120 lbs. (b. October 9, 1970 in Stockholm, Sweden). Golfer who was the best female golfer in the world in 2001, winning 8 tournaments out of 25 and finishing in the top ten 20 times. She was also the top-ranked women's professional golfer in the world in 1995, 1997, and 1998. She has won 31 titles since she joined the Ladies Professional Golf Association (LPGA) in October 1993. She has won the Rolex Player of the Year title four times, set the LPGA record for lowest scoring average for a single season, and became the only LPGA player to shoot a 59 in a competitive round of golf. Sorenstam set the LPGA single-season earnings record in 2001.

Photographed July 10, 2000 in New York, New York

Staciana Stitts 5' 10", 140 lbs. (b. September 12, 1981 in Columbus, Ohio). Breaststroke swimmer who earned a gold medal swimming the breaststroke leg of the 400m medley relay at the 2000 Olympics. Her personal bests are 31.24 in the 50m, an American record; 1:07.79 in the 100m; and 2:19.65 in the 200m. In 2001, she won a bronze medal at the Goodwill Games as a member of the 400m medley relay team. She is a Pan American Games record-holder in the 100m.

Photographed December 20, 2000 in Marin County, California

Stacy Sykora 5' 10", 135 lbs. (b. June 24, 1977 in Fort Worth, Texas). Volleyball player with the U.S. national team who also plays professionally in Italy. In 2001, the U.S. team placed first in the Grand Prix, the North America/Central America/Caribbean (NORCECA) Championships, and the World Championship Qualifying rounds. She won the Best Receiver Award at NORCECA. In 2000, she played on the U.S. team in the Olympics, and won the Best Digger award at the World Championships in Japan in 2001.

Photographed July 28, 2000 at the Olympic Training Center, Colorado

Wally Szczerbiak 6' 7", 244 lbs. (b. March 5, 1977 in Madrid, Spain). Shooting guard with the Minnesota Timberwolves basketball team. He was named to the 1999–2000 All-Rookie first team and was named Most Valuable Player, scoring 27 points. He was a member of the 1998 U.S. basketball team that won the gold medal in the Goodwill Games. He also played on the gold-medal-winning U.S. basketball team at the Tournament of the Americas in 1999.

Photographed May 31, 2000 in New York, New York

Dara Torres 6' 0", 150 lbs. (b. April 15, 1967 in Beverly Hills, California). Freestyle and butterfly swimmer. She won five medals at the 2000 Olympics in Sydney and is the only U.S. woman to swim in four Olympics, winning a total of nine Olympic medals — four gold, one silver, and four bronze. In the 2000 Games, at age 33, she became the oldest female medalist in the history of U.S. swimming. She won 13 U.S. national titles, eight in the 50m freestyle, four in the 100m free and one in the 200m free. She is the American record holder in the 50m freestyle, the 100m freestyle and the 100m butterfly.

Photographed March 13, 2001 in New York, New York

Sean Townsend 5' 4", 135 lbs. (b. January 20, 1979 in Temple, Texas). Gymnast who is the 2001 U.S. national champion in the all-around, the floor exercise, the still rings, and the parallel bars. At the 2001 World Championships, he won the gold medal on the parallel bars and the silver in the team event. In 2000, he was a member of the U.S. national team at the Olympics in Sydney.

Photographed December 4, 2001 in New York, New York

Terrence Trammell 6' 2", 175 lbs. (b. November 23, 1978 in Atlanta, Georgia). 110m hurdler. He won the silver medal at the 2000 Olympics and a gold at the 2001 Indoor World Championships. In 1999, he won the hurdles at the NCAA indoor and outdoor championships and the World University Games. He was named 1997 *Track & Field News* Male High School Athlete of the Year.

Photographed February 1, 2001 in New York, New York

Brian Viloria 5' 2", 106 lbs. (b. November 24, 1980 in Honolulu, Hawaii). Boxer. He was 2000 Olympic Trials champion, 1999 U.S. champion, National Golden Gloves champion, and world champion. In 1995 and 1996 he was Junior Olympic champion. Viloria made his professional debut in May 2001, moving up to the 112 lbs. flyweight class, and is presently undefeated with a 3-0 record. Viloria was a member of the 2000 Olympic boxing team.

Photographed August 1, 2000 at the Olympic Training Center, Colorado

Vadim Vinokur 5' 8", 140 lbs. (b. March 19, 1976 in Kharkov, Ukraine). Rock climber who has won four U.S. climbing national competitions and finished third at the 1998 X-Games. He was ranked #1 in the United States for two years in a row. In 2000, Vinokur successfully scaled a limestone line on Mt. Potosi in Nevada — one that had never before been climbed.

Photographed March 12, 2001 in New York, New York

Ron Warren, Jr. 5'4", 115 lbs. (b. March 17, 1964, in Covina, California). Professional thoroughbred jockey who began racing in 1982 and won his first race (at Del Mar racetrack) on August 16, 1982, on just his fourth professional mount, Fabulous Too. He has consistently been ranked among the top ten riders and as one of the best turf riders in the nation. Warren has won many graded

stakes races including the 2000 California Derby aboard Bet on Red and the 2001 El Camino Real Derby aboard Hoovergetthekeys.

Photographed May 30, 2001 in San Mateo, California

Tyree Washington 6' 0", 180 lbs. (b. August 28, 1976 in Riverside, California). 200m and 400m sprinter. He won a bronze medal in the 400m and a gold medal as anchor for the 4 × 400m relay team at the 1997 World Championships. He is a member of the 4 × 400m relay team, which set the world record of 2:54.20 in the 1998 Goodwill Games. He also finished second in the 200m and 400m in the Goodwill Games. In 2001, he was undefeated in ten races.

Photographed June 23, 2001 in Eugene, Oregon

Saskia Webber 5' 9", 145 lbs. (b. June 13, 1971 in Princeton, New Jersey). Soccer goalkeeper with the Philadelphia Charge in the new WUSA league and the U.S. national team. She was on the 1999 Women's World Cup championship team, and on the 1995 World Cup team. She was named "Goalkeeper of the Decade, 1990–2000" by *Soccer America*.

Photographed April, 25, 2001 in New York, New York

Chris Wheir 6' 0", 203 lbs. (b. December 5, 1972 in Ashland, Wisconsin). Natural bodybuilder who earned his World Natural Bodybuilding Federation (WNBF) pro card when he won the 2000 Mr. Great Lakes Heavyweight Championship. In his first Mr. Pro International competition, in 2001, he finished sixth in the heavyweight division. In 1997, he was Midwest Wisconsin champion and Mr. Junior Wisconsin champion in the middleweight class. In 1998, he won the Mr. Wisconsin title in the heavyweight class, and was fourth in the Mr. United States Championship. In 1999 he was second in the Mr. America competition.

Photographed September 7, 2001 in New York, New York

Corey Wheir 5' 10", 205 lbs. (b. May 7, 1969 in Kewaunee, Wisconsin). Bodybuilder and a pro in the World Natural Bodybuilding Federation (WNBF). He began his career as an amateur in 1991 when he won the Mr. Southern California overall title. He was Mr. Northern California in 1992 and Mr. Wisconsin in 1994. He was second in the 1996 U.S. Championships, second in the 1996 U.S. Championships, and third in the 1997 Mid-States pro qualifier. He earned his WNBF pro card when he won the 1998 U.S. Championships as a heavyweight. From 1999 through 2001, he finished in the top five four times in major international championships, including third place in the Mr. Universe competition of 2000. He and his younger brother, Chris, are the first professional brothers in the WNBF.

Photographed February 12, 2000 and September 7, 2001 in New York, New York

Wolf Wigo 6' 2", 195 lbs. (b. May 8, 1973 in Abington, Pennsylvania). Water polo player, playing the position of driver, on the U.S. national team. He was a member of the Olympic teams that finished seventh in 1996 and sixth in 2000. He was the leading U.S. scorer in the 1999 World Cup and the 2000 Olympic Games and was named U.S. Water Polo Player of the Year in 1999 and 2000. In the 2000 Olympics, he had a shooting percentage of 64 percent, the highest in the Games. In 1997, he was a member of the team that won the La Federation Internationale De Natation (FINA) World Cup. While at Stanford University, he was a member of the NCAA Championship team in 1993 and 1994, a four-time All-American, and a National Scholar-Athlete.

Photographed August 30, 2001 in Marin County, California

Blaine Wilson 5' 4", 135 lbs. (b. August 3, 1974 in Columbus, Ohio). Gymnast. He was the first male gymnast to win five consecutive U.S. national titles (1996–2000). He was a member of the 1996 and 2000 Olympic teams. In 2000

at Sydney, he was the most successful American gymnast, male or female, placing sixth all-around. He won the all-around at the 2000 Senior Pacific Alliance in New Zealand. In 1999, he won all-around at the Visa American Cup. At the 1998 International Team Championship in Knoxville, Tennessee, he was first with the team and in all individual events.

Photographed November 20, 2000 in New York, New York

Emanuel Yarbrough 6' 8", 700 lbs. (b. September 6, 1964 in Jersey City, New Jersey). Sumo wrestler, certified fourth Dan by the Japanese Sumo Association. Yarbrough was a world champion in the Open Division in 1995. He was runner-up in 1992, 1994, and 1996, and finished third in 1993. He was North American champion in 1996 and 1997. While at Morgan State University, he was NCAA All-American in wrestling and NCAA Division I-AA All-American in football, playing defensive tackle.

Photographed June 6, 2000 in New York, New York

Tabitha Yim 4' 8", 85 lbs. (b. November 2, 1985 in Los Angeles, California). Gymnast who, in her first year of senior competition, finished second in the all-around at the 2001 U.S. National Championships while taking first in the floor exercise. She finished seventh all-around at the World Championships, taking a bronze medal in the team event. In the 2001 Pan American Championships she won the gold medal with the team and was third in the all-around. Yim is a competitive figure skater as well, training on the ice in the mornings and as a gymnast in the afternoons.

Photographed August 24, 2001 in Covina, California

David Zhuang 5' 10", 165 lbs. (b. September 1, 1963 in Guondung, China). Table tennis player who has played the game for 29 years and has been on the U.S. national team since 1995. He was U.S. national singles champion in 1994, 1995, 1998, and 2000, five-time U.S. national doubles champion, and six-time U.S. national mixed doubles champion. He also won gold medals at the Pan American Games for both men's singles and men's team's in 1999. He was a member of the 1996 and 2000 US Olympic teams.

Photographed October 10, 2001 in Princeton, New Jersey

George Vecsey (b. July 4, 1939 in Jamaica, New York). Sports writer for the *New York Times* since 1968. Vecsey has written and edited twenty books including: *Joy in Mudville*, a history of the New York Mets; *Loretta Lynn, Coal Miner's Daughter*, a bestseller that was made into the 1980 movie starring Cissy Spacek, *Martina*, the autobiography of Martina Navratilova, also a bestseller, and *A Year in the Sun*. In 1990, he collaborated with Barbara Mandrell on her autobiography *Get to the Heart*, a *New York Times* bestseller for 19 weeks. In 2001 he was inducted into the Hall of Fame of the National Association of Sportswriters and Sportcasters.

Ira Berkow (b. January 7, 1940 in Chicago, Illinois). Sports writer for the *New York Times* since 1981 and a freelance writer since 1976. He is the author of nineteen books, among them: *Red: A Biography of Red Smith*, the noted sports columnist; *Pitchers Do Get Lonely, and Other Sports Stories*; *Rockin' Steady: A Guide to Basketball and Cool*, with Walt Frazier; *Carew* with Rod Carew; and *Beyond the Dream*, a collection of sports columns. He was a runner-up for the 1988 Pulitzer Prize for distinguished commentary. He also wrote the HBO documentary film *Champions of American Sports*, which was a finalist for the cable ACE Award for Best Sports Documentary in 1983.

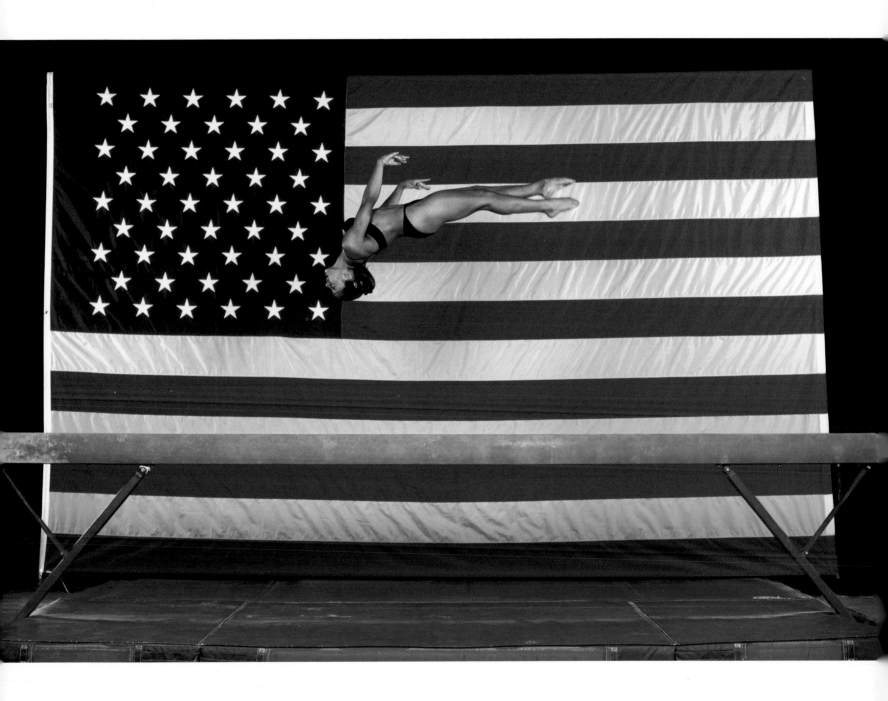

Tasha Schwikert
Gymnastics

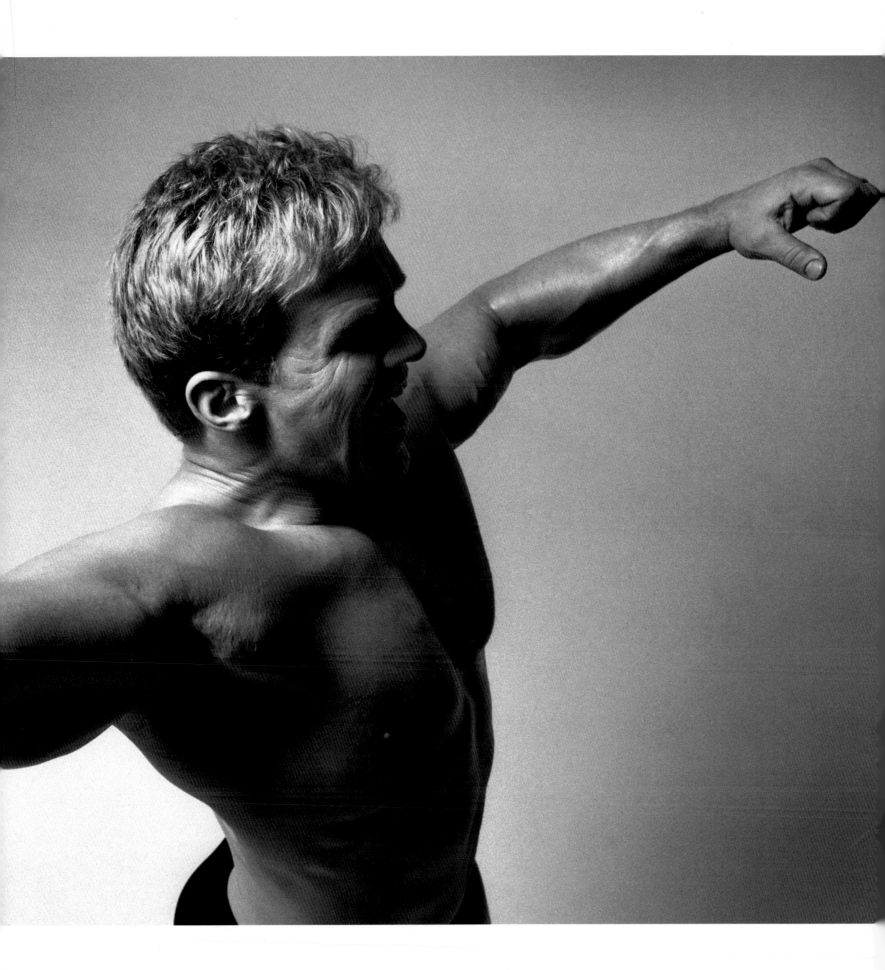

Adam Setliff
Discus
249

Acknowledgments

Agents

We are grateful to have had the cooperation of the following agents who
made it possible for us to work with this distinguished group of athletes.

Allan Houston Enterprises, Jocelyn Monroe; Capital Sports Ventures, Mark Higgins; D & F Group, Jeff Wexler;
Entertainers + Athletes Group, Denise White; Flynn Sports Management, Ray Flynn, Chris Layne; HSInternational, Caryn Nguyen,
Emanuel Hudson, John Smith; IMG , Jay Burton, Mark Ervin, Jeanne Miller, Sandy Montag, J. Ogden, Mark Steinberg, Gary Swain;
Indiana Invaders, Gregory J. Harger; ISA, Todd Diamond; Joseph Athletic Management, David Joseph; LeadDog Marketing Group,
Beth Jowdy; Management Plus, Cynthia Atterberry; Maximum Sports Management, Shelly Schmidt; Octagon, Cynthia Wilson,
Renaldo Nehemiah; Personalities & Promotions, Mary Knox; Pier Entertainment , Jacob Koo; Premier Management Group,
Evan Morgenstein; Pro Sports International, Caroline Feith; SFX Sports Group, L. Keenan Delaney, Cathy Fitzwater; Shade Global,
Jordan Dabby; Sport Inside Management, Peter Stubbs, Andy Stubbs; Sports Corporation, Steve Kotlowitz; SportsNet, Inc.,
Richard Motzkin, Scott Margolis; Stars & Strategy, Sue Rodin; Suttle Advisors LLC, Michael Suttle; Vector Sports Management,
Ashley Russell; White & Williams, Eric Hall; Wilhelmina Models, Kristi McCormick, Florence Spidalieri.

Steve Baker and Sasha Taylor; Jim Bush; Brooke Bushnell; Lisa Buster; Tony Campbell; Jeff Freedman; Yefim Furman;
Helen Karmansky; Sandra Khannouchi; Mary Knox; Bob Larsen; Ethan Lock; Bryant McBride; Tamara Moskvina;
John Nubani; Paul Parilla; Tom Ratcliffe; John Rizzuti; Anne Roberts; Cooper Schell; Craig Sharon; David Sloane;
Marcel Wouda; Debby Zealley.

Athletic Organizations

These organizations exist to facilitate the work of the athletes they
represent, but they went out of their way for us time and time again.

Association of Tennis Pros, Greg Sharko; German Volleyball Team, Hartmut Hellweg; Jockey's Guild; Miami Heat,
Tim Donovan; NBA; NFL Players Association, Carl Francis; New Jersey Nets, Leo Ehrline; San Francisco 49ers,
Chad Steele; San Francisco Giants, Peter Magowan; U.S. Handball Association, Vern Roberts; U.S. Olympic Committee, Barry King,
Mary Greenwood, John Krimsky; U.S. Rowing Association, Brett Johnson; U.S. Ski and Snowboard Association, Tom Kelly;
Speedskating; U.S. Tennis Association, Bruce Levy, Suzanne McGuire, Julio Guzman; USA Basketball,
Craig Miller; USA Boxing, Shilpa Bakre; USA Cycling, Rich Wanninger; USA Gymnastics, Courtney Caress; USA Rugby,
Scott Compton; USA Soccer, Pam Perkins; USA Swimming, Tarrah Smith; USA Track & Field, Craig Masback,
James Thornton, Tom Surber; USA Triathlon, BJ Evans, Steve Locke; USA Volleyball, Chris Stuart, Gavin Markovits;
USA Weightlifting, Jim Fox; USA Wrestling, Gary Abbott, Heather Vanpeursem; WNBA; Yankees & Nets, Harvey Schiller.

Venues

The following people and the venues which they represent gave us access to photograph. Their help was invaluable.

American Airlines Arena, Darlene Cooper; Baker Field, Columbia University, Albert Carlson; Bay Meadows Race Track, Tom Ferrell;
Ben Kitay Studios; C+C Die Engraving, Sal Chavez; ; Charter Oak Gymnastics-Gliders, Beth Kline and Steve Rybacki, Renee Garcia;
Chelsea Piers, Brad Fazzone; Comisky Park, David Orth; Del Mar Race Track, Dan Smith; Eastern National Academy, Craig Zappa;
Fourth Street Studios, San Francisco; Giants Stadium, The Meadowlands, Eric Stover, Henry Rzemieniewski; Gleason's Gym,
Bruce Silverglade, Chris Manger; Gymcats, Cassandra Rice; Gymnastics Team, USA, Michelle Gerlach; Gymnastique, Lori Perretta
and Dawn Wilensky; LaSalle High School, Tim Sceibe; New Jersey Table Tennis Club; Northwest Event Management, Tom Jordon;
Oceanside Studios, Los Angeles, CA; Riverbank State Park, Oscar Smith; San Francisco 49ers Training Camp, Kirk Reynolds;
San Francisco Giants — PacBell Park, Jorge Costa, Blake Rhodes, Aaron McCombs; San Rafael High School; Staten Island Skating Pavilion,
Steve DeCarlo, Sal Tirro; UCLA: Drake Stadium & Pauley Pavilion, Rich Mylin; University of Oregon, Eugene (Athletic Department);
Wrigley Field, Paul Rathje, Owen Deutsch; U.S. Olympic Training Center, Colorado Springs , Rick Minor, Jimi Flowers.

Photographic Equipment and Project Services

We appreciate all the support provided by the following companies and individuals.

Hensel Studiotechnik: Thomas Meyer, for the use of portable lighting equipment for our location shoots;
Kodak: Scott DiSabato, Darcy Eggers; Nikon: Lindsay Silverman; Hasselblad: Allan Zimmerman, Bob Finucane,
Richard Schleuning, Patrik Mark, Paul Claeson; Chimera: Eileen Healy, studio lighting banks;
Adobe: John Warnock and Mary Wright; Oliphant Backdrops: Sarah Oliphant, Adelaide Murphy Tyrol;
Creo-Scitex: Michal Adar; Sinar-Bron: Jim Reed; PhotoGroup Productions: Peter Strongwater, Mary Pratt;
Air Metro Helicopter: Pete Zanlugie; Steven Hellerstein; Tony Color: Kahn;
and Kathryn Shaughnessy of Calligraphics who donated all of the calligraphy for the project's "Book of Memories."

Athletic Equipment

These companies provided equipment for many of the athletes.

Atomic Racing Department, Eduardo Guzman; Benetton USA, Chris Fiorillo; Everlast Worldwide,
Adam Geisler; M-F Athletic Company, Al St. Jean; Omni Fitness Gym Source, Ron Miller;
TaylorMade Golf Company, Zack Smith; Julie Chandler, U.S. Marketing; UCS Equipment, Jim Grogan.

Special Thanks

We are grateful to the many other individuals who contributed to the
success of this project with their time, enthusiasm, skill and knowledge.

Dusty Baker, San Francisco Giants; Brenna Brittan, *EXPN Magazine*; Dick Button; Bud Collins, Anita Collins, the *Boston Globe*, NBC;
Donna De Varona. Women's Soccer World Cup; Frank Deford, *Sports Illustrated*; Anita DeFrantz, Amateur Athletic Foundation;
Harry Edwards, Ph.D.; David Esch; Peggy Fleming; Bill Frakes, *Sports Illustrated*; Jamal Gaines; Jamie Horowitz, NBC Sports;
Walter Iooss; Kipchoge Keino; Kristin Keller; Esmerelda Kent, Esmerelda Designs; Jerry Krause, Chicago Bulls; Anani Lawson;
Joe Madden, Goal Line Productions; John Madden; Glen Mathes, NY Racing Association; Sharon Monplaisir; Patrick Plevin, City of New
York, Department. of Film & Television; Joe Pobereskin; Terrence Ranger, Artists Untied; Jack Reznicki; Frank Robinson, Office of the
Commissioner of Baseball; Dick Schaap, ABC/New York Bureau; Howard Schneider, M.D.; David Specter, David K. Specter & Association;
Hannah Storm, NBC; Larry Stumes, *San Francisco Chronicle*; Martha Whetstone; Mike Wise, the *New York Times*.

Claudia Kahn, Senior Vice President, Merrill, Lynch & Co., Inc.;
Stephen Fine, Senior Photography Editor, *Sports Illustrated.*
Our grateful thanks to John Campbell, the publisher of The Wonderland Press.

Production Staff:
We could not have done this project without our studio staff, producers, archivist, assistants,
post-production experts and printers. Each made a unique and most important contribution to the project:

Anita Verschoth, Producer; Molly Nee, Location Producer; Monique Reddington, Archivist

Jennifer Hosier; Maryline Damour, Office Assistants

Assistants:
Ben Law-Viljoen; Virginie Blachere; Charles Eshelman; Chris Ryan; Pascale Treichler; Jeff Amurao; Alexander Bitar; Scott Clinton;
P. Cunningham; Michael Floyd; Pete Frey; Art Gallegos; Constance Giamo; Greg Habiby; Kathryne Hall; Jeremy Harris;
Keith Hedgecock; Sue Hudelson-Leland; Beth Huerta; Alice Jordan; Joseph Kaiser; John Keenan; Zandy Mangold; Chris Pendergast; Keith
Pitts; Dave Studerus; Carlin Sundell; Von Thomas; Jerry Vaughn; James Wall; Todd Williams; Alfeo Dixon, location scout.

Printing and Post-Production
Dimitris Dritsas
J. Maislich Mole; Micaela Rossato; Robert Mills; Nadia Georgiou,
Allison Malcolm
Olivier Robert, Russ Gorman, Adam Wiseman, Frank Marshal

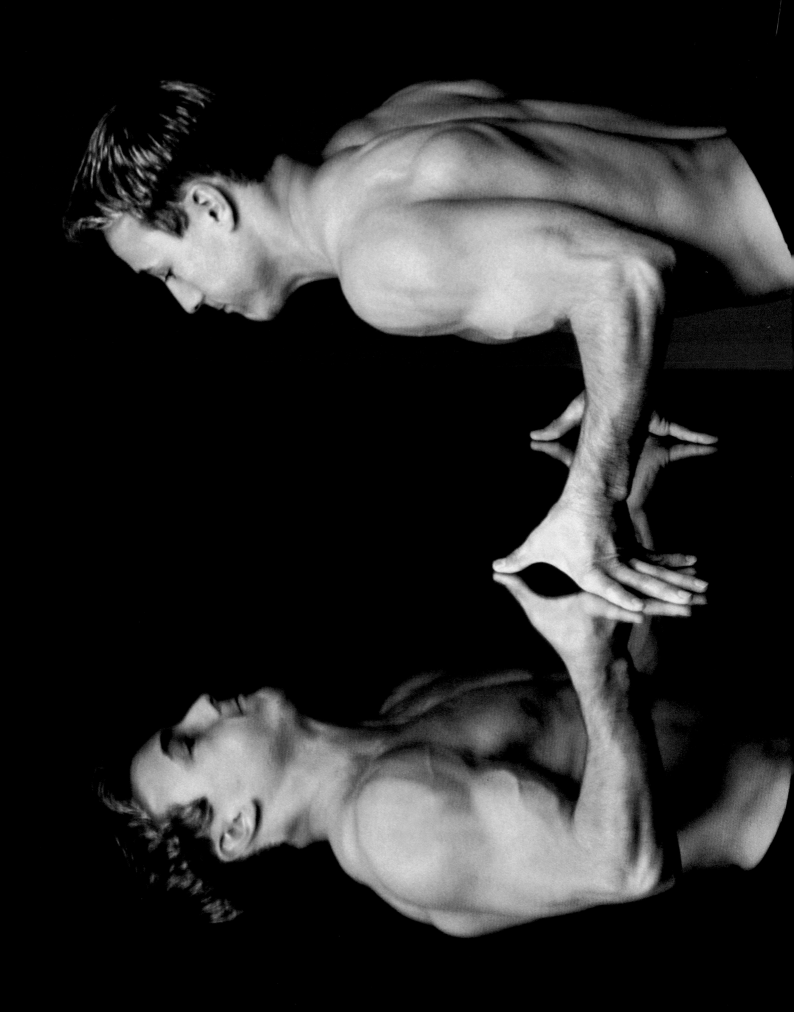

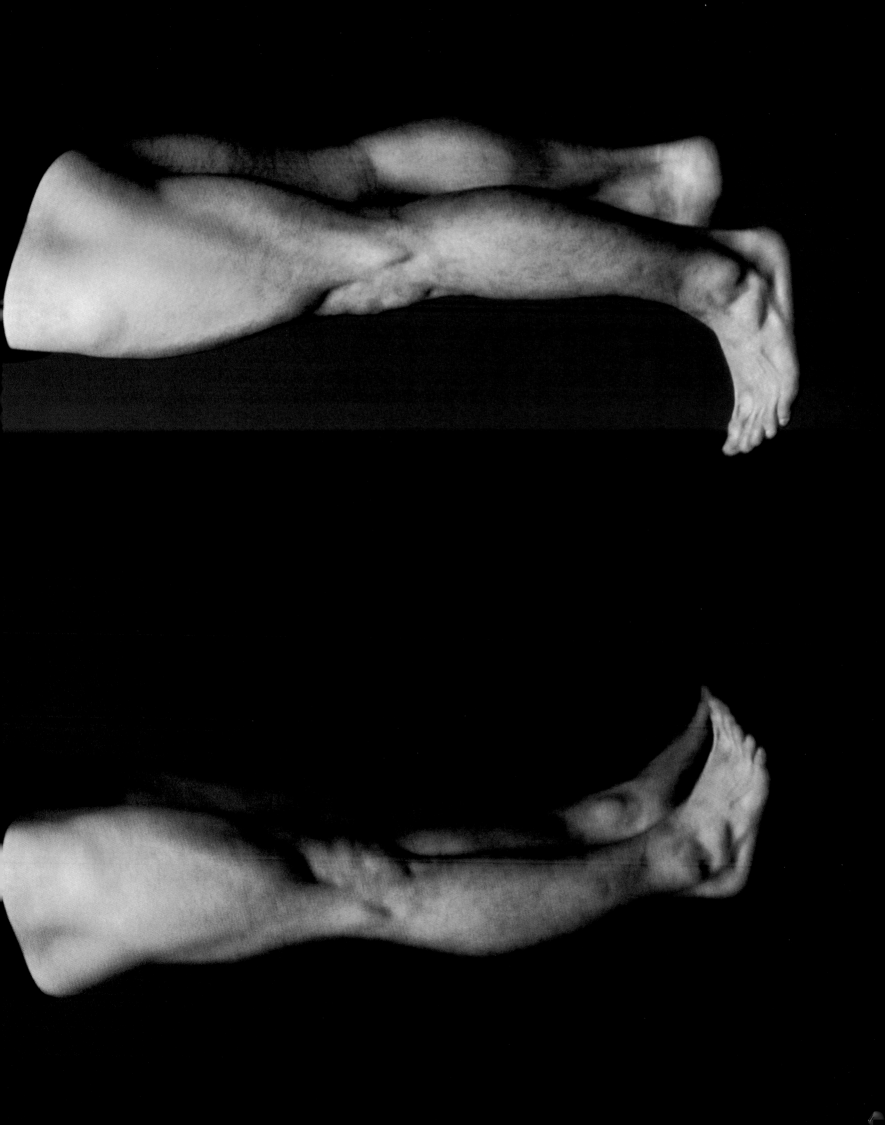

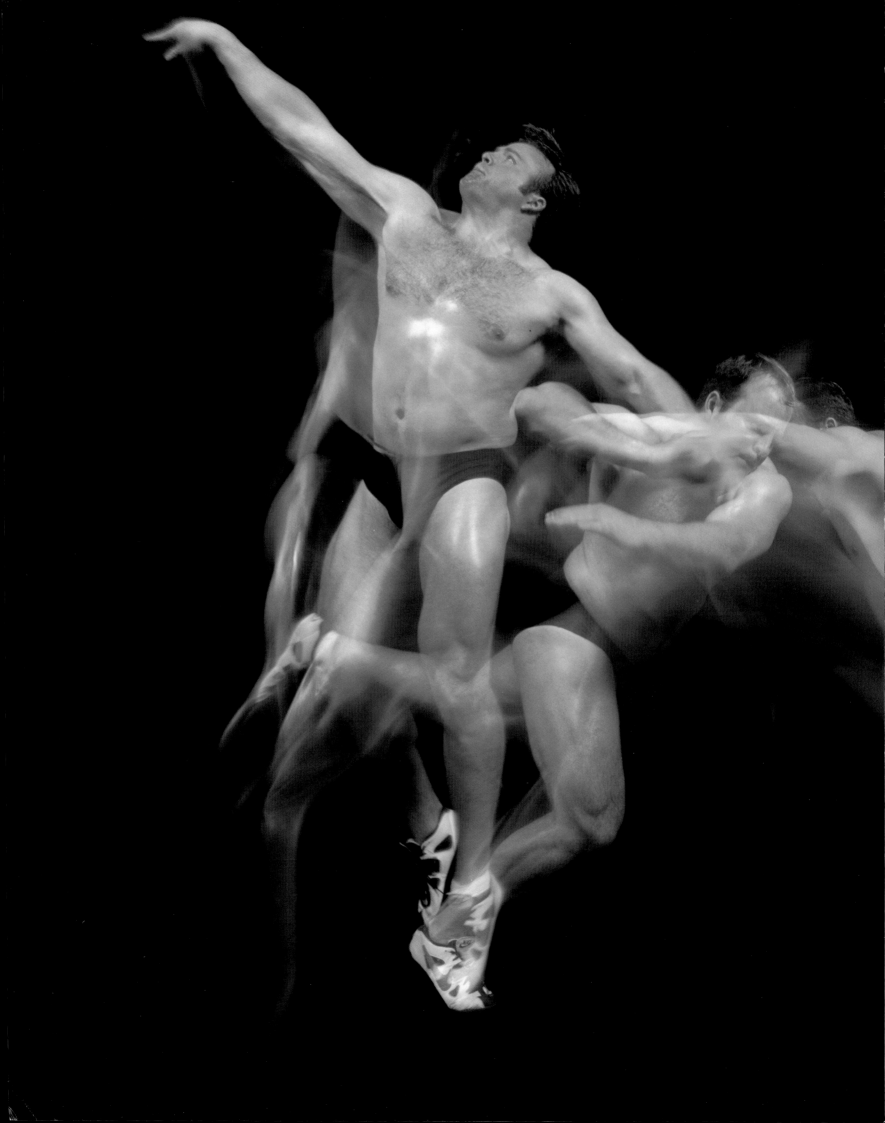

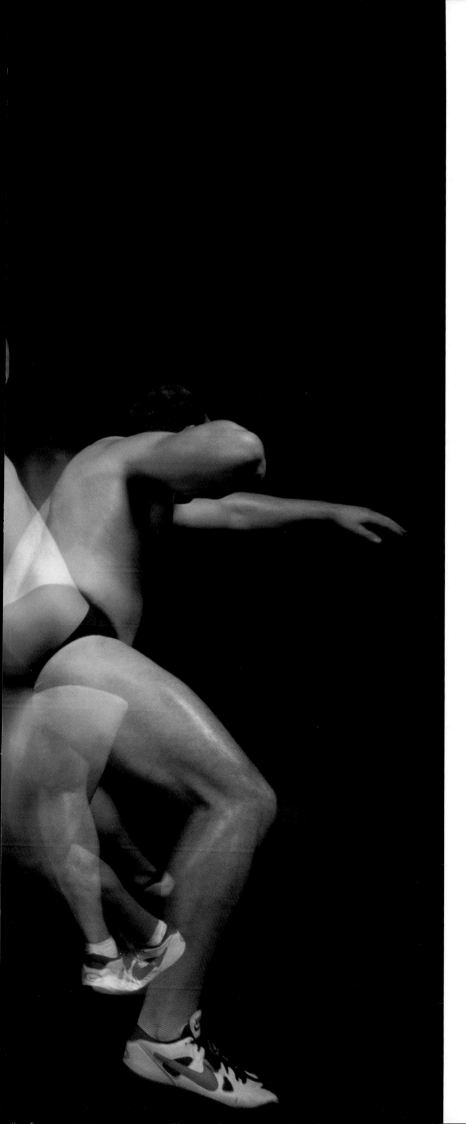

Adam Nelson
Shot Put

Sean Townsend
Gymnastics

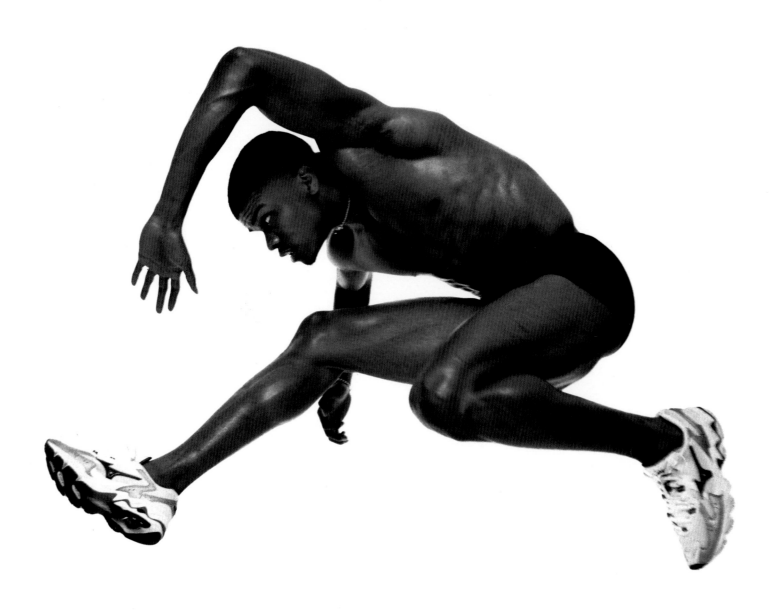

Terrence Trammell
Hurdles (110m)